P9-EKD-763

KITCHENS

CALGARY PUBLIC LIBRARY

MAR - - 2006

KITCHENS

Edited by Encarna Castillo

HARPER
DESIGN

An Imprint of HarperCollins*Publishers*

KITCHENS: GOOD IDEAS
Copyright © 2005 by HARPER DESIGN and LOFT Publications

First published in 2005 by:
Harper Design,
An Imprint of HarperCollins*Publishers*
10 East 53rd Street
New York, NY 10022
Tel.: (212) 207-7000
Fax: (212) 207-7654
harperdesign@harpercollins.com
www.harpercollins.com

Distributed throughout the world by:
HarperCollins International
10 East 53rd Street
New York, NY 10022
Fax: (212) 207-7654

HarperCollins books may be purchased for educational, business, or sales promotional use.
For information, please write: Special Markets Department, HarperCollins Publishers Inc.,
10 East 53rd Street, New York, NY 10022

Executive Editor:
Paco Asensio

Editorial coordination:
Encarna Castillo

Translation:
Wendy Griswold

Art Director:
Mireia Casanovas Soley

Graphic Design and Layout:
Cris Tarradas Dulcet

Library of Congress Cataloging-in-Publication Data

Castillo, Encarna
 Kitchens : good ideas / by Encarna Castillo.
 p. cm.
 ISBN 0-06-074977-6 (plastic-cover pbk.)
 1. Kitchens. 2. Interior decoration. 1. Title
 NK2117.K5C375 2005
 747.7'97--dc22

 2005007719

All rights reserved. No part of this book may be used or reproduced in any manner whatsoever,
without written permission except in the case of brief quotations embodied in critical articles and reviews.
For information, address Harper Design, 10 East 53rd Street, New York, NY 10022.

Printed by: Anman Gràfiques del Vallès
Spain
D.L: B-31.629-05

First Printing, 2005

Introduction

T HE kitchen is, perhaps, the place in the house that, along with the sleeping quarters, has most closely followed human evolution and has been adapted, century after century, to human needs, mirroring the lifestyle and customs of those who live in the home. Today's vertiginous changes in social habits have transformed the aesthetic of the kitchen and made it a bright space, mostly free of superfluous implements, with a minimalist style and functional features.

The model of the eat-in kitchen, consisting of an open area incorporated into the living room, or the whole residence if it's a small space, is being slowly but inexorably imposed on the traditional model of the kitchen as an self-contained space, separate from the rest of the home, which is especially typical of the European countries.

Along with this process, experimentation with different materials, such as stainless steel, and the renewed use of wood and composites, has given today's kitchens more aesthetic diversity and the opportunity to employ cutting-edge design concepts.

In addition to illustrating these concepts, this book offers examples of how to solve the problem of space shared by many big-city homes, and provides an overview of the concept of the traditional kitchen typical of small rural towns.

Types

TYPE refers to the spatial distribution model that each kitchen follows. There are numerous and varied types, but the four most common are presented here: kitchens located in self-contained spaces, separate from the rest of the home; open kitchens adjoining the living room or dining room; eat-in kitchens; and kitchens that include an island, usually found in the center of the space, which facilitates cooking by making more surface area available for utensils and centralizing the appliances.

The choice of one or another type of kitchen reflects cultural variations and different habits. For instance, self-contained kitchens are more typical of European countries such as France or Spain, which are more inclined to separate the different rooms of the home. Kitchens that are open to the dining room are more typical of Anglo-Saxon regions, such as England and the United States. Eat-in kitchens combine the cooking and eating areas, which is perhaps a reflection of a faster-paced life. Those with a central island are reminiscent of large industrial kitchens and have more work space.

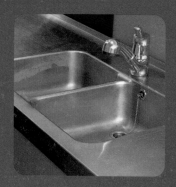

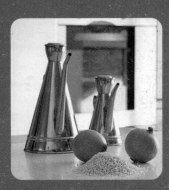

Self-contained

Adjoining the Dining Room

Island

Eat-in

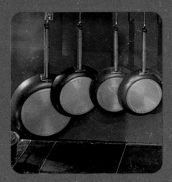

Self-contained

INDEPENDENT kitchens involve the visual isolation of a room of the home that some people feel should not be put on display. To many, the kitchen is a space as private as the bathroom or the bedroom.

The biggest problems with this type of kitchen are the lack of space and the difficulty in arranging the appliances and cabinets. However, it has the advantage of preventing odors and grease from pervading the home.

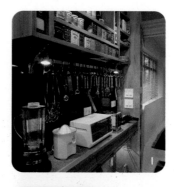

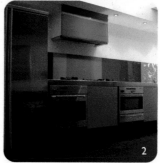

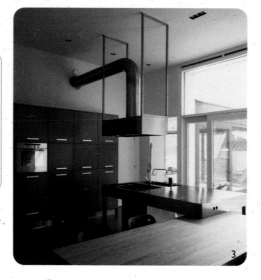

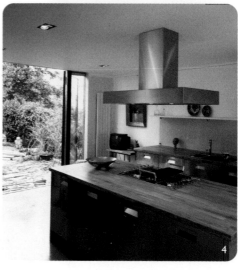

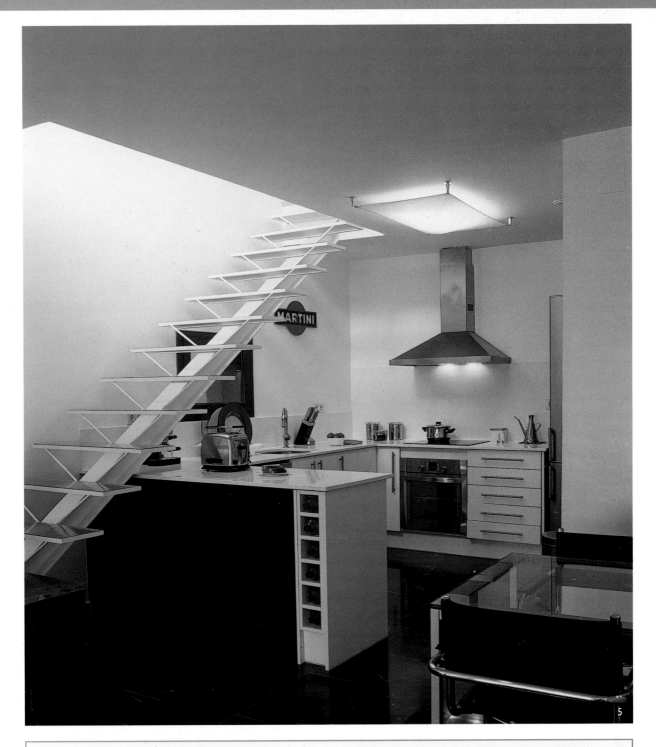

1 Architect: Guillermo Arias; Photographers: Pablo Rojas & Álvaro Guitiérrez

2 Architect: Fernando Rihl; Photographer: Fernando Rihl

3, 4 Architect: Asselberg Arch.; Photographer: Luuk Kramer

5 Architect: Ramón Berga; Photographer: Pep Escoda

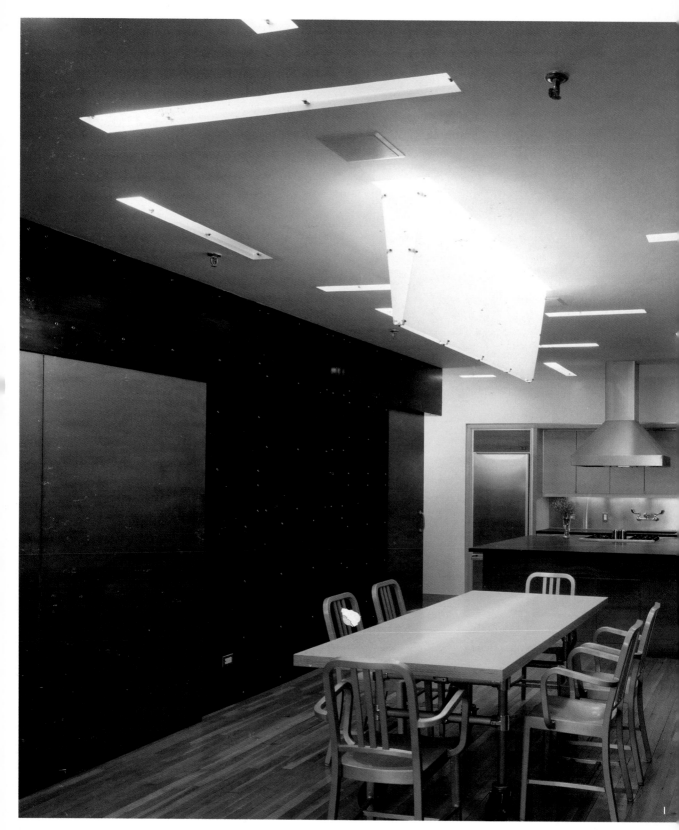

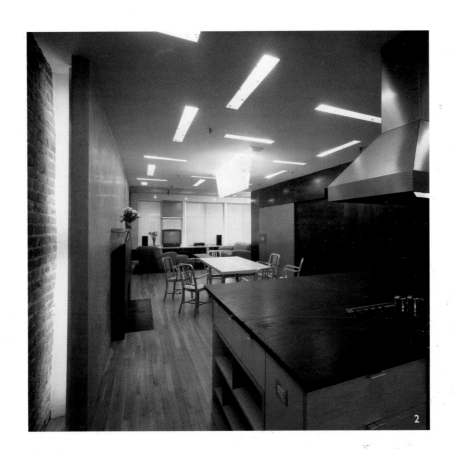

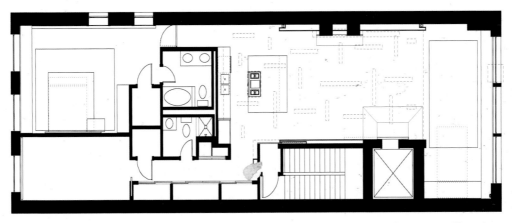

Floor plan

1, 2 Architect: Resolution 4 Architecture; Photographer: Eduard Hueber

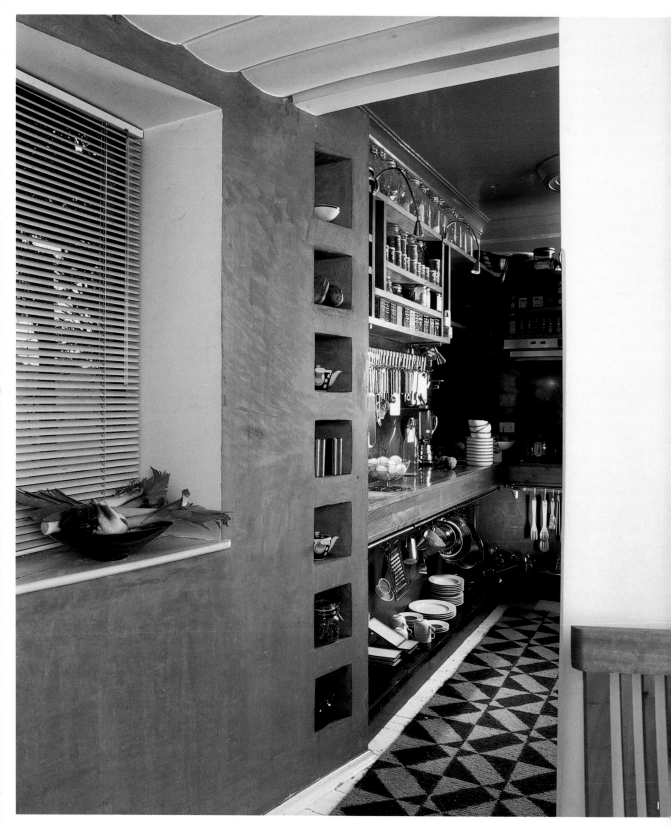

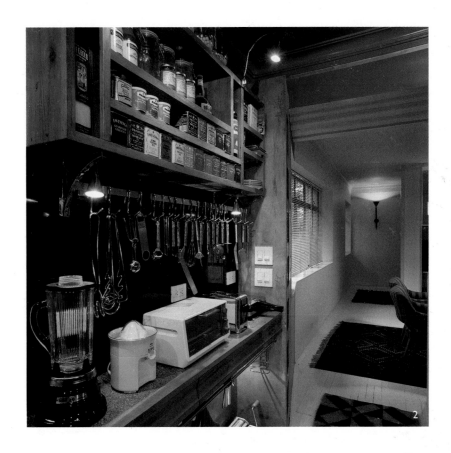

Elevations

1, 2 Architect: Guillermo Arias; Photographers: Pablo Rojas & Álvaro Guitiérrez

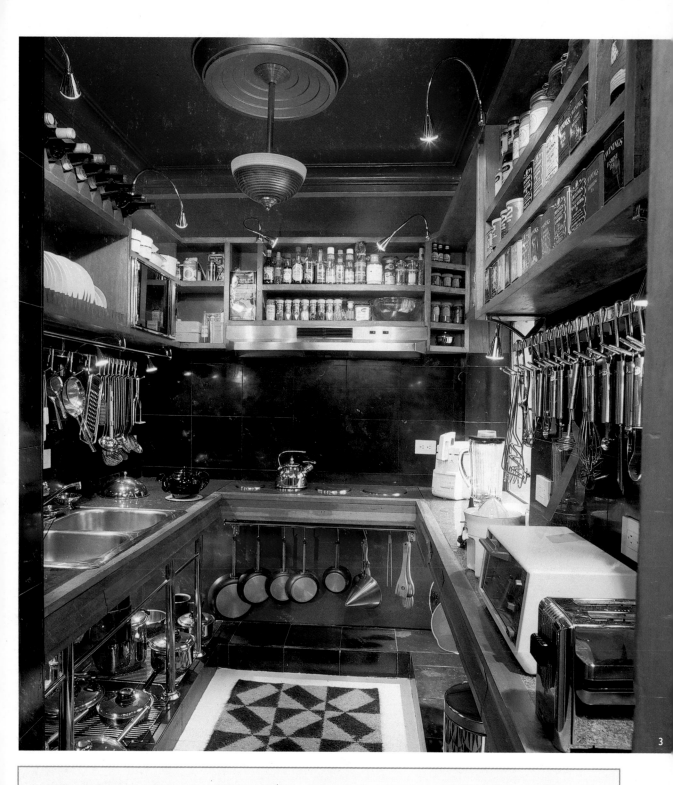

3 Architect: Guillermo Arias; Photographers: Pablo Rojas & Álvaro Guitiérrez

1 Architect: Fernando Rihl; Photographer: Fernando Rihl

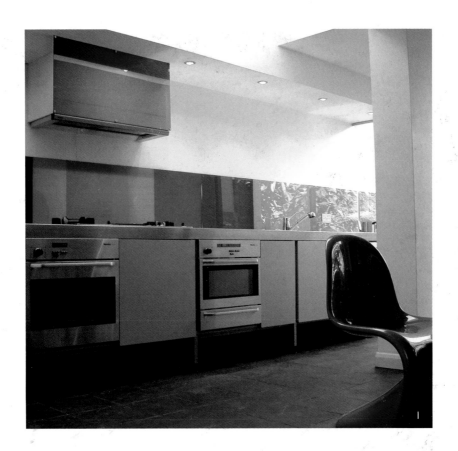

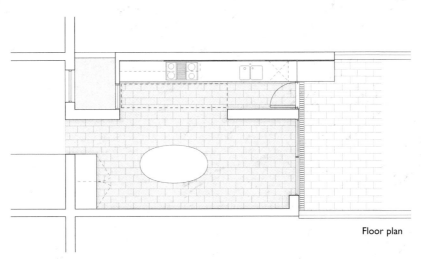

Floor plan

When space is limited, it's best to use light colors in combination with thin materials, such as stainless steel or glass.

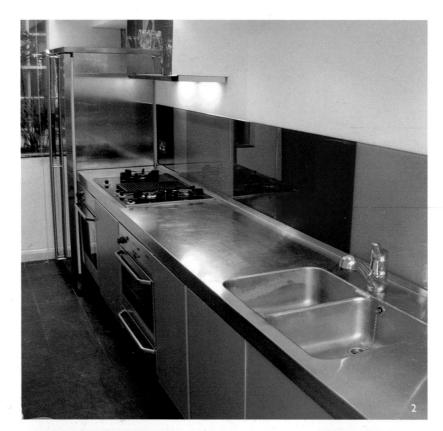

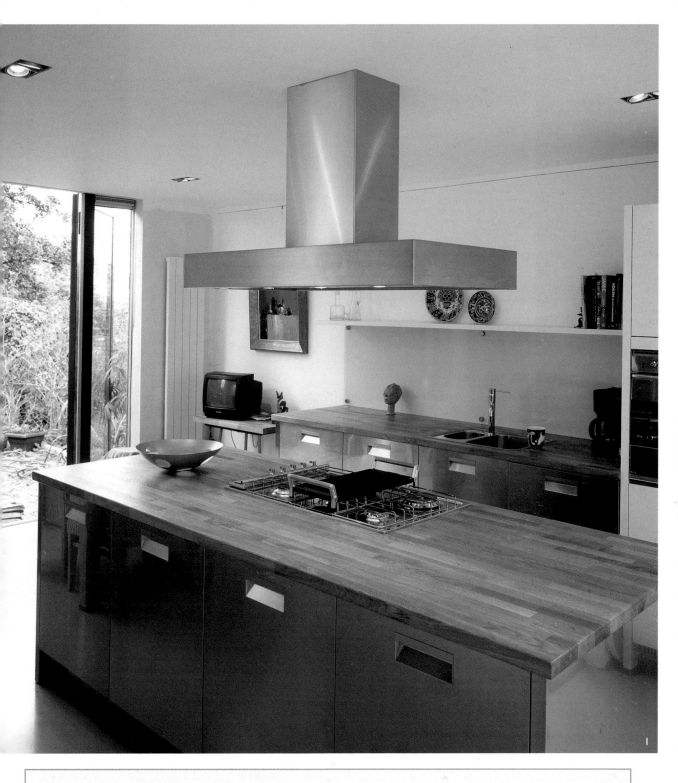

2, 3 Architect: Fernando Rihl; Photographer: Fernando Rihl

1 Architect: Moriko Kira; Photographer: Luuk Kramer

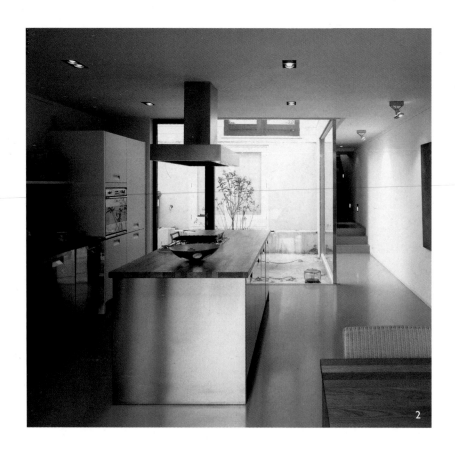

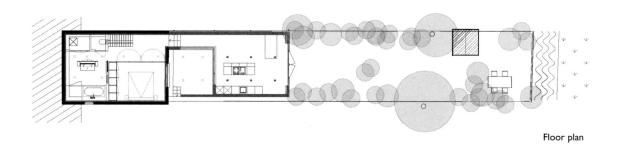

Floor plan

2 Architect: Moriko Kira; Photographer: Luuk Kramer

1 Architect: Asselberg Arch.; Photographer: Luuk Kramer

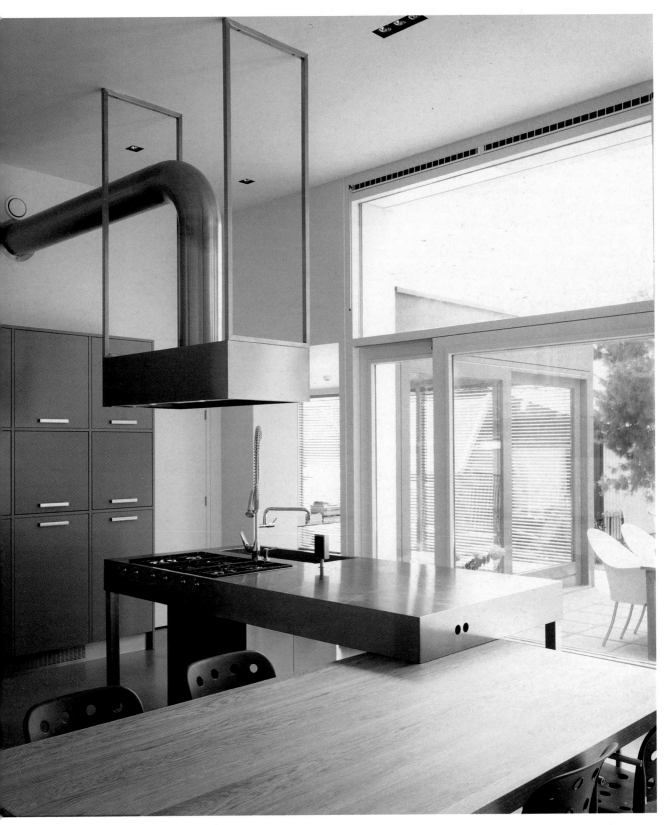

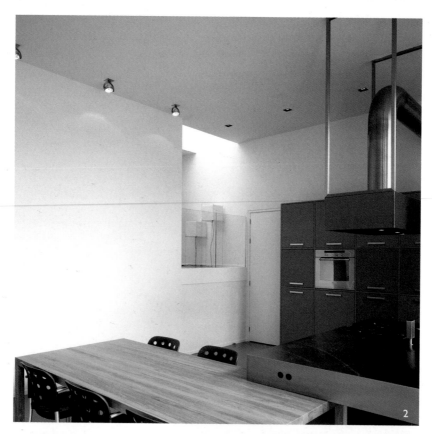

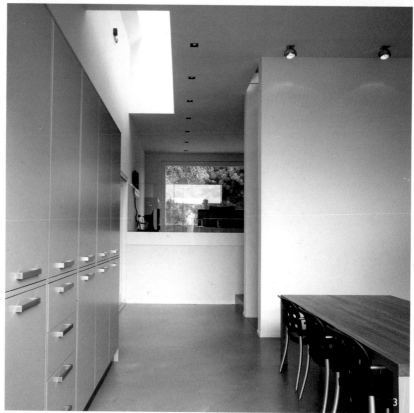

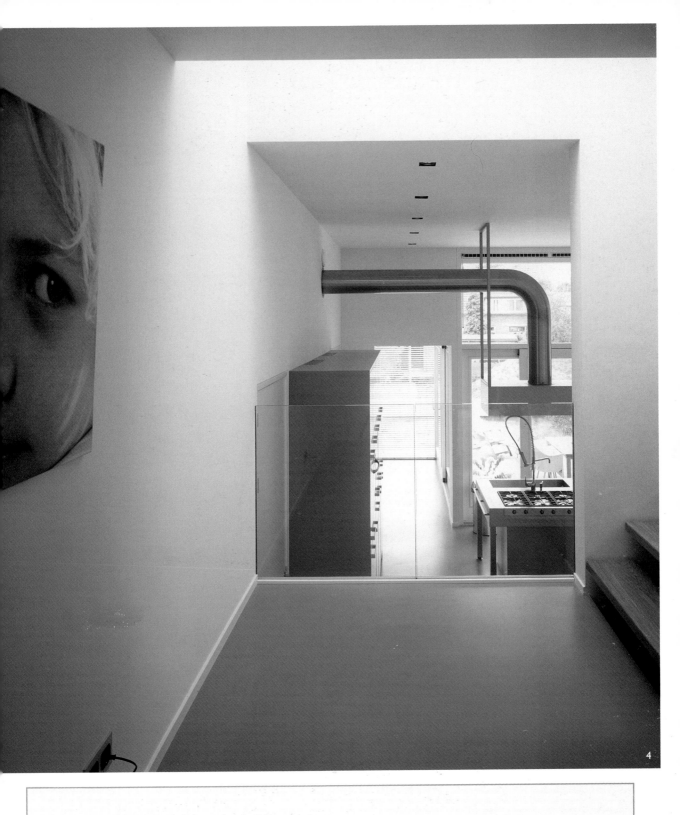

4

2, 3, 4 Architect: Asselberg Arch.; Photographer: Luuk Kramer

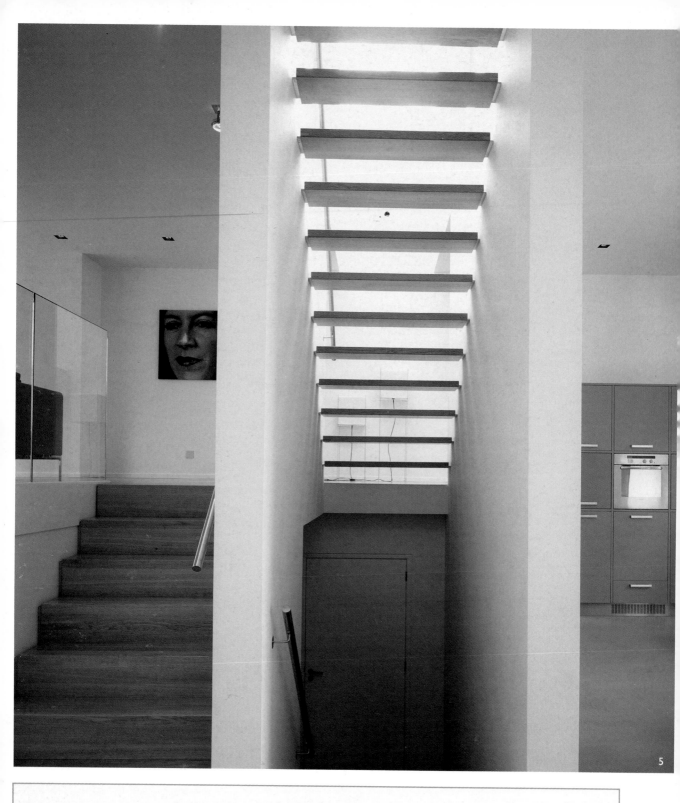

5

Technical advances and the flexible spatial distribution that they allow for
make it possible to arrange the elements of this kitchen in new and innovative ways.

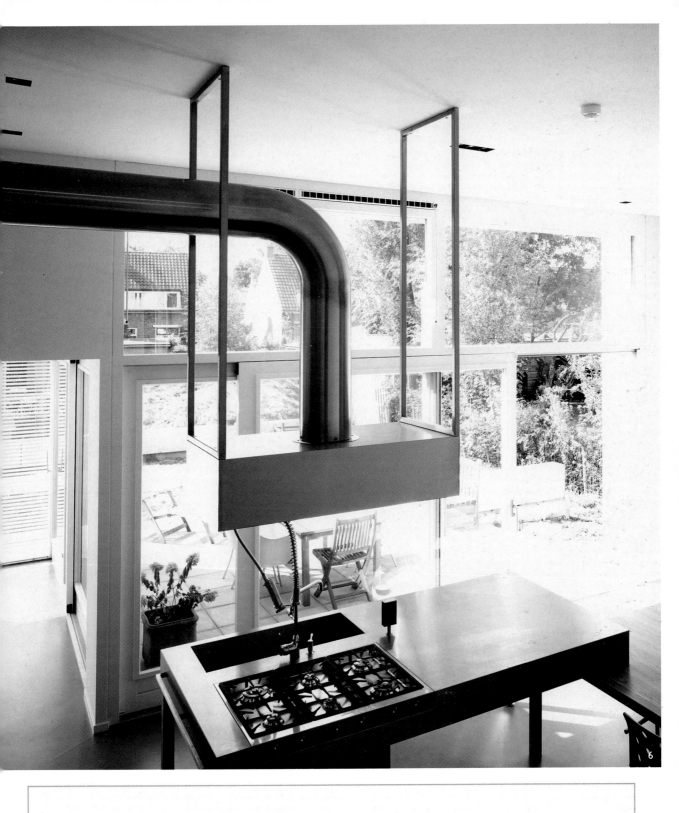

5, 6 Architect: Asselberg Arch.; Photographer: Luuk Kramer

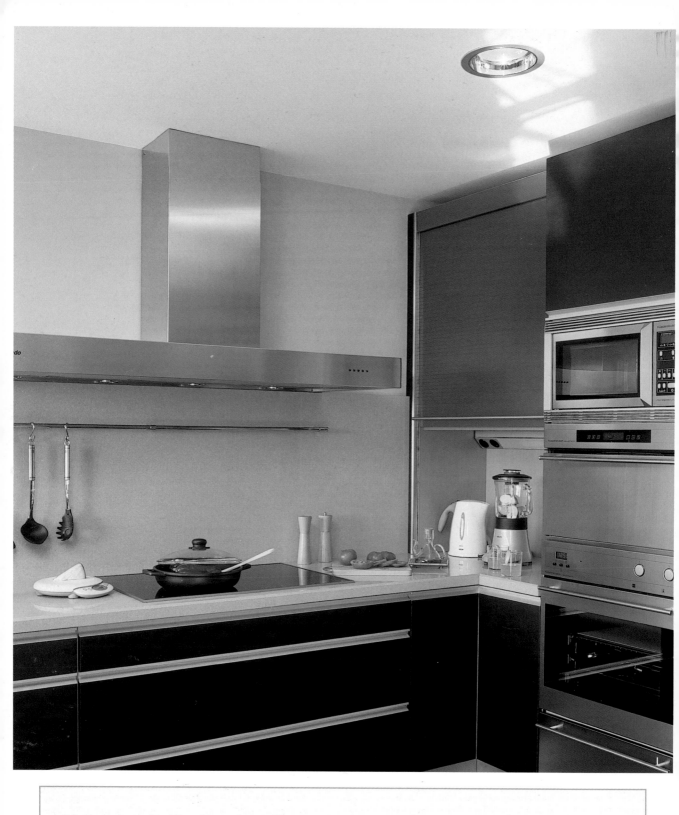

1, 2, 3 Interior Design: Estudi Trevi; Photographer: José Luis Hausmann

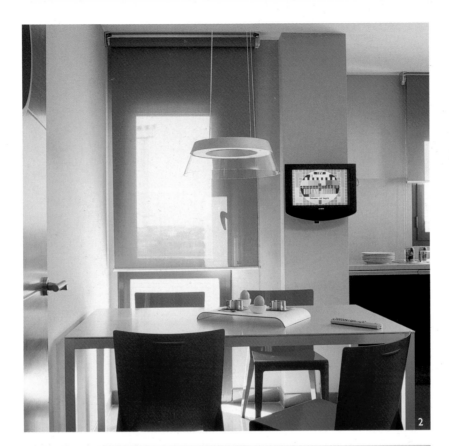

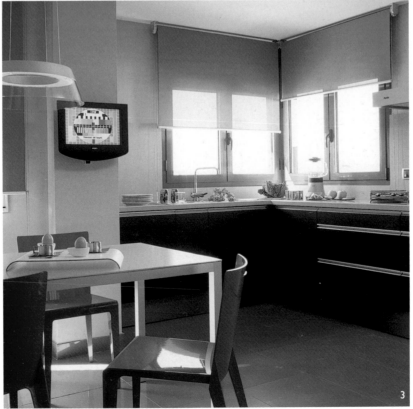

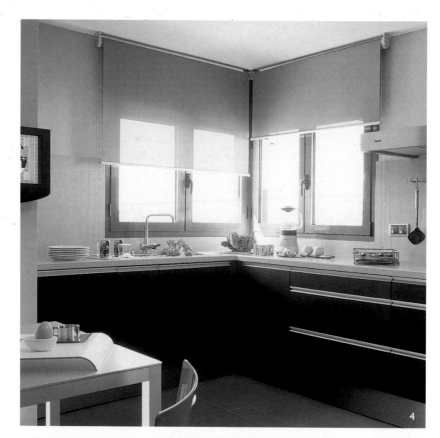

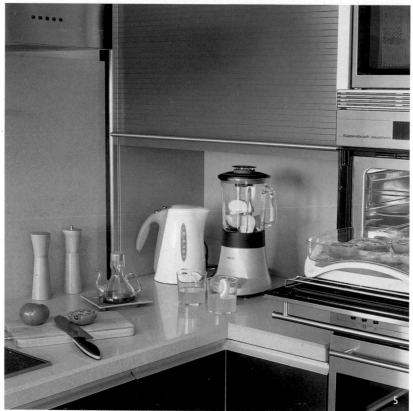

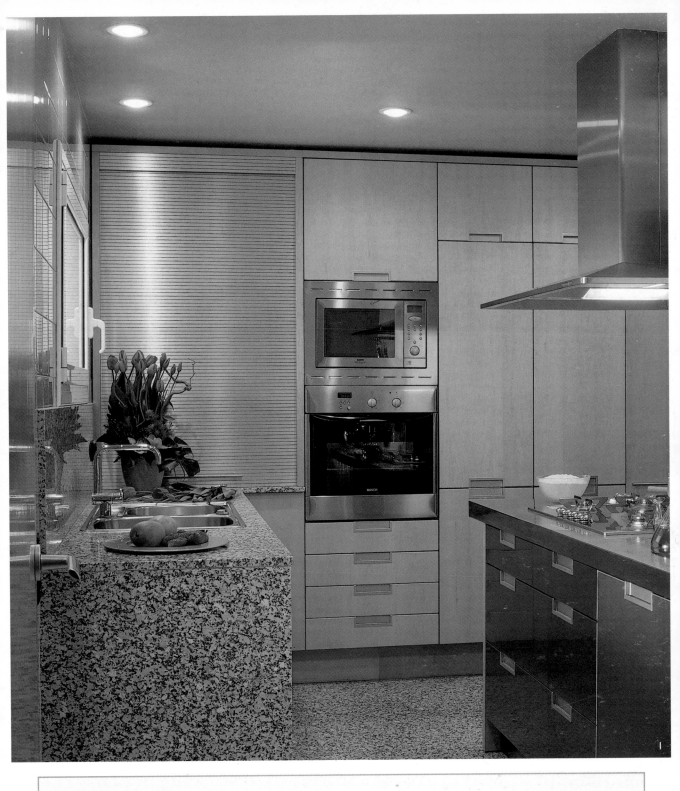

4, 5 Interior Design: Estudi Trevi; Photographer: José Luis Hausmann

1 Interior Design: L'Eix; Photographer: José Luis Hausmann

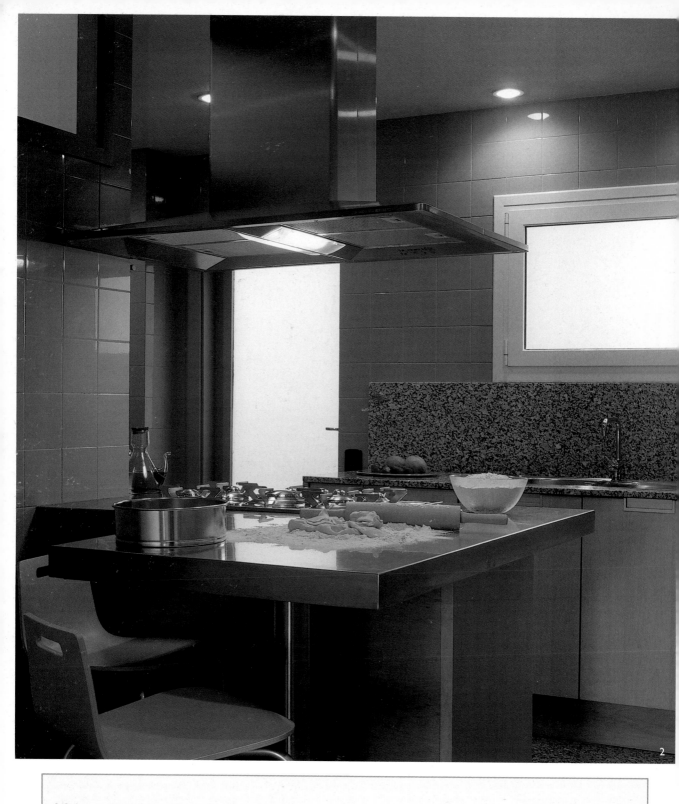

2, 3 Interior Design: L´Eix; Photographer: José Luis Hausmann

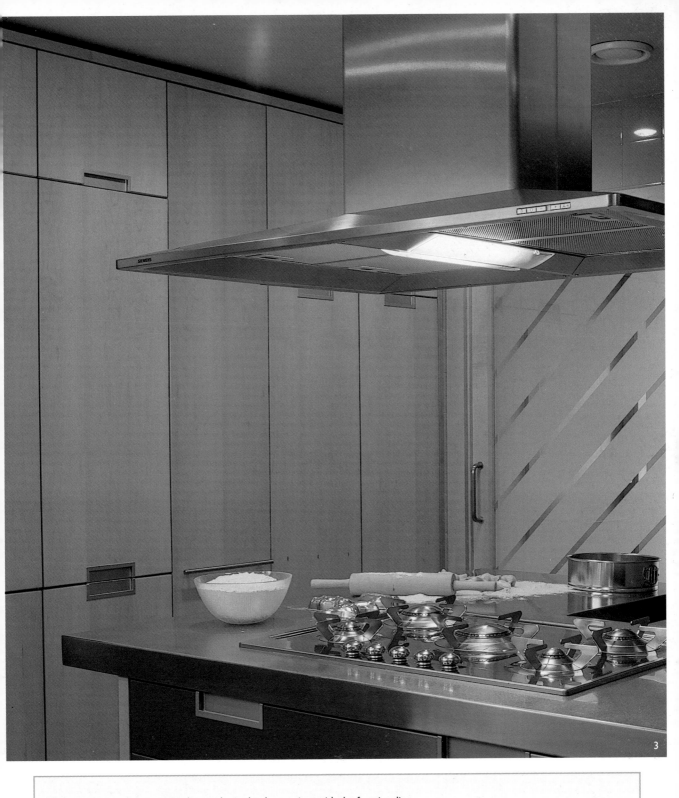

3

The storage areas have a minimalist aesthetic that harmonizes with the functionality
of all the elements of this kitchen.

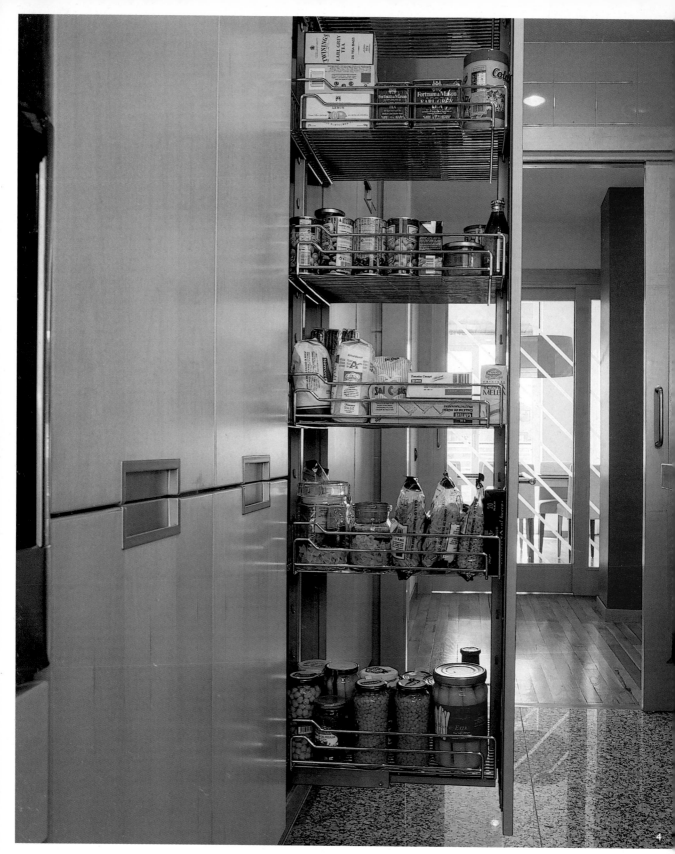

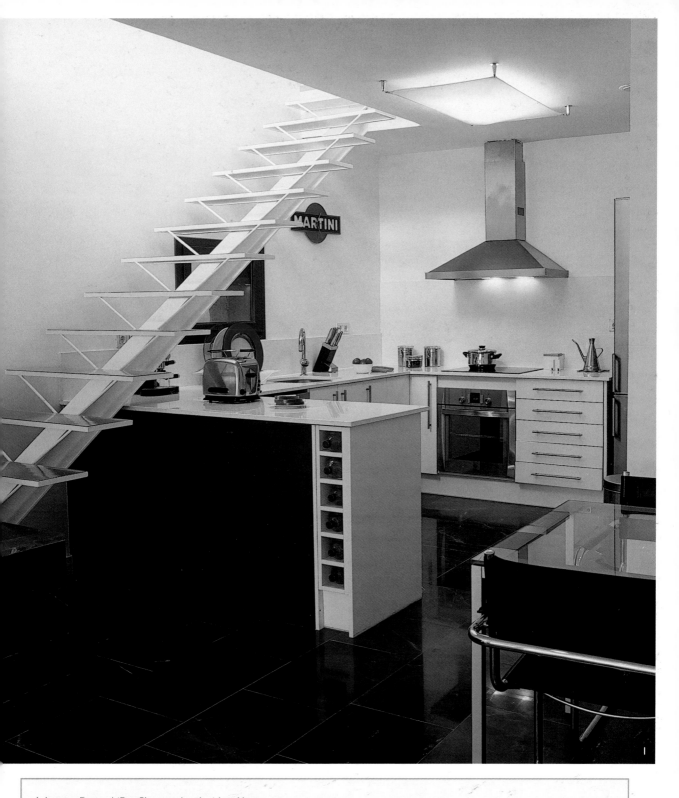

4 Interior Design: L´Eix; Photographer: José Luis Hausmann

I Interior Design: Ramón Berga; Photographer: Pep Escoda

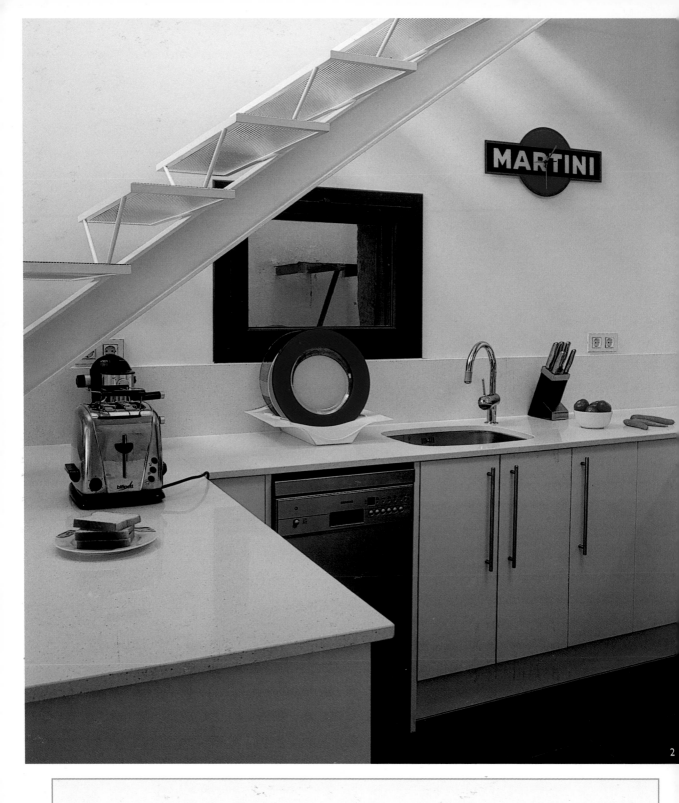

2

2, 3 Interior Design: Ramón Berga; Photographer: Pep Escoda

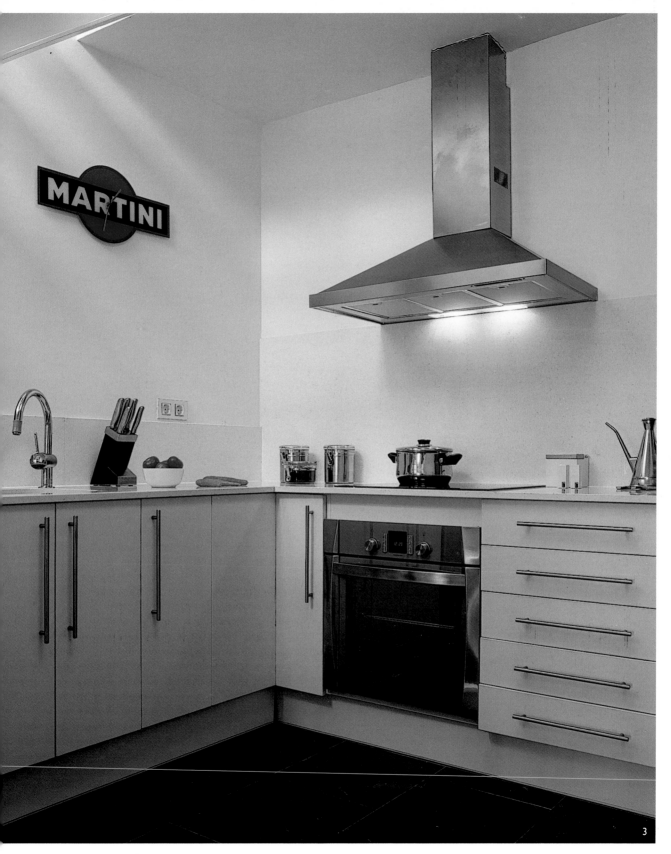

3

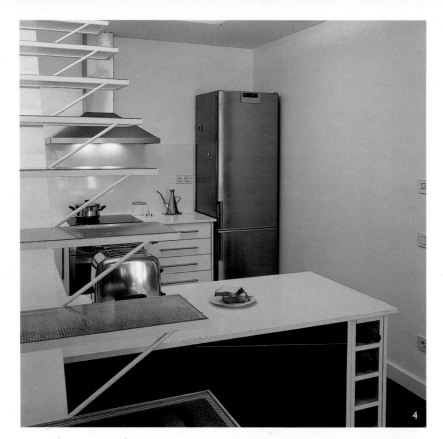

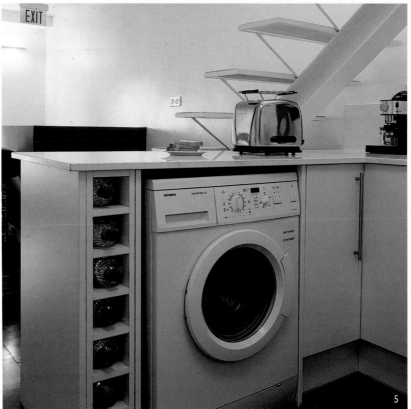

4, 5, 6 Interior Design: Ramón Berga; Photographer: Pep Escoda

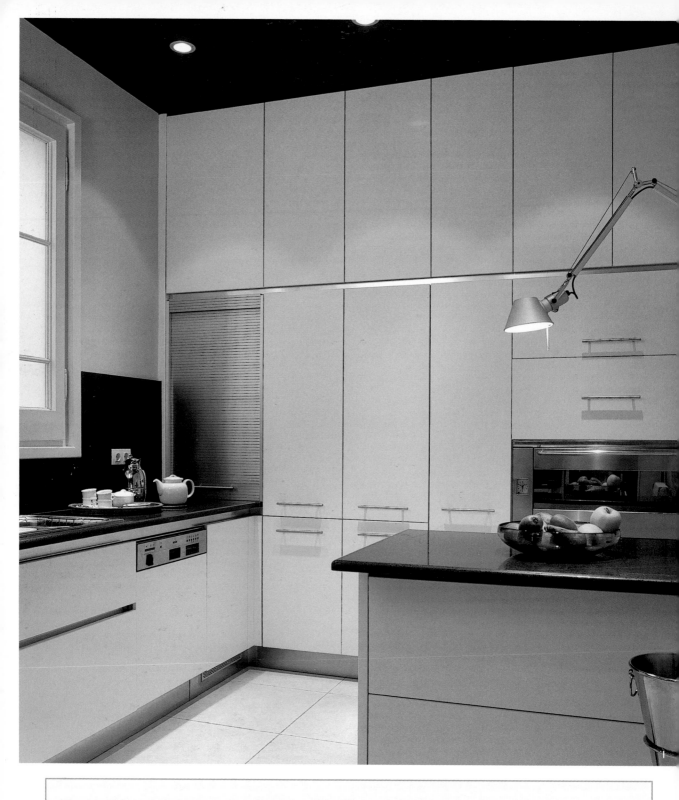

One of the walls has been fitted out as a storage area, making better use of the available space.
This structure creates space for a built-in oven and the distribution of appliances throughout the area.

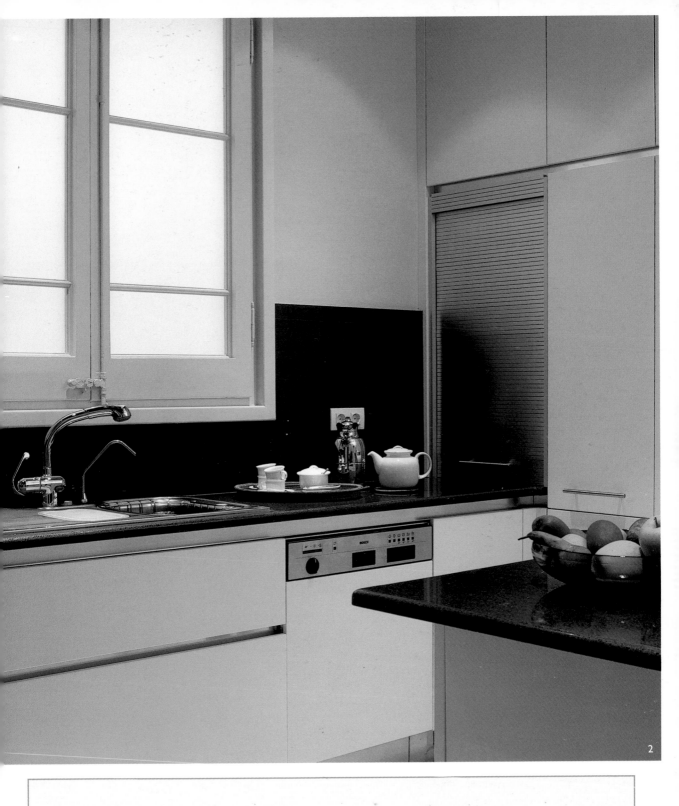

2

1, 2 Interior Design: L´Eix; Photographer: José Luis Hausmann

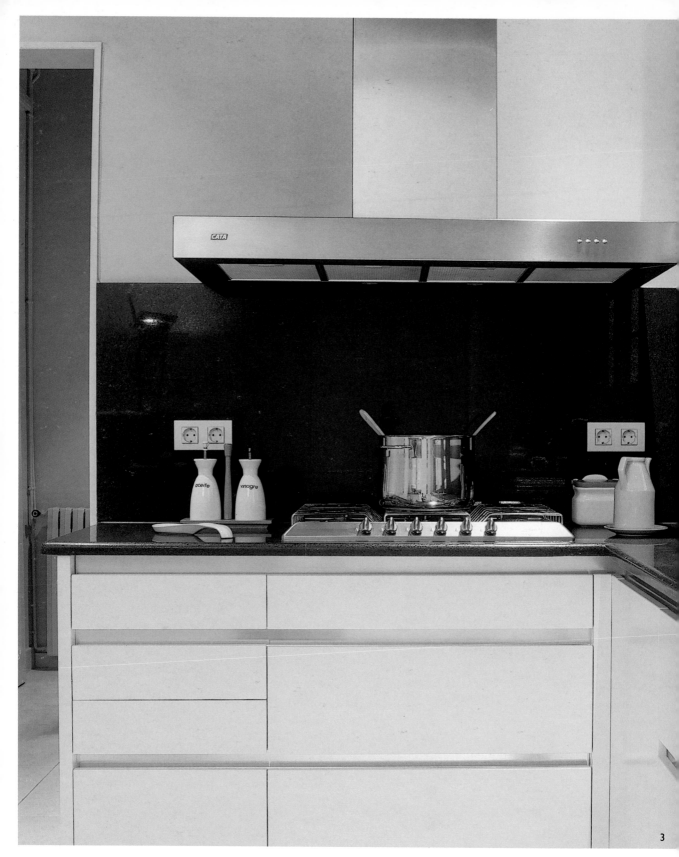

3

4

3, 4 Interior Design: L´Eix; Photographer: José Luis Hausmann

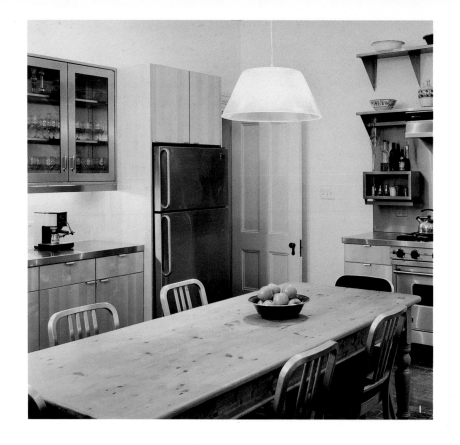

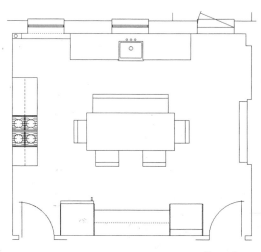

Floor plan

1, 2 Architects: Messana O´Rorke; Photographer: Elizabeth Felicella

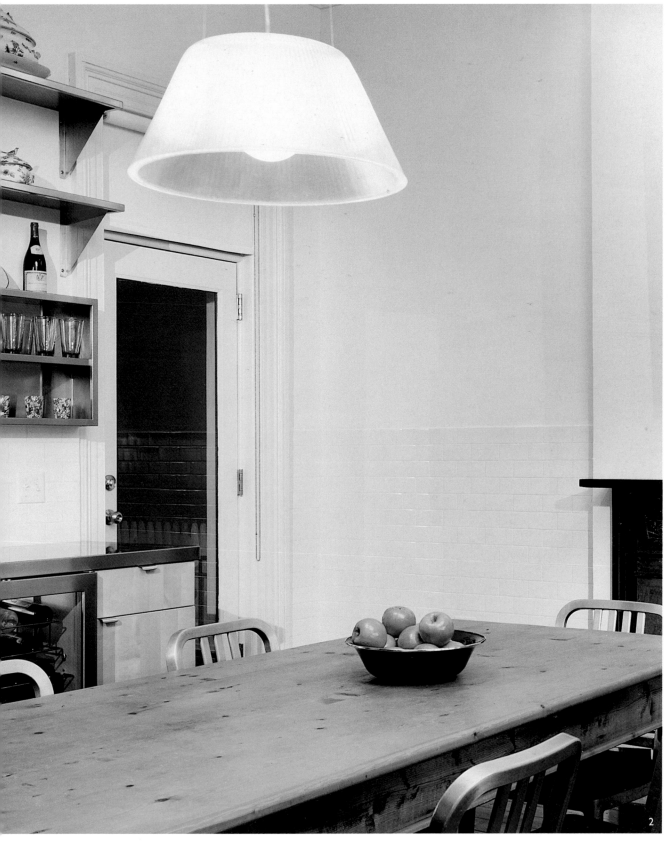

2

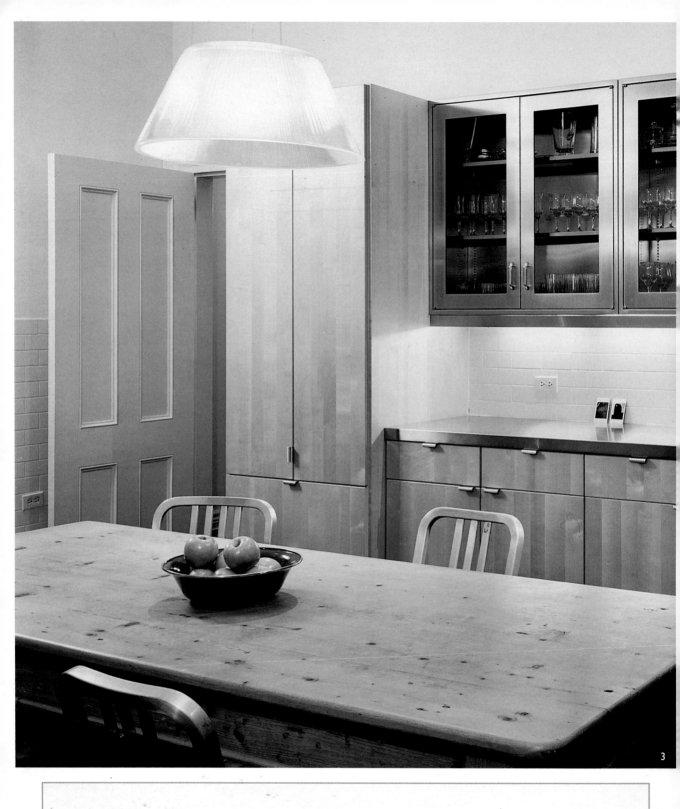

3

3, 4 Architects: Messana O´Rorke; Photographer: Elizabeth Felicella

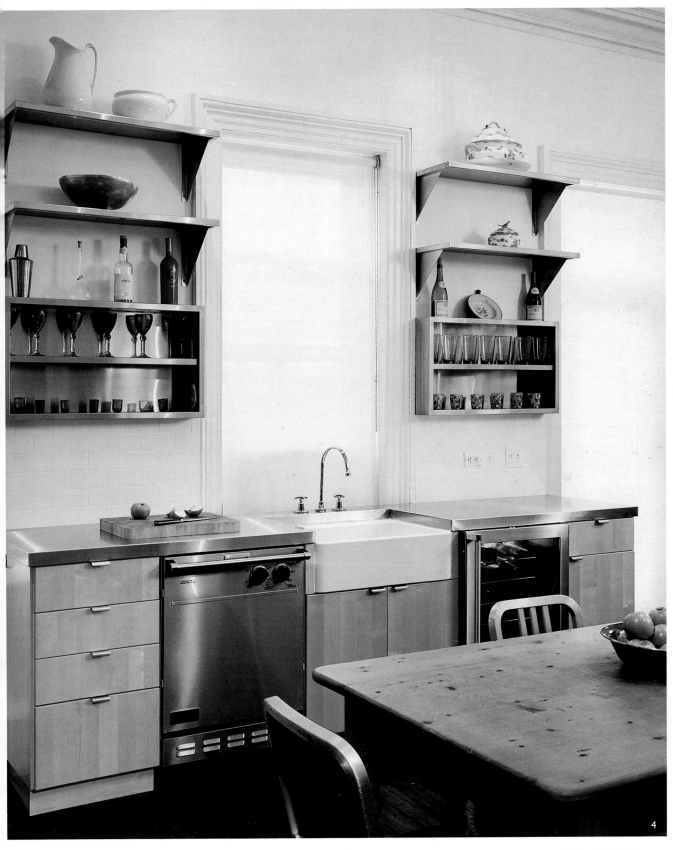

Adjoining
the Dining Room

THIS type of kitchen design is partially open, linking the dining room and the kitchen and making them independent, but related, spaces. This proximity allows for greater functionality, better use of space, and a smoother flow of traffic between the rooms. A remodeling project to increase the size of the kitchen often requires no more than the removal of the partition separating these two spaces.

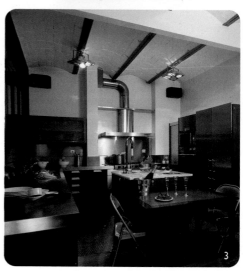

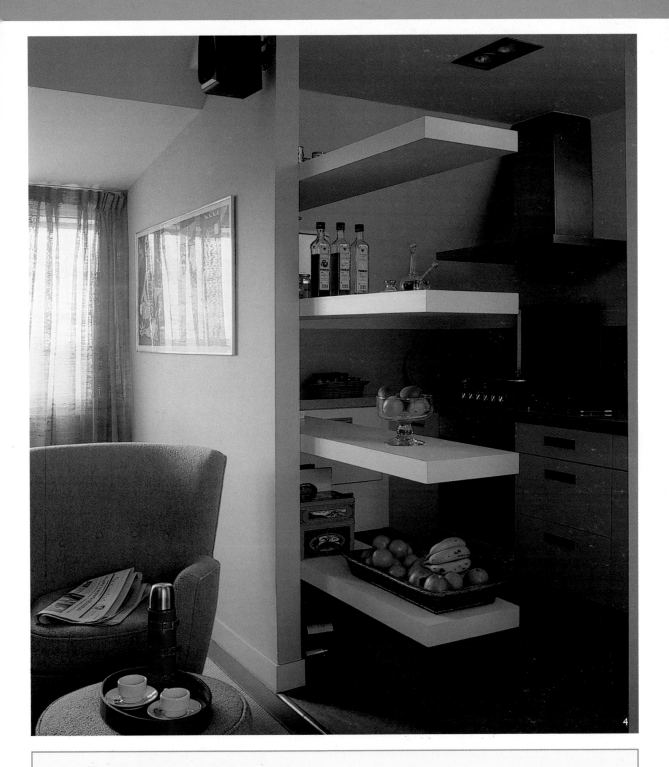

1 Interior Design: Marc Llanas; Photographer: José Luis Hausmann 3 Interior Design: Ares Fernández; Photographer: José Luis Hausmann

2 Interior Design: Ares Fernández; Photographer: José Luis Hausmann 4 Interior Design: Patricia Gómez; Photographer: José Luis Hausmann

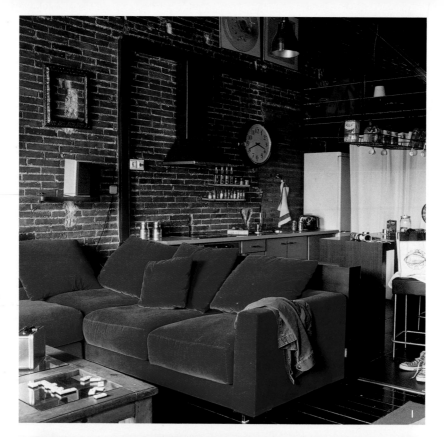

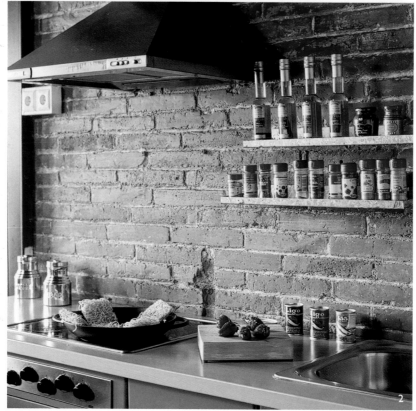

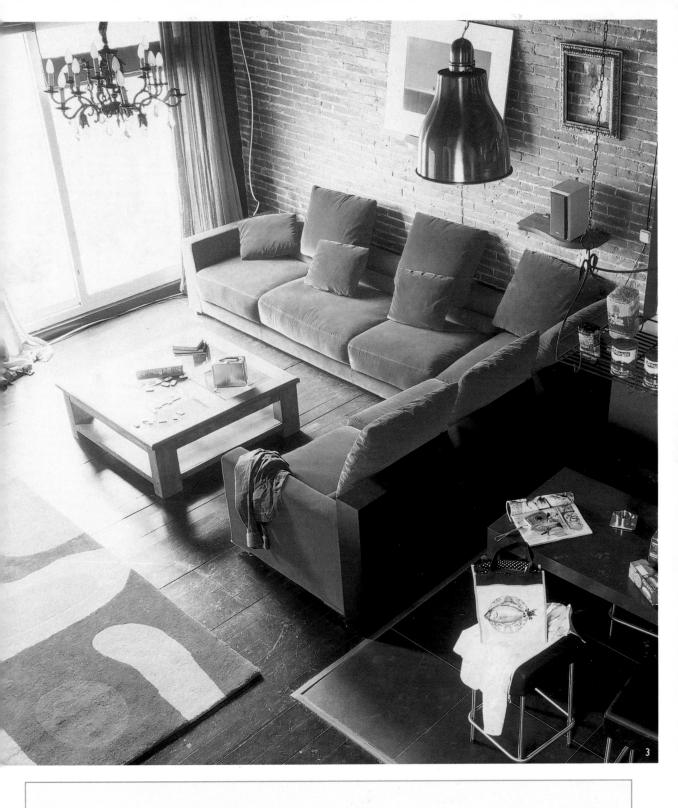

1, 2, 3 Interior Design: Marc Llanas; Photographer: José Luis Hausmann

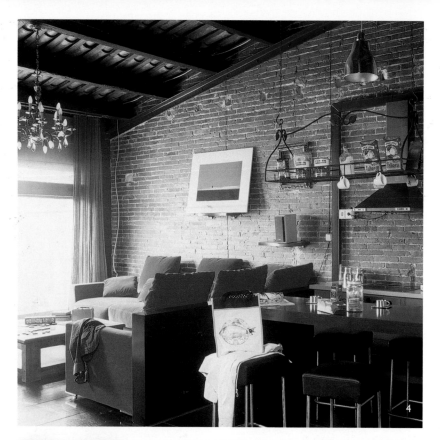

6

4, 5, 6 Interior Design: Marc Llanas; Photographer: José Luis Hausmann

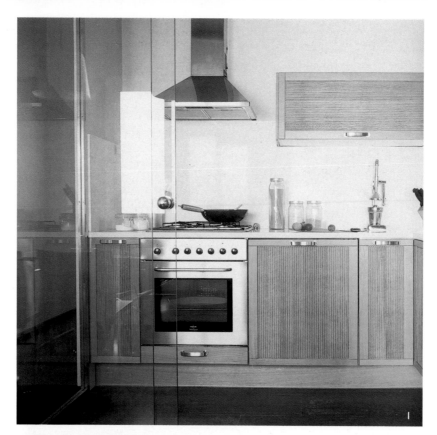

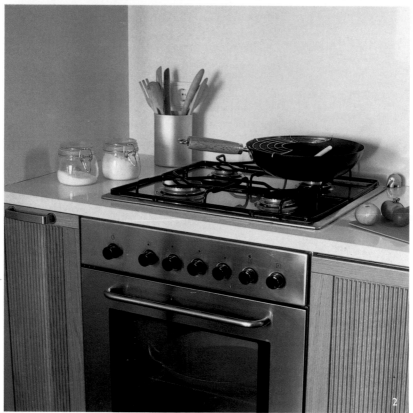

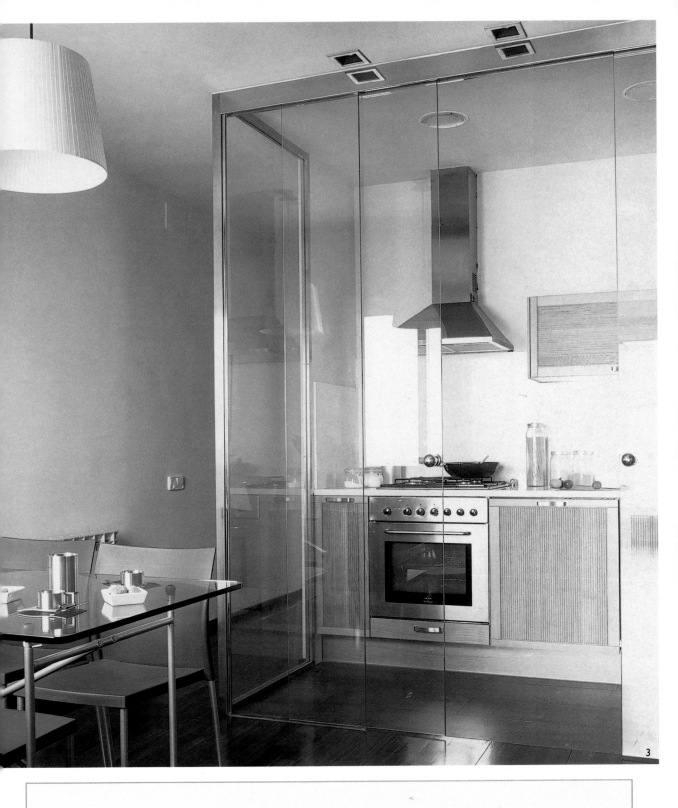

3

1, 2, 3 Interior Design: Ares Fernández; Photographer: José Luis Hausmann

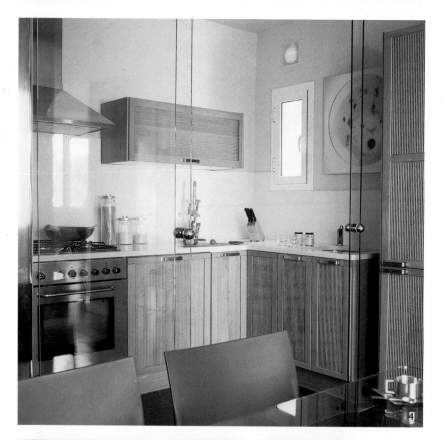

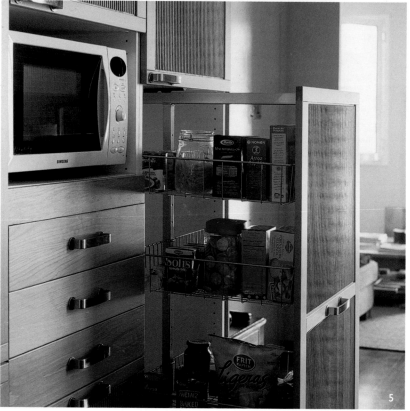

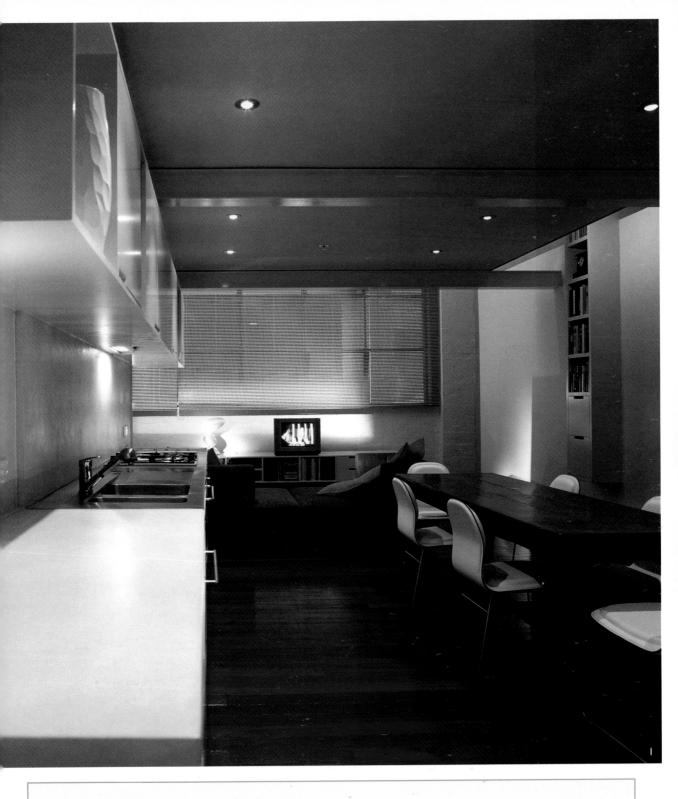

4, 5 Interior Design: Ares Fernández; Photographer: José Luis Hausmann

1 Architects: AKM Warehouse A.; Photographer: Trevor Mein

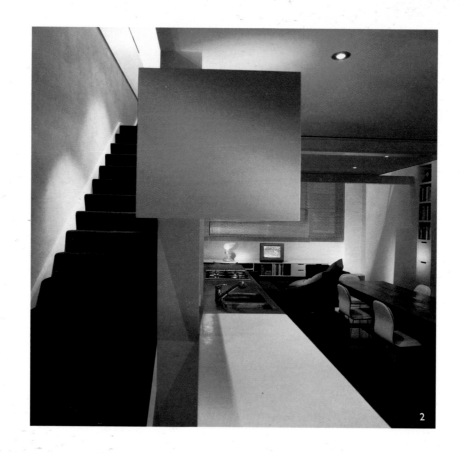

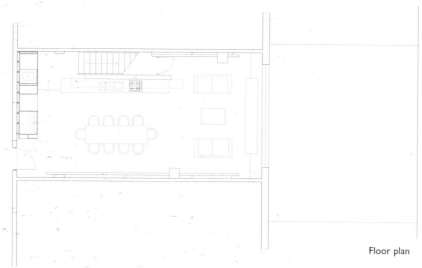

Floor plan

2, 3 Architects: AKM Warehouse A.; Photographer: Trevor Mein

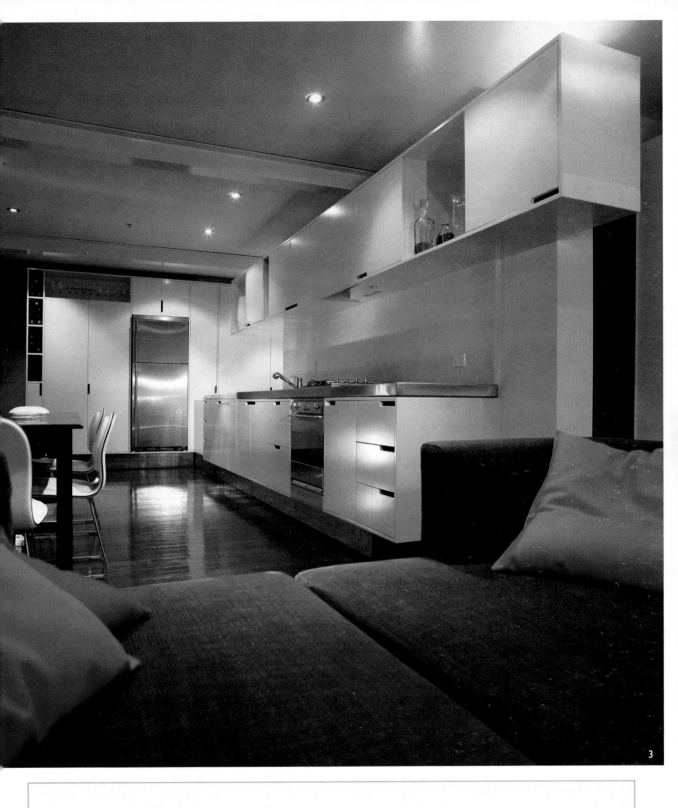

3

This kitchen takes up most of the lower floor. As a result, the living room area has been minimized.

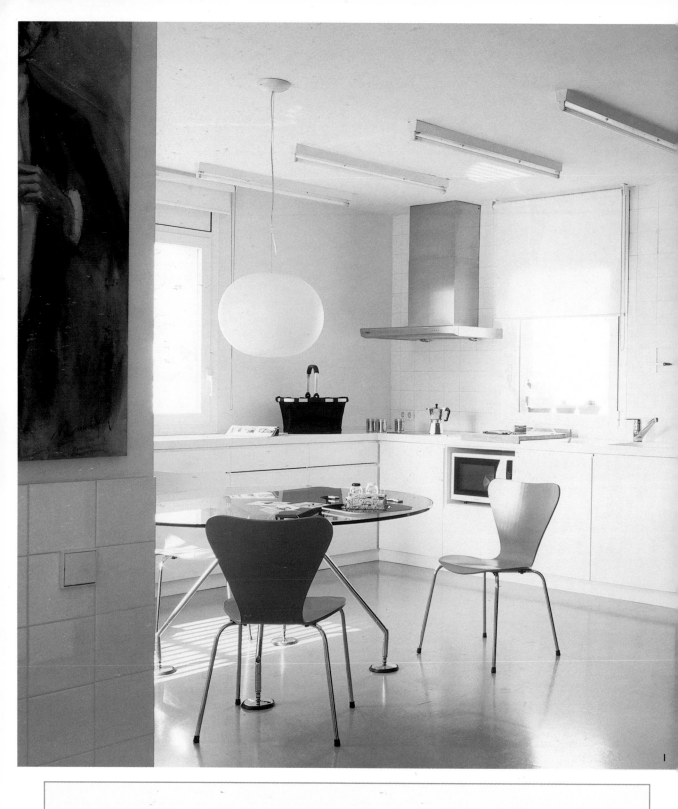

1, 2, 3 Architects: Patricio Martínez & Cristina Alga; Photographer: José Luis Hausmann

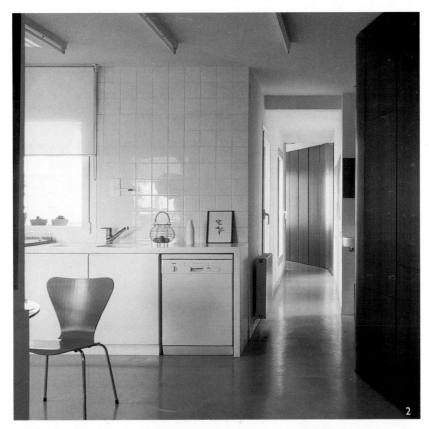

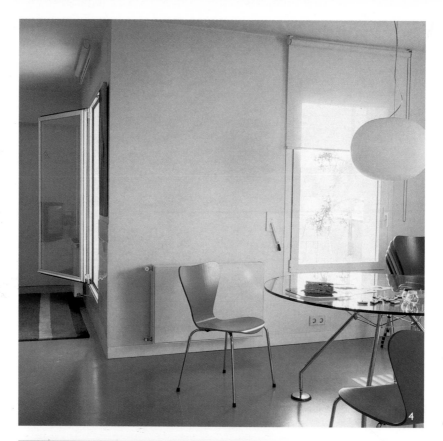

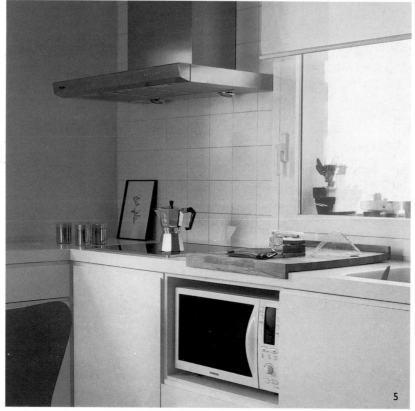

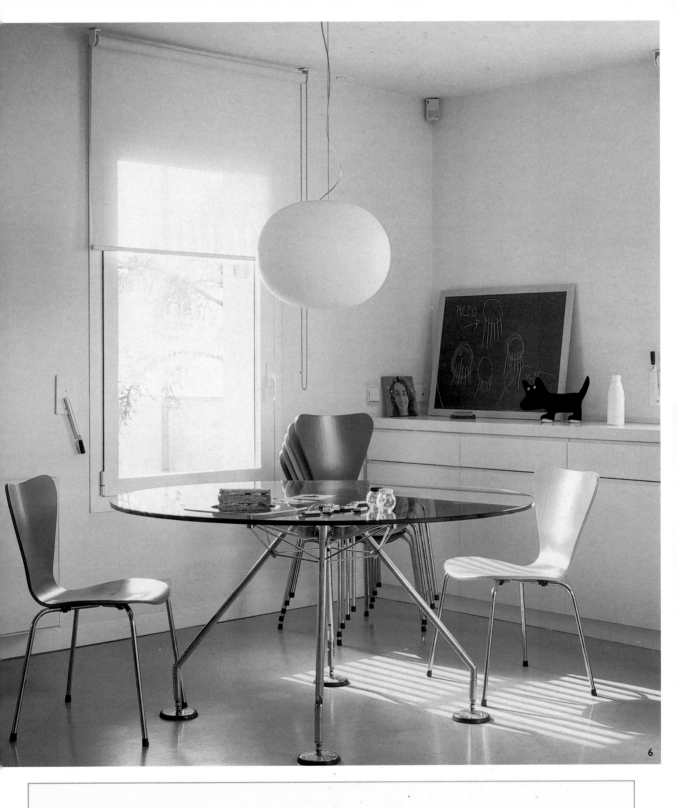

6

4, 5, 6 Architects: Patricio Martínez & Cristina Alga; Photographer: José Luis Hausmann

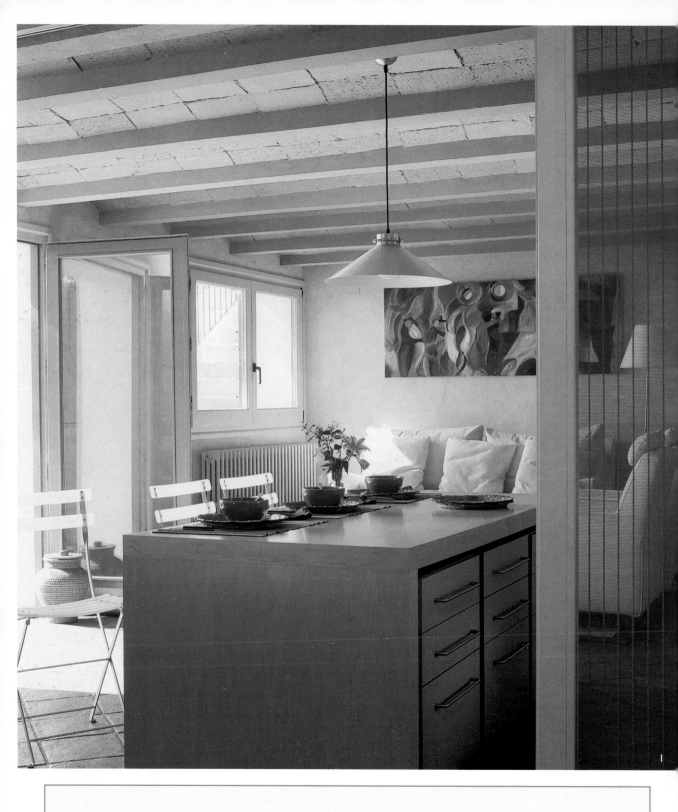

1, 2 Architects: Estudio GCA; Photographer: José Luis Hausmann

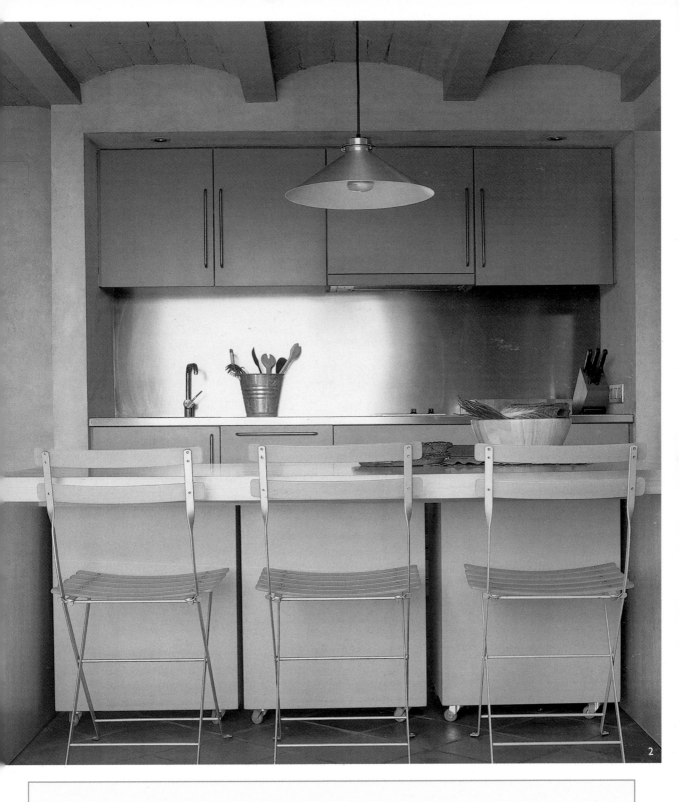

Integrated into the living room, this kitchen takes up just a small amount of space, allowing more room for social gatherings.

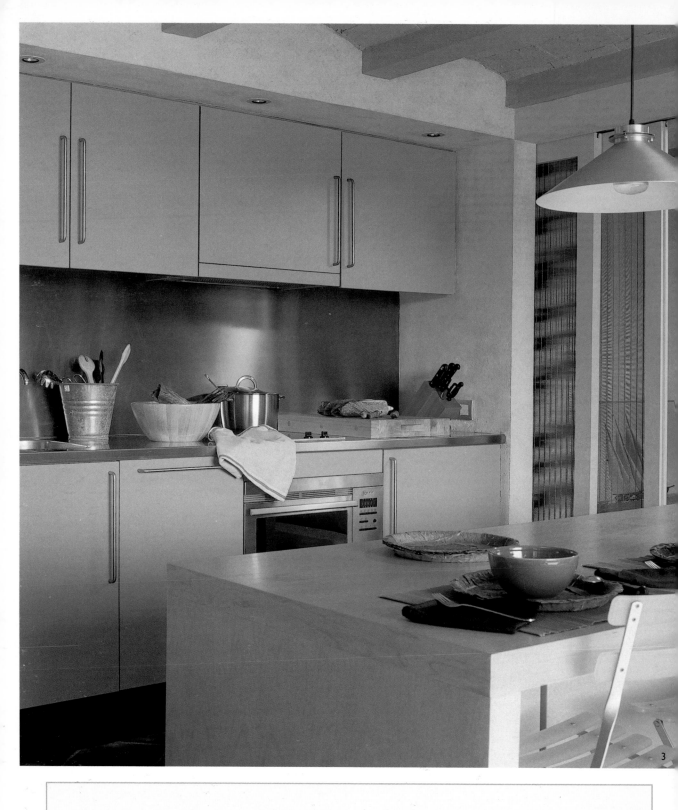

3

3, 4 Architects: Estudio GCA; Photographer: José Luis Hausmann

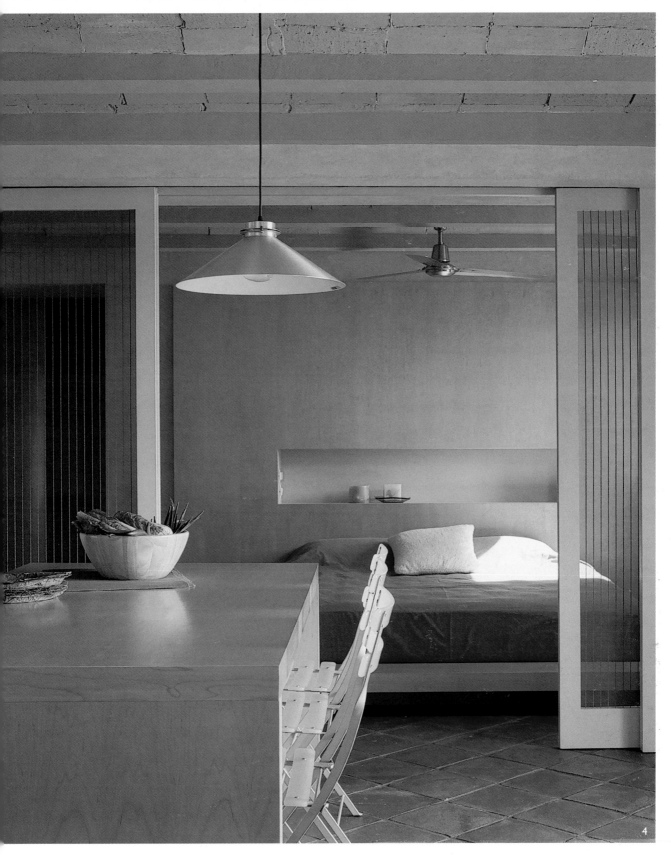

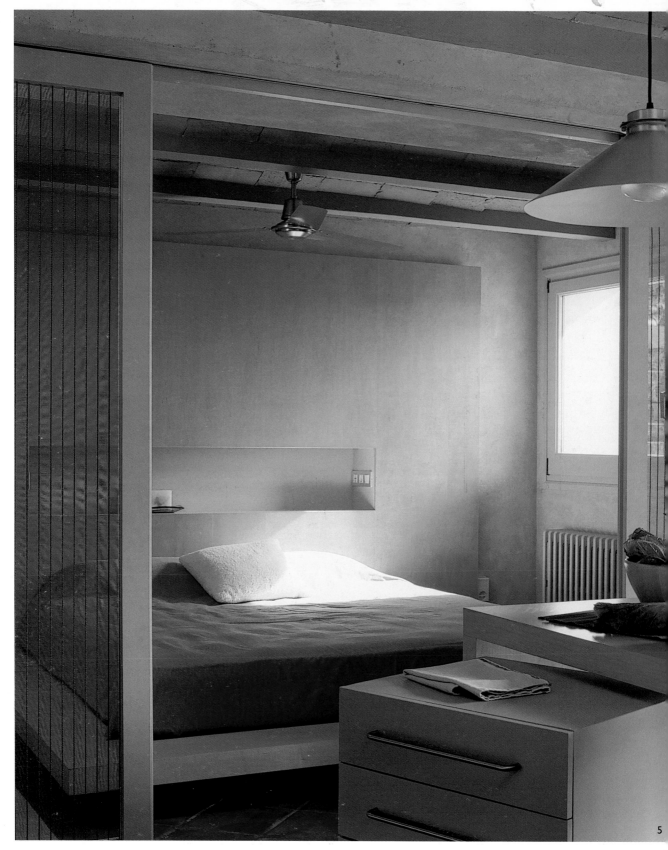

5

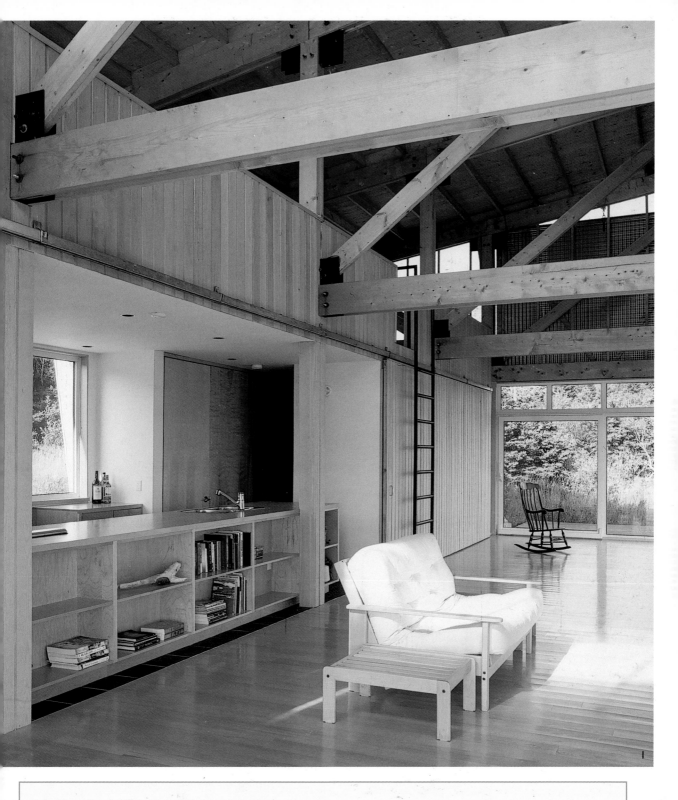

5 Architects: Estudio GCA; Photographer: José Luis Hausmann

1 Architects: Mackay-Lyons; Photographer: Undine Pröhl

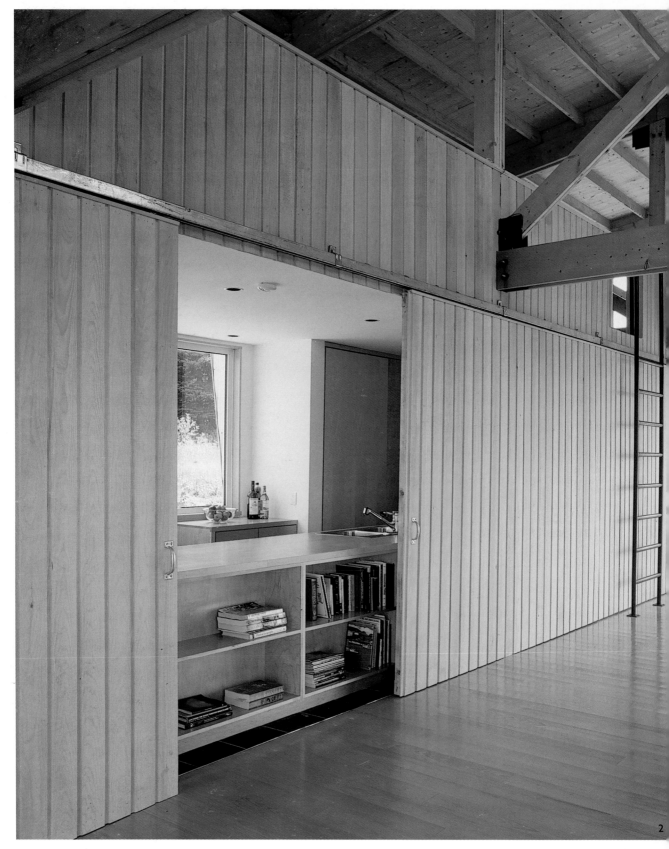

2

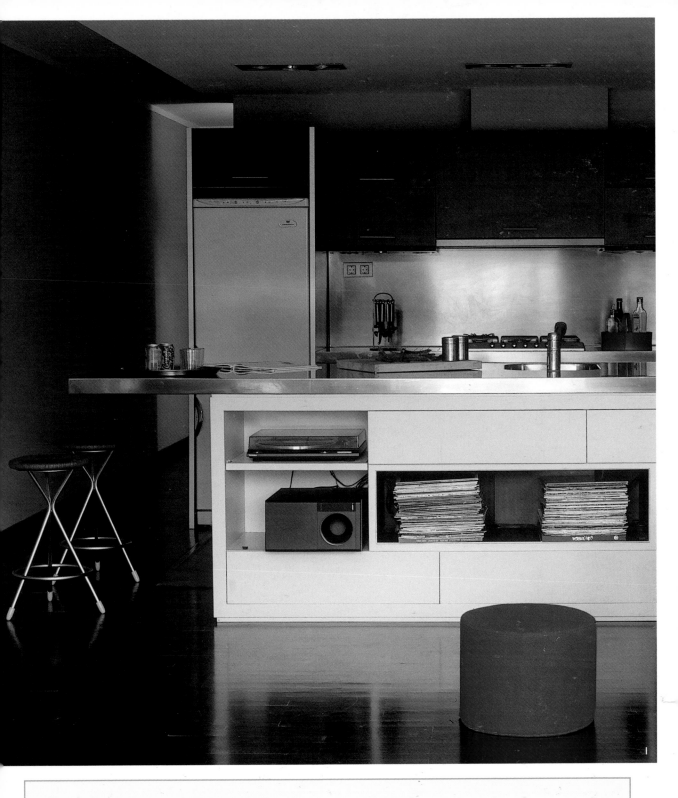

2 Architects: Mackay-Lyons; Photographer: Undine Pröhl

1 Interior Design: Natalia Gómez; Photographer: José Luis Hausmann

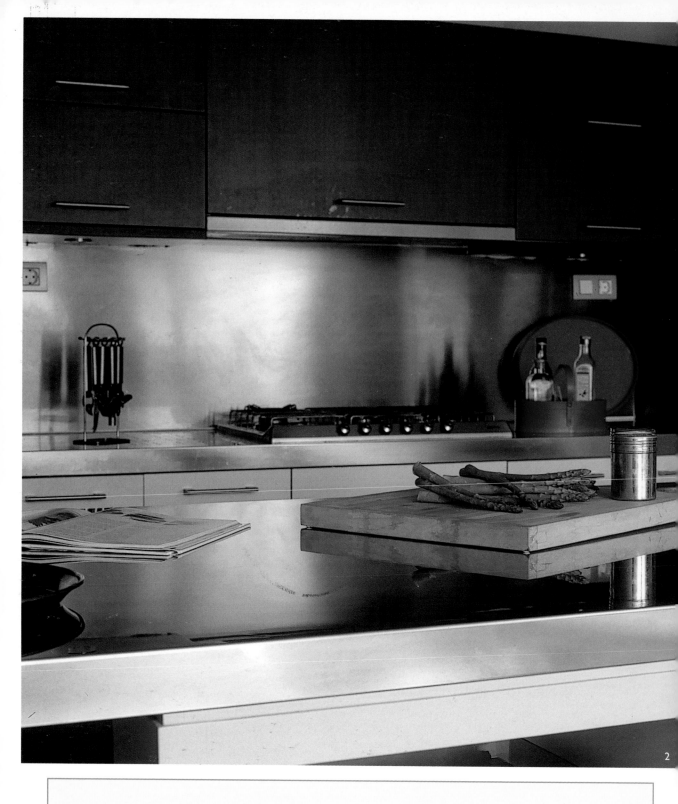

2

2, 3 Interior Design: Natalia Gómez; Photographer: José Luis Hausmann

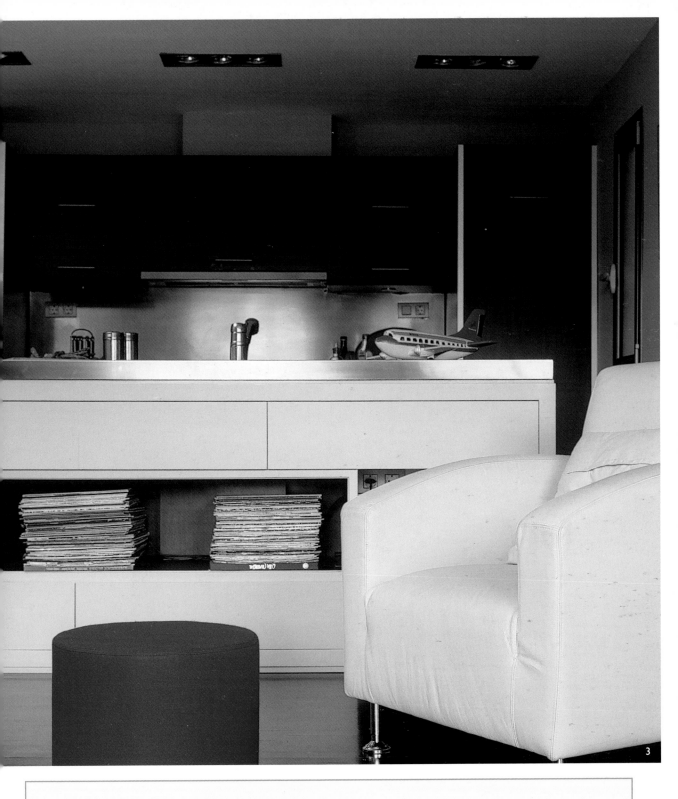

The décor of this kitchen extends to the living room, uniting the two spaces.
The central block is used for storing kitchen utensils and as living room furniture.

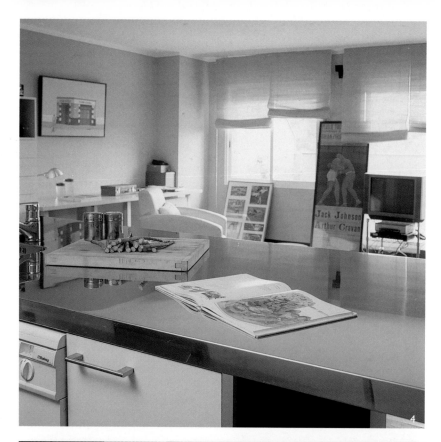

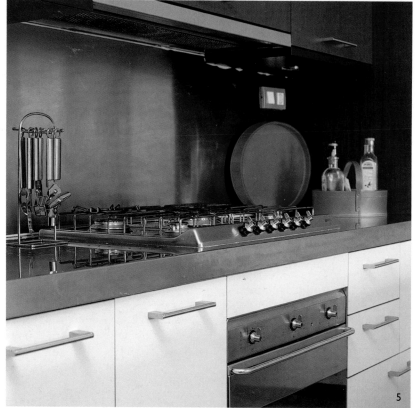

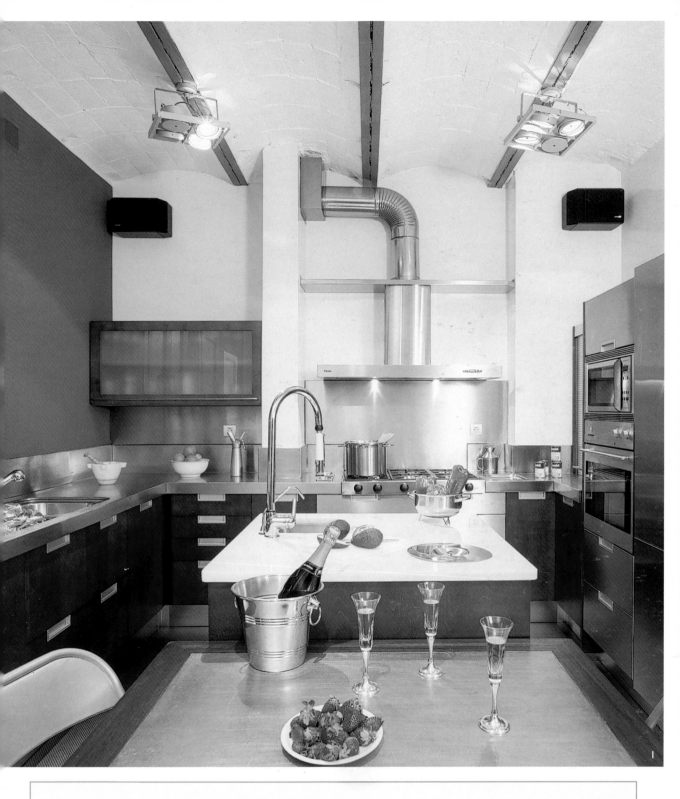

4, 5 Interior Design: Natalia Gómez; Photographer: José Luis Hausmann

1 Interior Design: L´Eix; Photographer: José Luis Hausmann

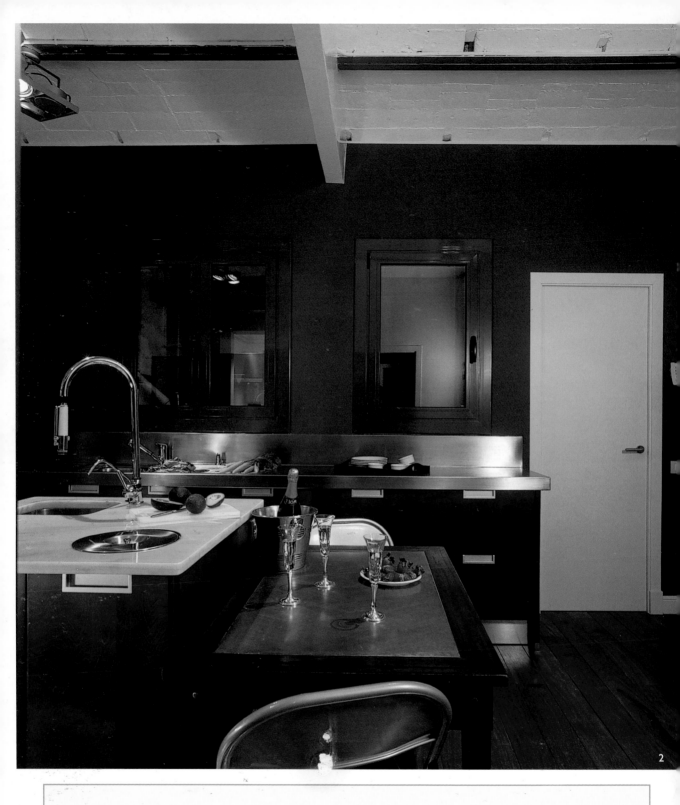

2

2, 3 Interior Design: L'Eix; Photographer: José Luis Hausmann

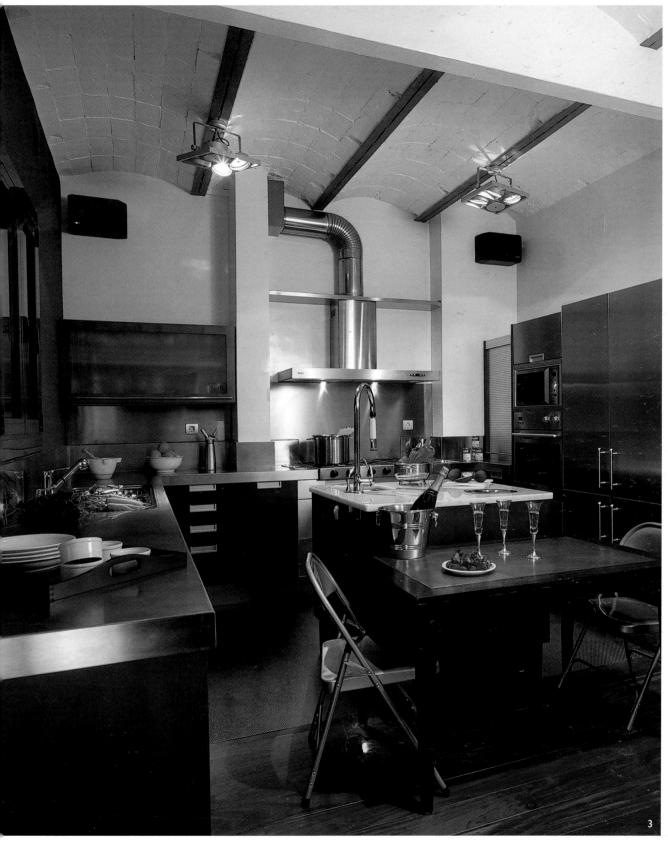

3

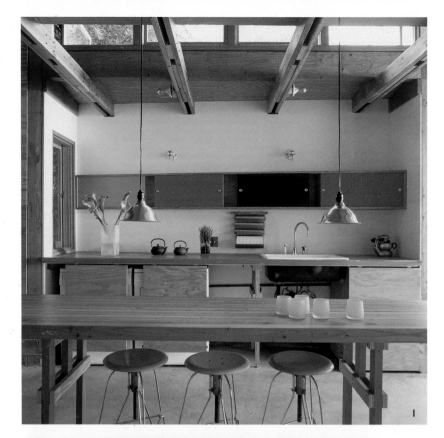

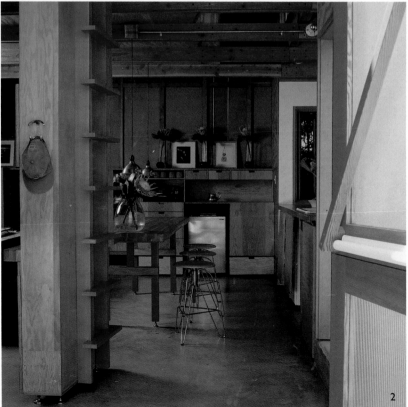

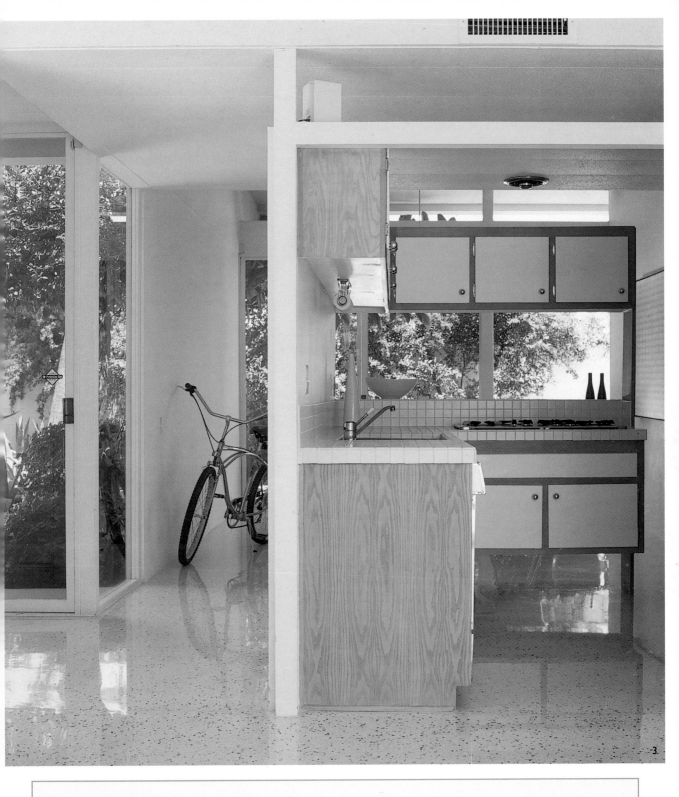

1, 2 Architect: Dry Design; Photographer: Undine Pröhl

3 Architect: Donald Wexler; Photographer: Undine Pröhl

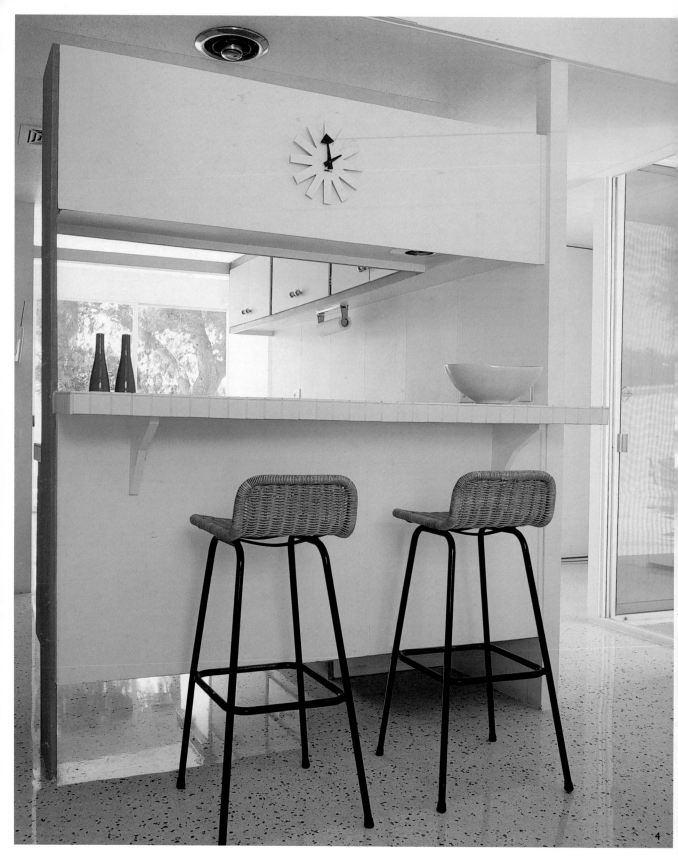

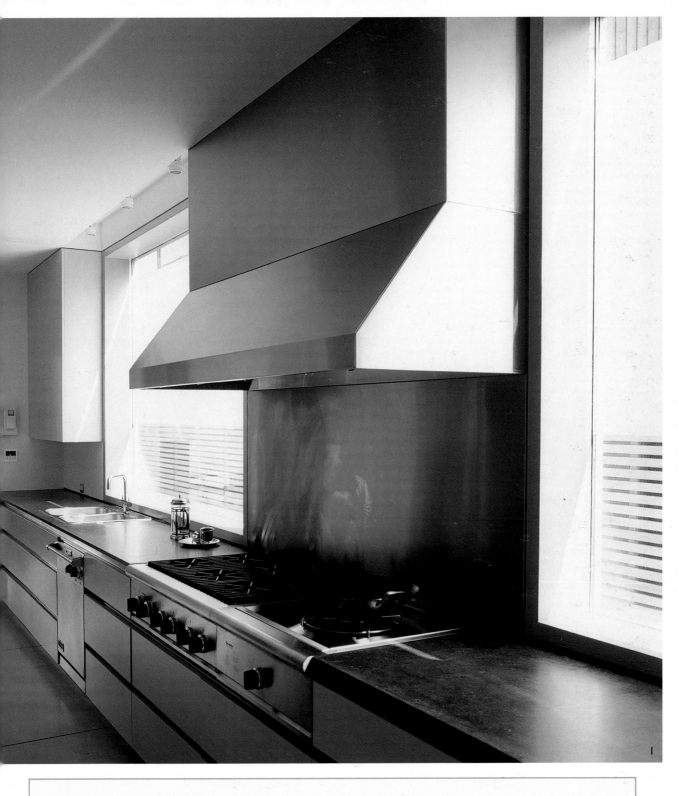

4 Architect: Donald Wexler; Photographer: Undine Pröhl

1 Architect: Patkau; Photographer: Undine Pröhl

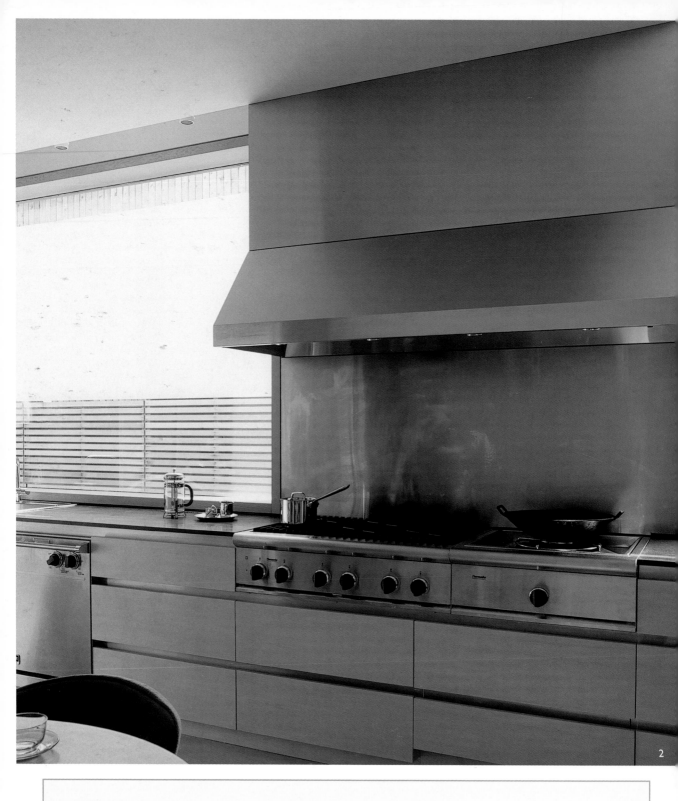

The number of cooktops and ovens in a kitchen can be increased in accordance with individual needs.
Here, the traditional four burners have been replaced by six to provide more cooking space.

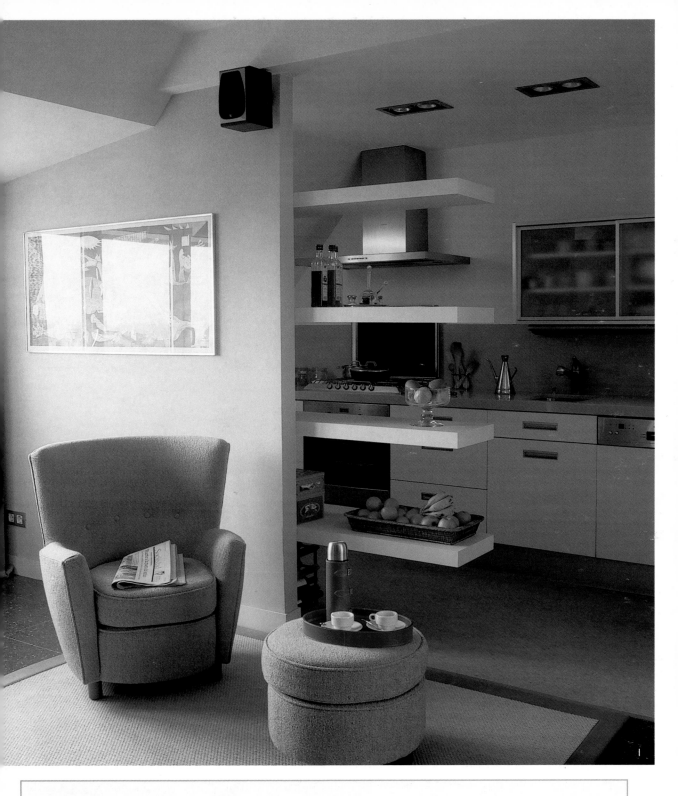

2 Architect: Patkau; Photographer: Undine Pröhl

I Interior Design: Patricia Gómez; Photographer: José Luis Hausmann

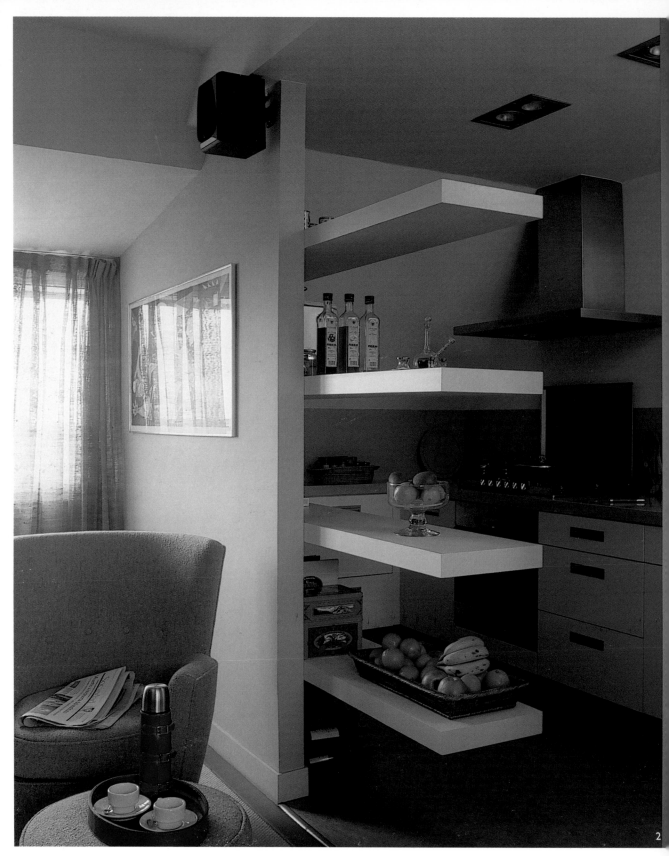

2

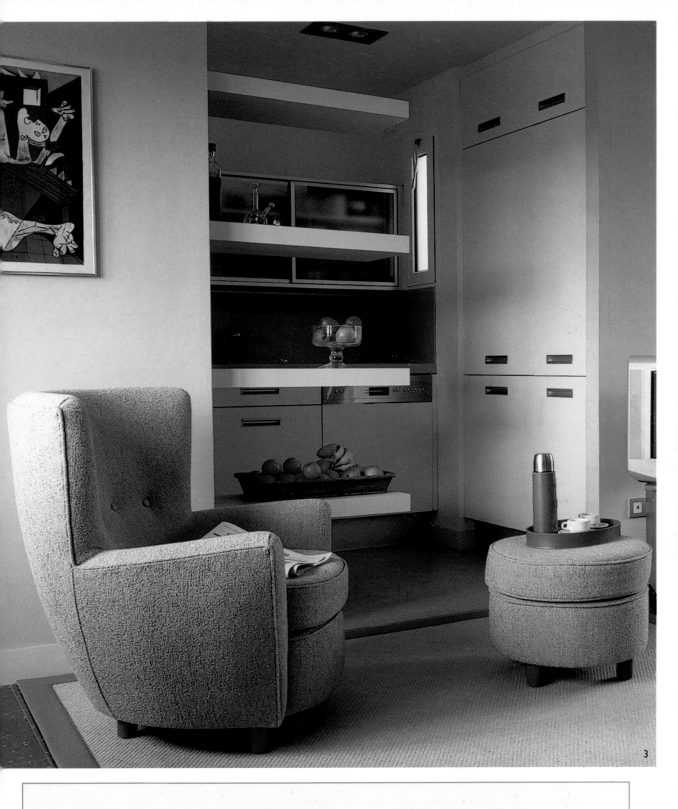

3

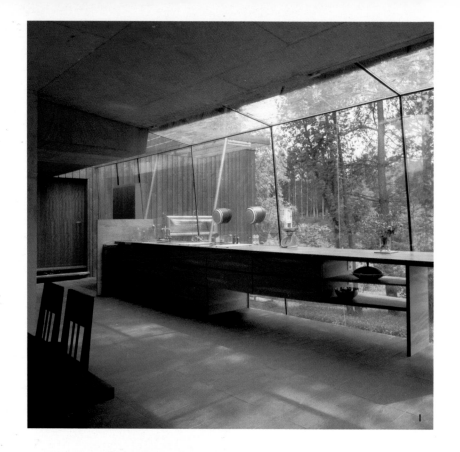

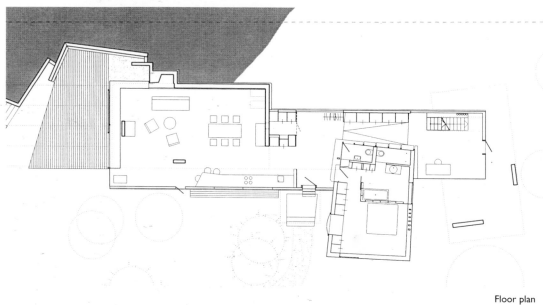

Floor plan

1, 2 Architects: Feyferlik-Fritzer; Photographer: Paul Ott

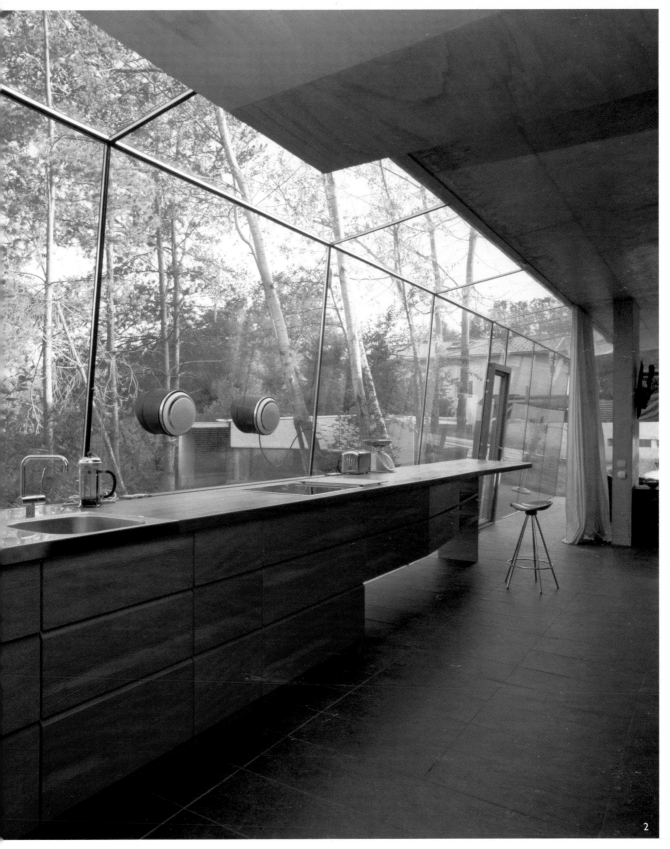

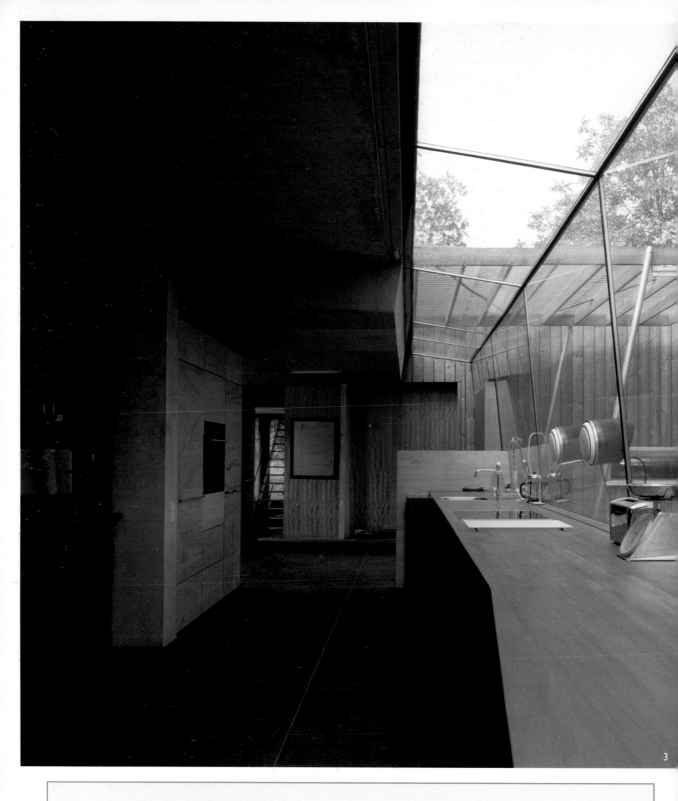

3

The rear extension, made of glass panels, creates the illusion of a larger space and provides natural light.
The kitchen components are arranged on a long block that is also used for storage.

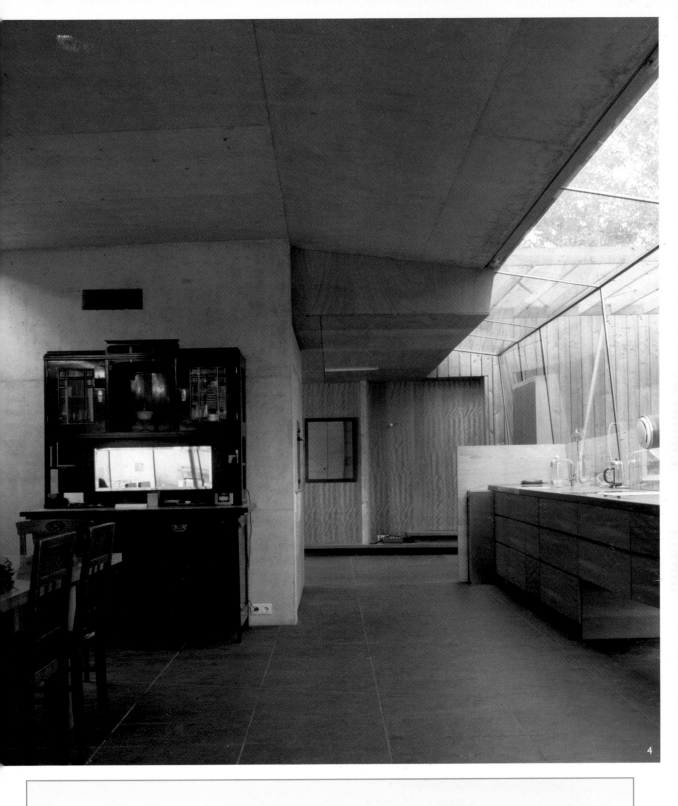

4

3, 4 Architects: Feyferlik-Fritzer; Photographer: Paul Ott

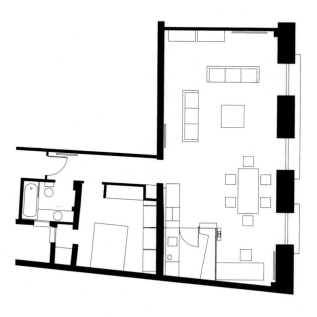

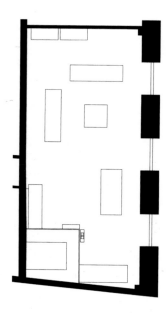

Floor plans

I Architects: Pablo Fernández Lorenzo & Pablo Redondo Díez; Photographer: Eugeni Pons

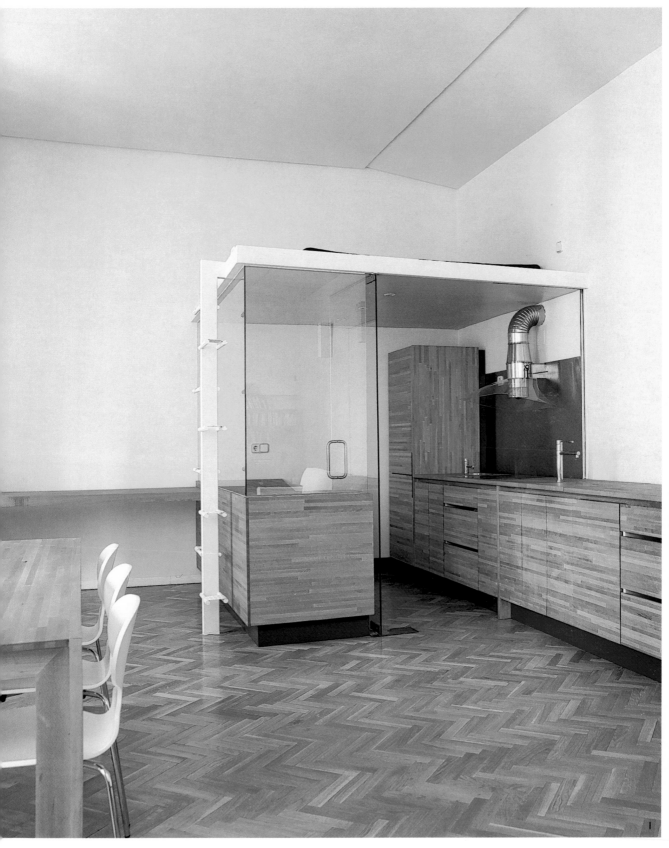

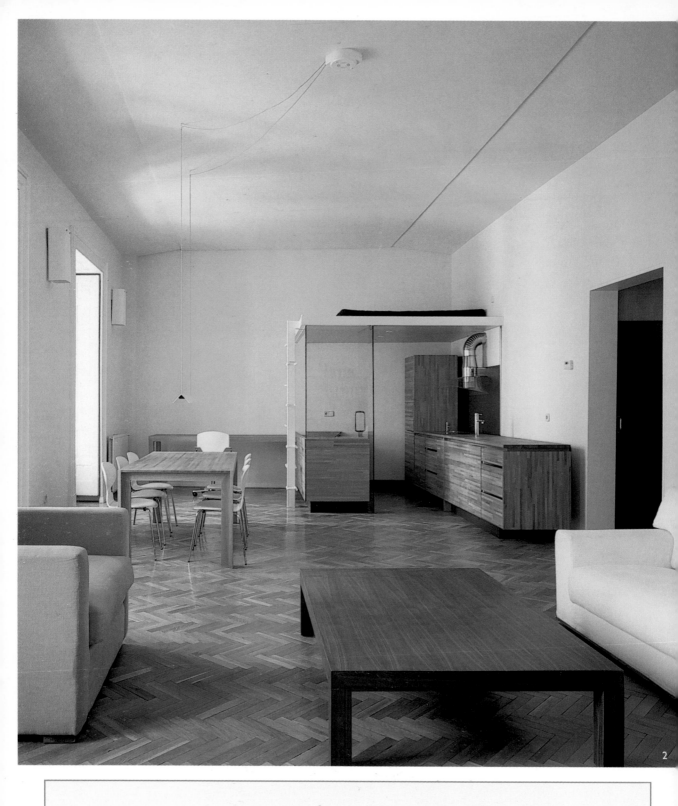

2, 3, 4 Architects: Pablo Fernández Lorenzo & Pablo Redondo Díez; Photographer: Eugeni Pons

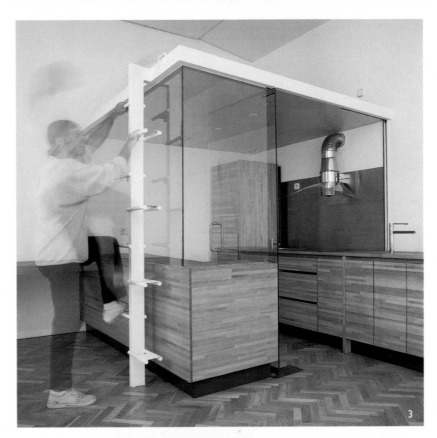

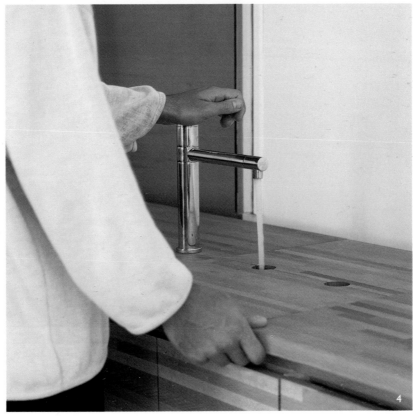

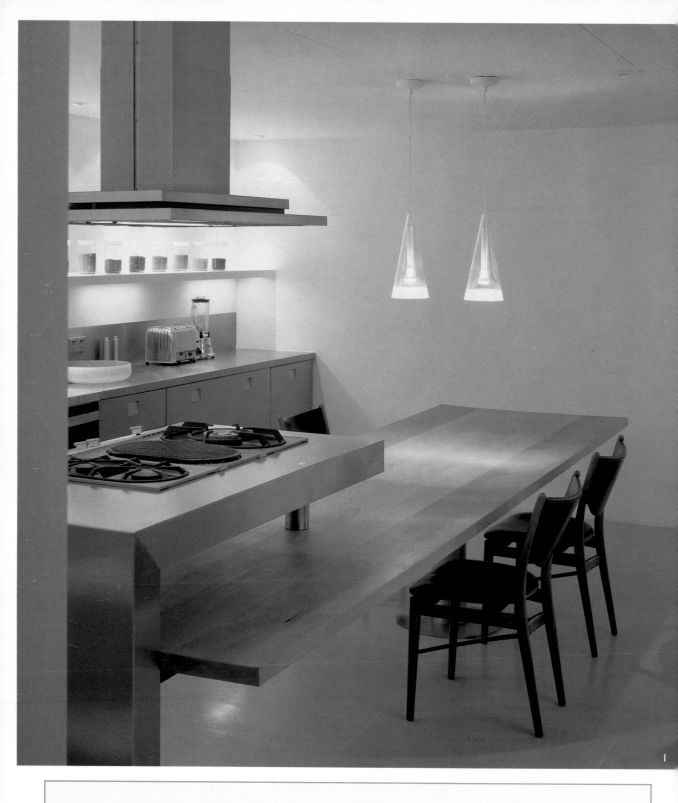

The combination of wood and stainless steel opens up new possibilities in this design, which combines the table and the cooktop into one piece.

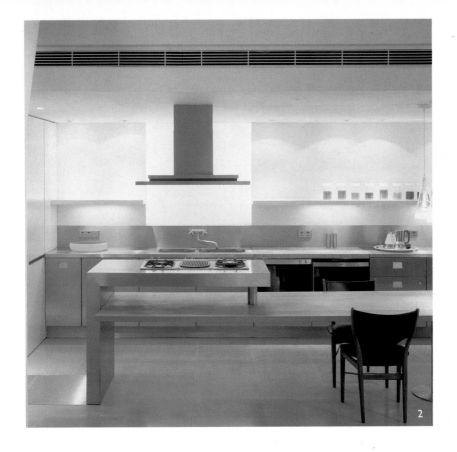

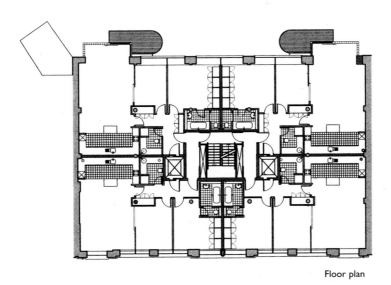

Floor plan

1, 2 Architects: Child Graddon Lewis; Photographer: Dennis Gilbert/View

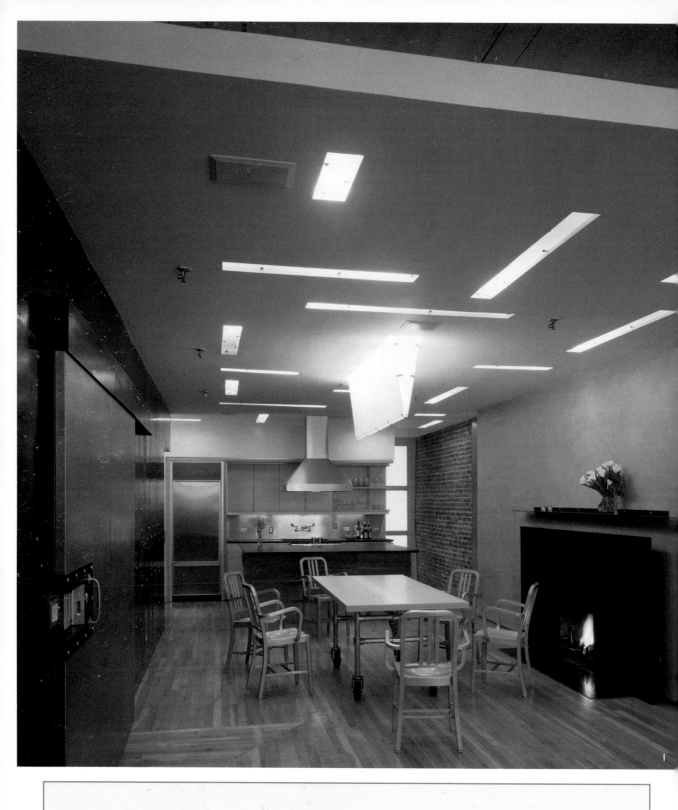

1, 2, 3 Architects: Resolution 4 Architecture; Photographer: Eduard Hueber

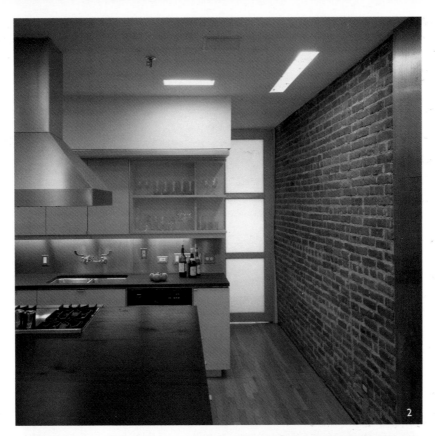

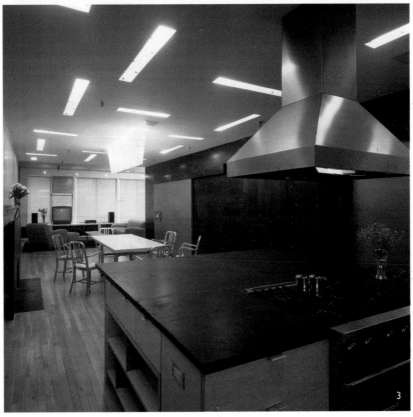

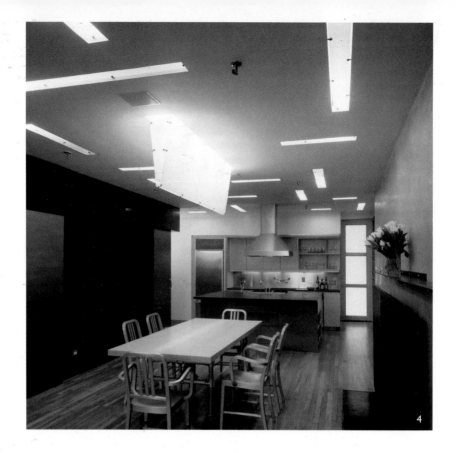

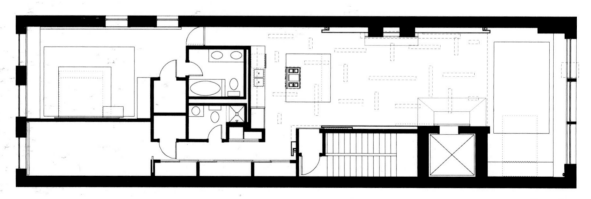

Floor plan

4 Architects: Resolution 4 Architecture; Photographer: Eduard Hueber

1 Architects: Olli Sarlin & Marja Sopanen; Photographer: Arno de la Chapelle

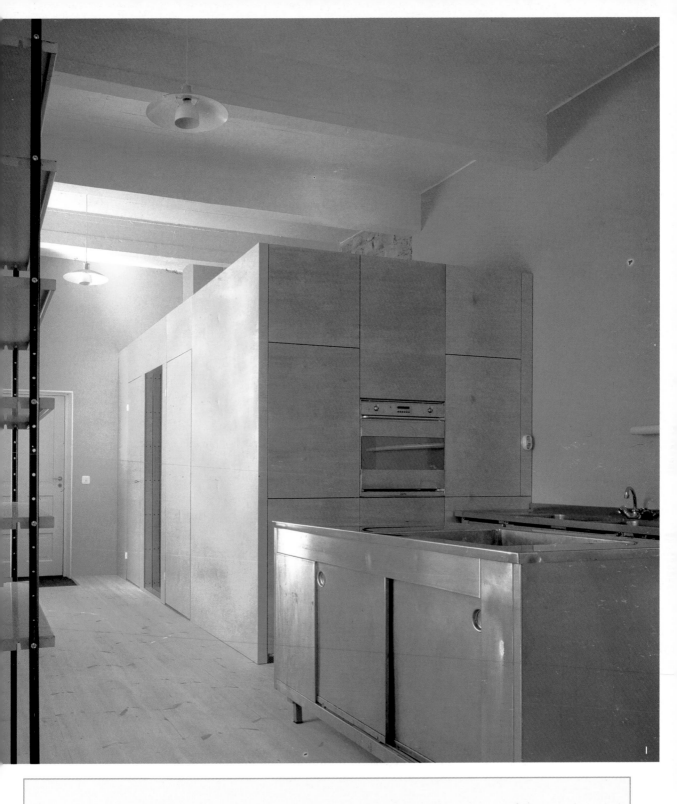

This kitchen was designed using independent modules, which give it a modern, industrial feel.

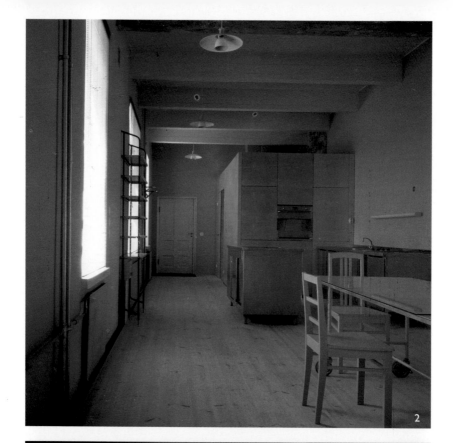

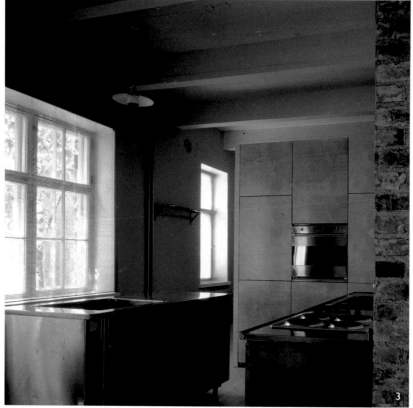

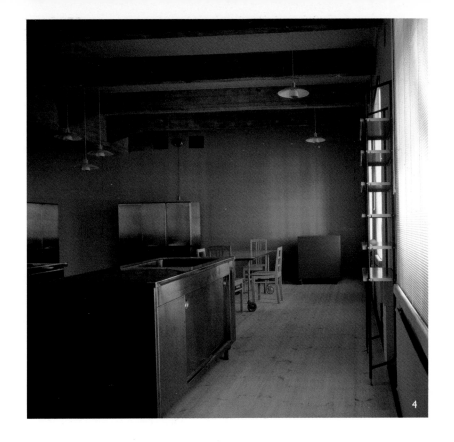

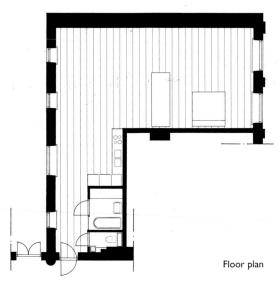

Floor plan

2, 3, 4 Architects: Olli Sarlin & Marja Sopanen; Photographer: Arno de la Chapelle

Island

ISLAND kitchens have the advantage of facilitating maneuverability during cooking, because the elements normally found in a kitchen are centrally located. These kitchens also allow for better use of space because storage units can be placed on the surrounding walls, while sinks and appliances such as cooktops and ovens can be placed in the center.

Because of their layout and functionality, island kitchens resemble industrial and restaurant kitchens, and are gaining popularity among homeowners of all kinds.

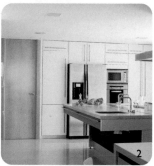

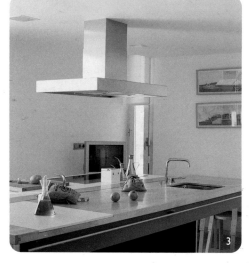

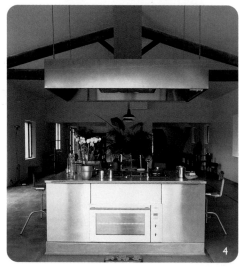

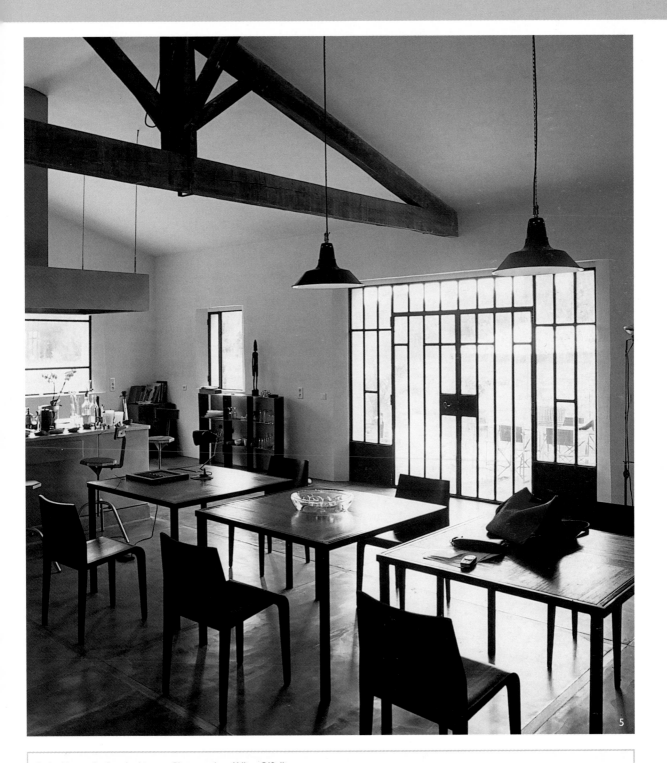

1 Architects: Surface Architects; Photographer: Killian O'Sullivan

2, 3 Architect: Jaime Sanahuja; Photographer: José Luis Hausmann

4, 5 Photographers: Guy Bouchet & Ana Cardinale

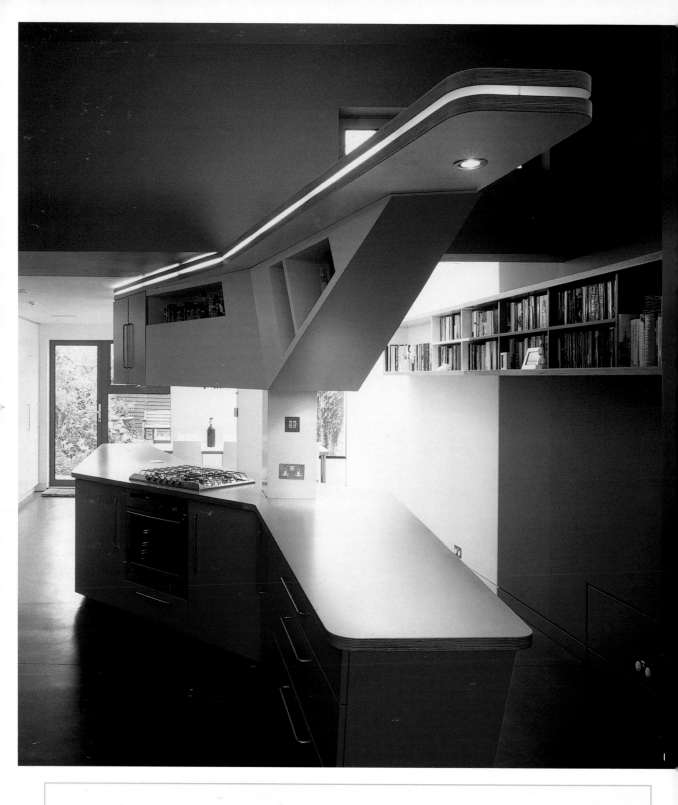

1, 2 Architects: Surface Architects; Photographer: Killian O'Sullivan

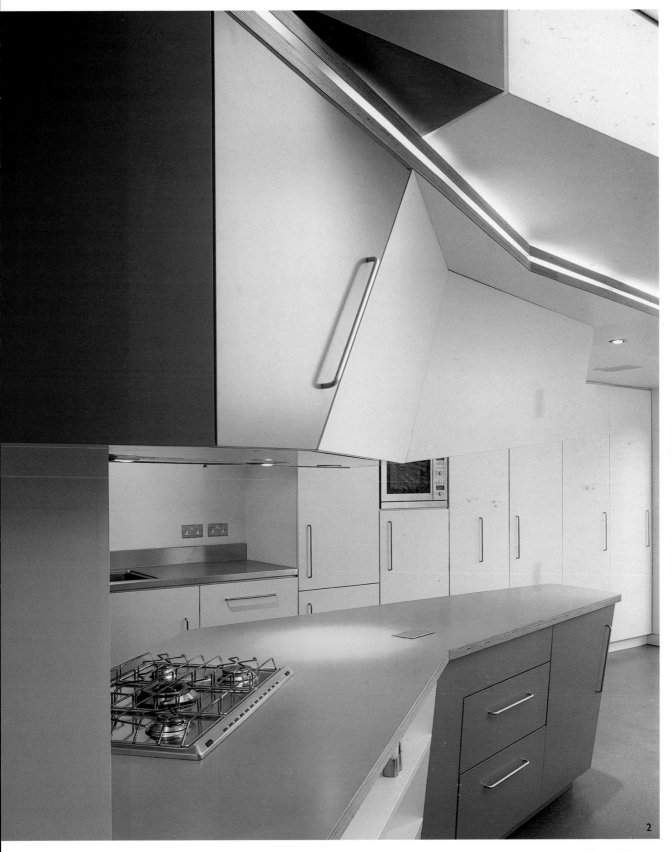

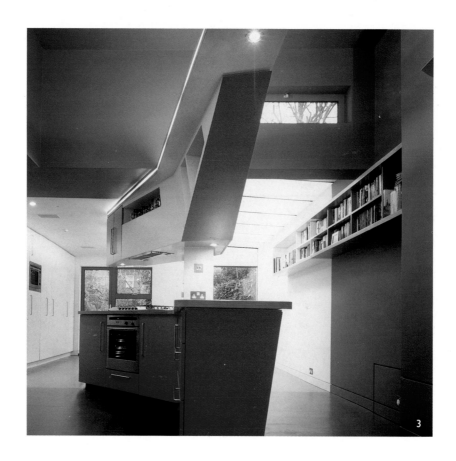

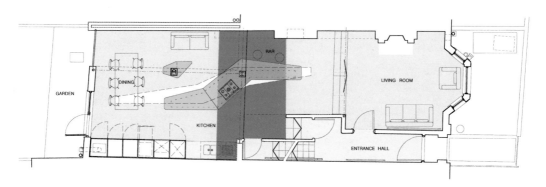

Floor plan

The V-shape of the central module allows for more fluid movement within the kitchen area
and makes it a transitional space between the living room and the rest of the home.

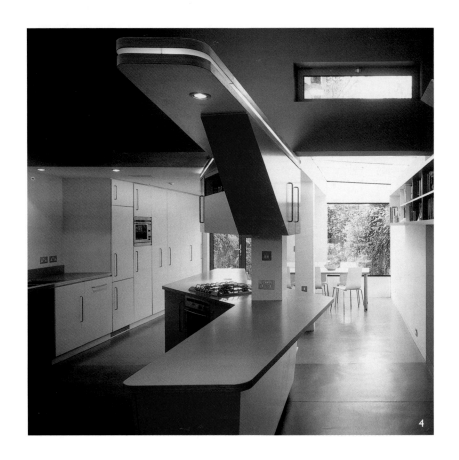

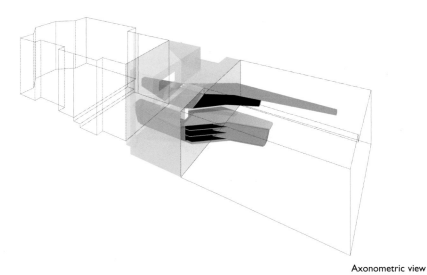

Axonometric view

3, 4 Architect: Surface Architects; Photographer: Killian O'Sullivan

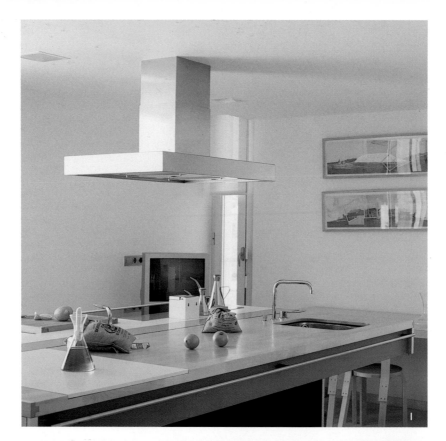

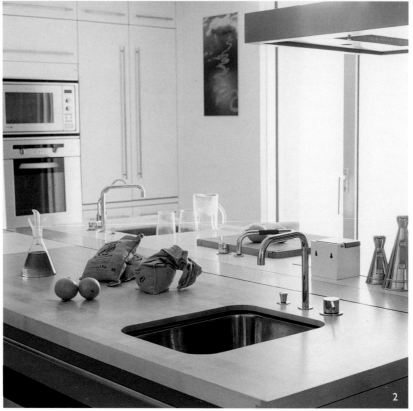

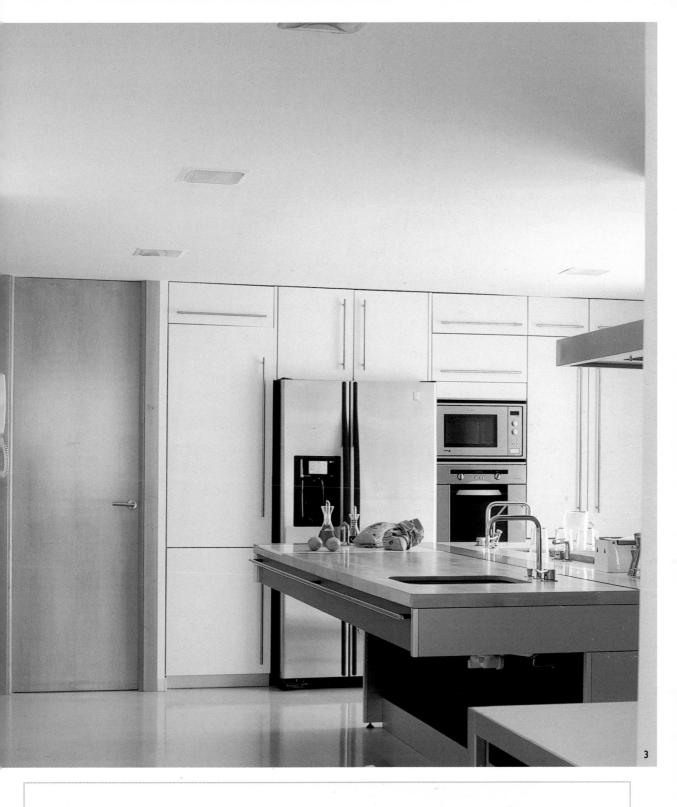

3

1, 2, 3 Architect: Jaime Sanahuja; Photographer: José Luis Hausmann

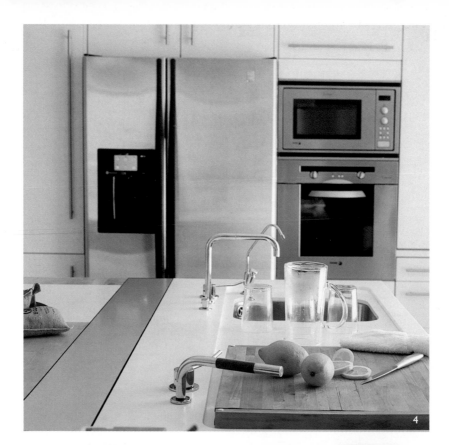

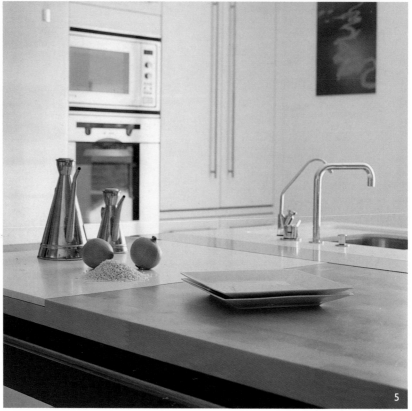

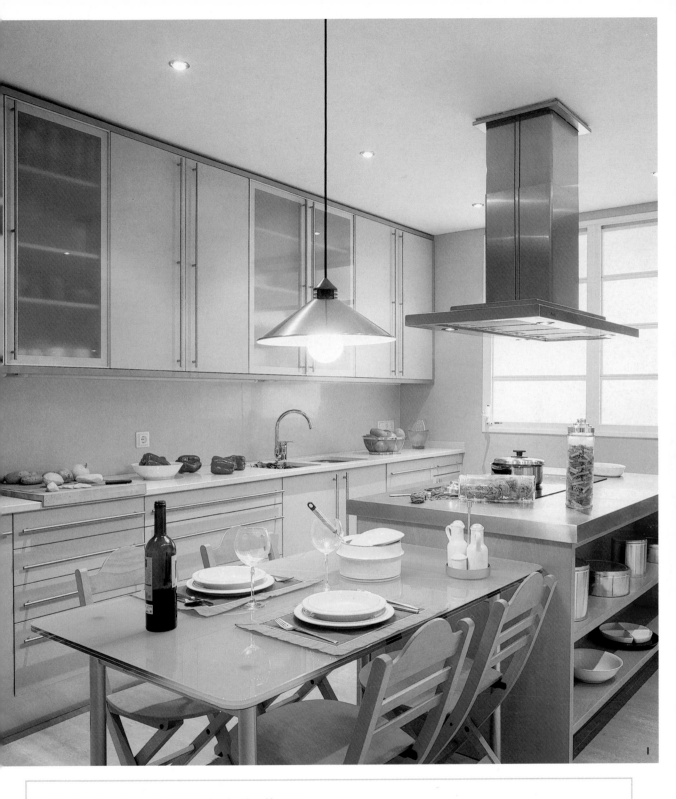

4, 5 Architect: Jaime Sanahuja; Photographer: José Luis Hausmann

1 Interior Design: L´Eix; Photographer: José Luis Hausmann

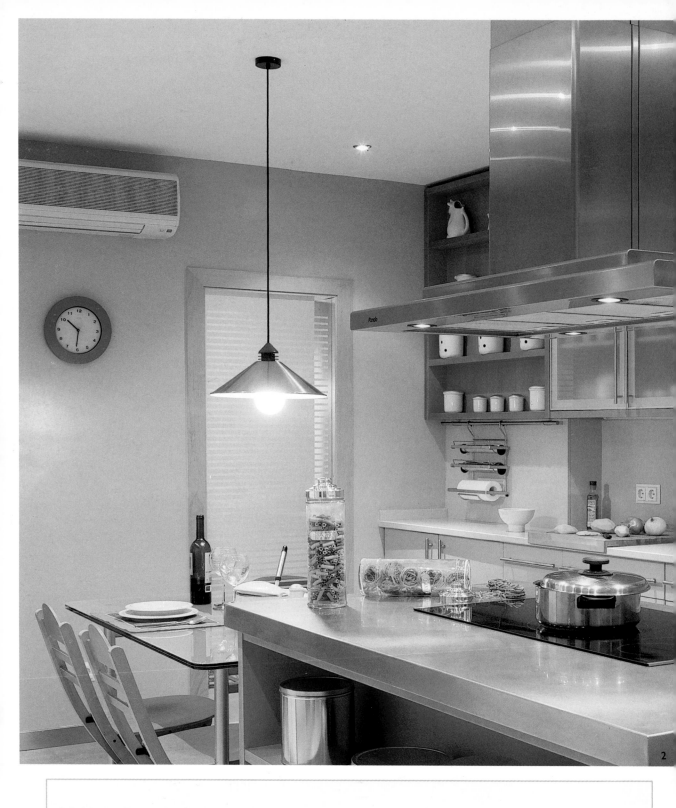

2, 3, 4 Interior Design: L´Eix; Photographer: José Luis Hausmann

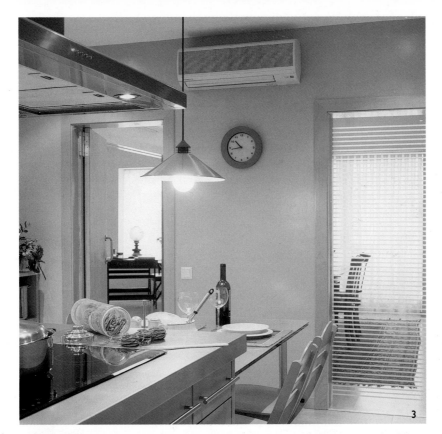

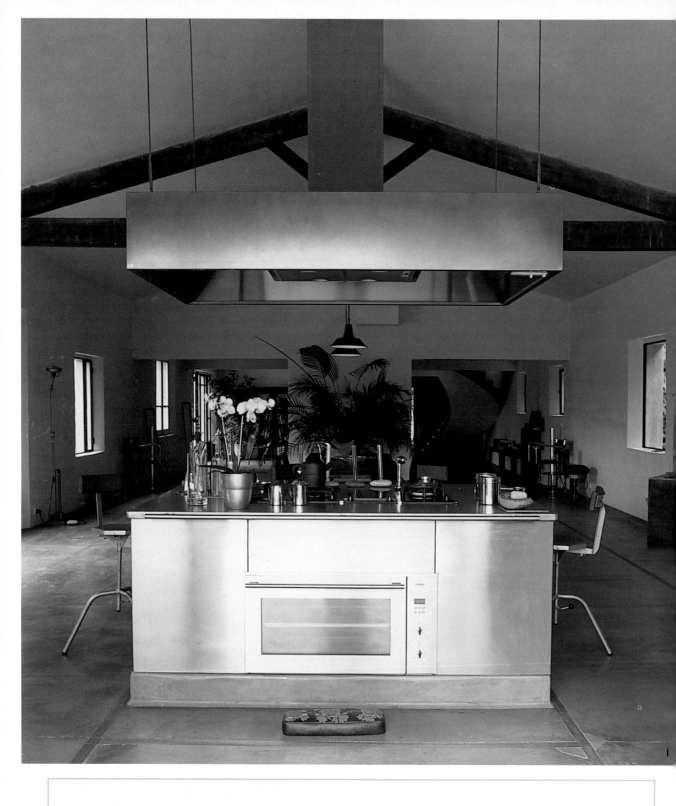

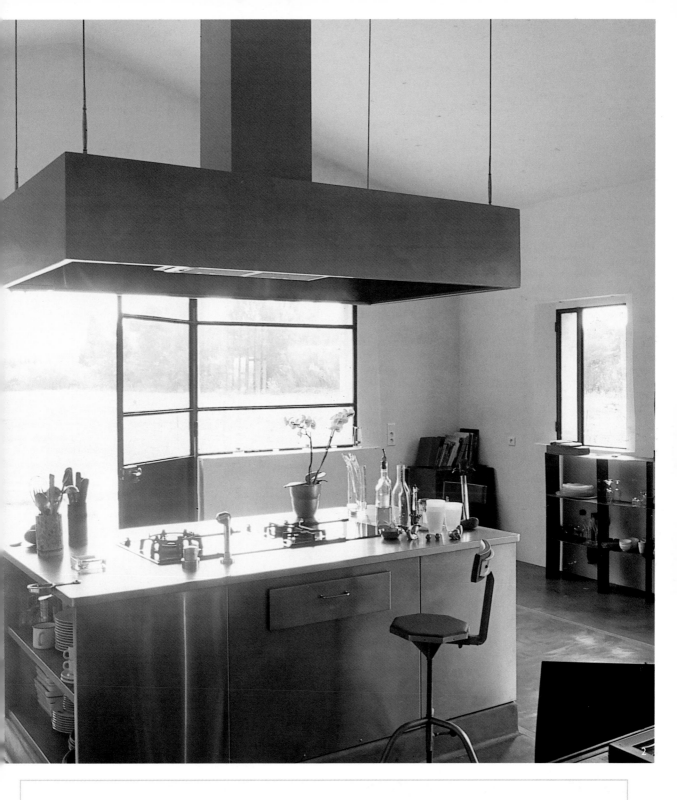

This type of kitchen groups most of the elements in its central module, freeing up the adjacent areas.

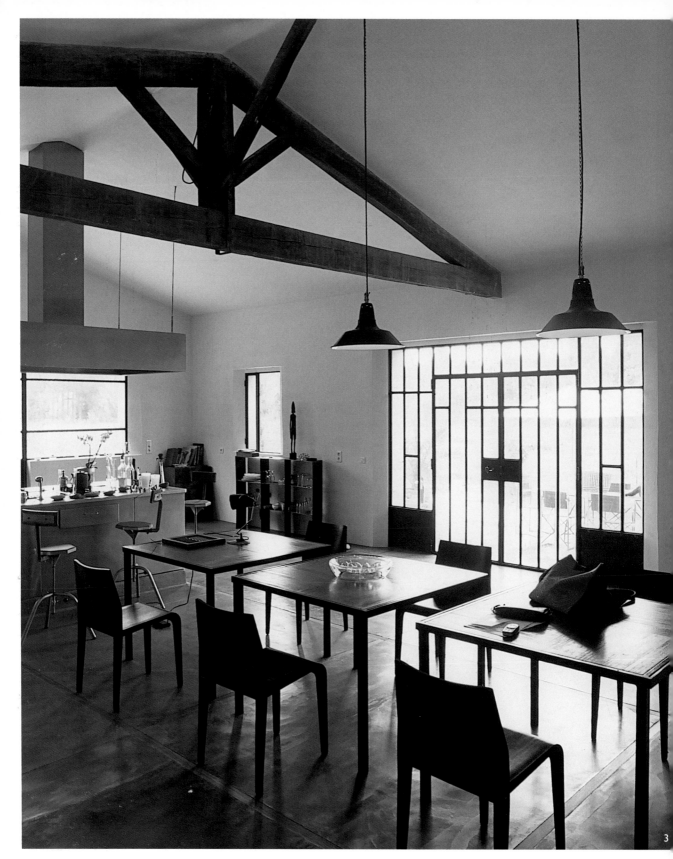

3

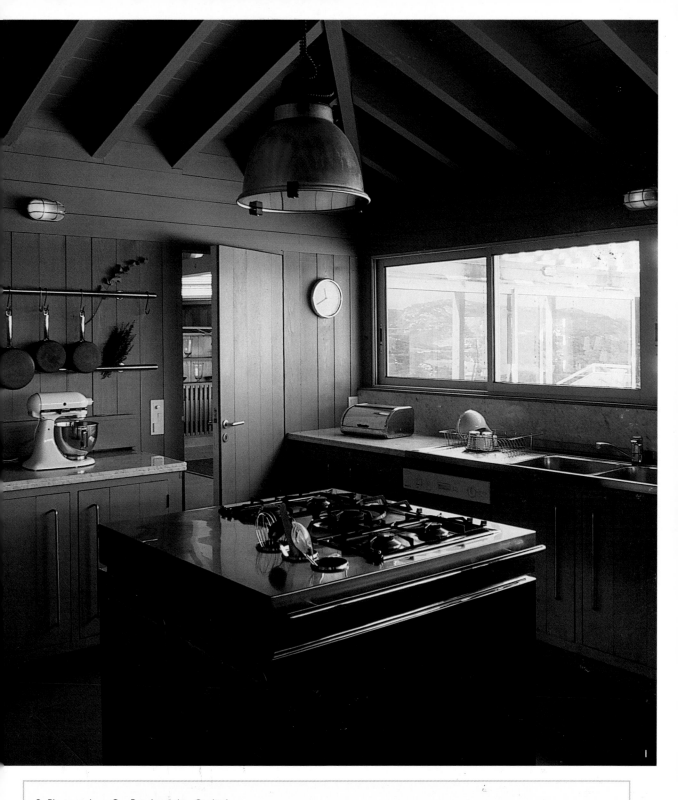

3 Photographers: Guy Bouchet & Ana Cardinale

1 Photographers: Guy Bouchet & Ana Cardinale

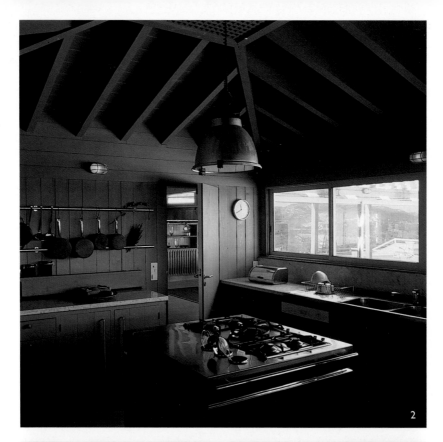

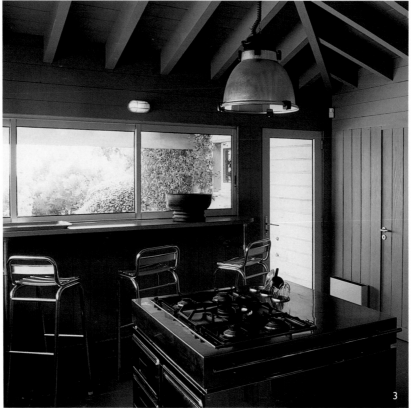

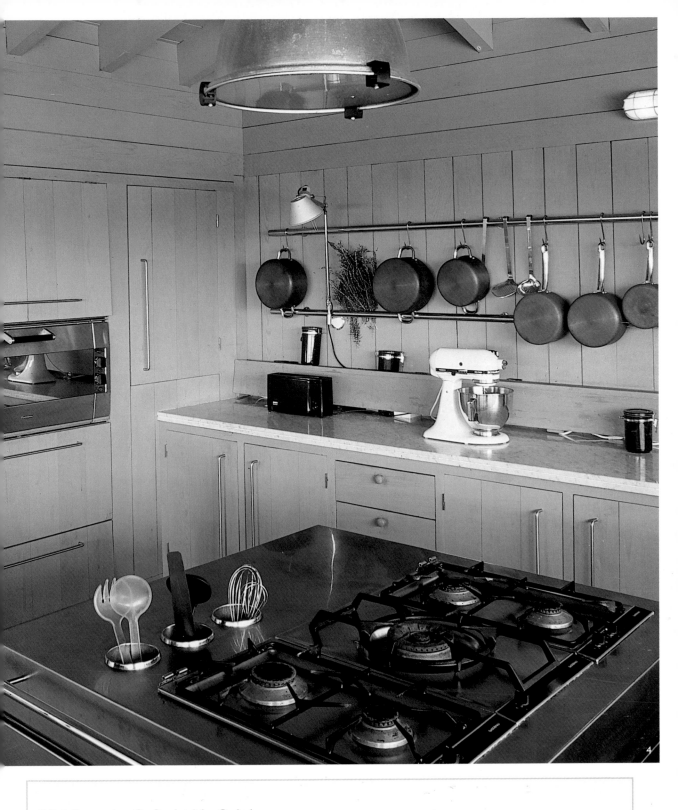

2, 3, 4 Photographers: Guy Bouchet & Ana Cardinale

Eat-in

WHAT is known as the eat-in kitchen originated with a type of construction developed in the United States. These spaces include the typical elements of a kitchen with a long bar that functions as a dining table.

This is an ideal formula for people who live alone, who live frenetic and informal lives, or whose family lives are low-key. It's perfect for homes in small spaces such as studios or apartments.

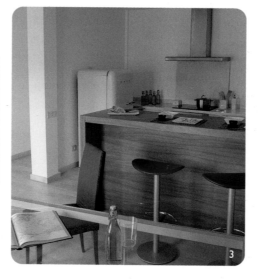

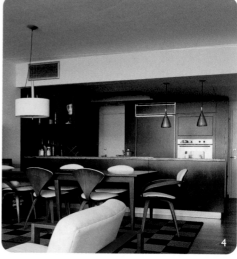

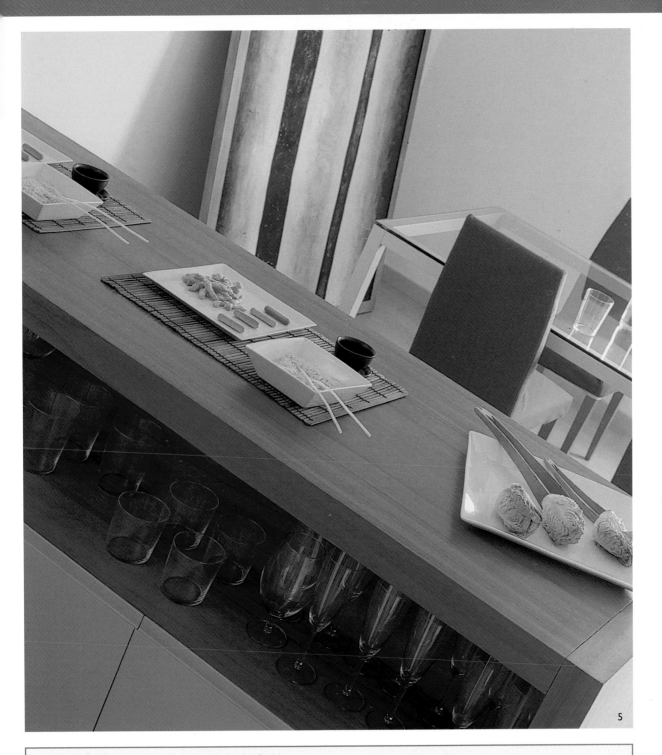

5

1 Architects: Adrià/Broid/Roy; Photographer: Undine Pröhl

2, 3, 5 Interior Design: Àlex Serra; Photographer: José Luis Hausmann

4 Architect: Allan Shullman; Photographer: Pep Escoda

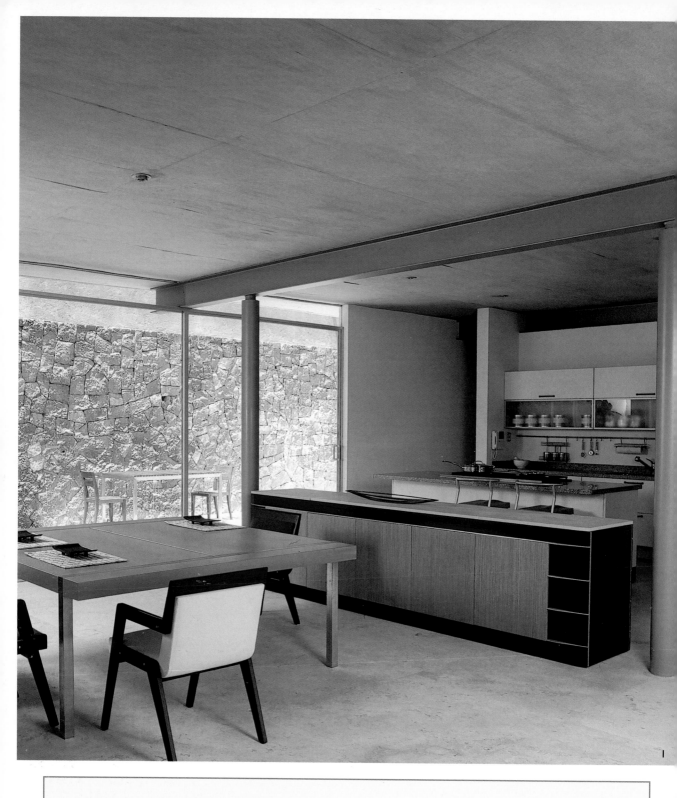

This granite surface next to the cooktop is a space that can be used as a table.

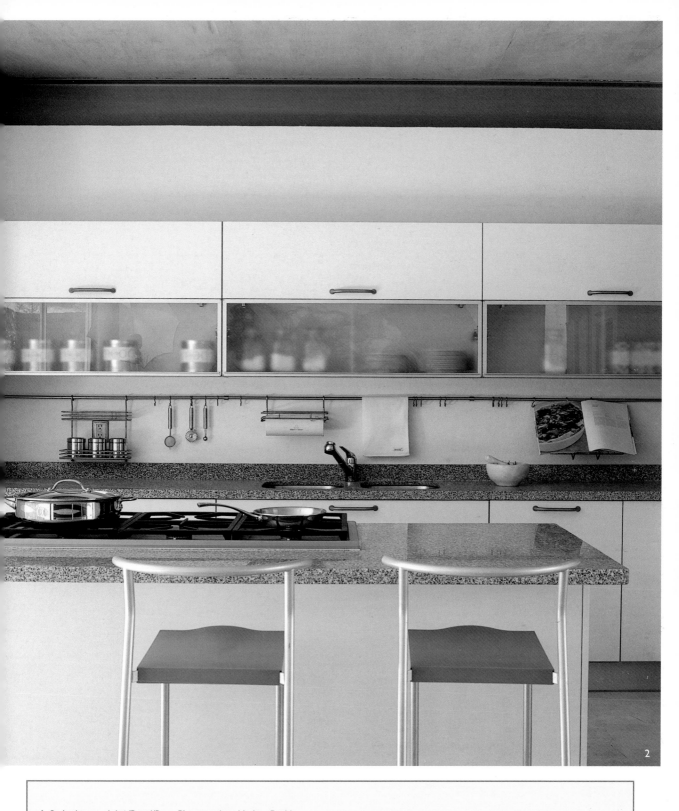

1, 2 Architects: Adrià/Broid/Roy; Photographer: Undine Pröhl

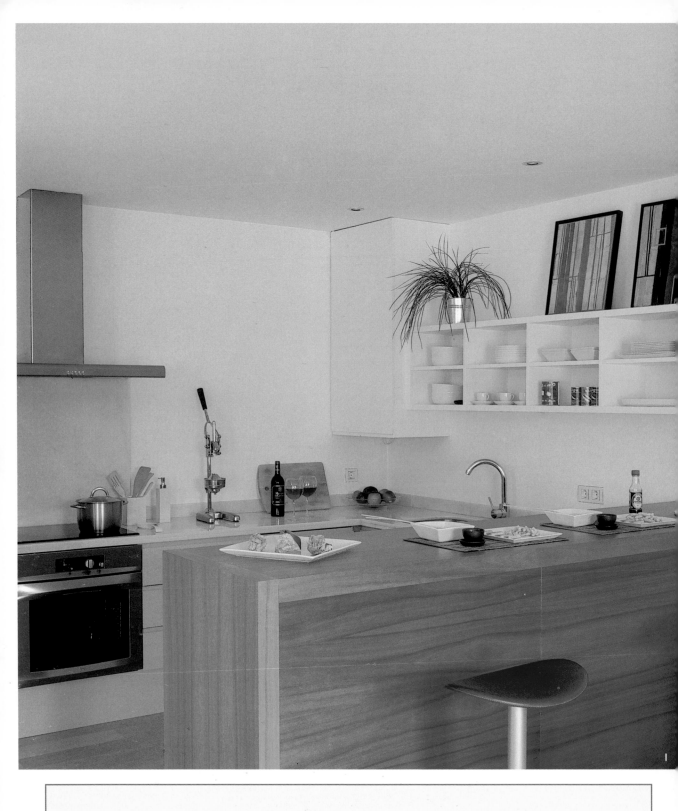

1, 2, 3 Interior Design: Àlex Serra; Photographer: José Luis Hausmann

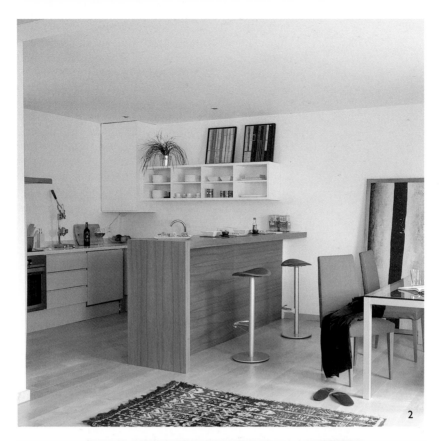

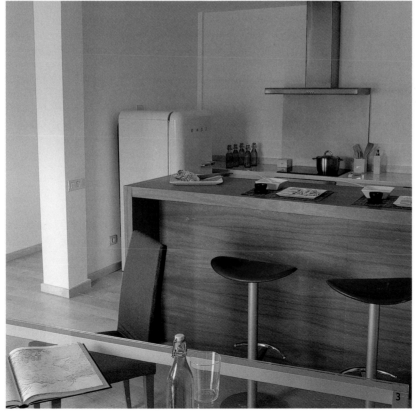

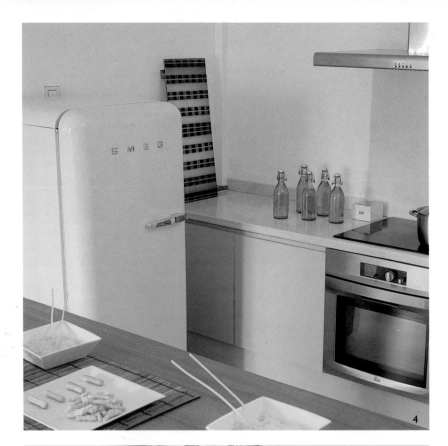

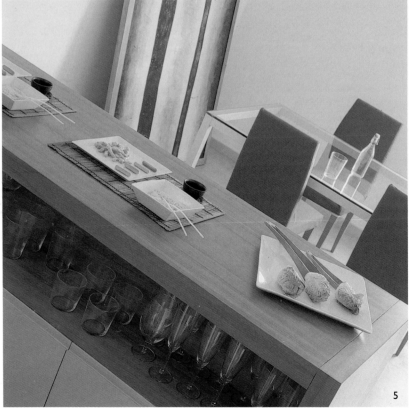

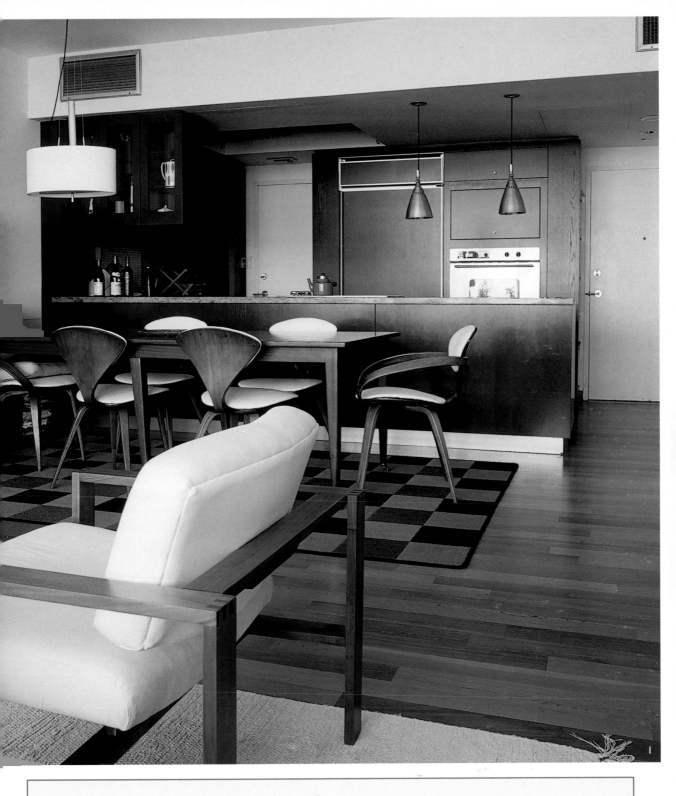

4, 5 Interior Design: Àlex Serra; Photographer: José Luis Hausmann

1 Architect: Allan Shullman; Photographer: Pep Escoda

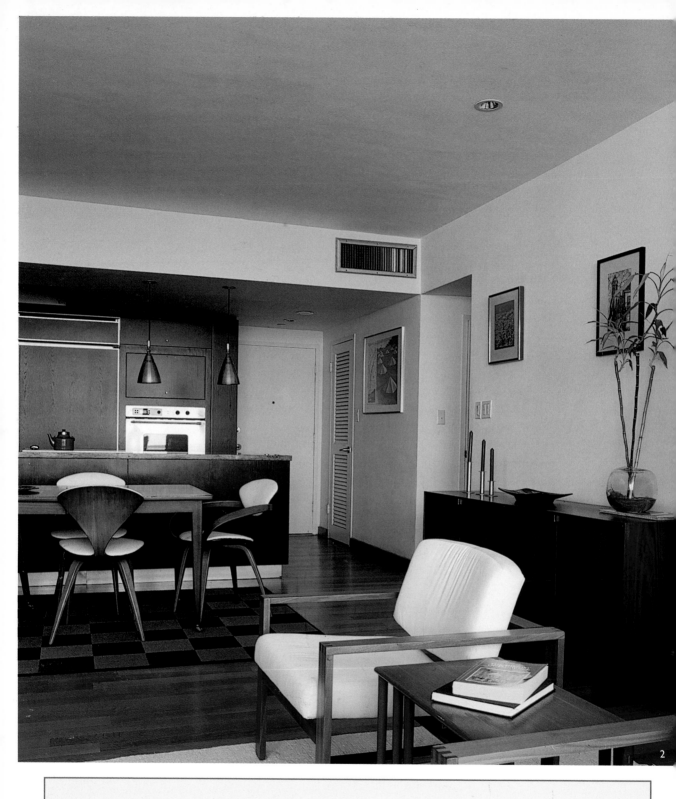

2

The optical effect created by the color of the kitchen furnishings contrasts
with the rest of the décor and visually delimits the spaces.

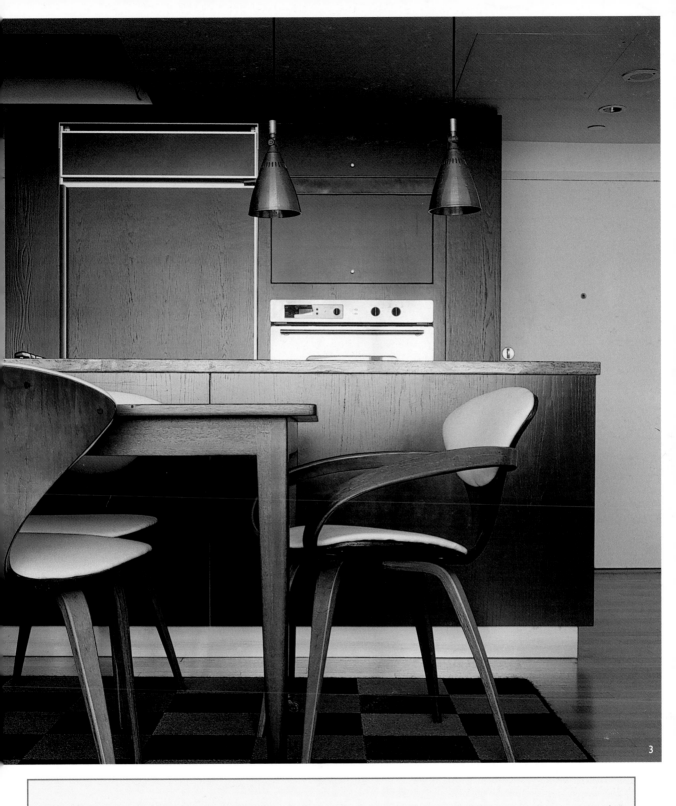

3

2, 3 Architect: Allan Shullman; Photographer: Pep Escoda

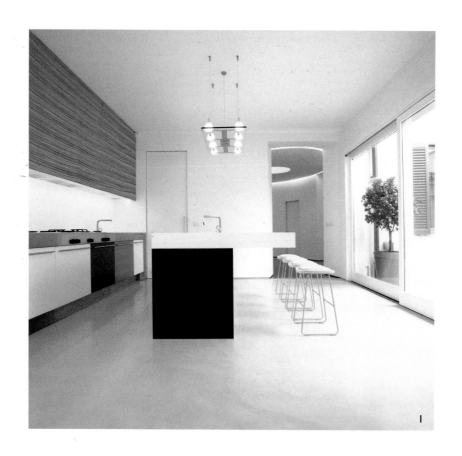

Floor plan

1, 2 Architect: Carlo Donati; Photographer: Matteo Piazza

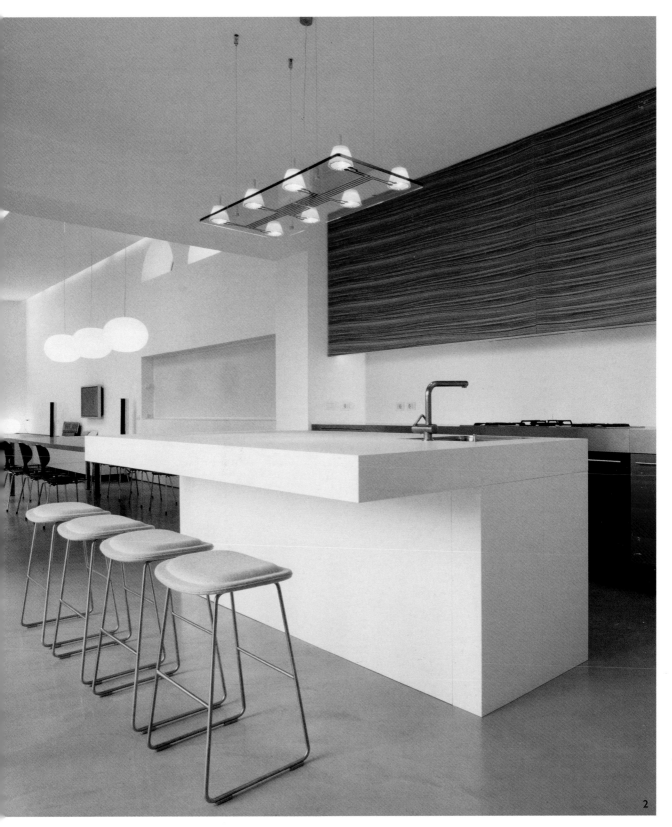

2

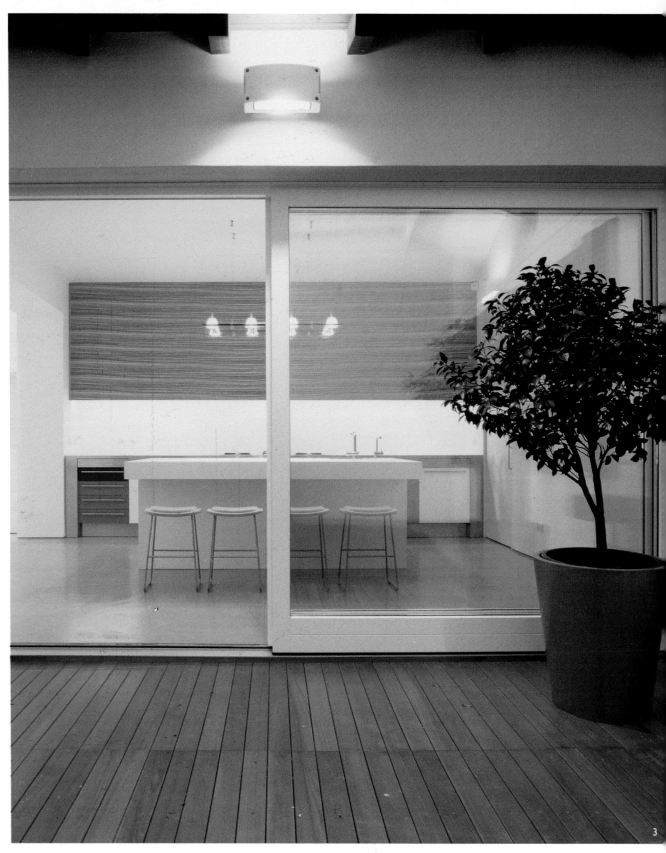

3

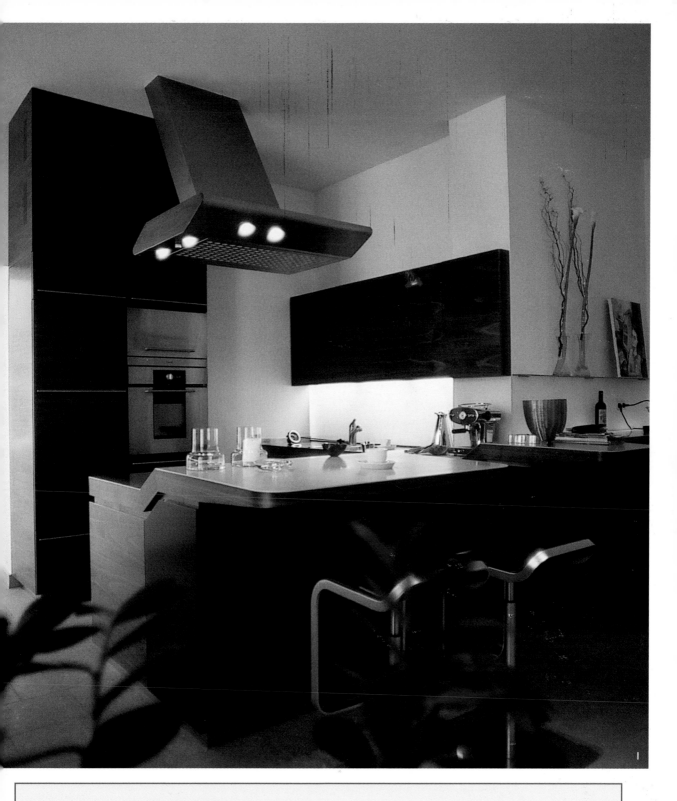

3 Architect: Carlo Donati; Photographer: Matteo Piazza

1 Interior Design: Chavanne & Holzer Design; Photographer: René Chavanne

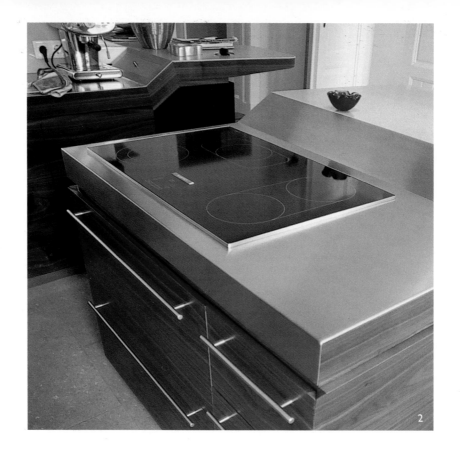

Floor plan

2, 3 Interior Design: Chavanne & Holzer Design; Photographer: René Chavanne

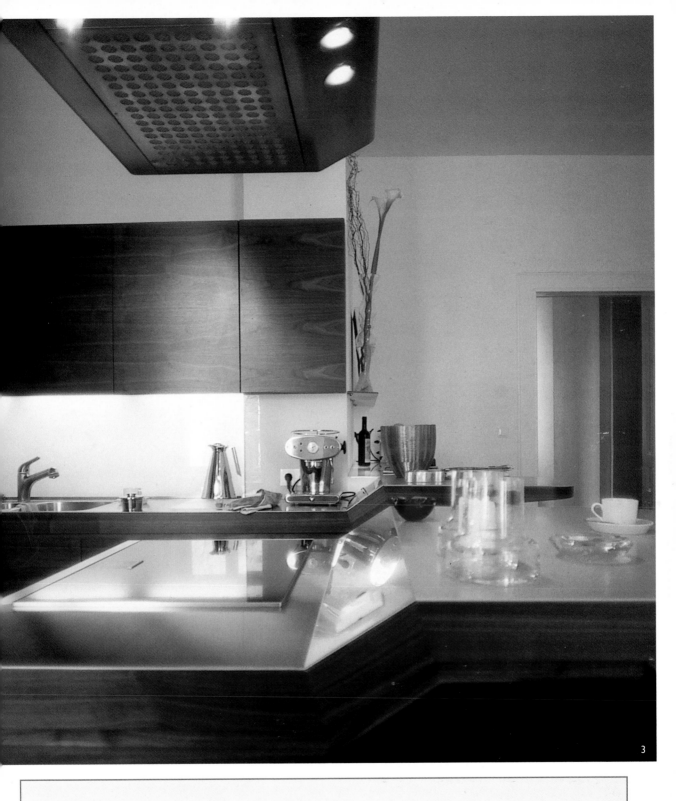

3

The different levels in the design of the furnishings creates a visual discontinuity that breaks the straight lines in this small space.

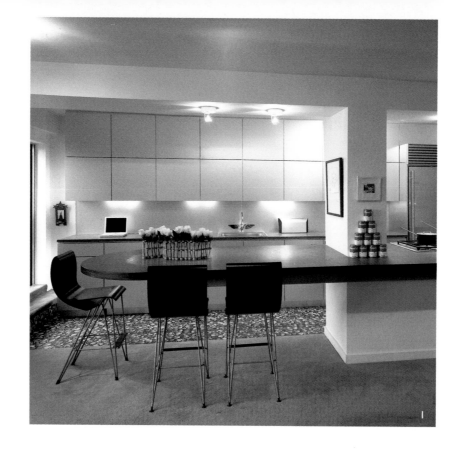

Floor plan

1, 2, 3 Architect: Ronnette Riley; Photographer: Dub Rogers

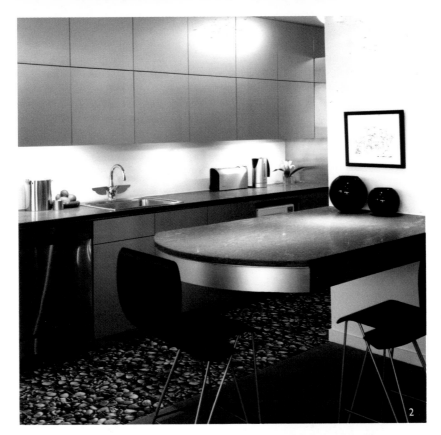

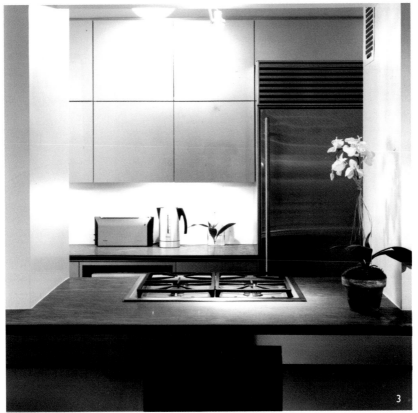

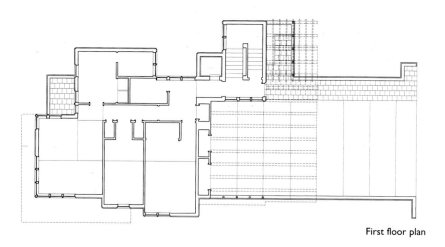

First floor plan

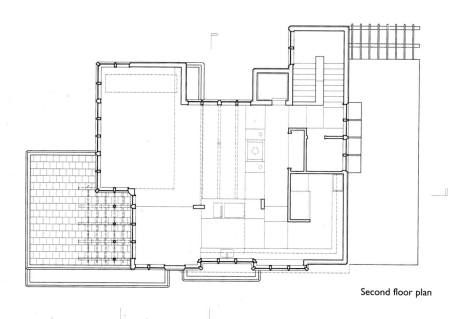

Second floor plan

I Architect: Jonathan Levi; Photographer: Anton Grassl & Jonathan Levi

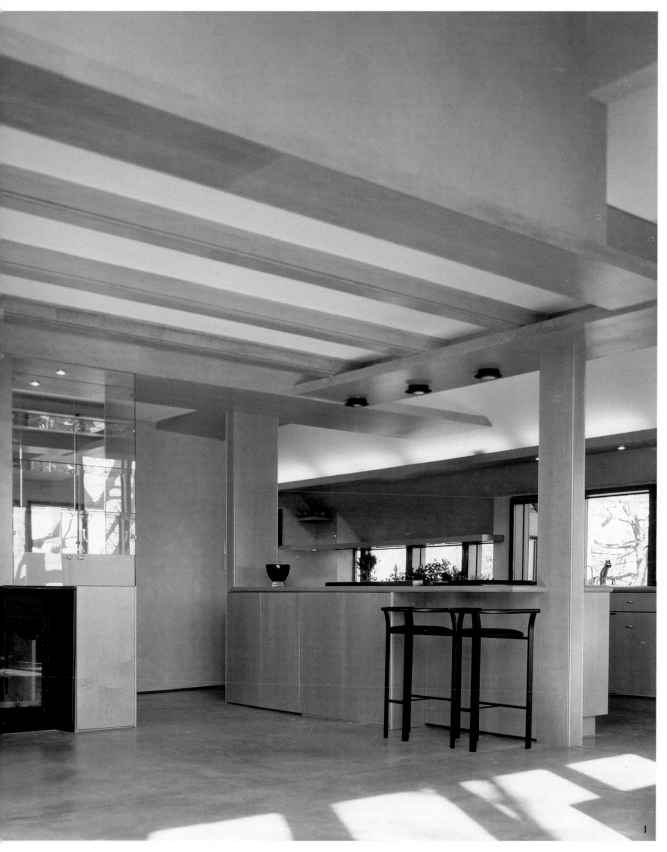

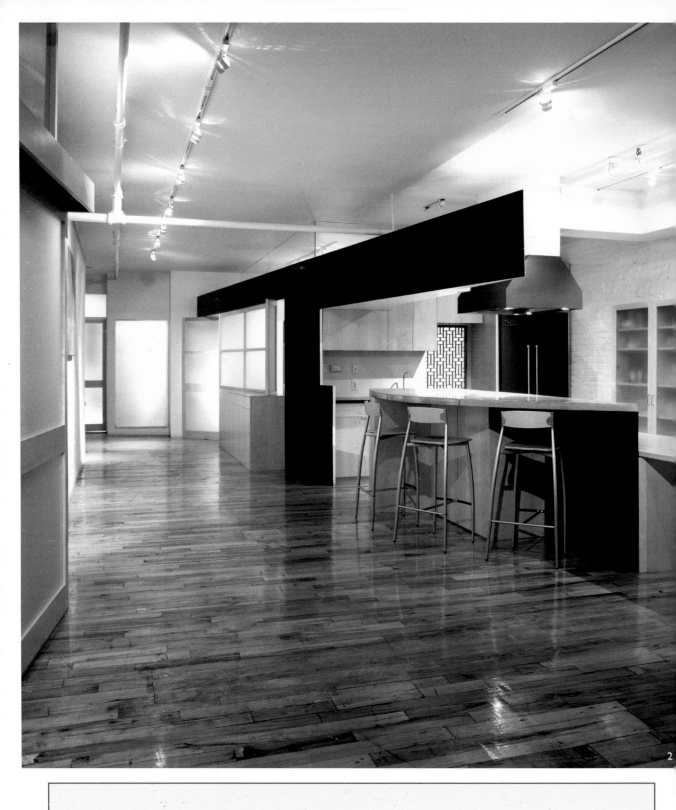

2, 3, 4 Architects: Smith & Thompson Architects; Photographer: Doug Baz

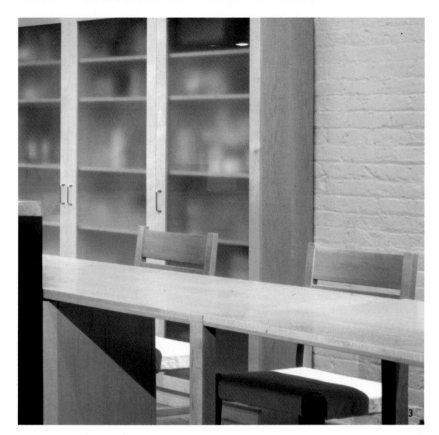

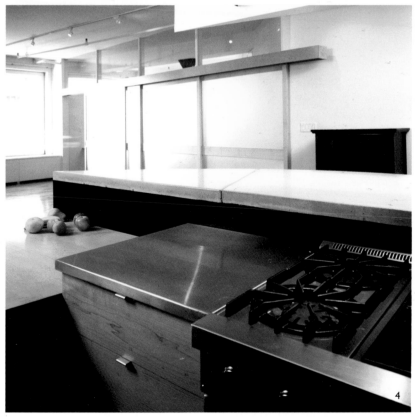

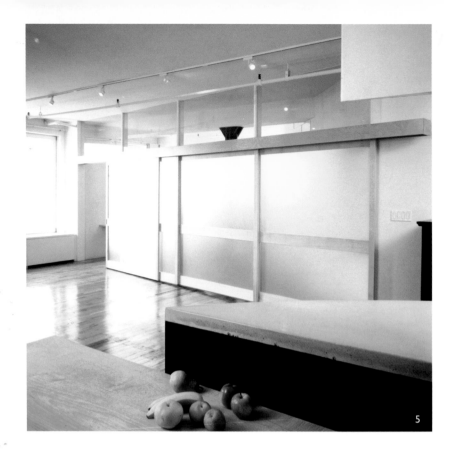

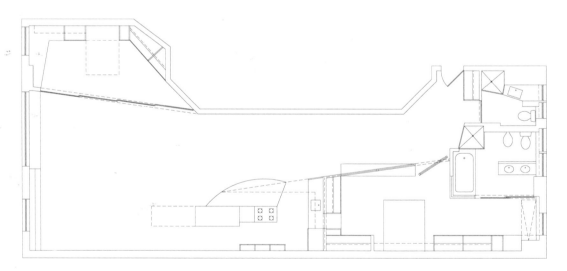

Floor plan

5, 6 Architects: Smith & Thompson Architects; Photographer: Doug Baz

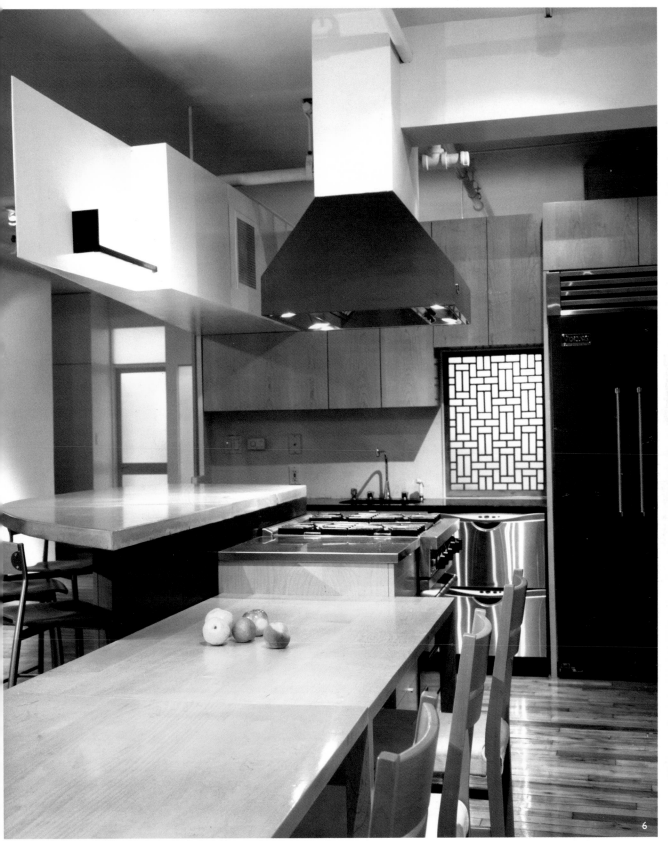

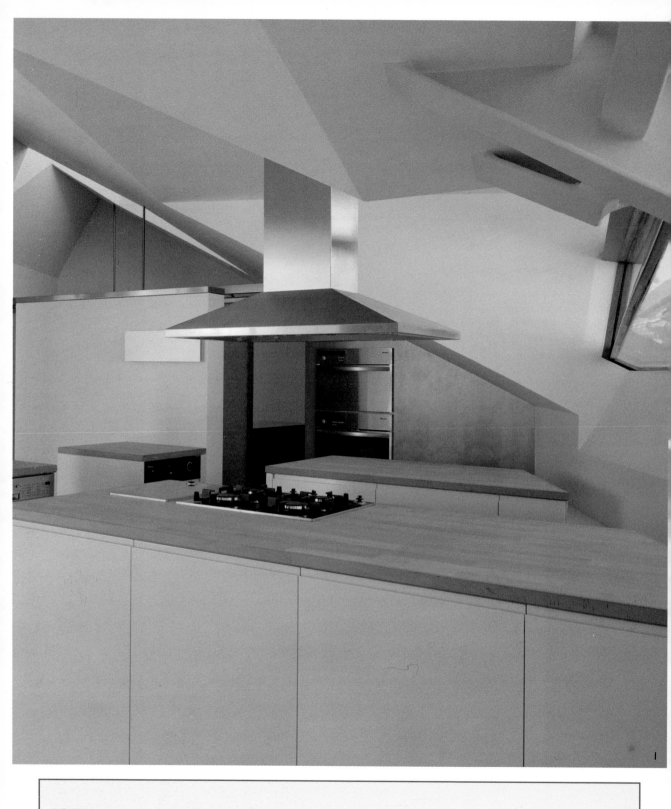

1, 2 Architect: Holodeck.at; Photographer: Veronika Hofinger

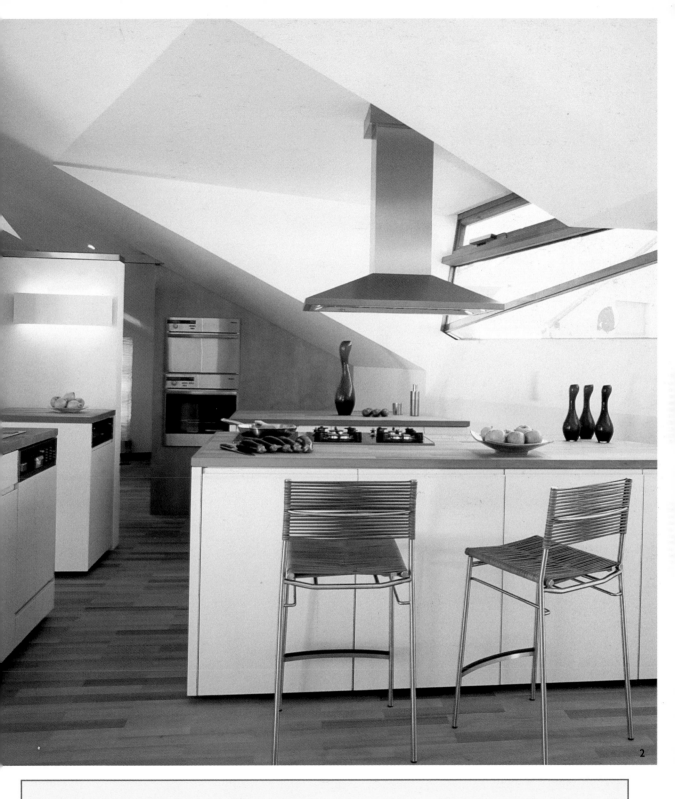

The placement of the extractor hood, with respect to the sloped ceiling,
balances the vertical and horizontal lines of this kitchen space.

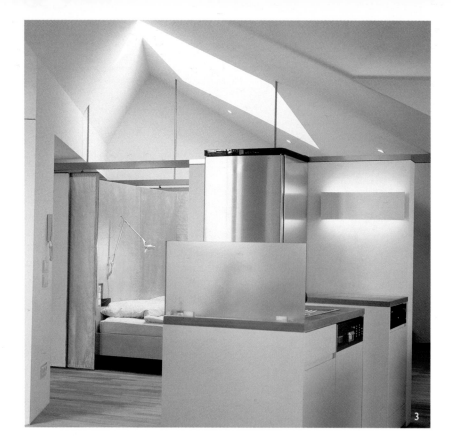

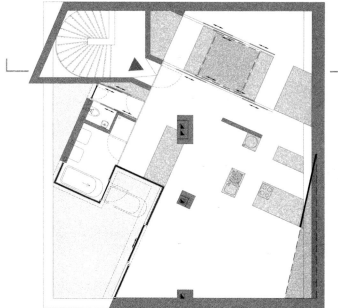

Floor plan

This kitchen is concealed and integrated into the home through the use of a minimalist, austere decor.

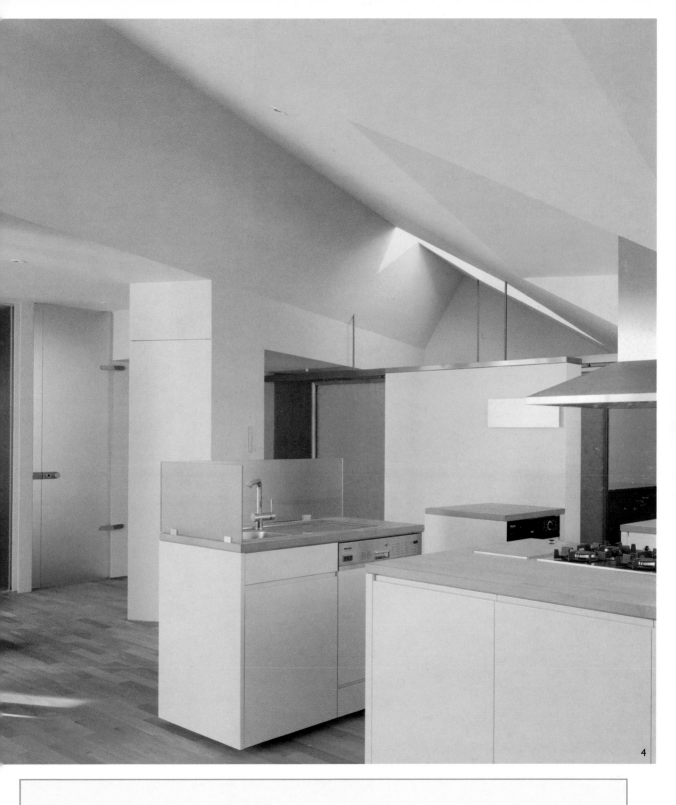

3, 4 Architect: Holodeck.at; Photographer: Veronika Hofinger

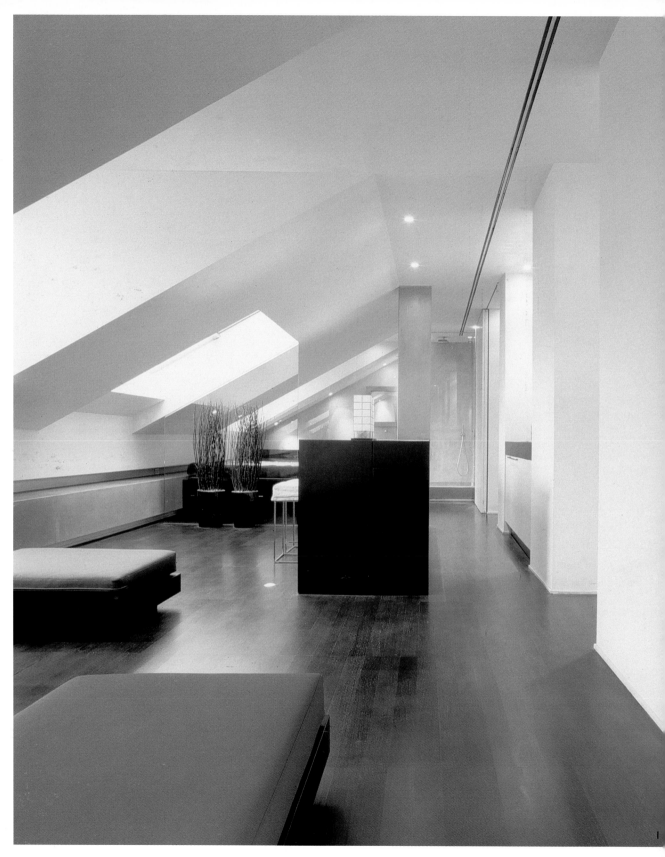

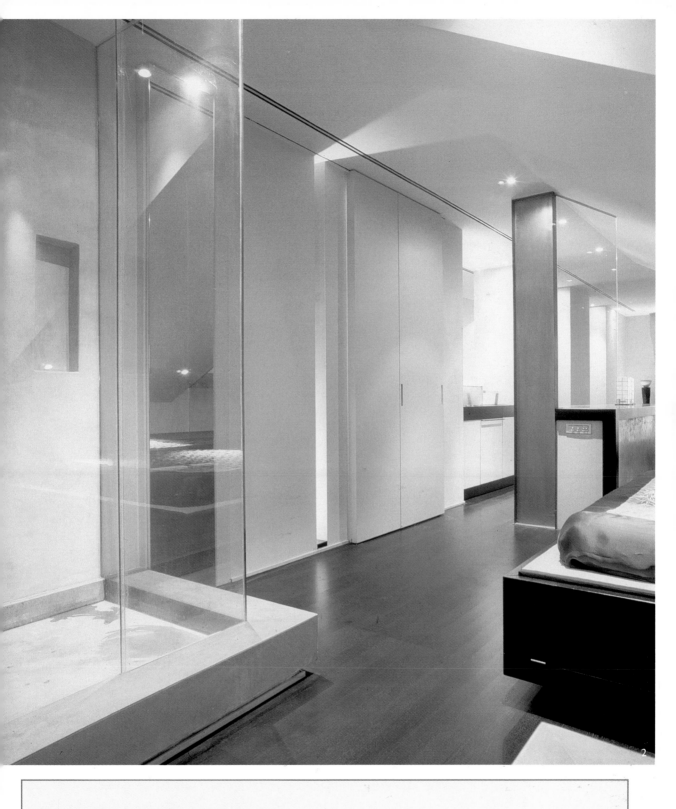

2

1, 2 Architect: Marco Savorelli; Photographer: Matteo Piazza

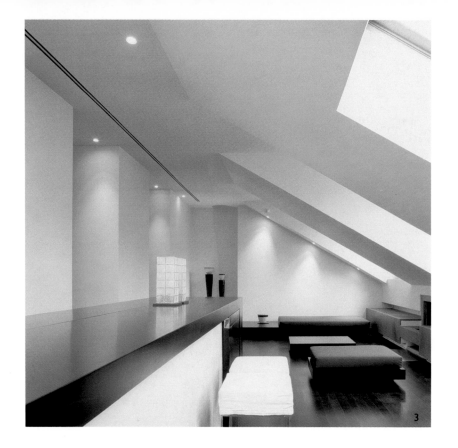

Floor plan

3, 4 Architect: Marco Savorelli; Photographer: Matteo Piazza

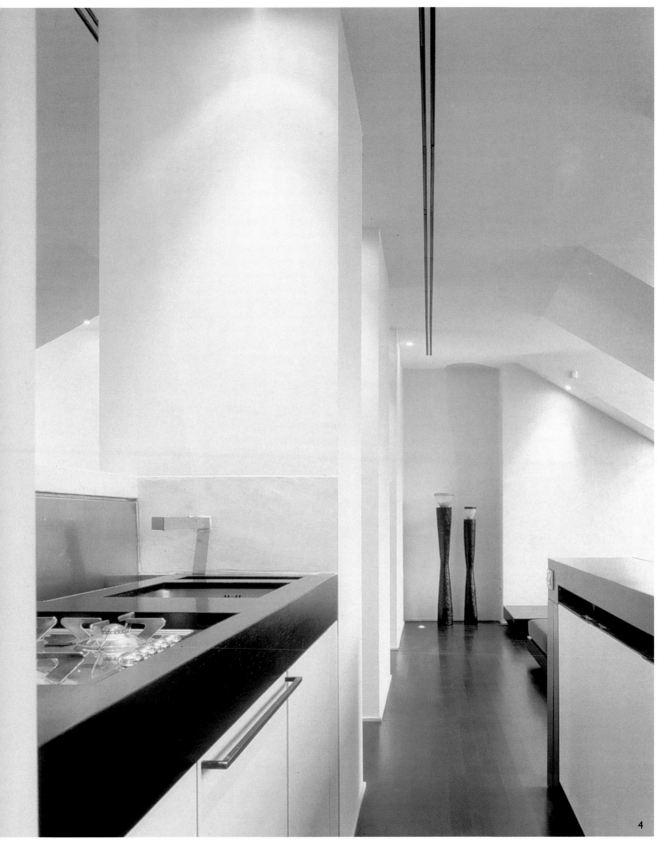

4

Styles

STYLE is the aesthetic trend chosen for each type of kitchen. It depends on the owner's taste and reflects certain habits as well as the owner's individual lifestyle. Highlighted are three of the many styles of kitchens made popular by the features that differentiate them: minimalist, urban, and rustic. Within each style, the use of different materials, such as metal or wood, produces varied results.

The urban style, the product of a fast-paced way of life characterized by a scarcity of time, is noteworthy for its functionality in a constantly changing setting. The minimalist style imposes a reductionist aesthetic on the kitchen décor, and has also become a lifestyle (summed up in the well-known slogan, "less is more"). The rustic style maintains the standards of the aesthetic and the elements of traditional structures and components.

These general aesthetic lines notwithstanding, each style belongs to a personal universe, that of the individual who inhabits the space. For this reason, combinations of styles, materials, and concepts are also quite common.

Minimalist

Urban

Rustic

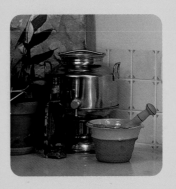

Minimalist

THE minimalist aesthetic has been employed in many homes for some years and entails a reduction of ornamentation. Minimalist kitchens often avoid even typical accoutrements, such as cabinet handles or racks for hanging ladles, pots, or dish towels.

Because one of its guiding principles is uniformity, this aesthetic tries to hide from view or camouflage the elements that are typical of a kitchen, in order to prevent it from clashing with the other rooms.

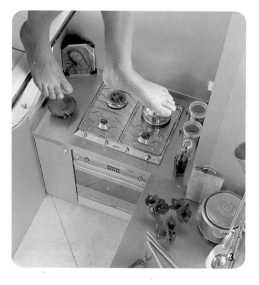

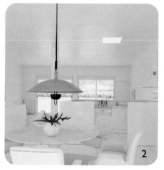

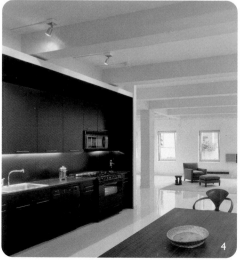

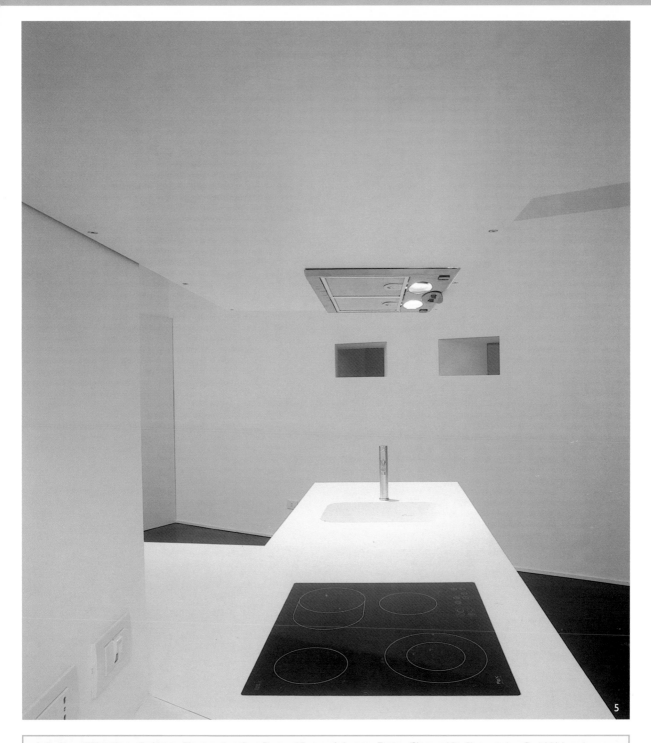

5

1 Architect: William Smart Architects; Photographer: Gene Raymond Ross	**4** Interior Design: Chroma AD; Photographer: David M. Joseph
2 Photographer: Eugeni Pons	**5** Architect : Fabrizio Leoni; Photographer: Dessì e Monari
3 Photographer: Jean-François Jaussaud	

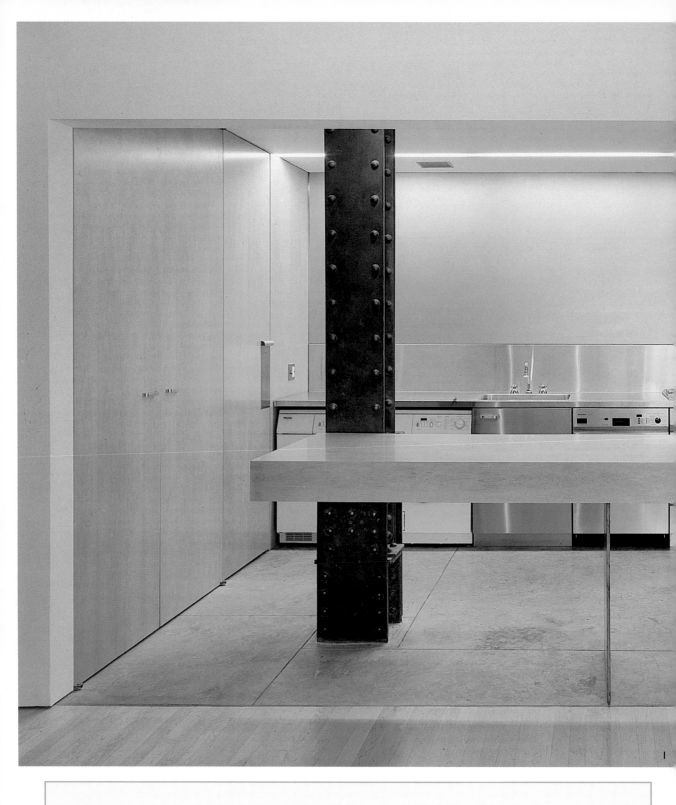

The straight lines and pure shapes of the design define this extremely simple structure.

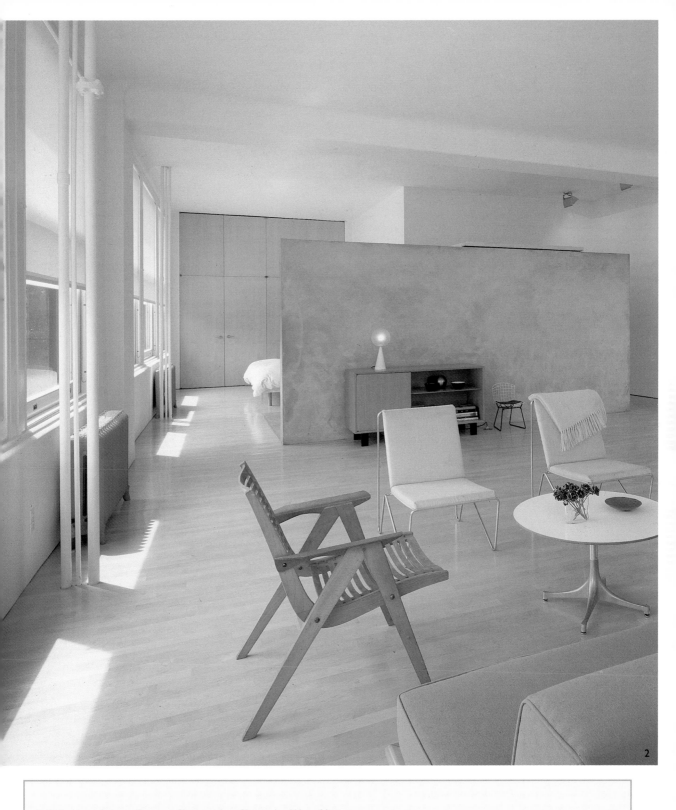

2

1, 2 Architect: Belmont Fraeman; Photographer: Christopher Wesnofske

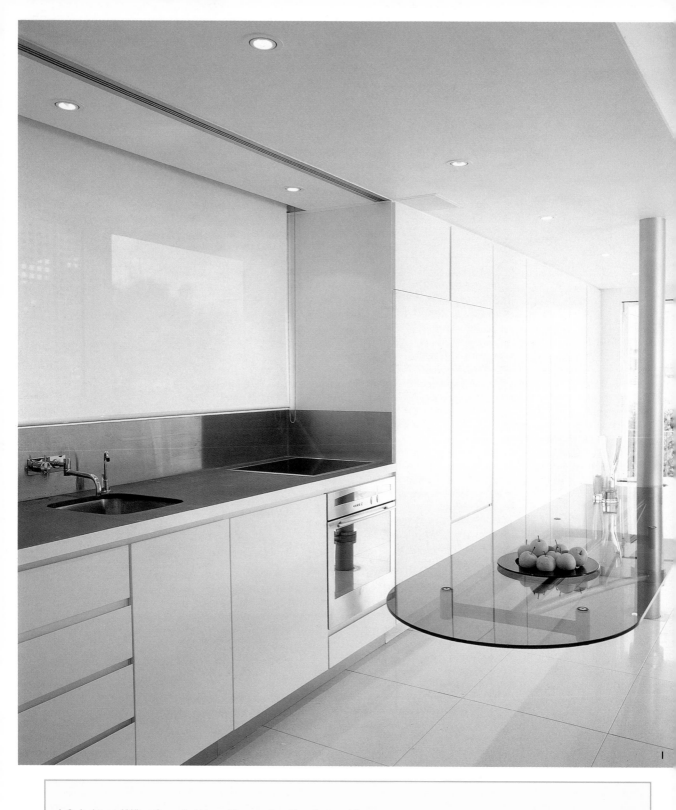

I

1, 2 Architects: William Smart Architects; Photographer: Gene Raymond Ross

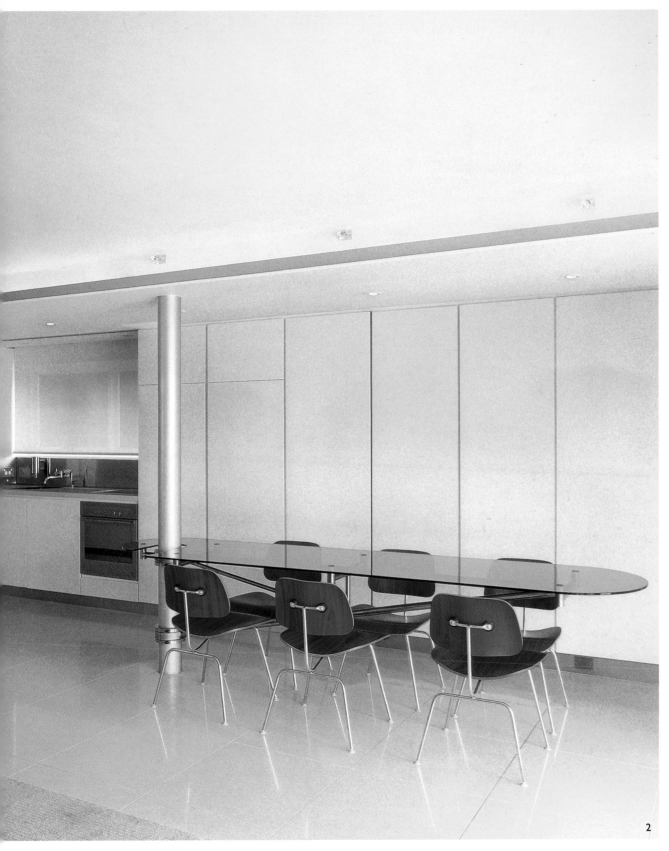

2

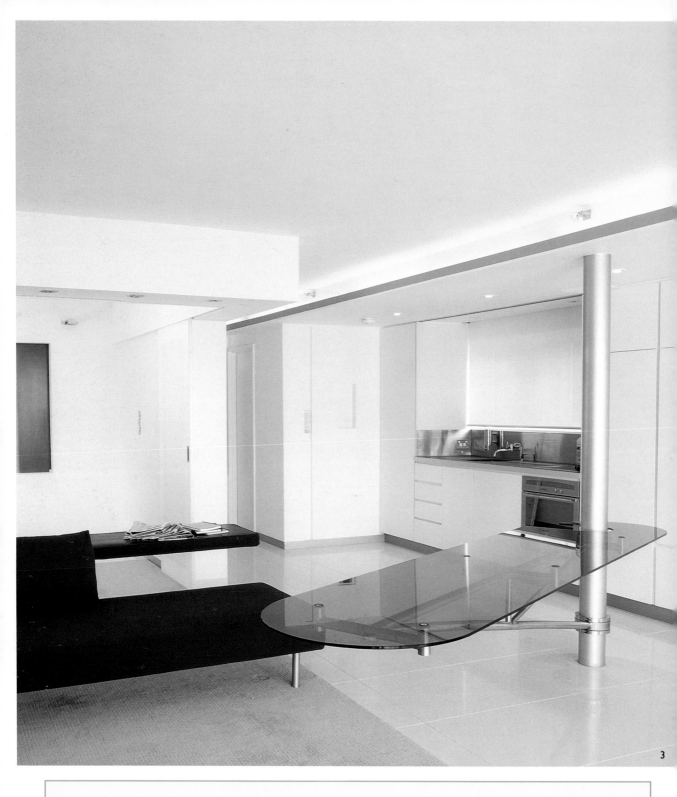

3

This movable glass structure serves as both a dining table and a work surface.

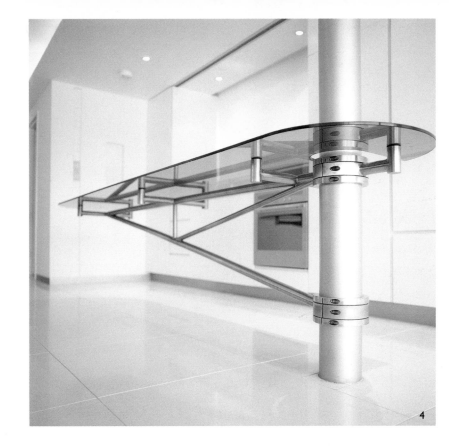

Floor plan

3, 4 Architects: William Smart Architects; Photographer: Gene Raymond Ross

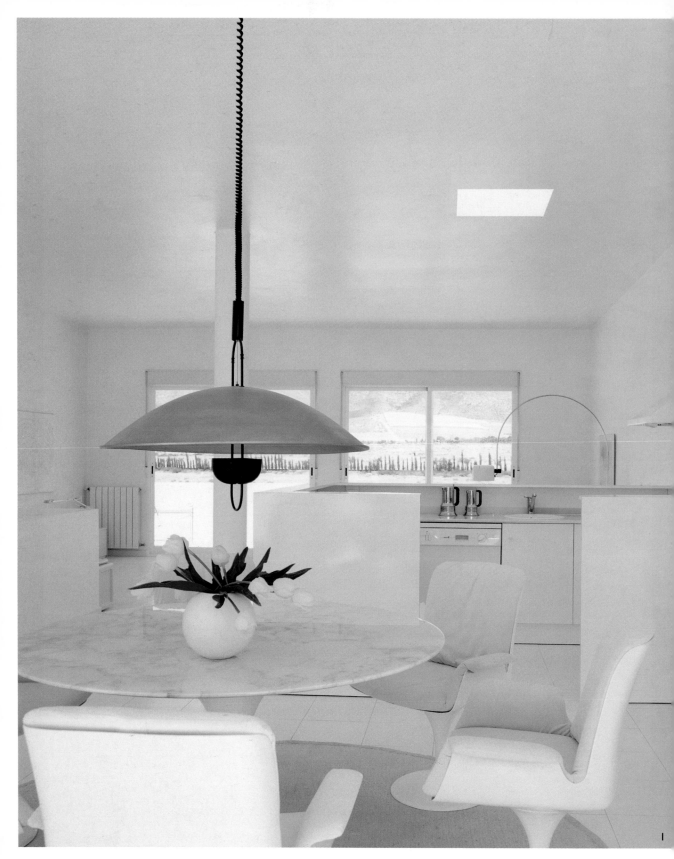

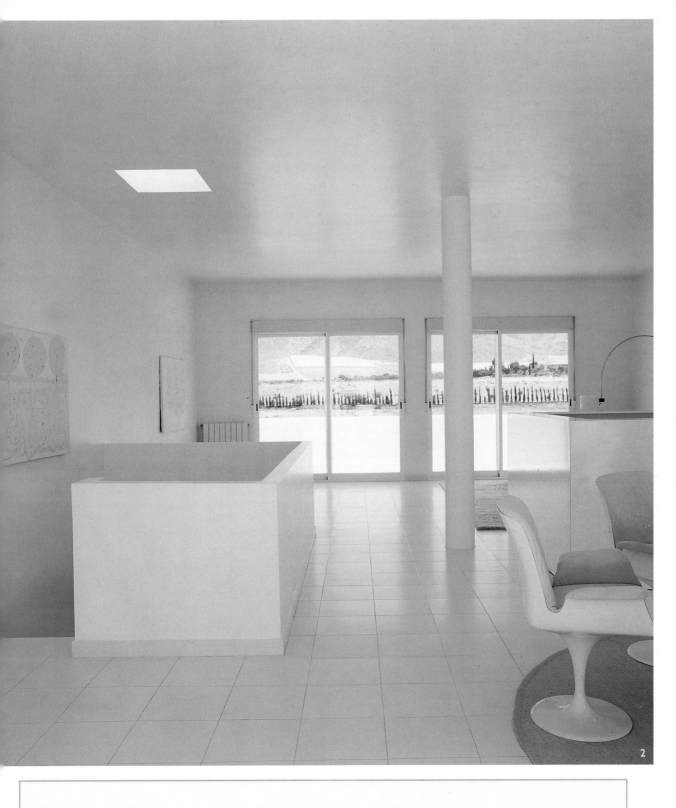

1, 2 Photographer: Eugeni Pons

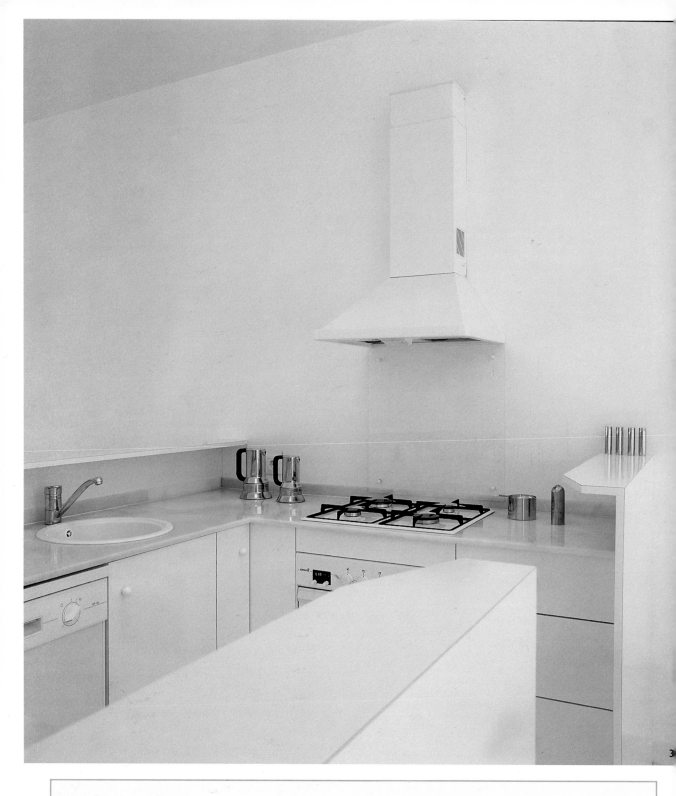

3

3 Photographer: Eugeni Pons

1 Photographer: Jean-François Jaussaud

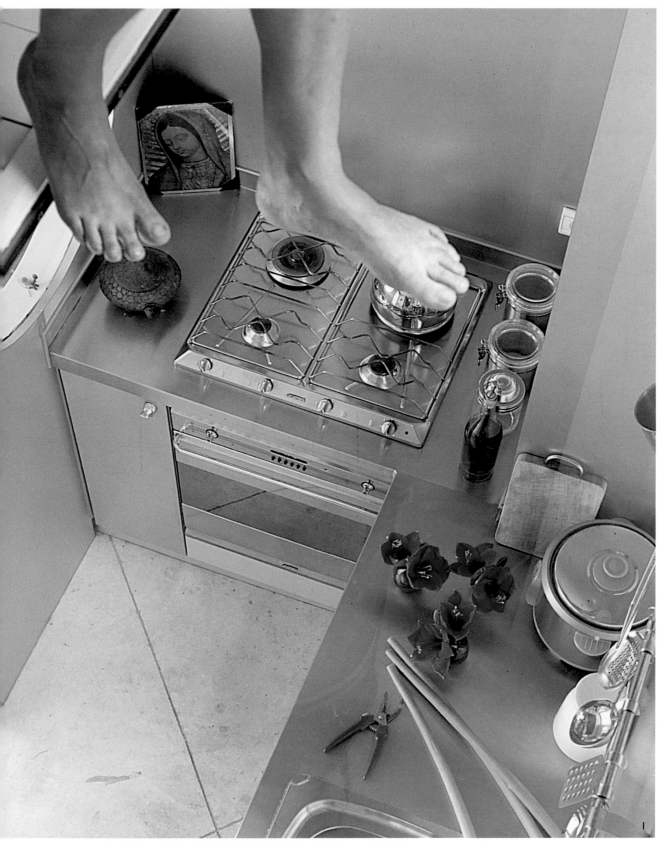

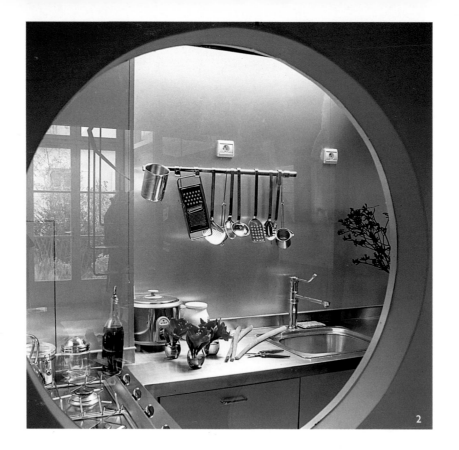

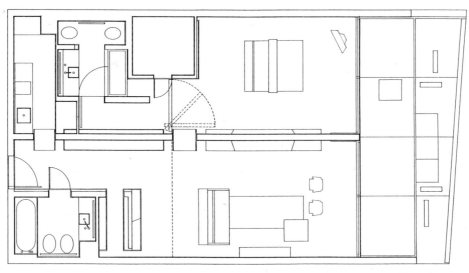

Floor plan

2 Photographer: Jean-François Jaussaud

1 Architects: AME; Collaborator: Peter Goldsborough; Photographer: Alan Williams

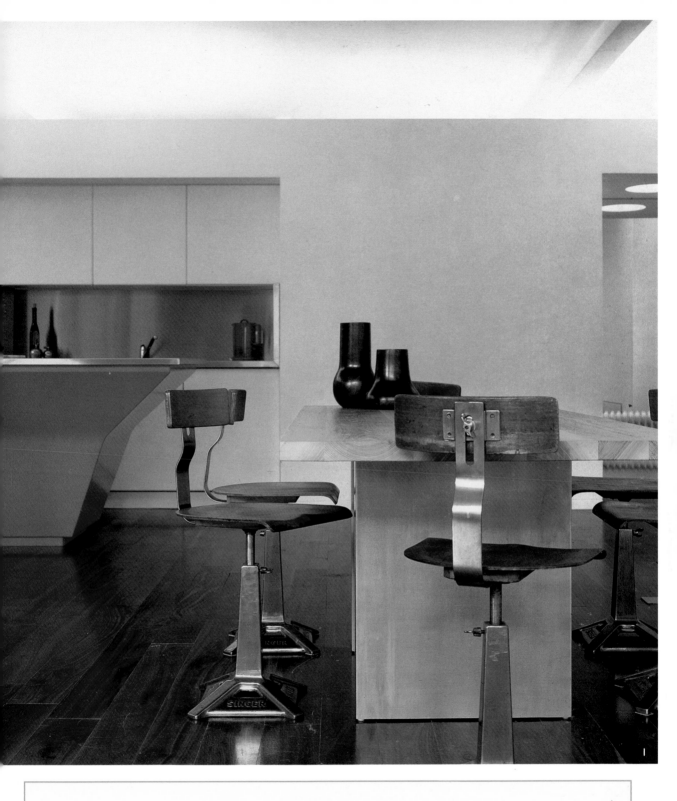

The red module directs one's attention to the kitchen, where the rest of the elements are white.

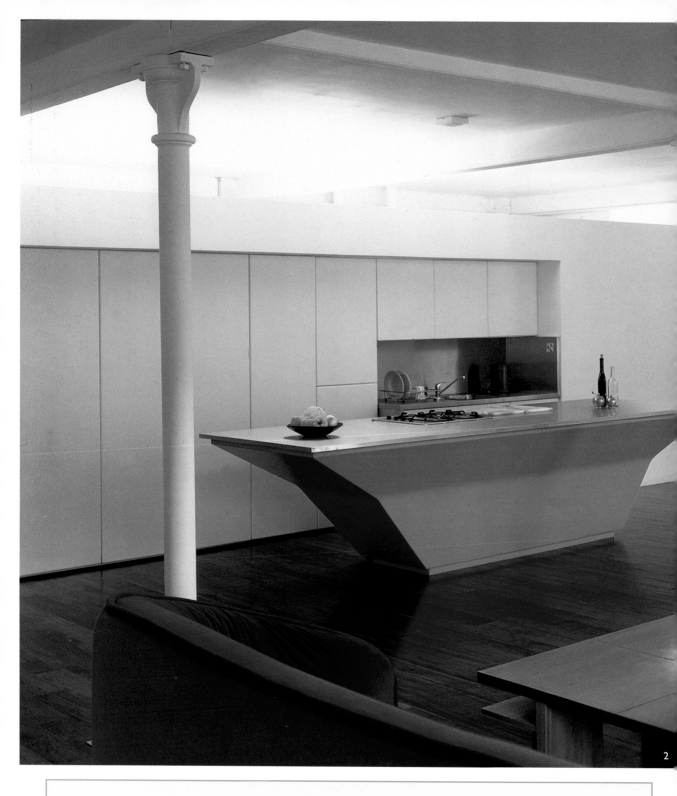

2

2 Architects: AME; Collaborator: Peter Goldsborough; Photographer: Alan Williams

1 Photographer: Duccio Malagamba

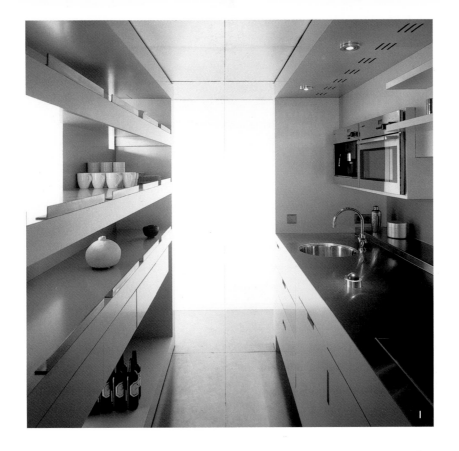

Floor plan

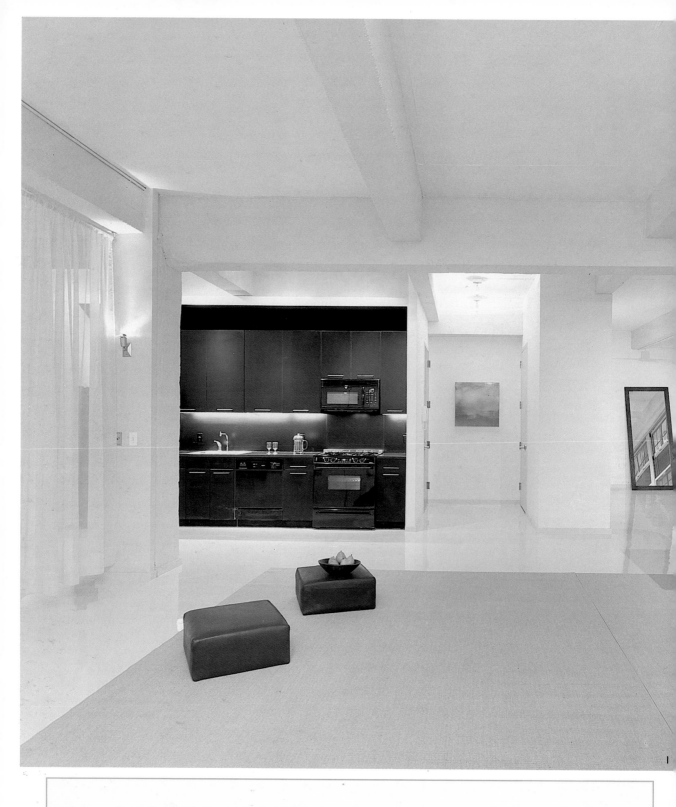

1, 2 Interior Design: Chroma AD; Photographer: David M. Joseph

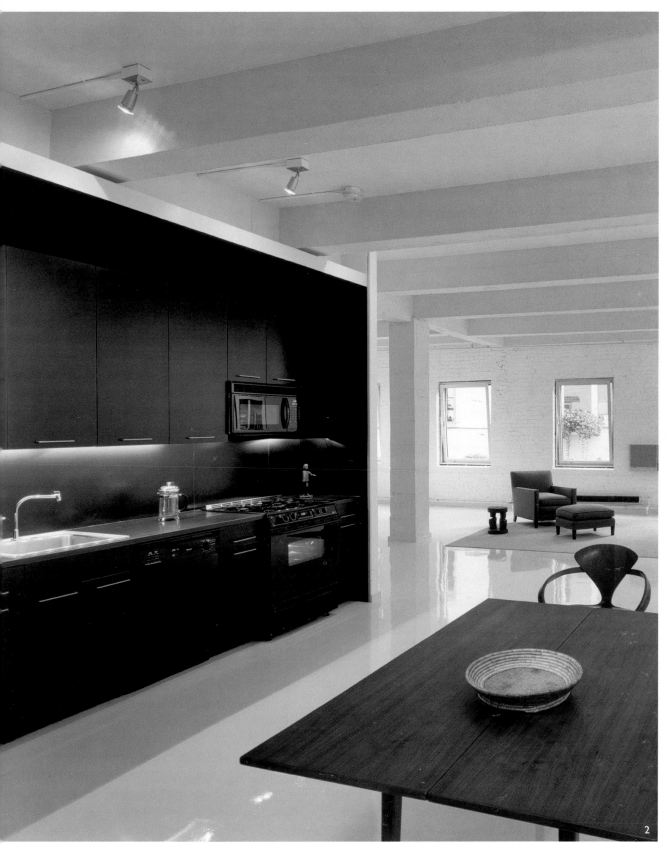

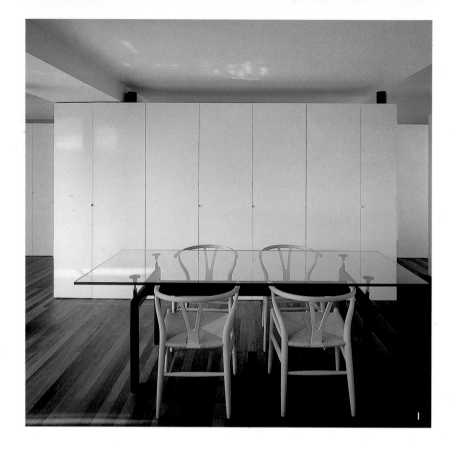

Floor plan

1 Photographer: César San Millán

2 Photographer: Pere Planells

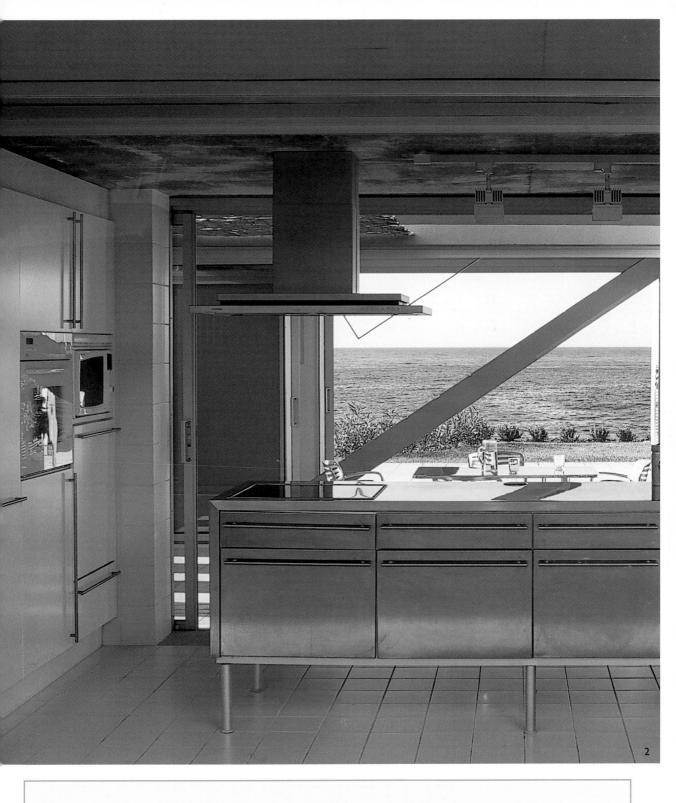

2

This kitchen's work area was placed in the center of the space to take advantage of fabulous exterior views.

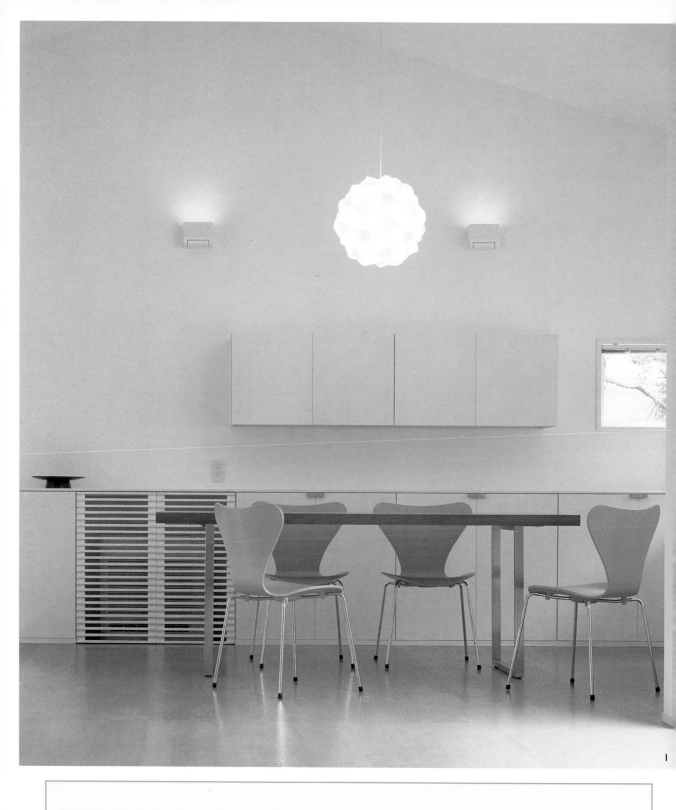

1

1, 2 Architect: Moriko Kira; Photographer: Luuk Kramer

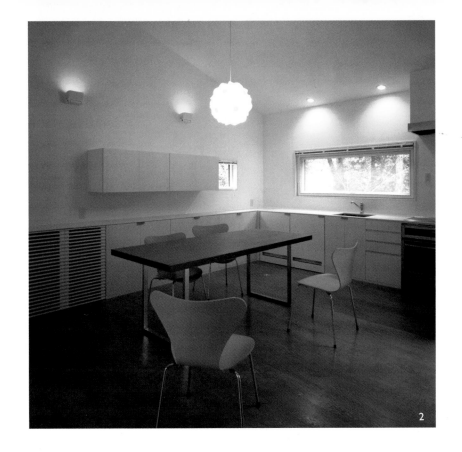

Floor plan

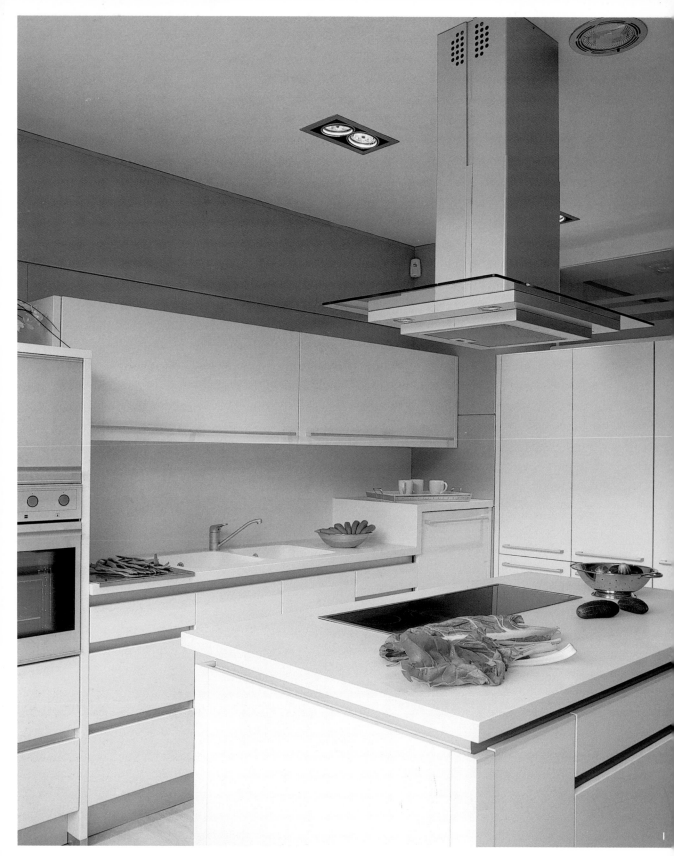

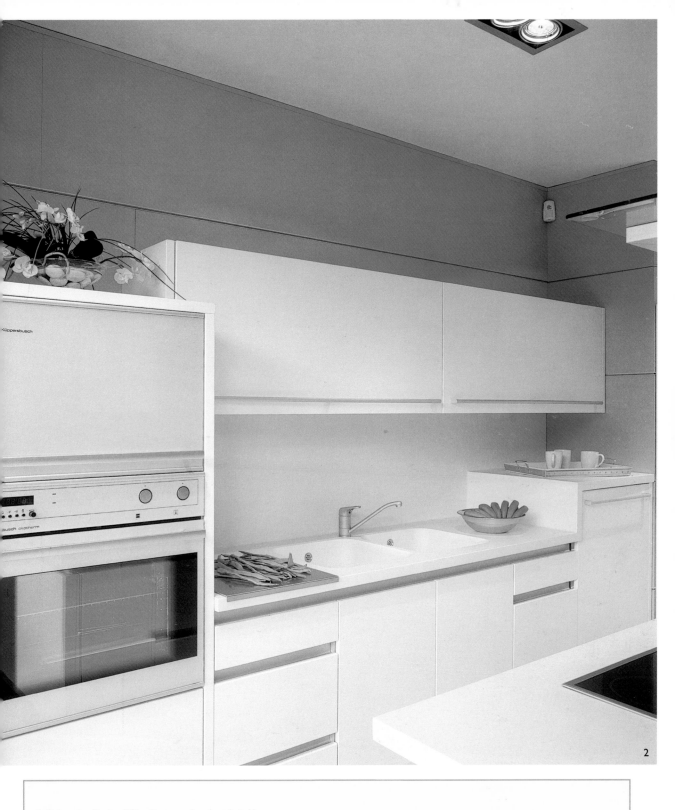

2

1, 2 Interior Design: L'Eix; Photographer: José Luis Hausmann

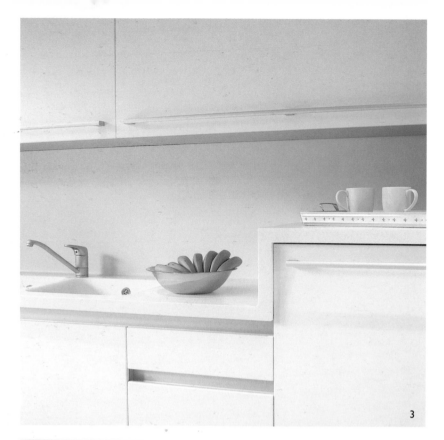

3

4

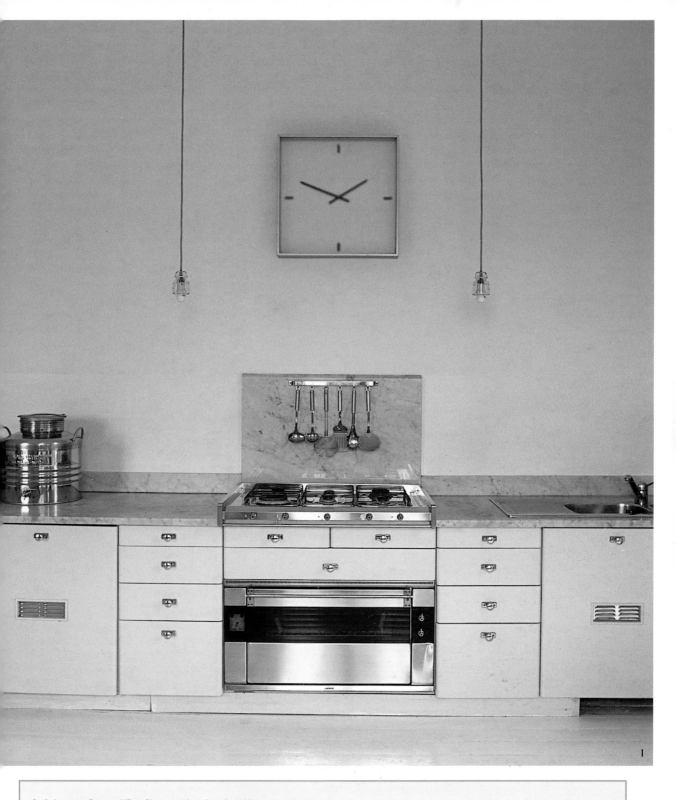

3, 4 Interior Design: L'Eix; Photographer: José Luis Hausmann

1 Photographer: Guy Bouchet & Ana Cardinale

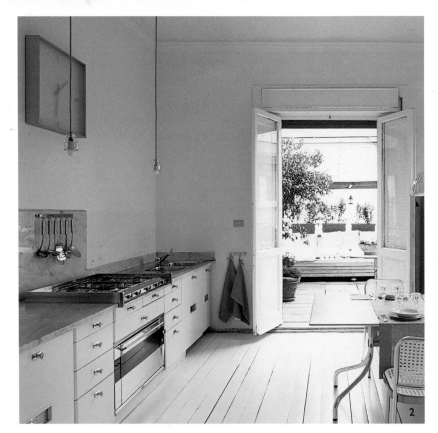

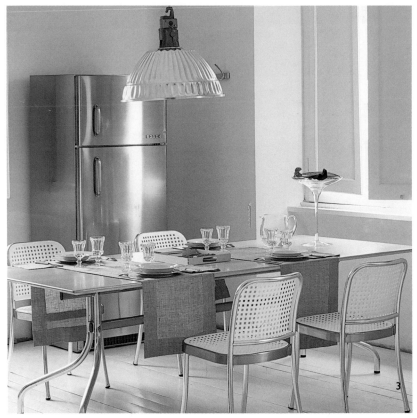

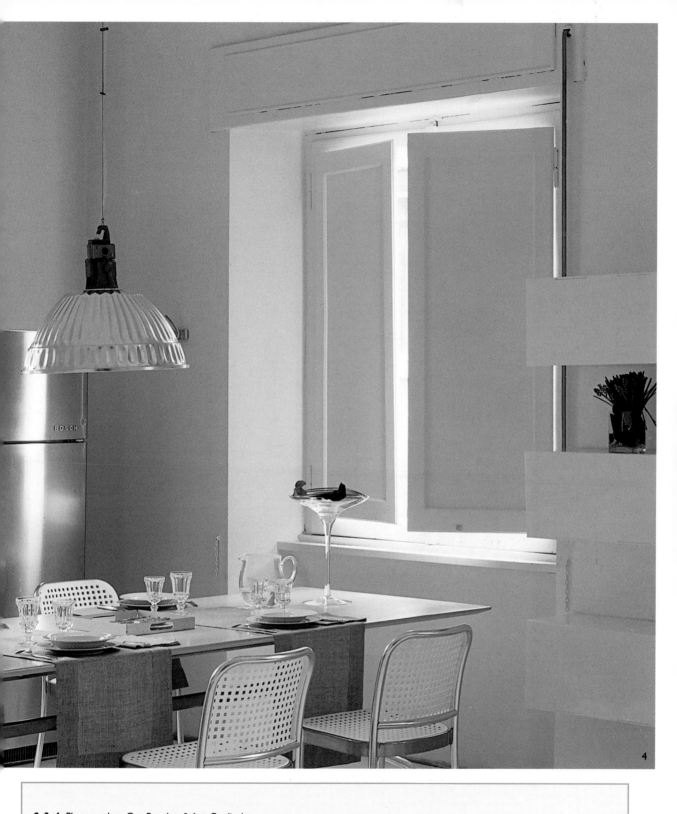

4

2, 3, 4 Photographer: Guy Bouchet & Ana Cardinale

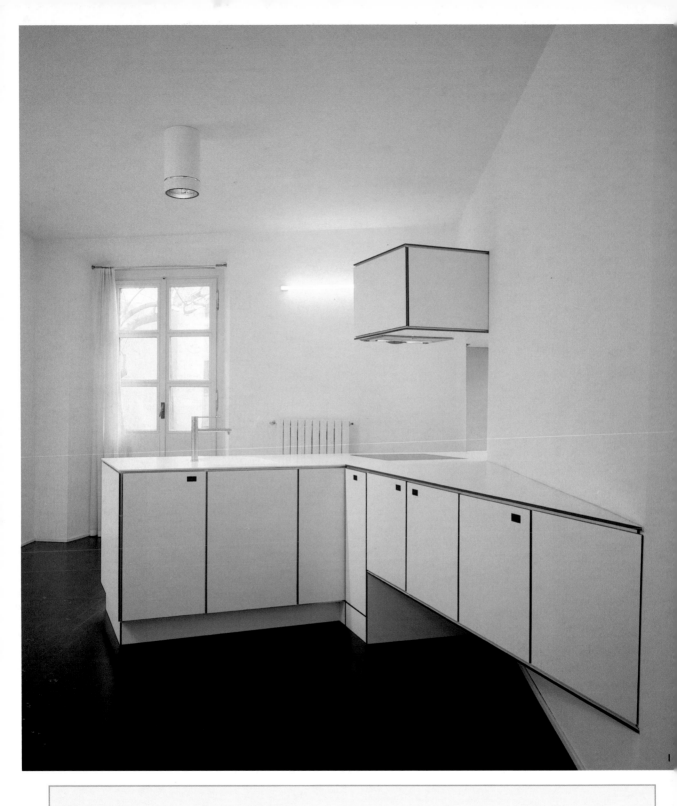

1, 2 Architect: Fabrizio Leoni; Photographer: Dessì e Monari

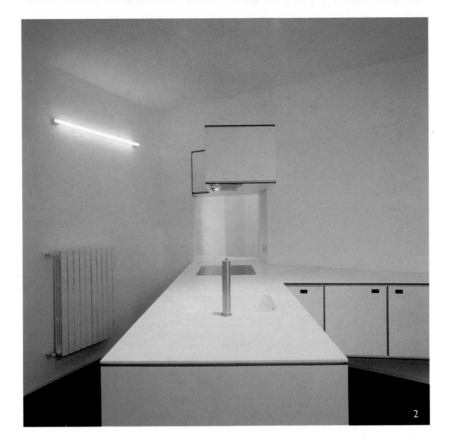

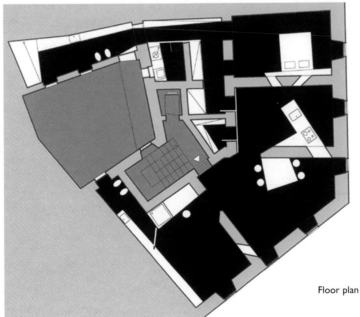

Floor plan

The furnishings of this space are an extension of the architecture, creating angles and defining other areas.

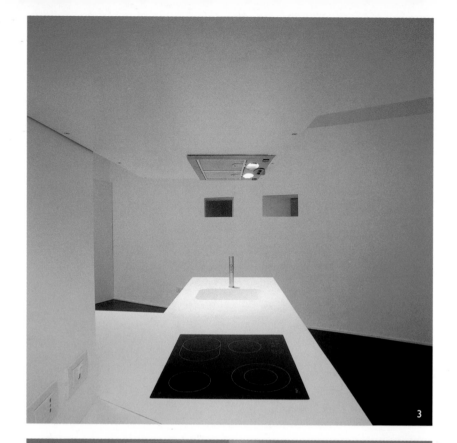

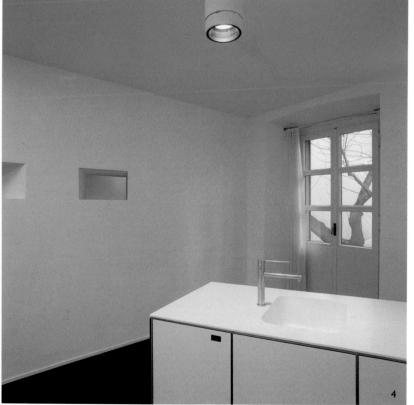

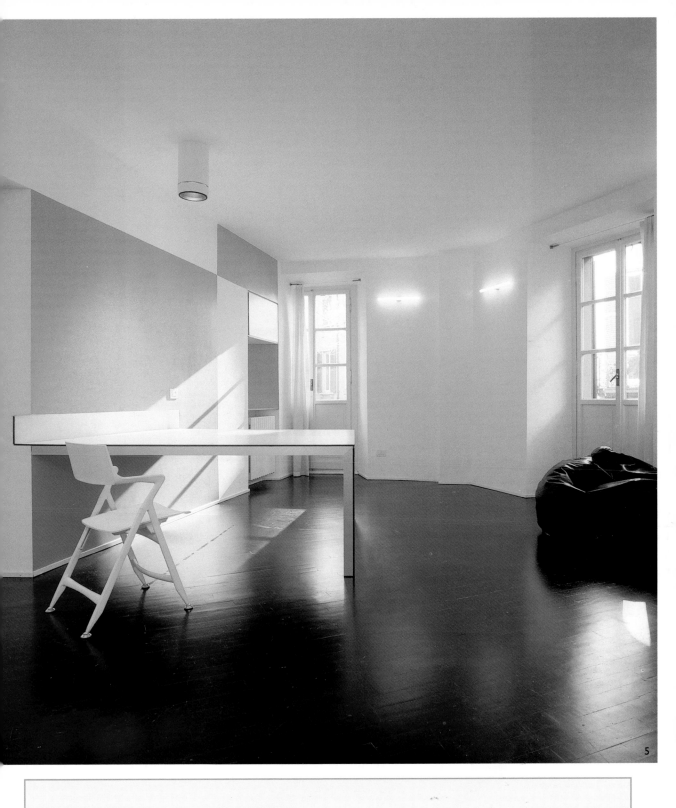

5

3, 4, 5 Architect: Fabrizio Leoni; Photographer: Dessì e Monari

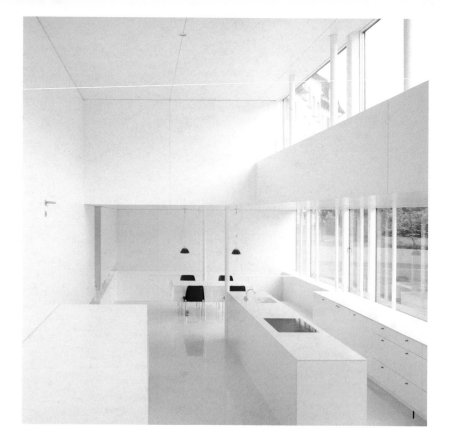

Ground floor plan

1, 2, 3 Architects: Oskar Leo Kaufmann; Photographer: Adolf Bereuter

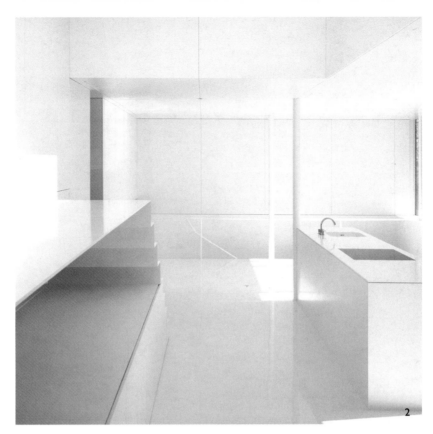

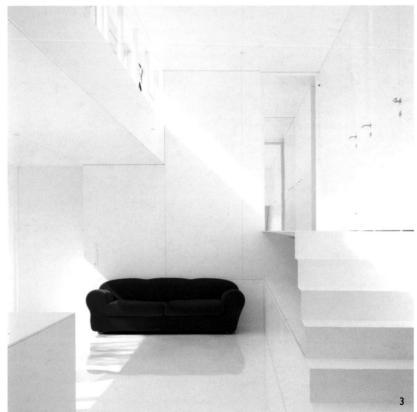

Urban

THE city is a place of constant change and evolution, which is reflected in urban interior design and architecture. Urban kitchens generally adhere to an aesthetic that is both informal and cutting-edge, as well as functional and practical.

Urban kitchens tend to use all types of materials, from wood to metal, with stainless steel, which gives the space a futuristic appearance. They likewise incorporate fashionable aesthetic trends and the creations of avant-garde designers into their décor.

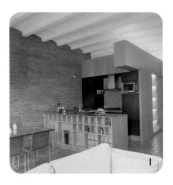

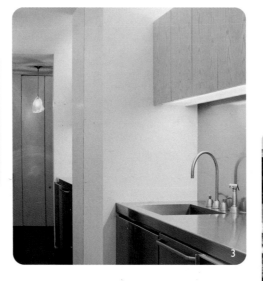

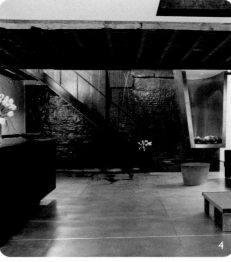

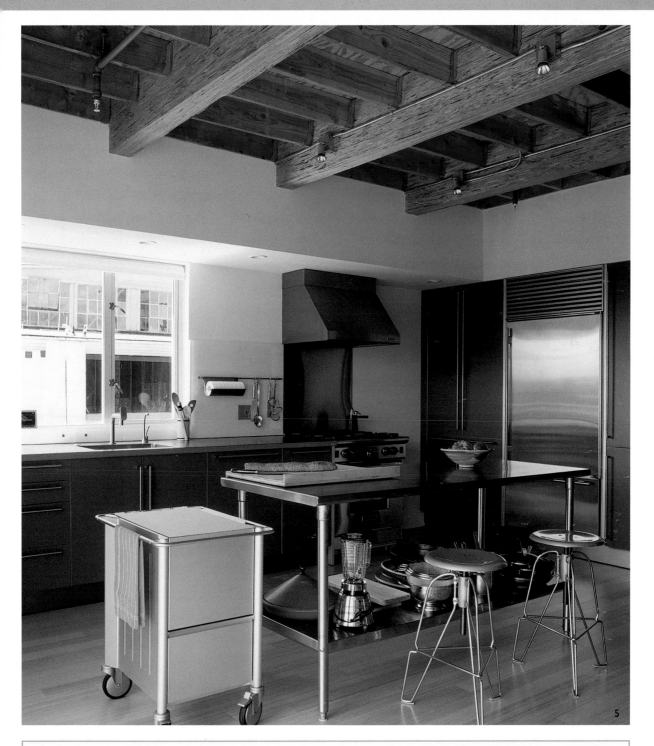

5

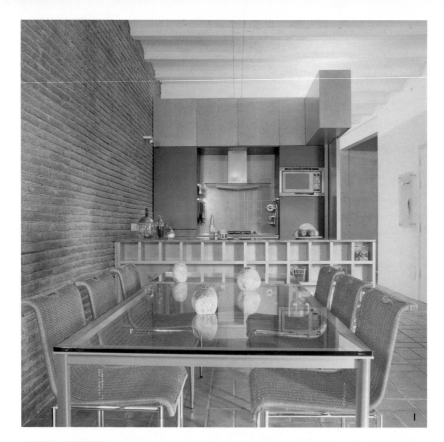

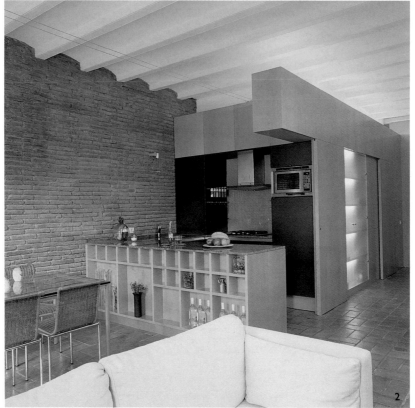

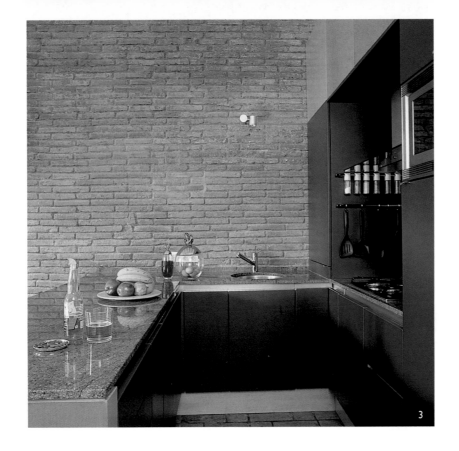

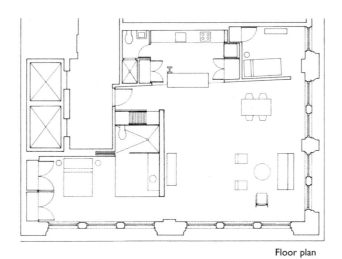

Floor plan

1, 2, 3 Architects: Simon Platt & Rob Dubois; Photographer: Eugeni Pons

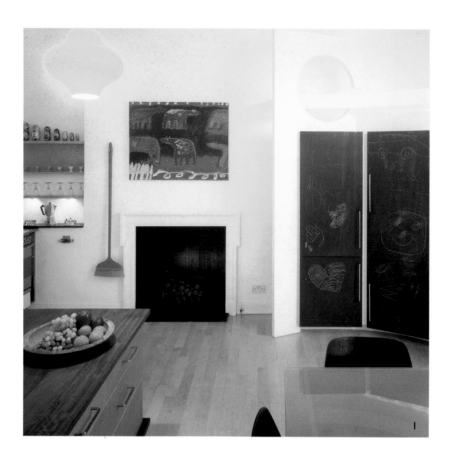

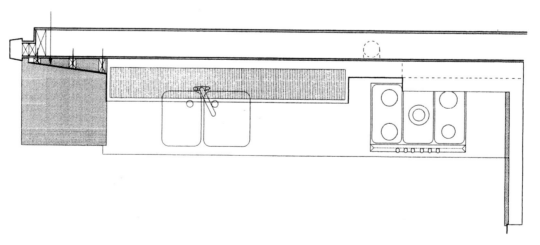

Kitchen plan

The doors of some of the cabinets are made of the same material used in classroom chalkboards, so the children also have their place in this kitchen.

Sections

I Architects: Ash Shakula Architects; Photographer: Edmond Sumner/View

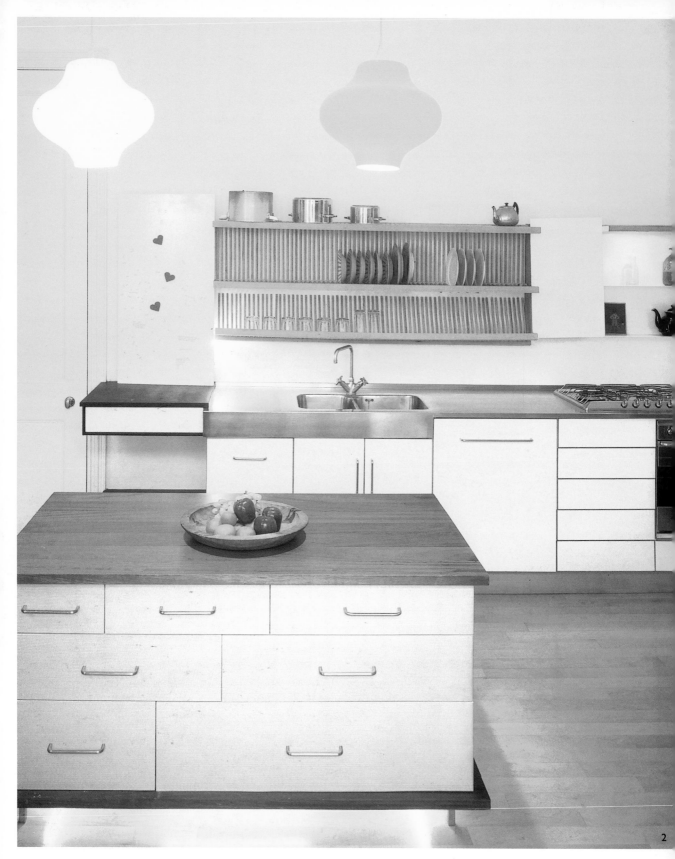

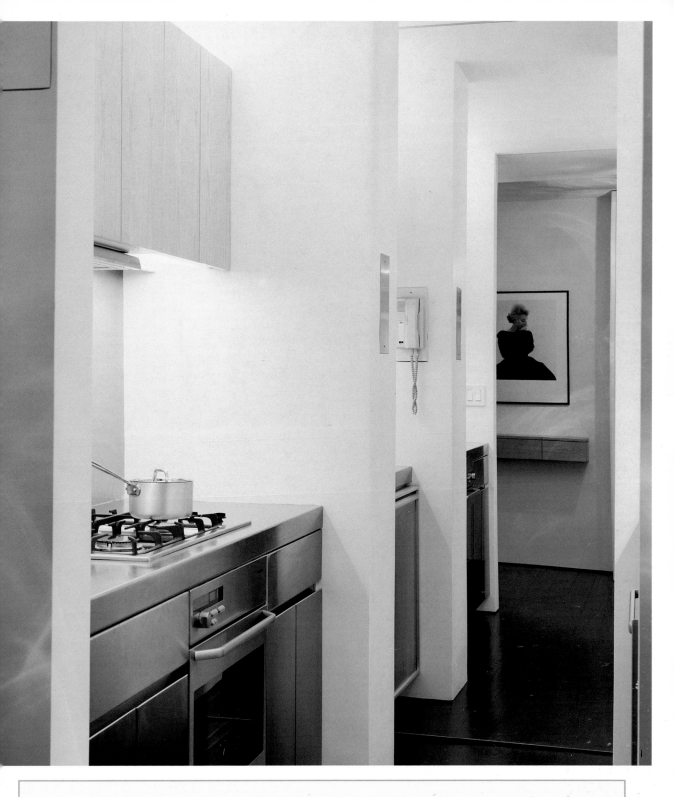

2 Architects: Ash Shakula Architects; Photographer: Edmond Sumner/View

1 Architect: Messana O'Rorke; Photographer: Elizabeth Felicella

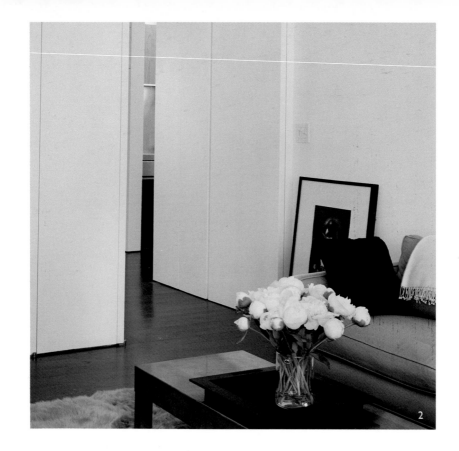

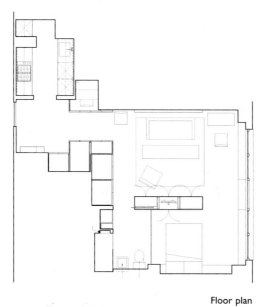

Floor plan

2, 3, 4 Architect: Messana O'Rorke; Photographer: Elizabeth Felicella

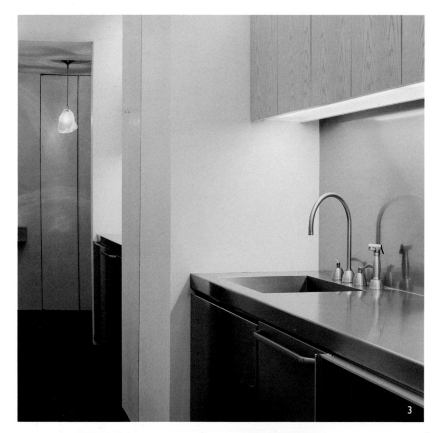

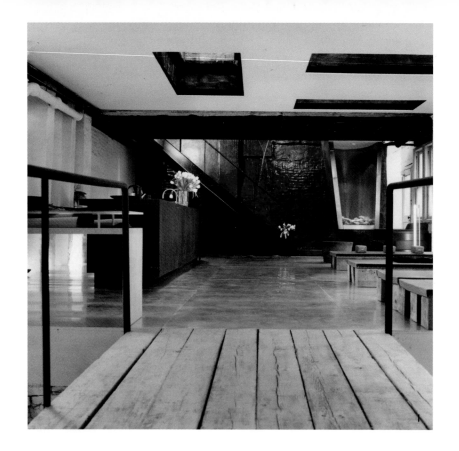

Roof plan

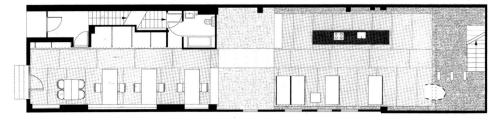

Floor plan

1, 2, 3 Architect: David Ling; Photographer: Bootz Antoine

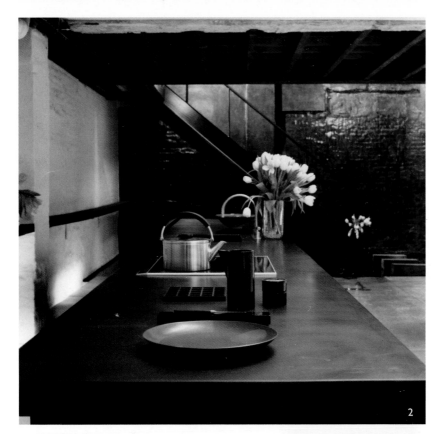

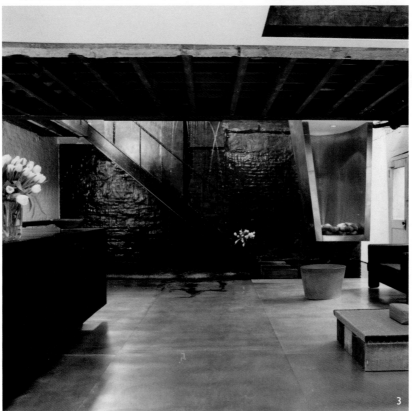

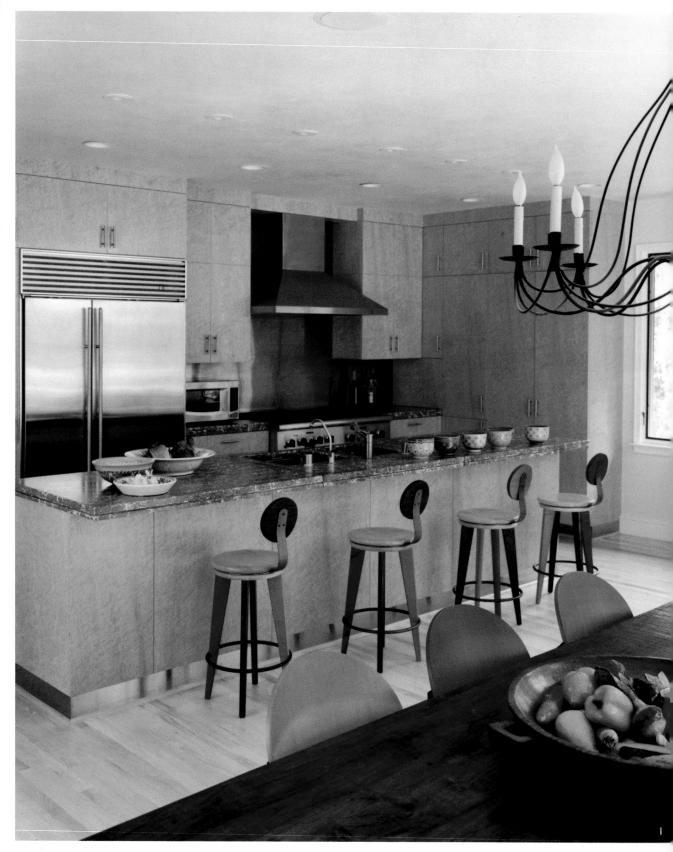

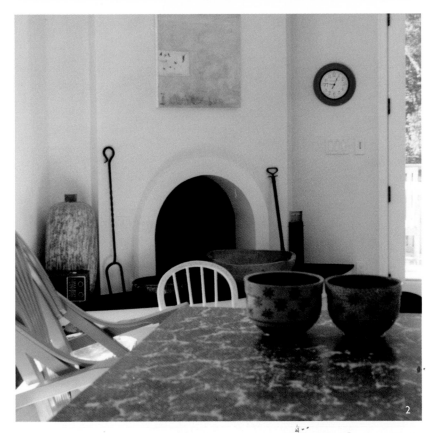

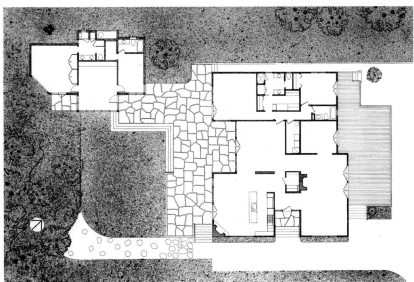

Ground floor plan

1, 2 Architect: Karin Payson Architecture and Design; Photographer: Karin Payson

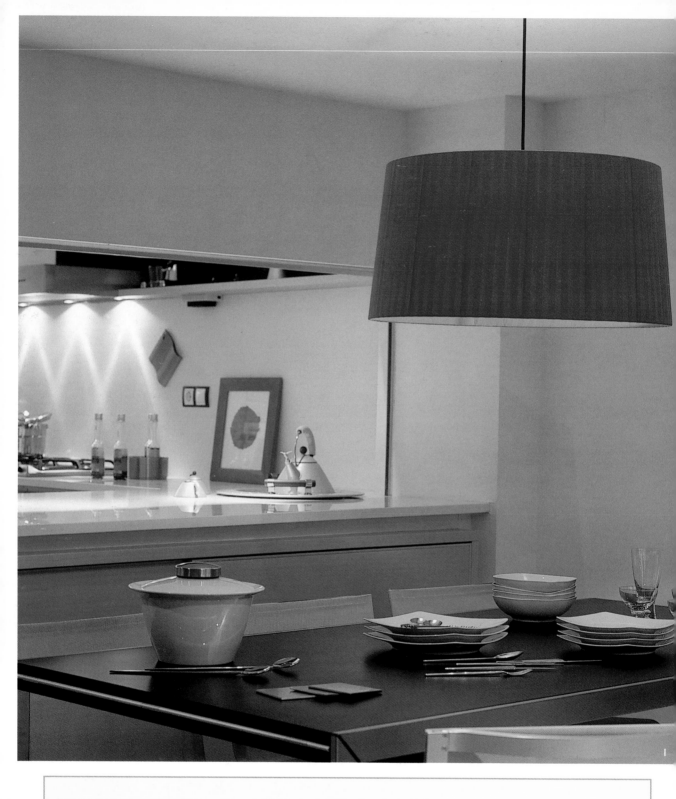

Adequate lighting is very important in creating a feeling of warmth and hominess in the kitchen, not just in the living room or bedroom.

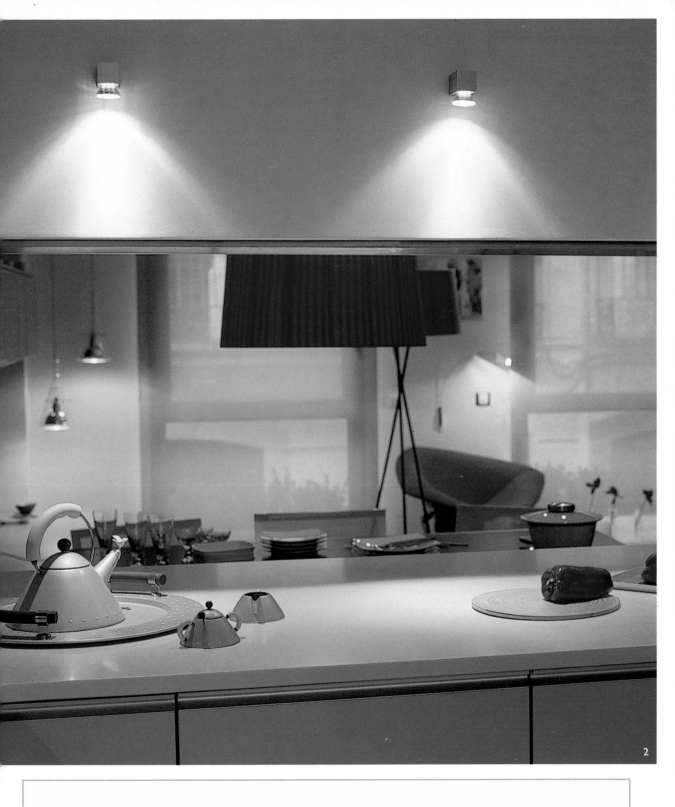

1, 2 Interior Design: Jorge Rangel; Photographer: José Luis Hausmann

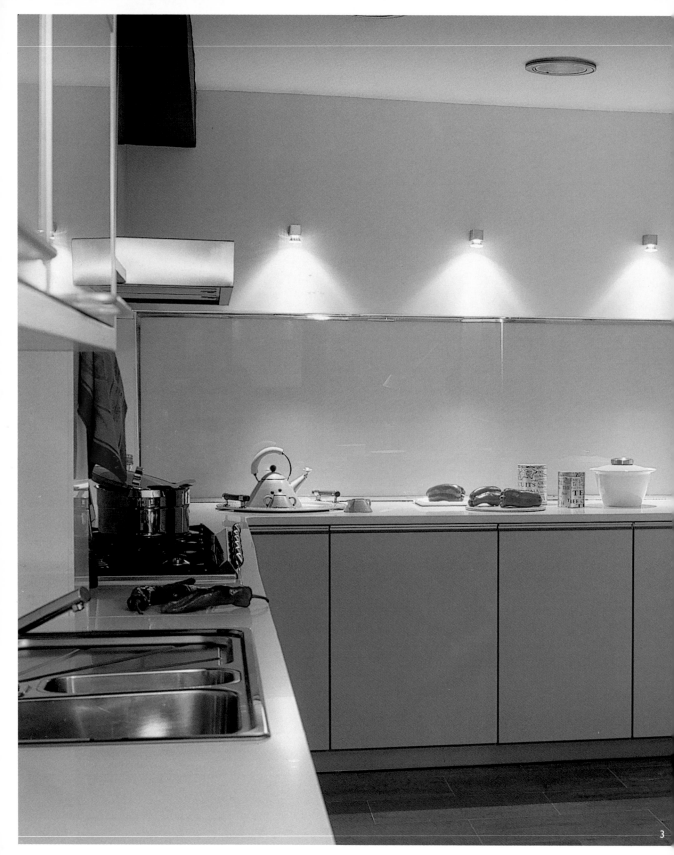

3

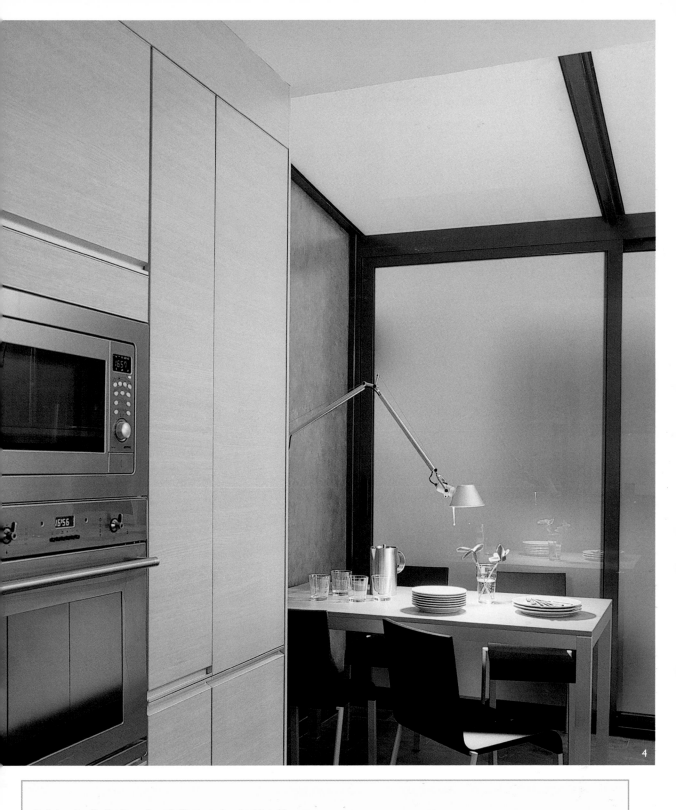

4

3, 4 Interior Design: Jorge Rangel; Photographer: José Luis Hausmann

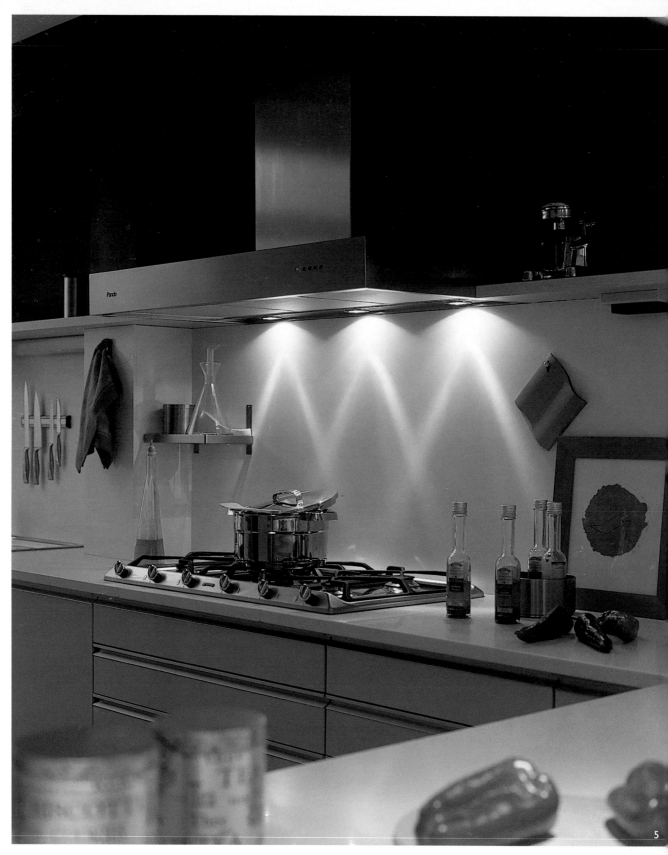

5

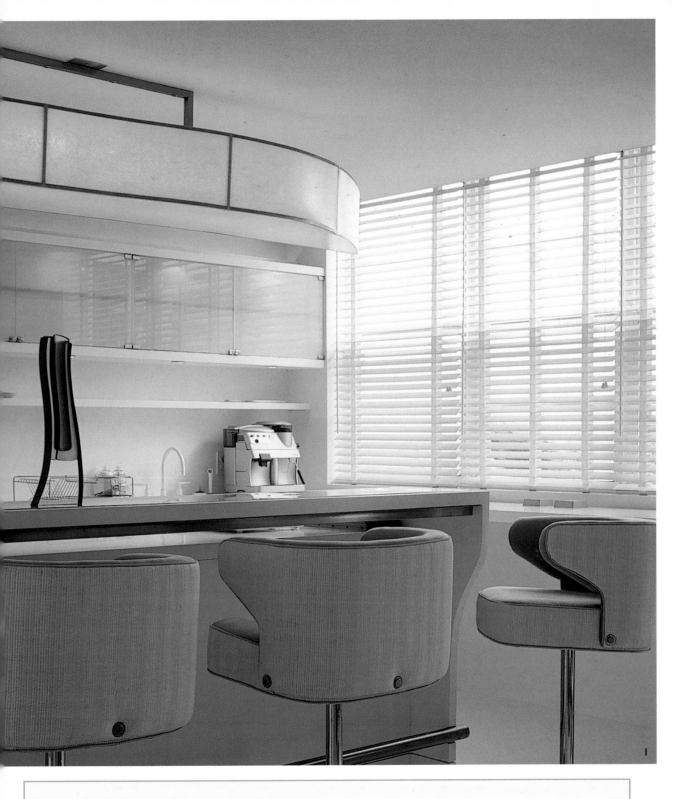

5 Interior Design: Jorge Rangel; Photographer: José Luis Hausmann

I Architect: D. D. Allen; Photographer: Pep Escoda

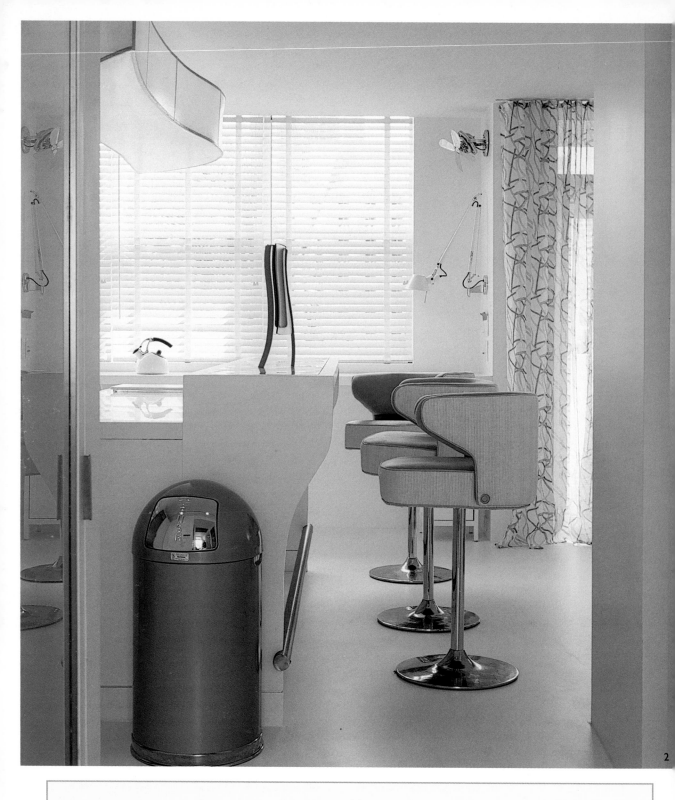

2

The design of the stools is reminiscence of drive-in restaurants, creating a retro aesthetic in this kitchen.

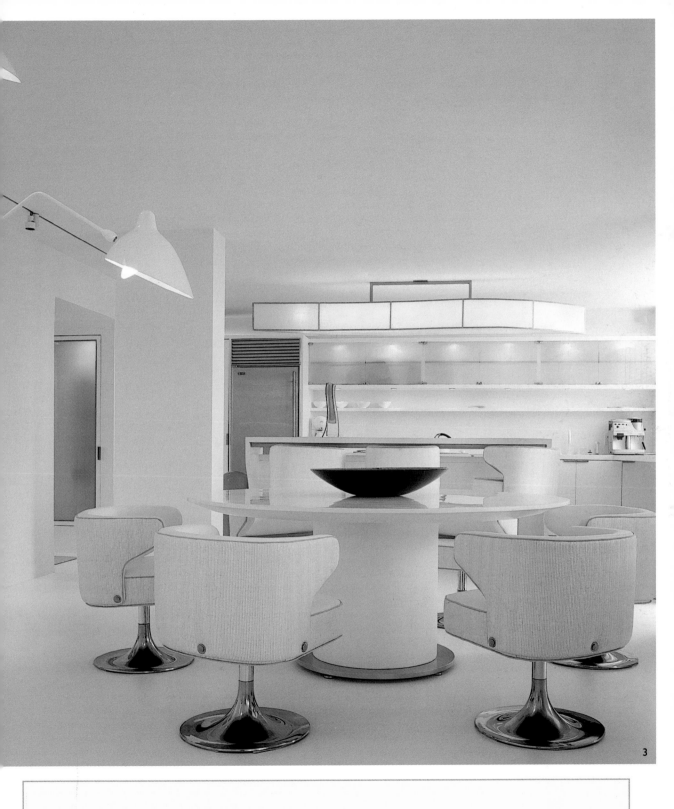

3

2, 3 Architect: D. D. Allen; Photographer: Pep Escoda

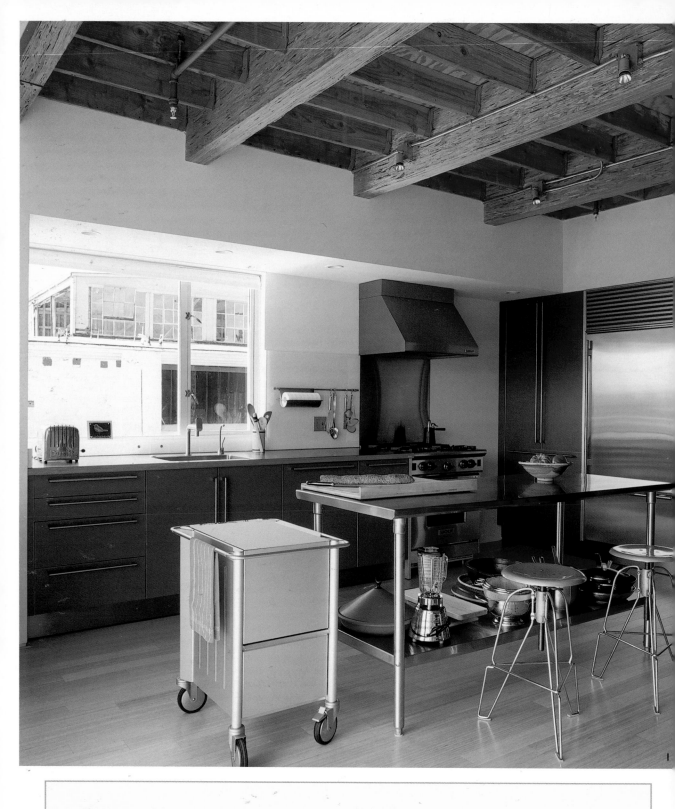

1, 2 Architect: Mark Mack; Photographer: Undine Pröhl

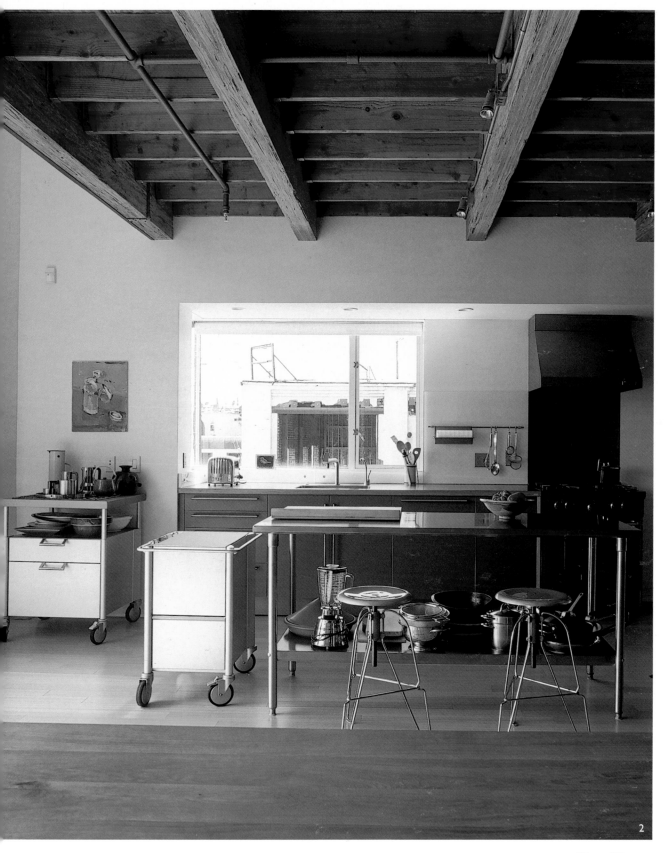

2

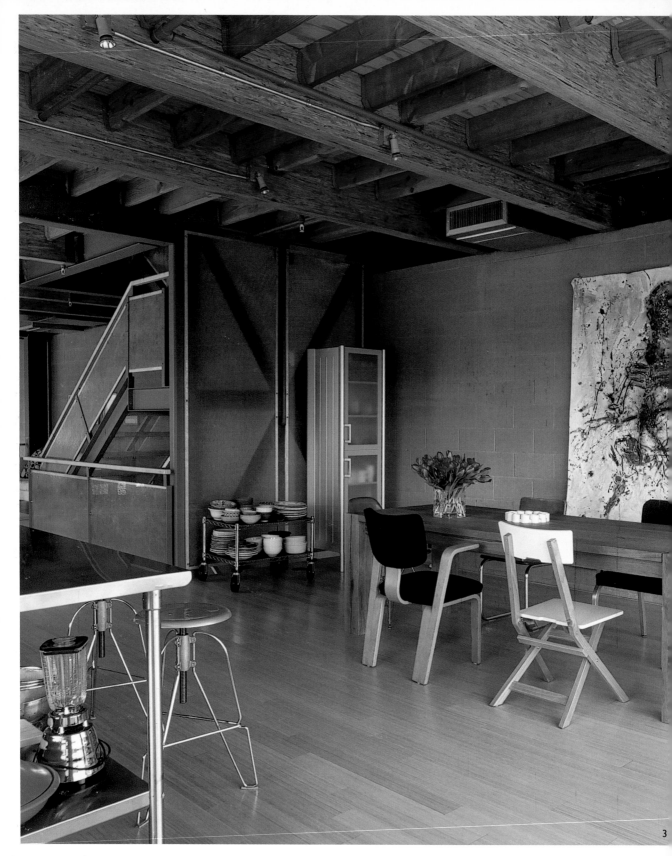

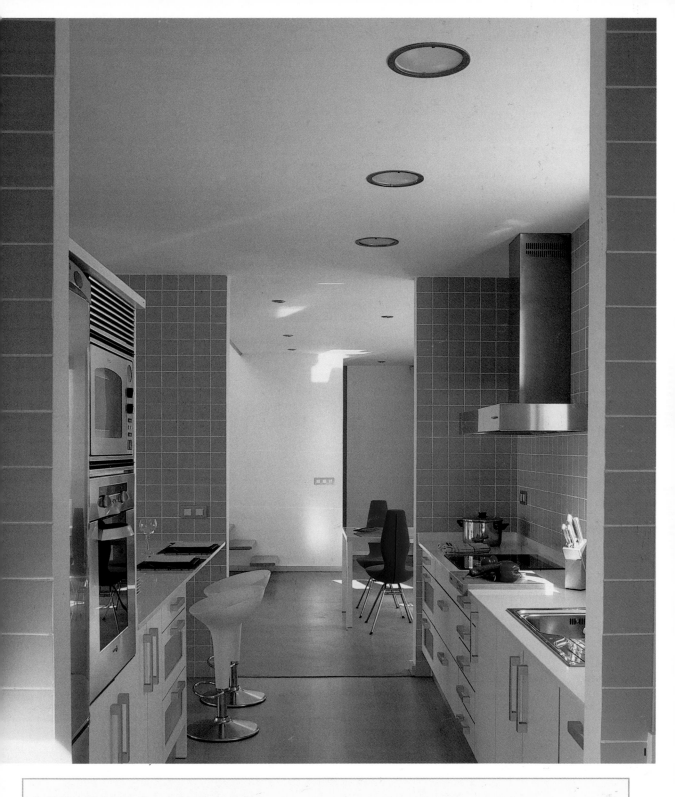

3 Architect: Mark Mack; Photographer: Undine Pröhl

I Architect: Jaime Sanahuja; Photographer: José Luis Hausmann

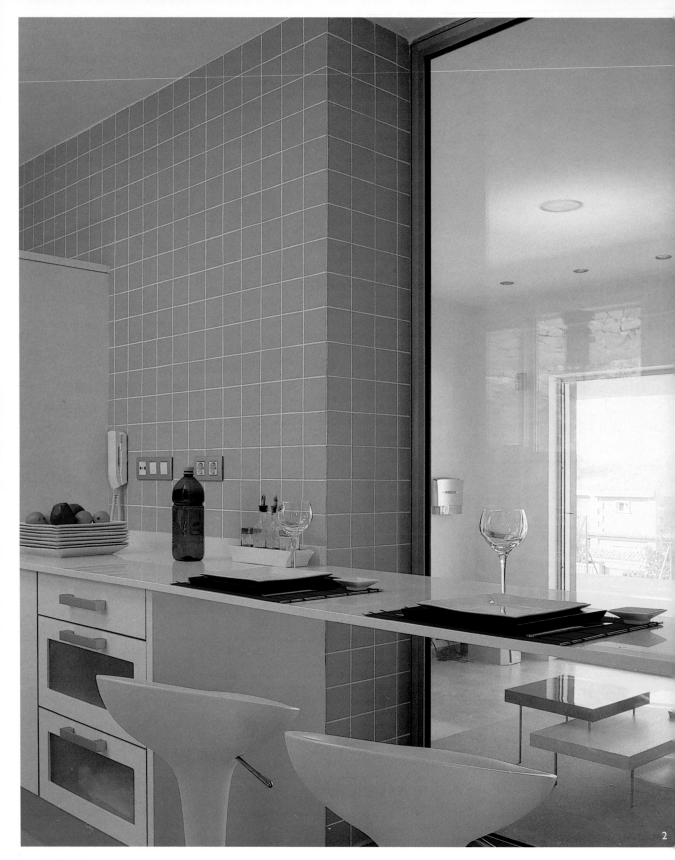

2

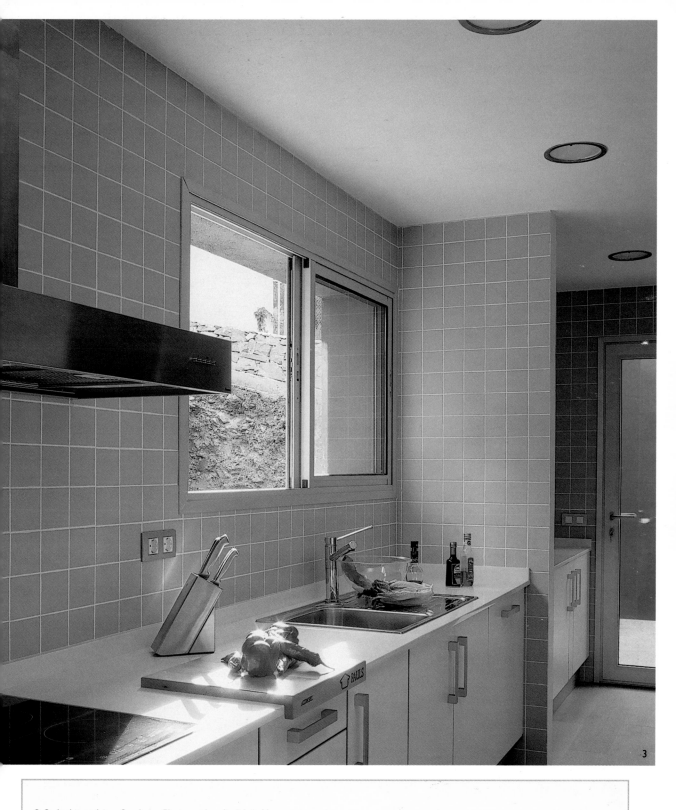

2, 3 Architect: Jaime Sanahuja; Photographer: José Luis Hausmann

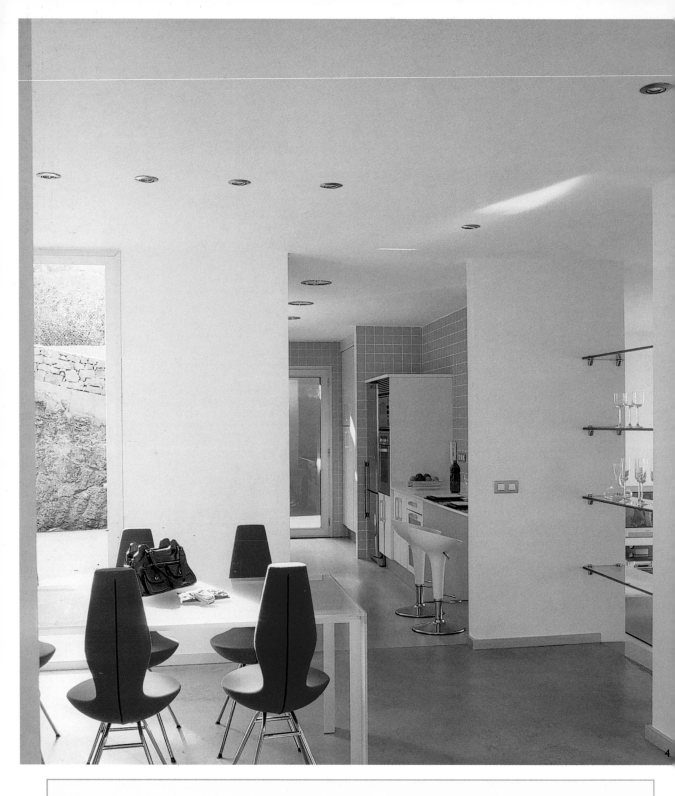

4, 5 Architect: Jaime Sanahuja; Photographer: José Luis Hausmann

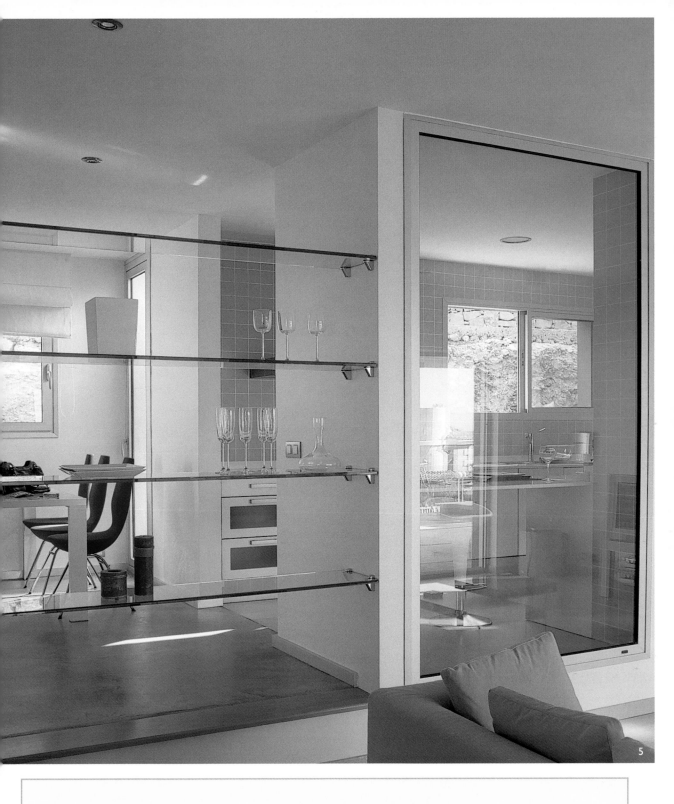

The visual connection between the living room and the kitchen is achieved with glass panels and shelving.

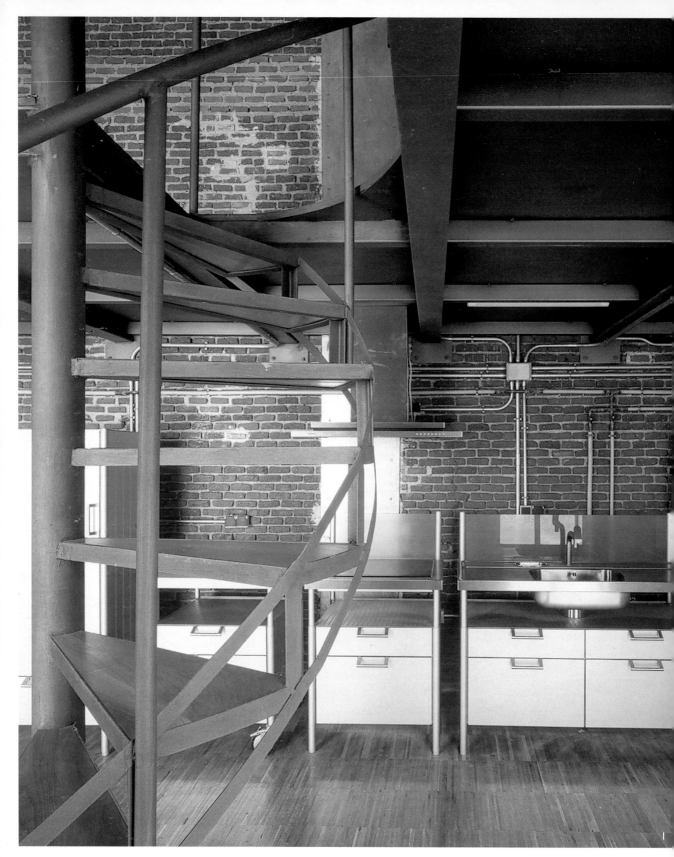

Ground floor plan

Second floor plan

Architects: Manuel Serrano Architects; Photographer: José Latova

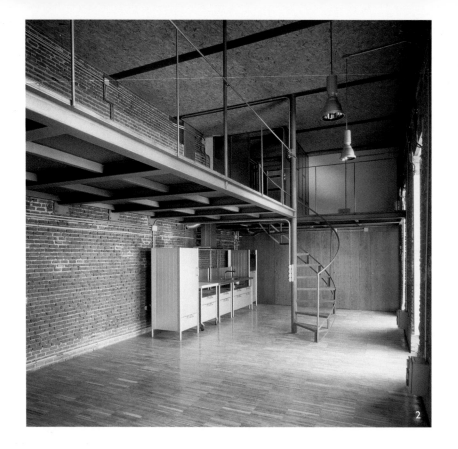

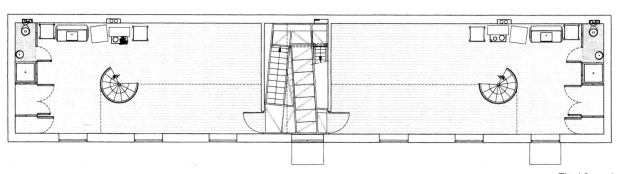

Third floor plan

2 Architects: Manuel Serrano Architects; Photographer: José Latova

1 Interior Design: Philippe Starck's Studio; Photographers: Ricardo Labougle & Ana Cardinale

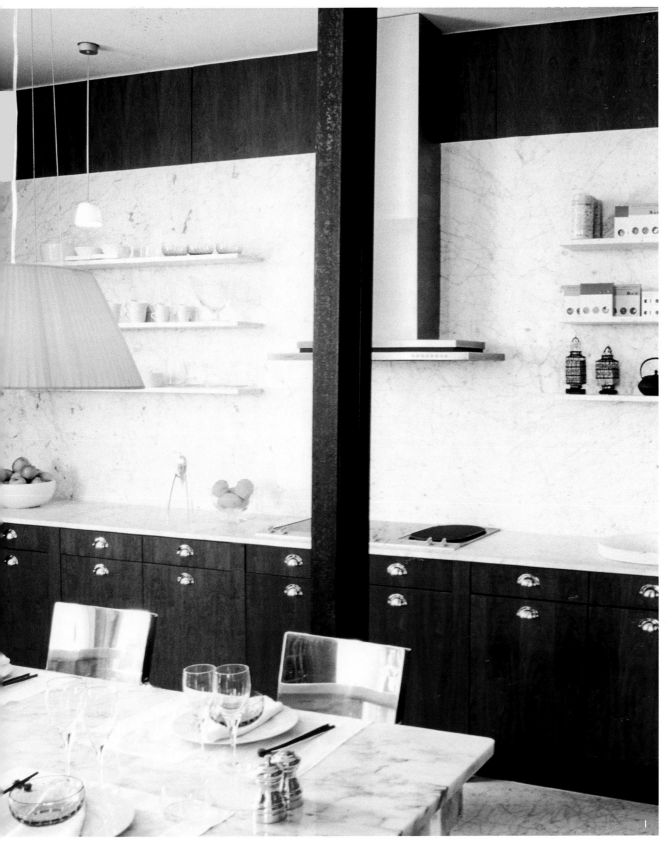

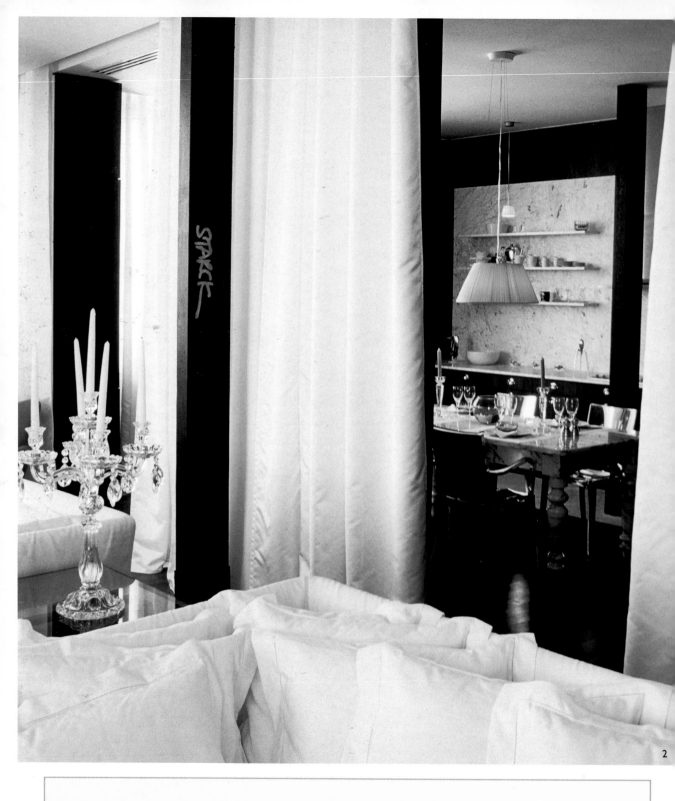

2

2, 3 Interior Design: Philippe Starck's Studio; Photographers: Ricardo Labougle & Ana Cardinale

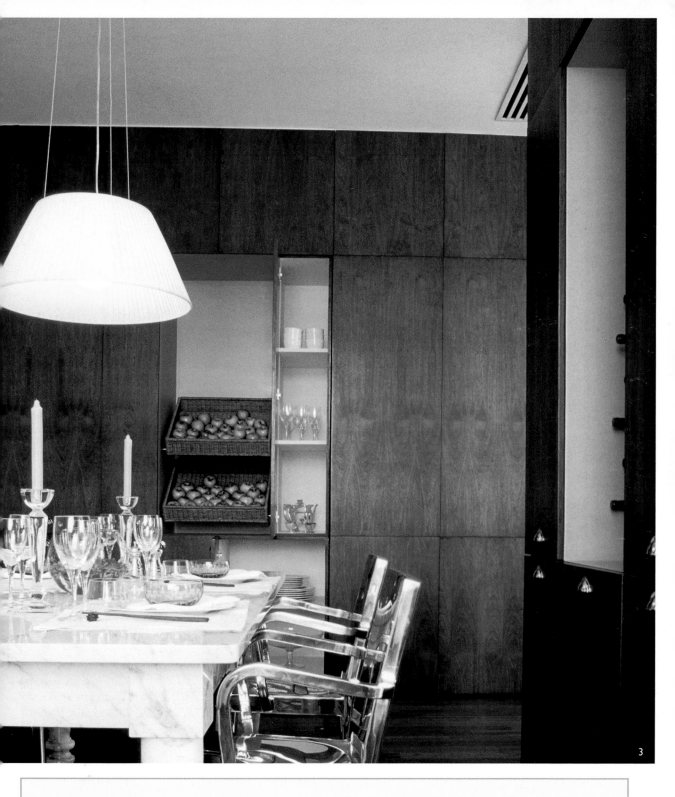

The combining of different aesthetics is the hallmark of this plan by noted French designer Philippe Starck.

Rustic

THE aesthetic of rustic kitchens is reserved mainly for homes in rural settings or nostalgic throwbacks in urban enclaves. These types of kitchens generally maintain the spirit of tradition, recreating or retaining the aesthetic of the kitchens of yesteryear. To accomplish this, vintage objects are rescued and used as part of the décor, and old accessories and appliances are converted for modern uses. For example, an old-fashioned oven may retain its exterior but be fitted with a modern heating element.

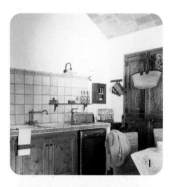

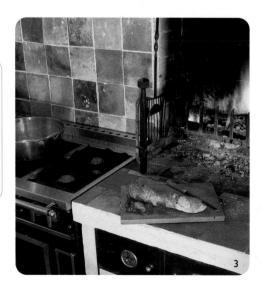

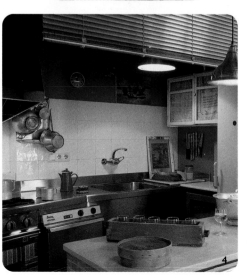

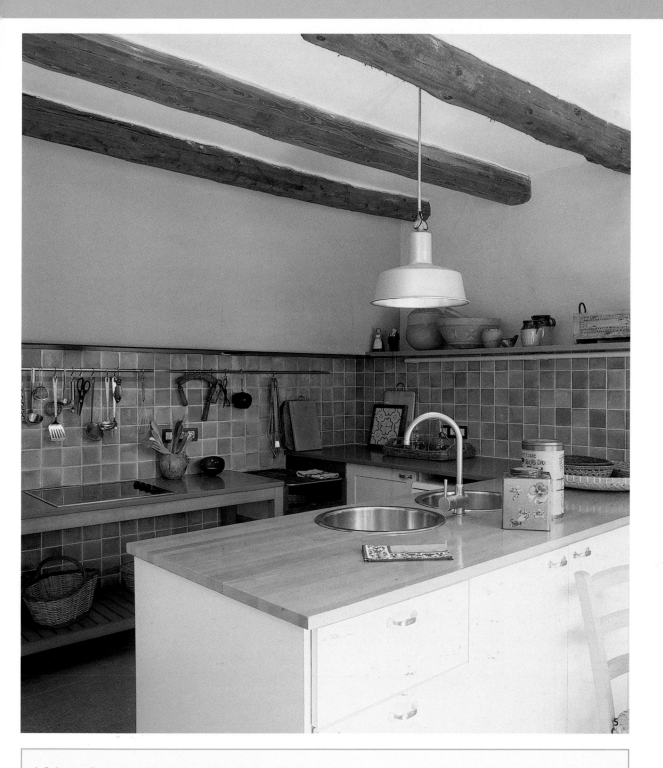

1, 5 Interior Design: Jorge Moser; Photographer: José Luis Hausmann

2, 3, 4 Photographer: José Luis Hausmann

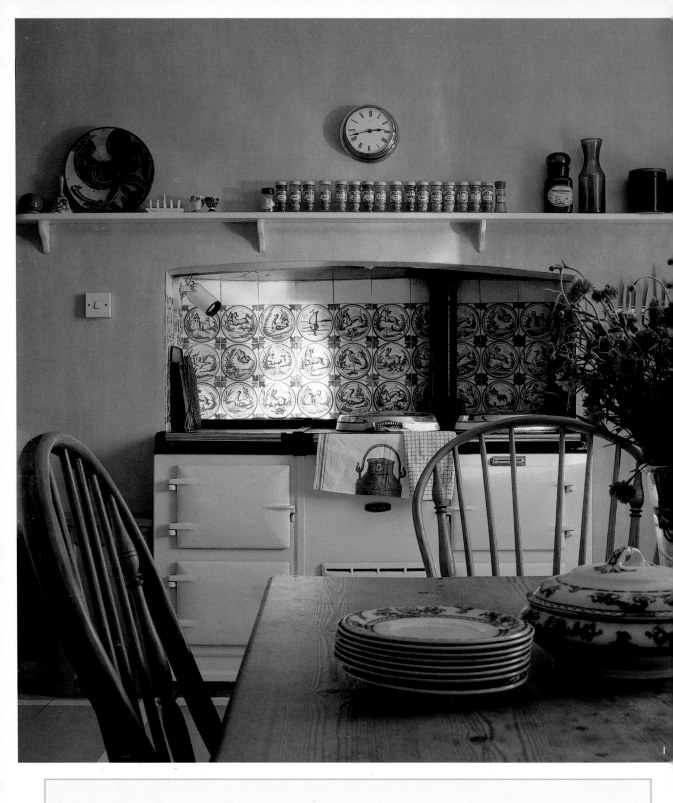

1, 2 Photographer: Montse Garriga

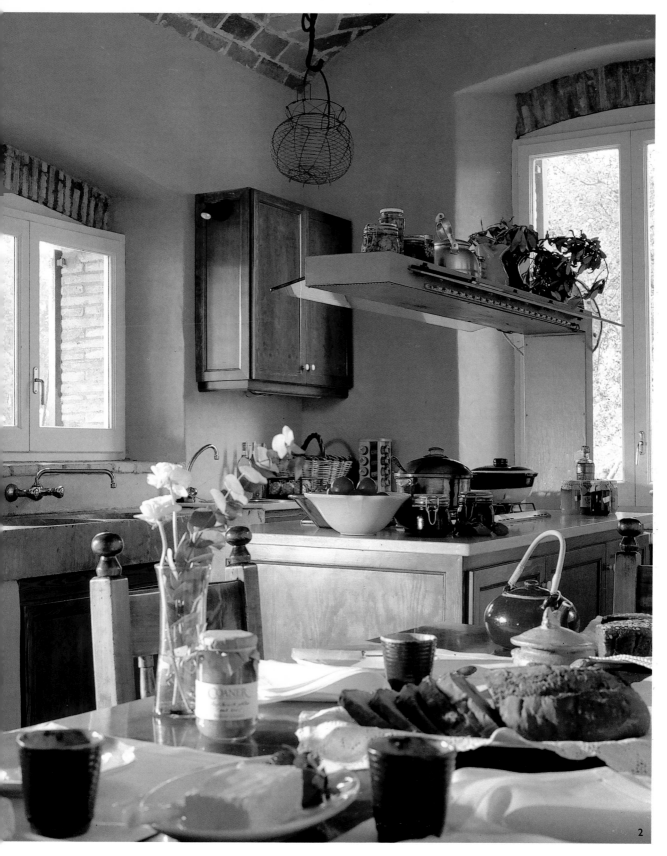

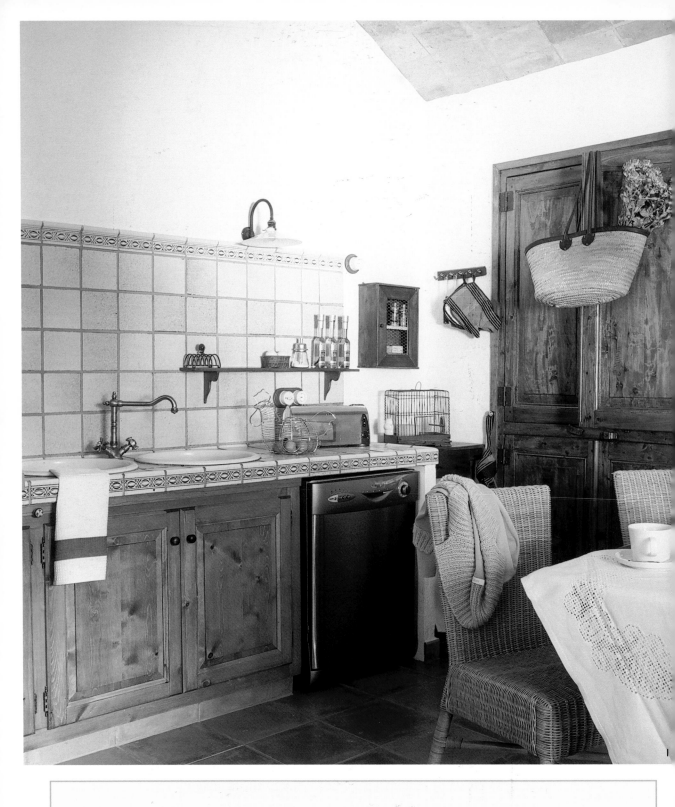

1, 2, 3 Photographer: José Luis Hausmann

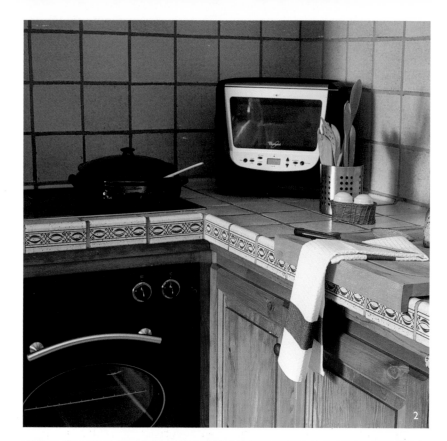

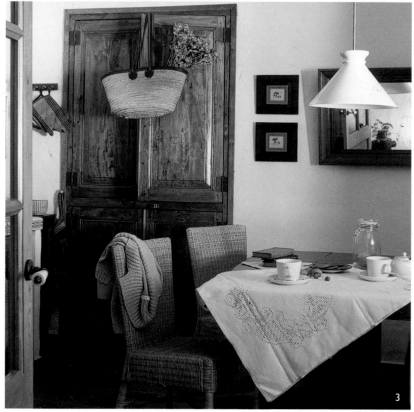

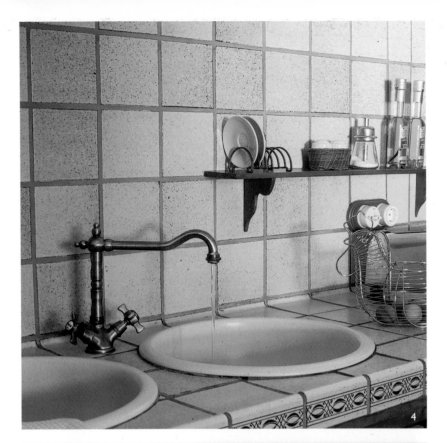

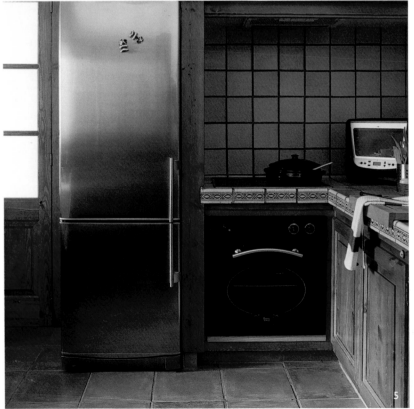

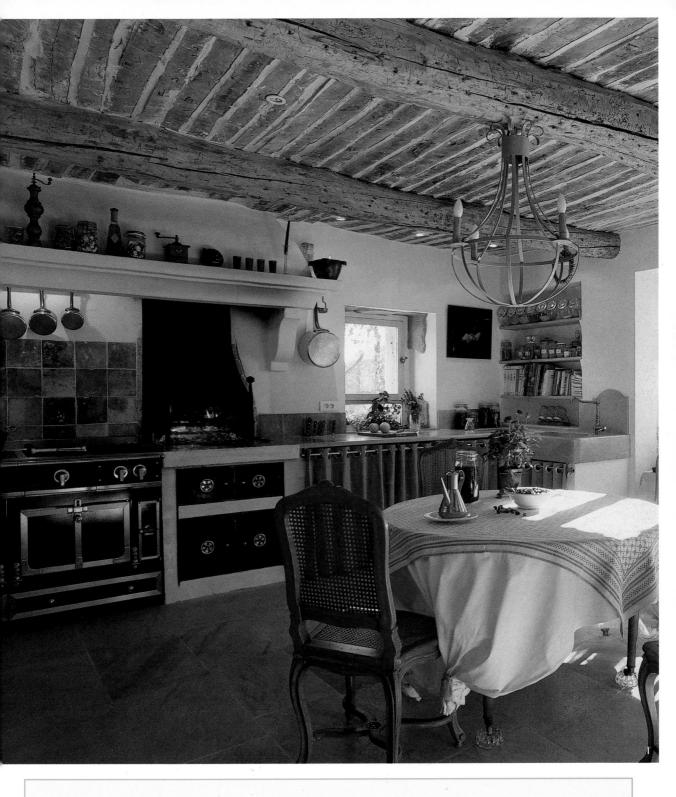

4, 5 Photographer: José Luis Hausmann

I Photographer: José Luis Hausmann

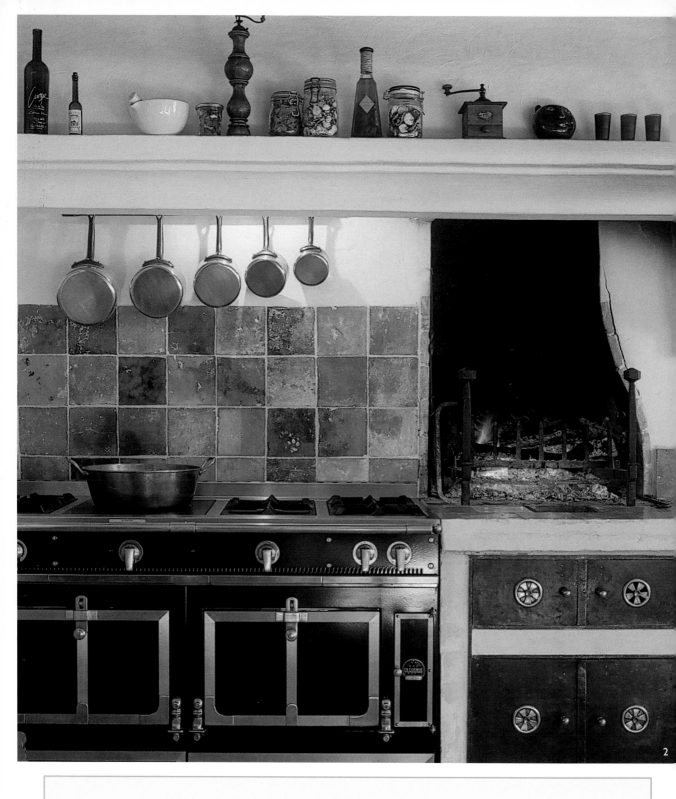

The original elements of this kitchen were preserved while new appliances were added to give the space a rustic look.

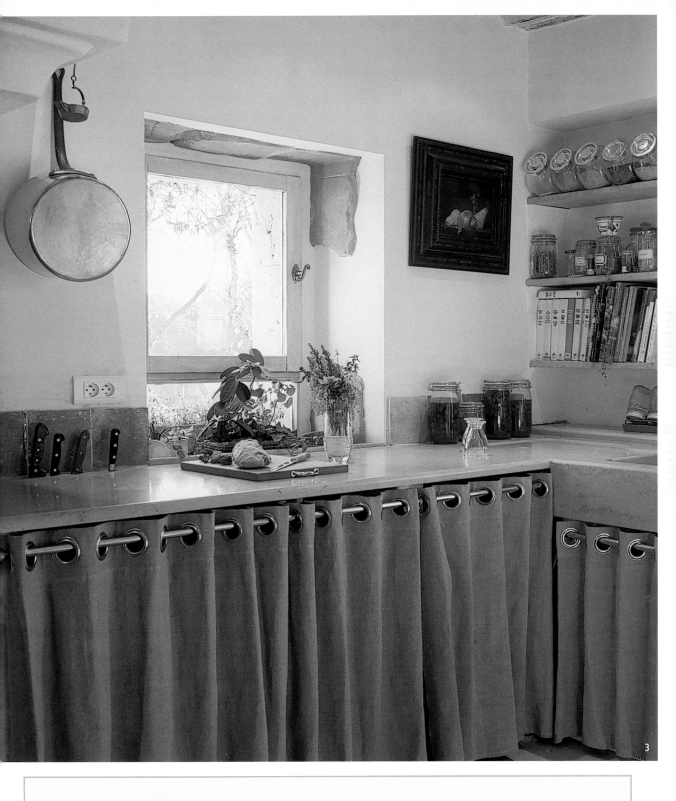

3

2, 3 Photographer: José Luis Hausmann

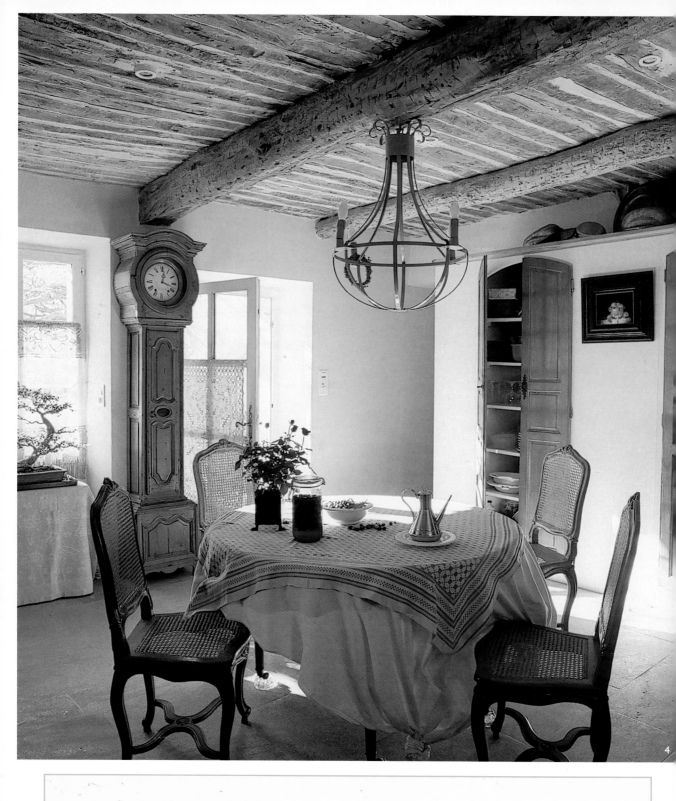

4

4, 5 Photographer: José Luis Hausmann

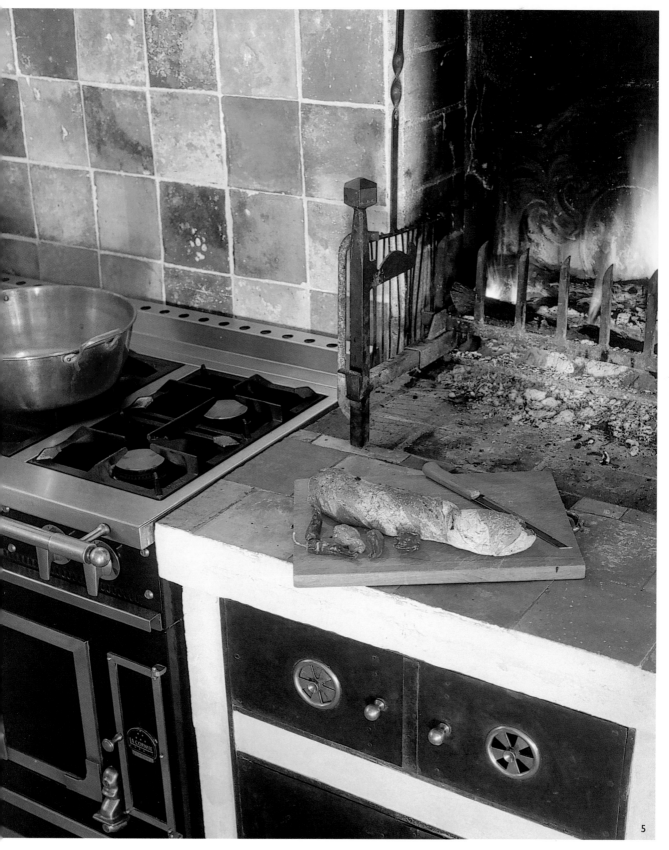

5

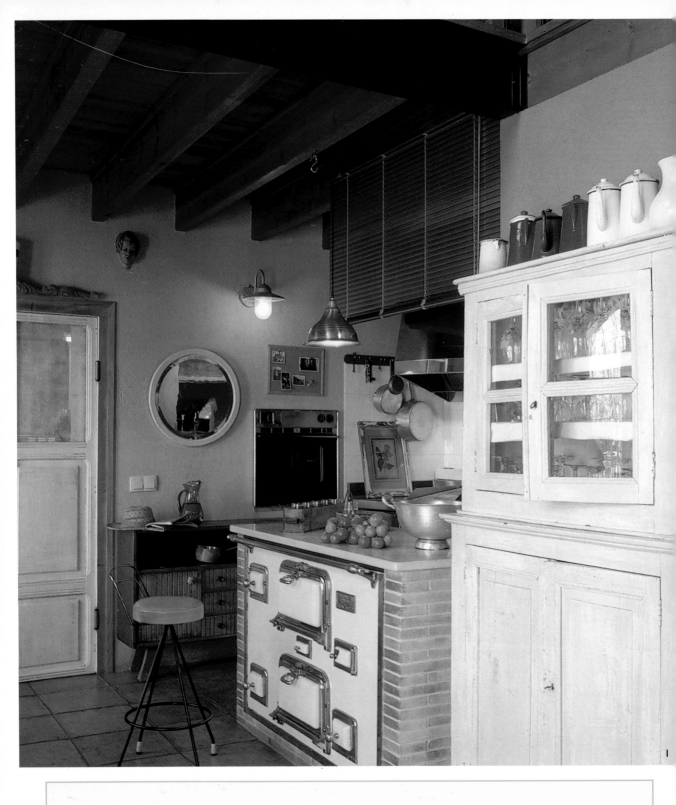

1, 2 Photographer: José Luis Hausmann

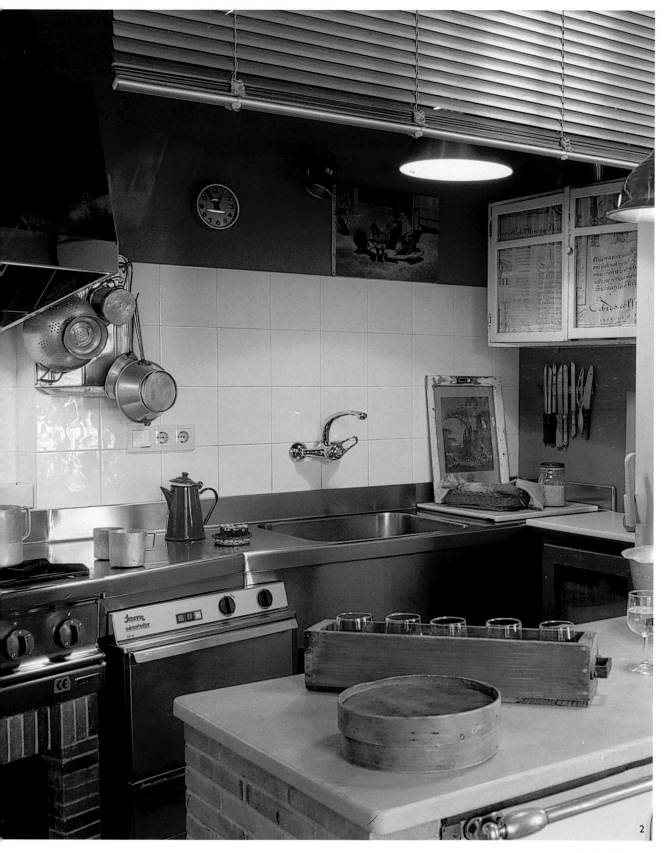

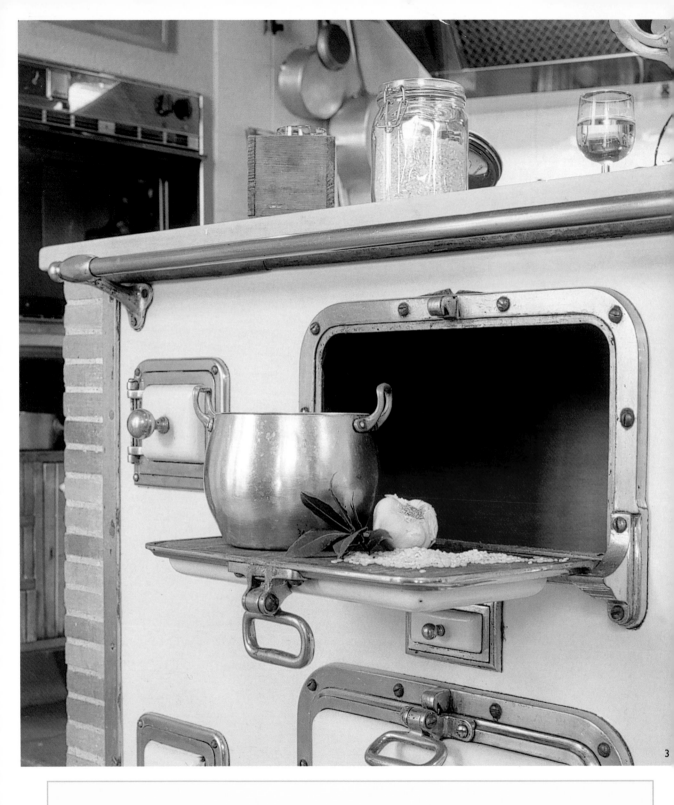

3

3, 4 Photographer: José Luis Hausmann

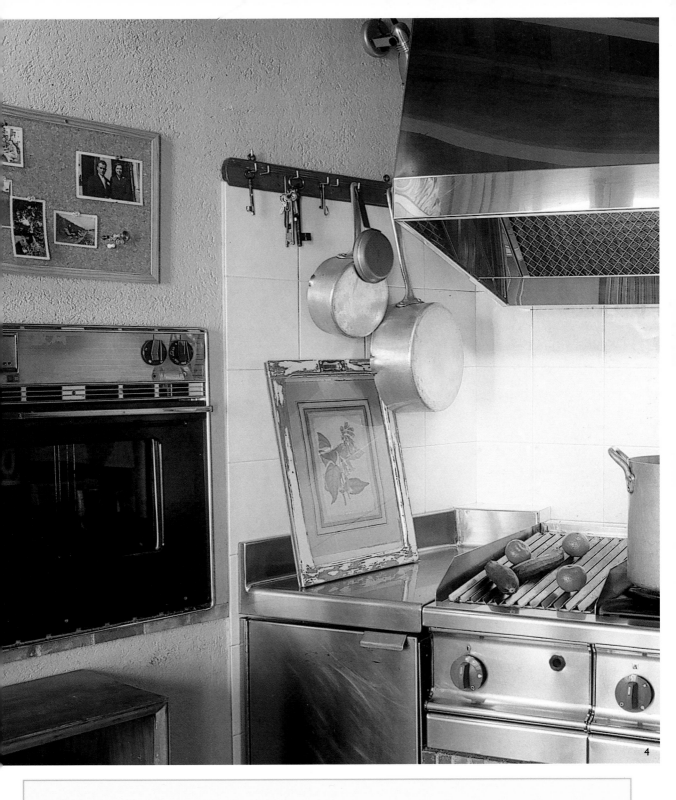

4

Tradition and modernity are combined harmoniously in this kitchen,
which maintains a rustic aesthetic without sacrificing modern conveniences.

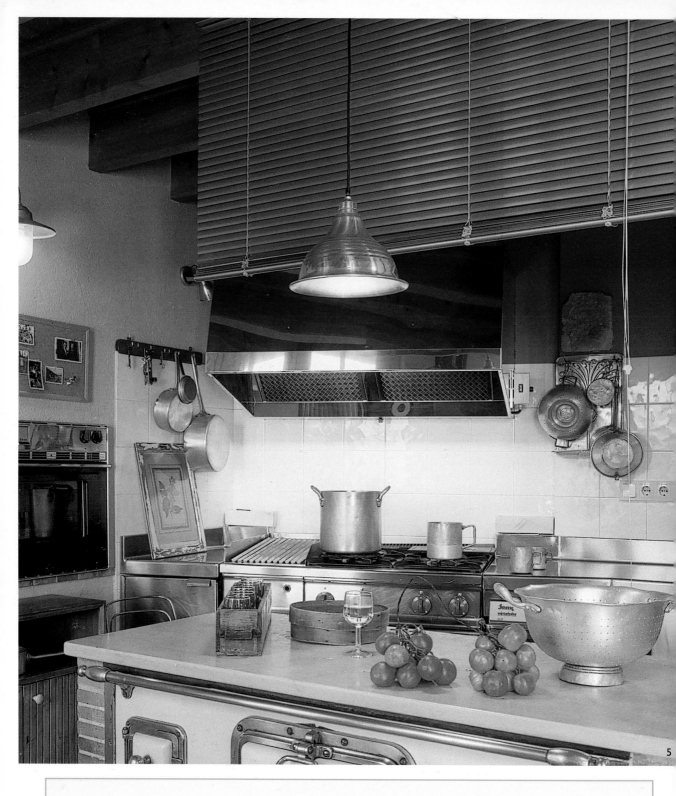

5

5 Photographer: José Luis Hausmann

1 Interior Design: Jorge Moser; Photographer: José Luis Hausmann

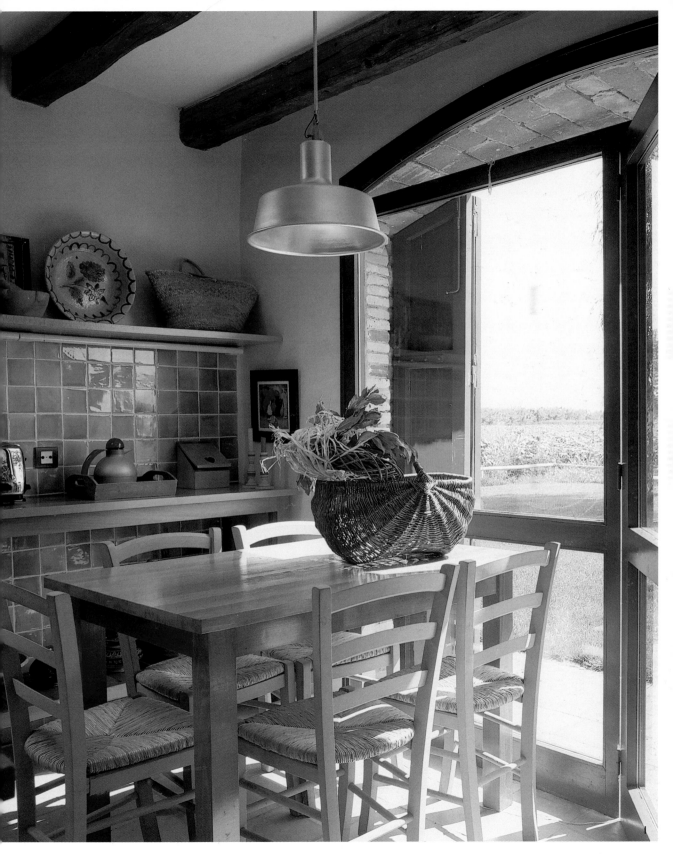

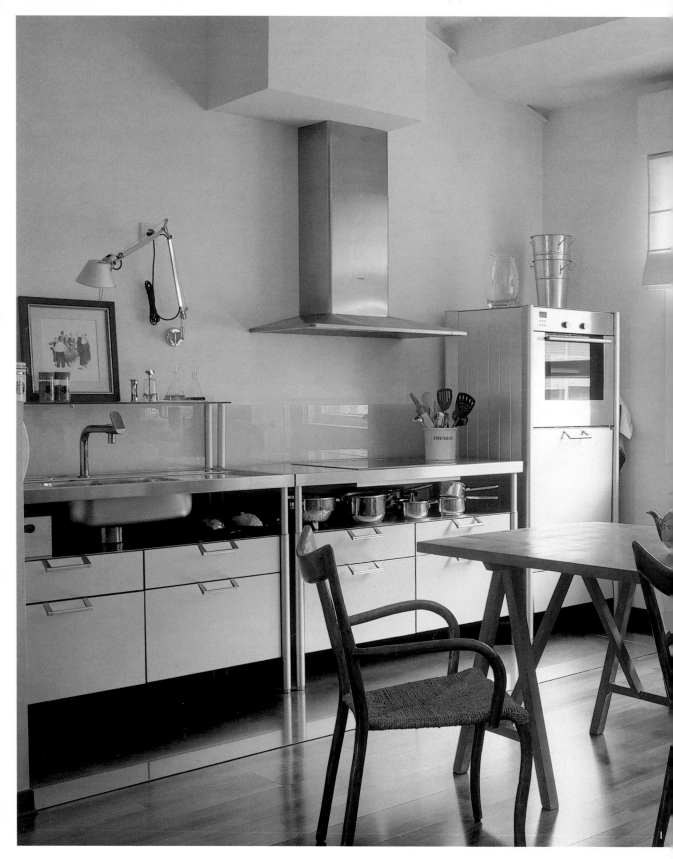

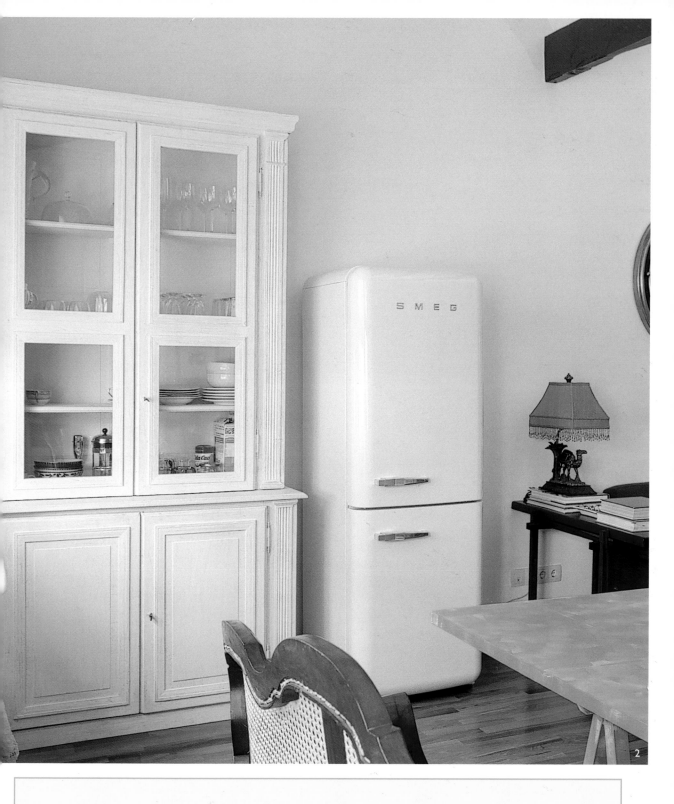

1, 2 Interior Design: Eva García; Photographer: José Luis Hausmann

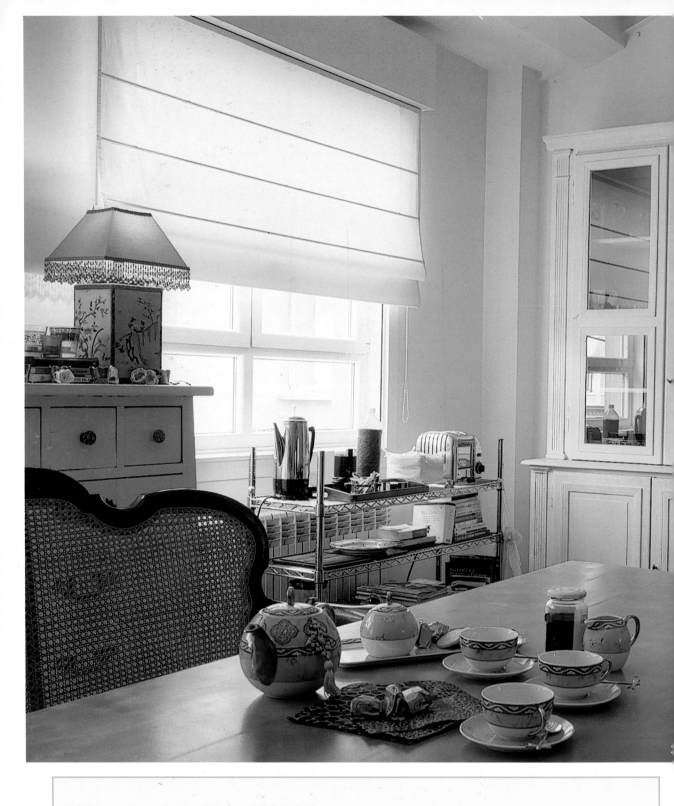

3, 4, 5 Interior Design: Eva García; Photographer: José Luis Hausmann

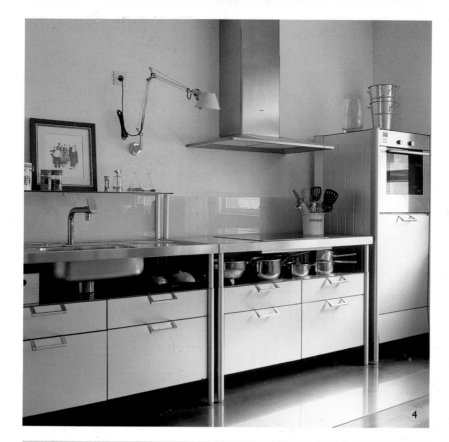

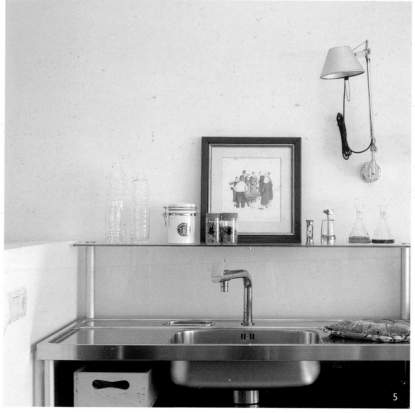

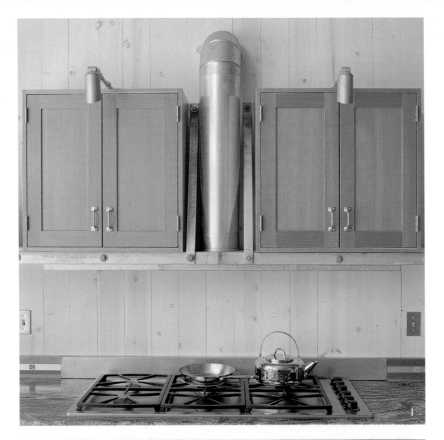

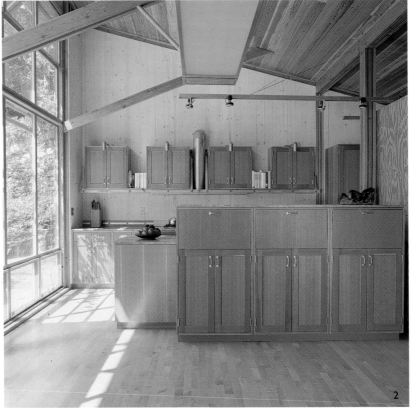

2

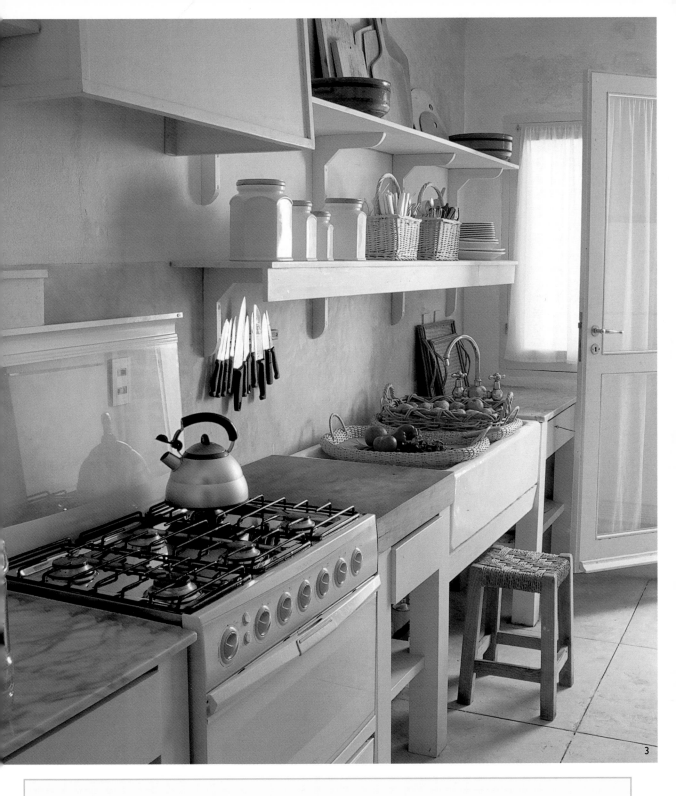

3

1, 2 Photographer: Undine Pröhl

3 Photographer: Ricardo Labougle

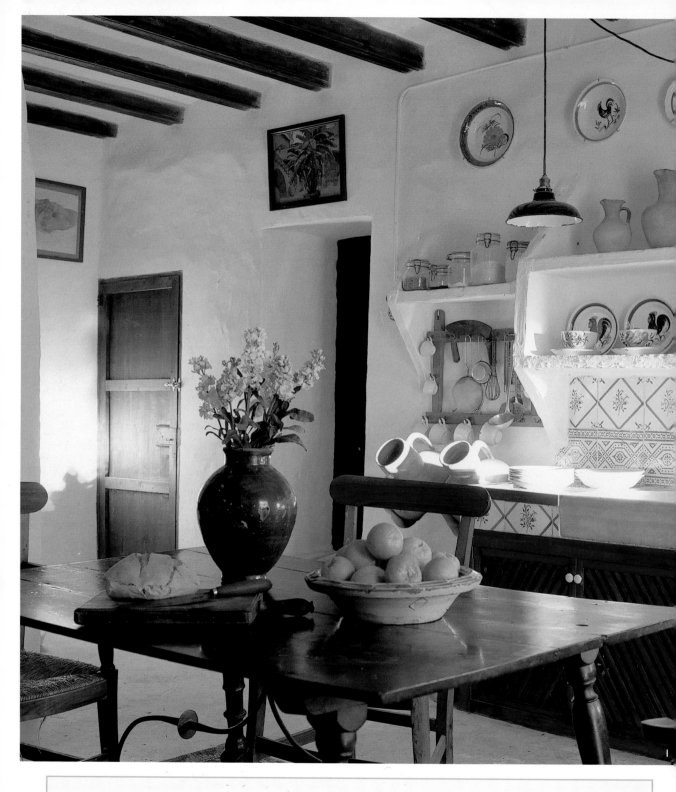

1 Photographer: Ricardo Labougle

2, 3 Photographer: Montse Garriga

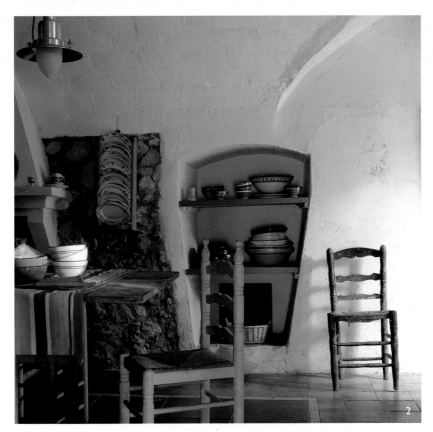

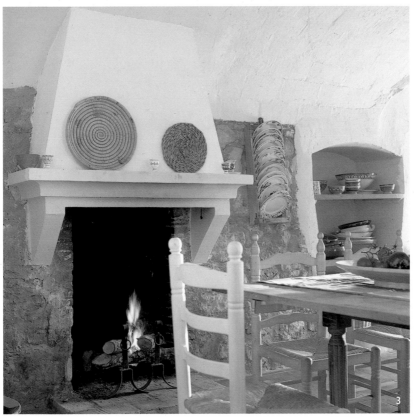

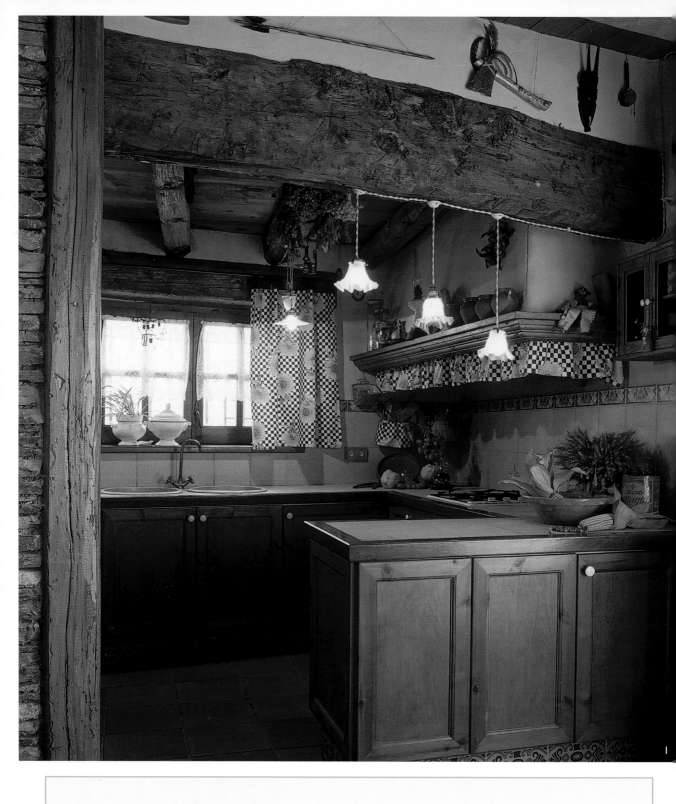

1, 2 Interior Design: Ramona Sal; Photographer: Pep Escoda

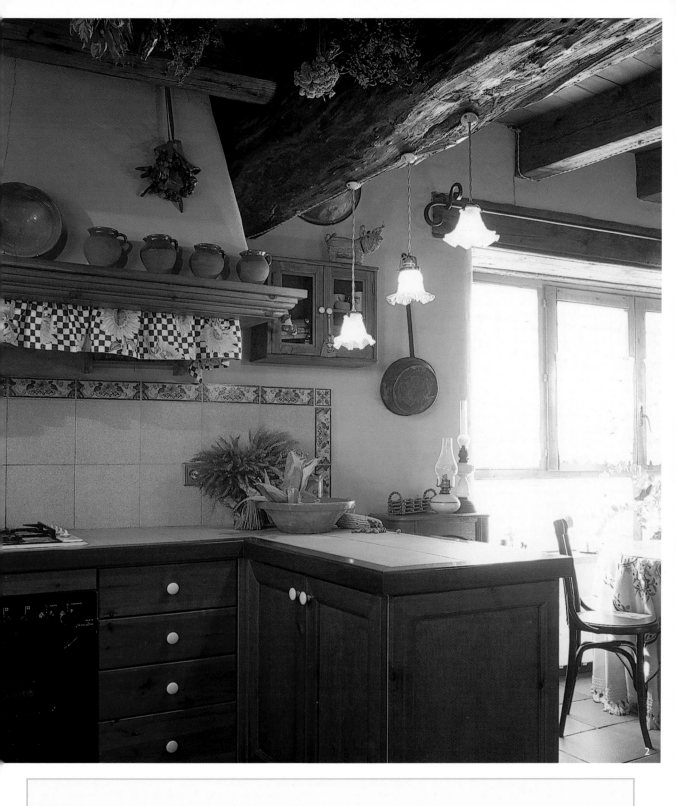

Some elements of this kitchen, such as the aromatic plants, the curtains, and the traditional vessels, help maintain a rustic aesthetic.

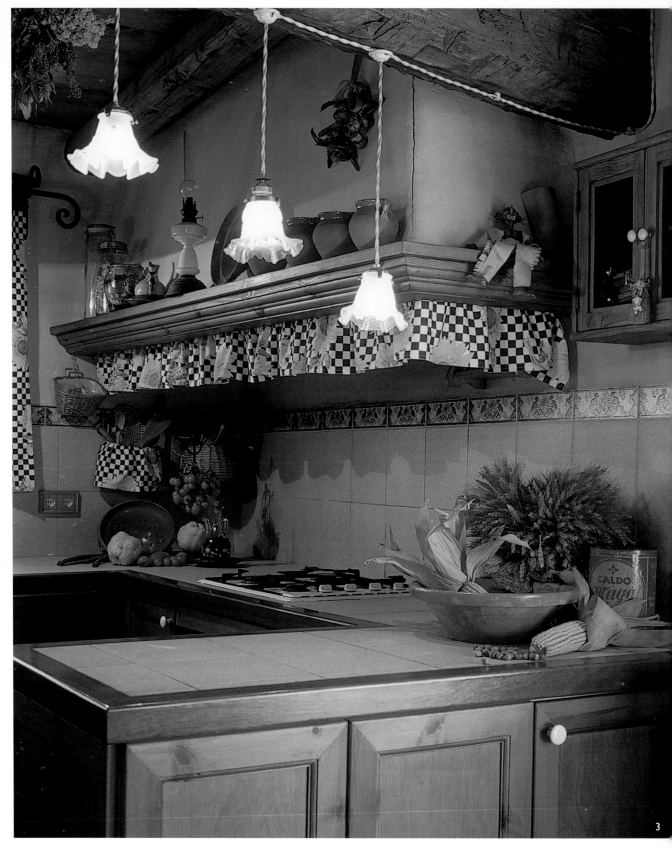

3

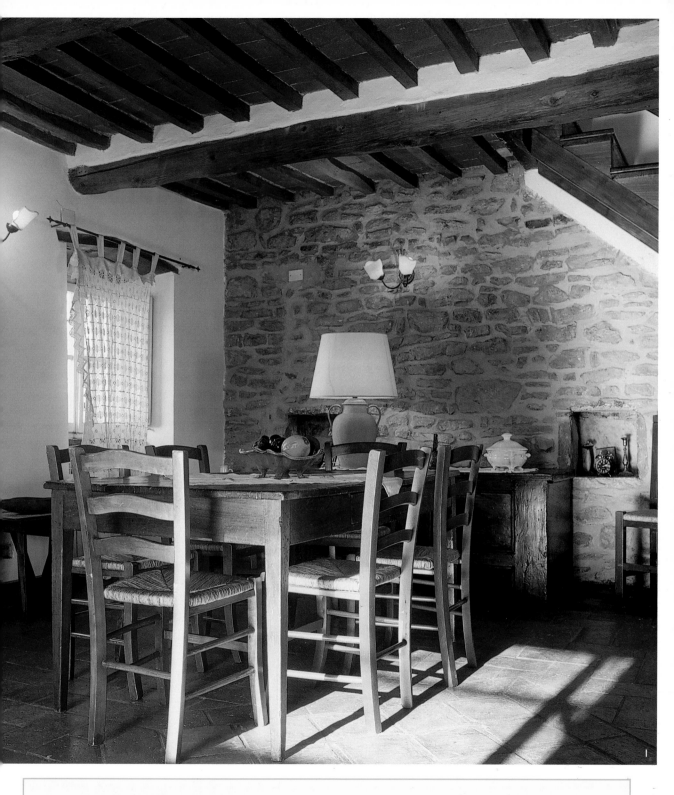

3 Interior Design: Ramona Sala; Photographer: Pep Escoda

1 Interior Design: Catacuriam; Photographer: Pep Escoda

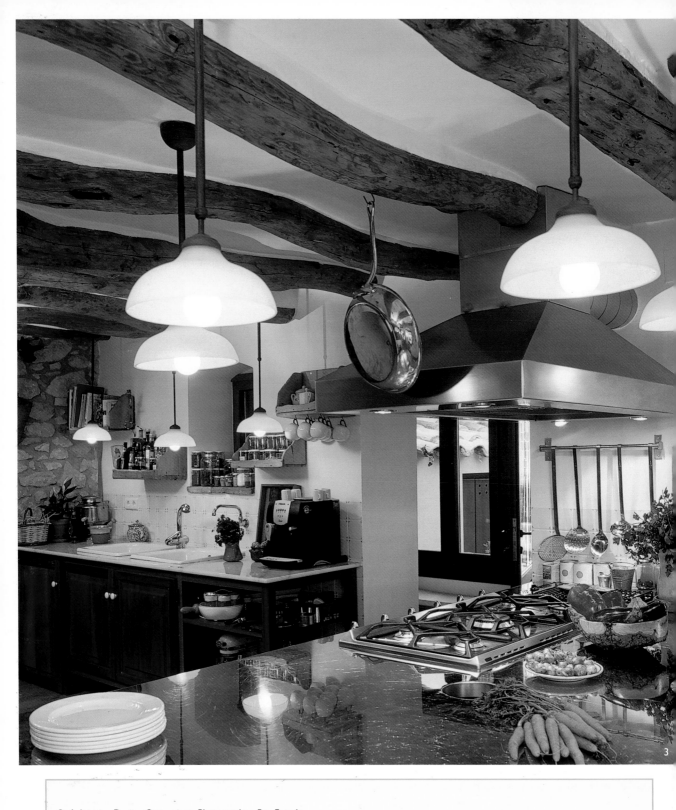

3

3, 4 Interior Design: Catacuriam; Photographer: Pep Escoda

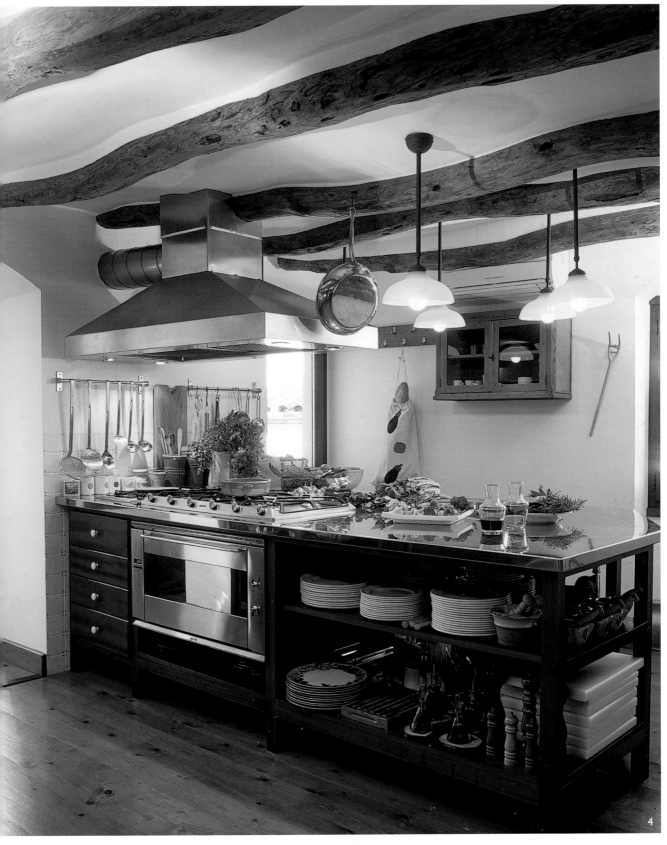

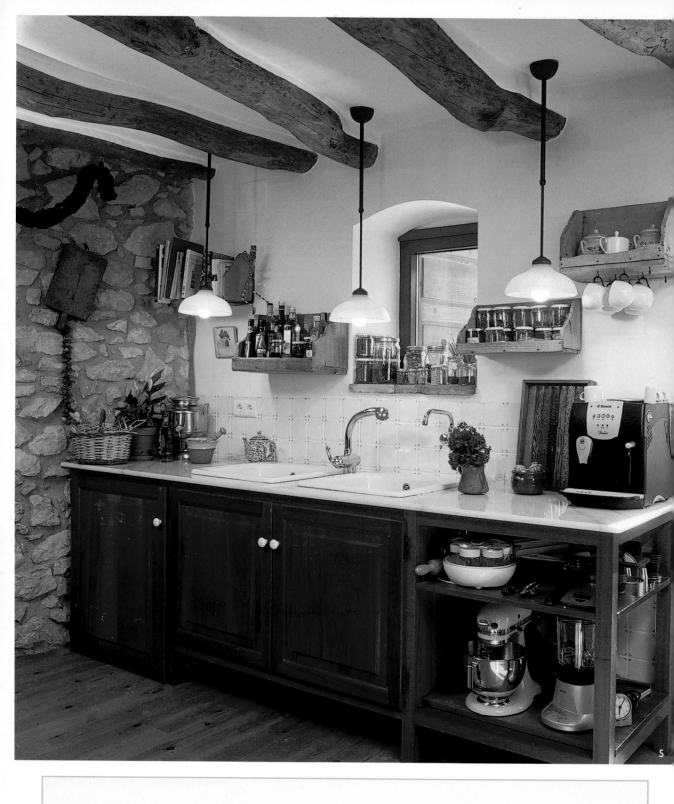

5

5, 6 Interior Design: Catacuriam; Photographer: Pep Escoda

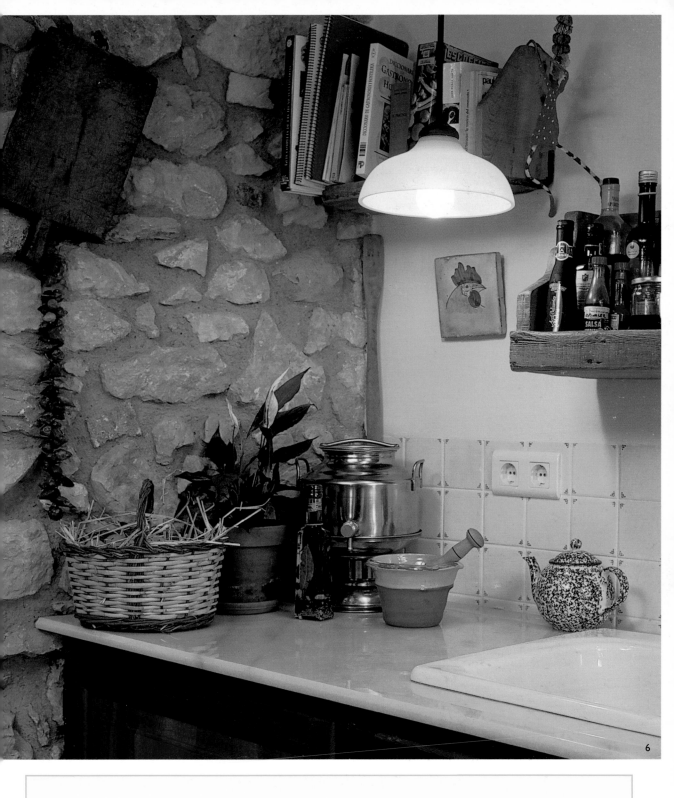

The combination of natural materials, such as stone and wood, dominates this rustic kitchen.

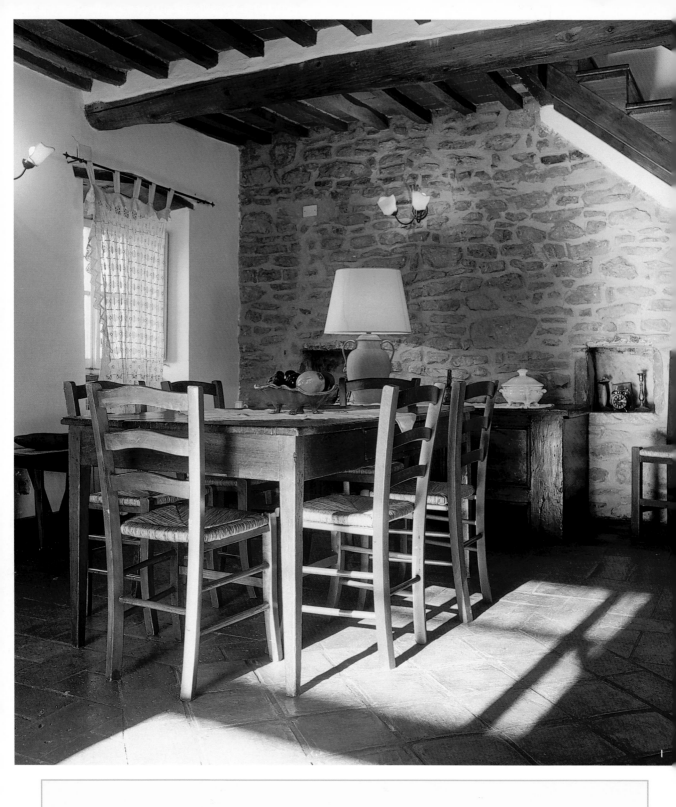

1, 2, 3 Interior Design: Fontelung; Photographer: Pep Escoda

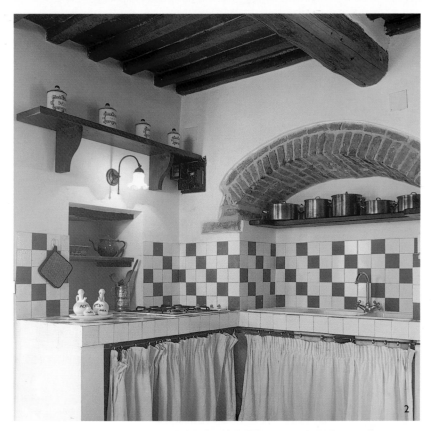

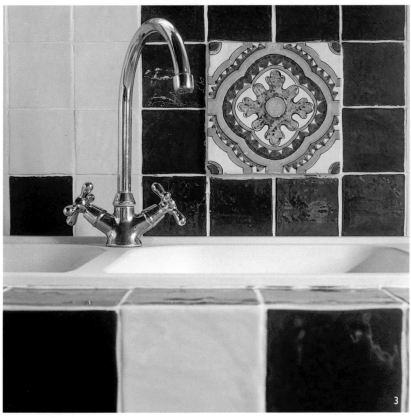

Materials

THE use of different materials depends upon the type and style of kitchen to be built, since specific materials provide the unique elements needed to create a particular aesthetic.

Continual experimentation with new materials allows for greater inventiveness in kitchen design and more possibilities in composition and layout. This is evident in the new designs of certain brands shown in "Designs for the Twenty-First Century."

This section is devoted to the two most common materials in the kitchens selected for this book: wood and metal. But the section could be expanded to include the many materials derived from them.

The use of woods and composites adds warmth to a space and suggests the idea of a traditional home. The colors of the woods range from the elegant dark tones of oak to cutting-edge reds and blues. Conversely, an avant-garde, modern feel is created through the use of metal and stainless steel, which has futuristic connotations and is reminiscent of industrial kitchens.

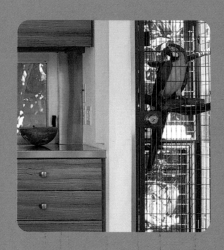

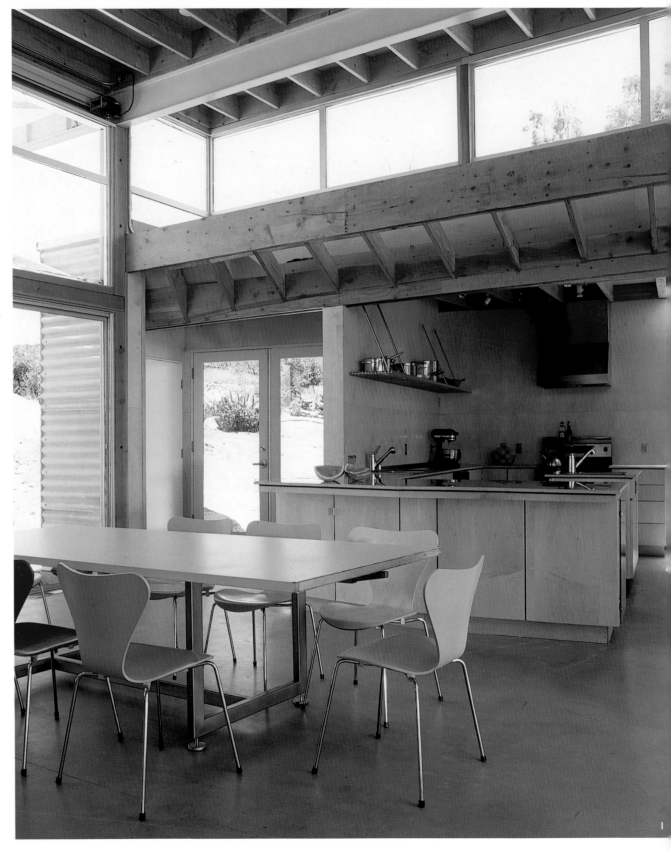

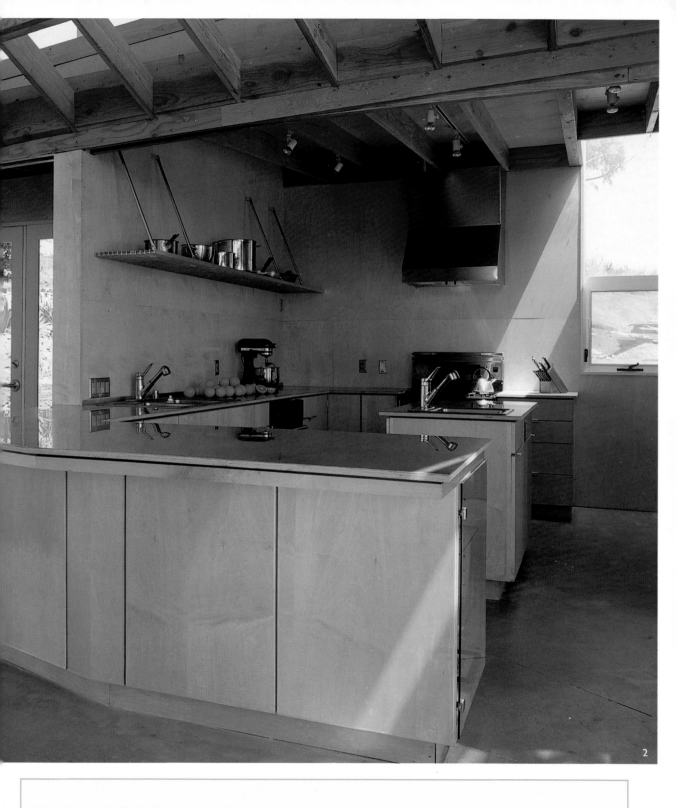

2

1, 2 Architects: Daly/Genik; Photographer: Undine Pröhl

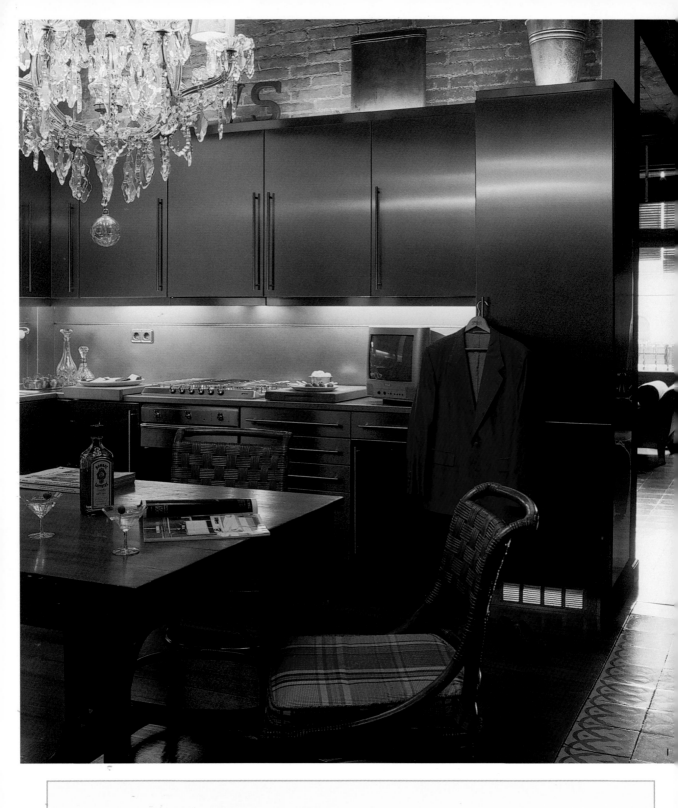

1, 2 Interior Design: Víctor Segura; Photographer: José Luis Hausmann

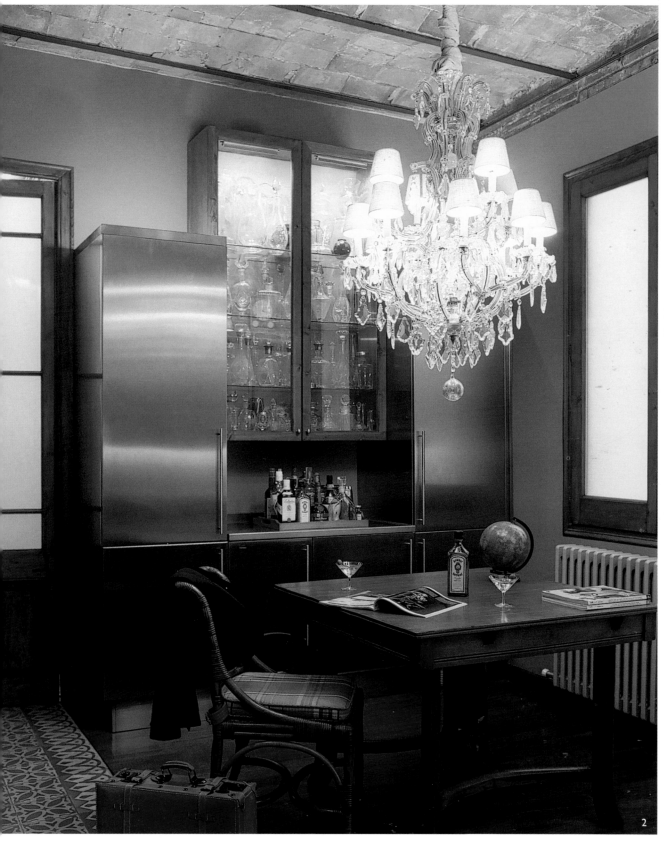

2

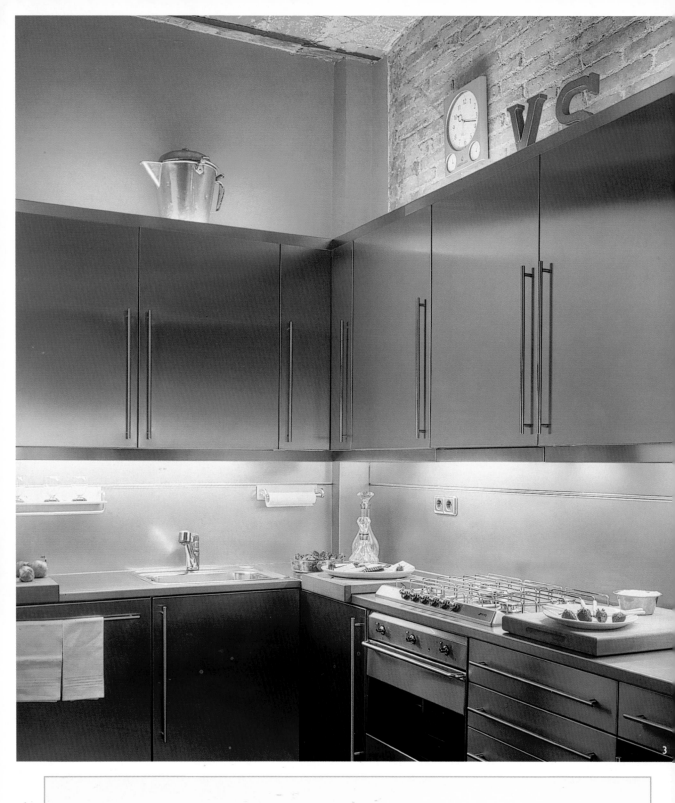

3, 4 Interior Design: Víctor Segura; Photographer: José Luis Hausmann

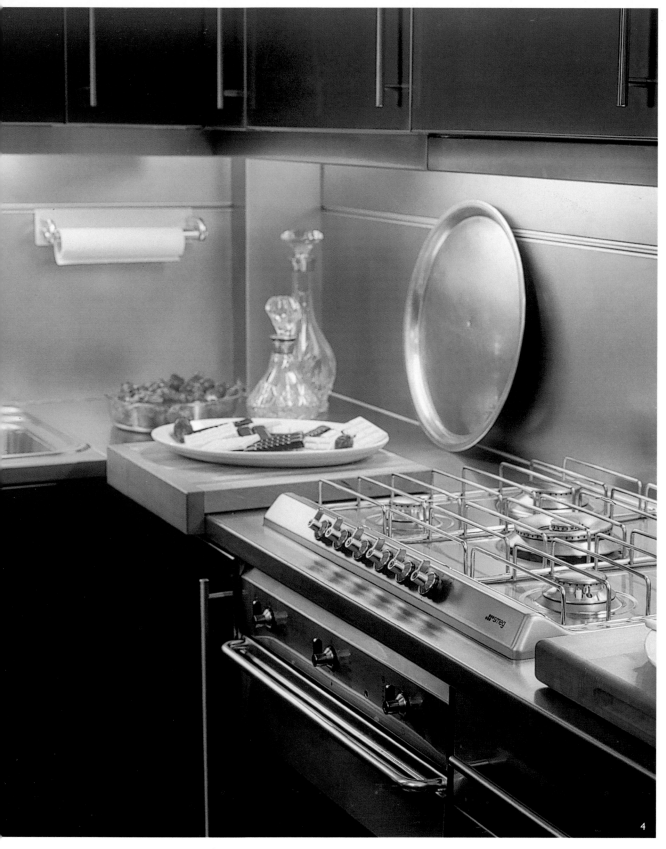

4

5 Interior Design: Víctor Segura; Photographer: José Luis Hausmann

I Architect: Philip Sunset; Photographer: Pep Escoda

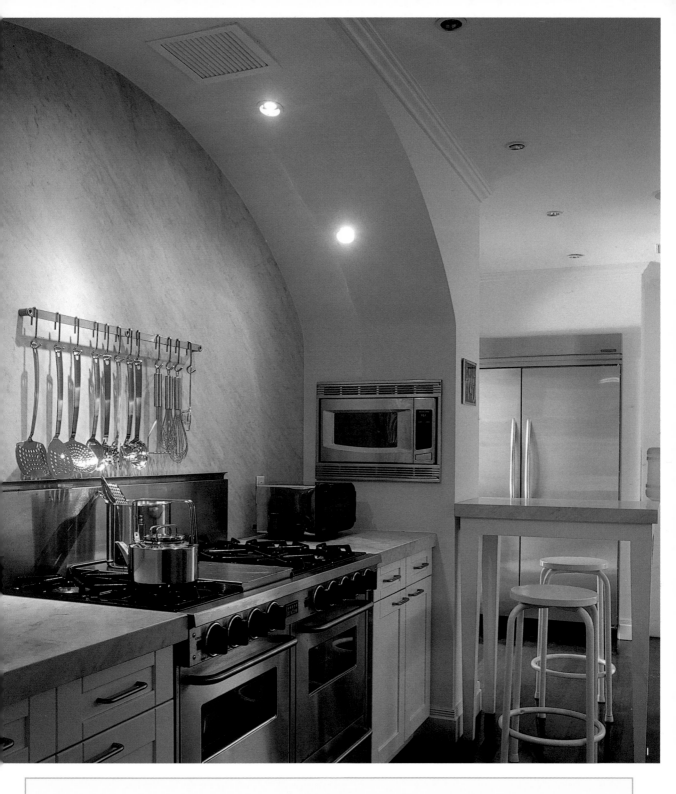

Wood adds warmth to cold spaces and can blend into any kitchen setting.

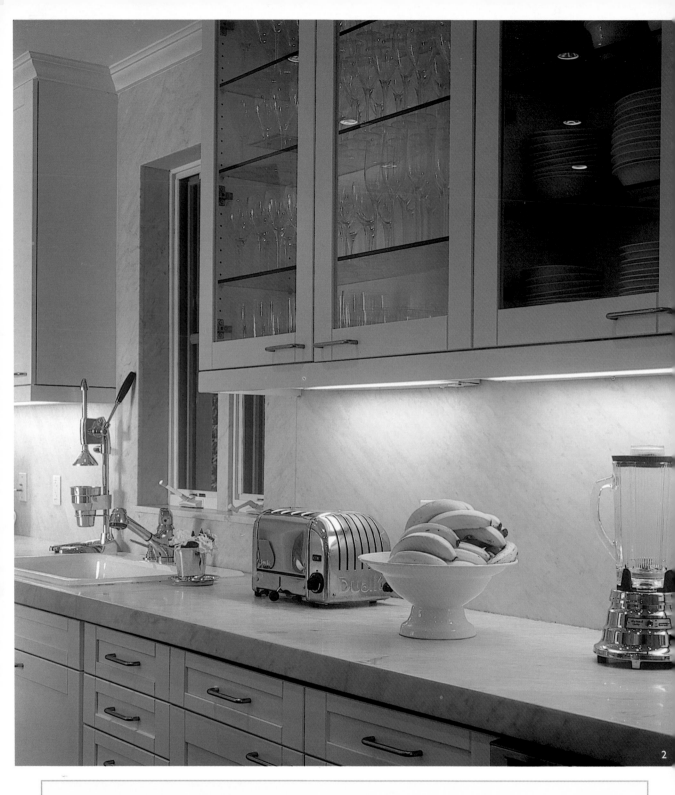

2 Architect: Philip Sunset; Photographer: Pep Escoda

I Interior Design: Josep Font/Greek; Photographer: José Luis Hausmann

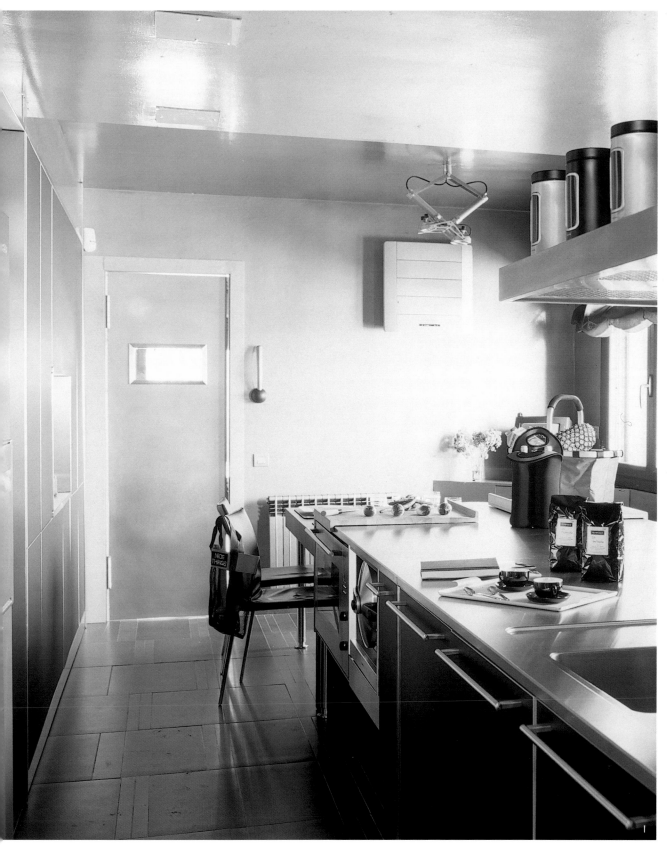

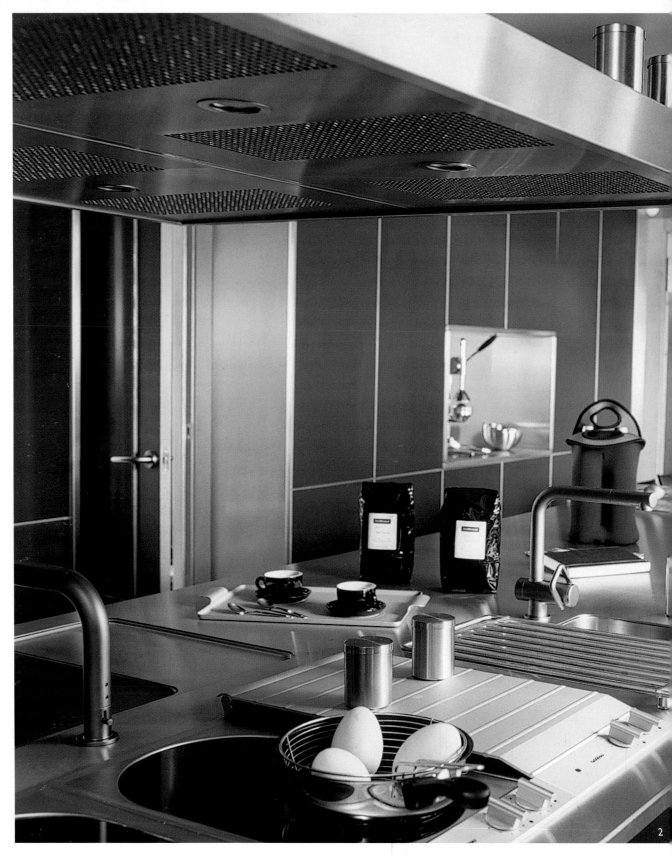

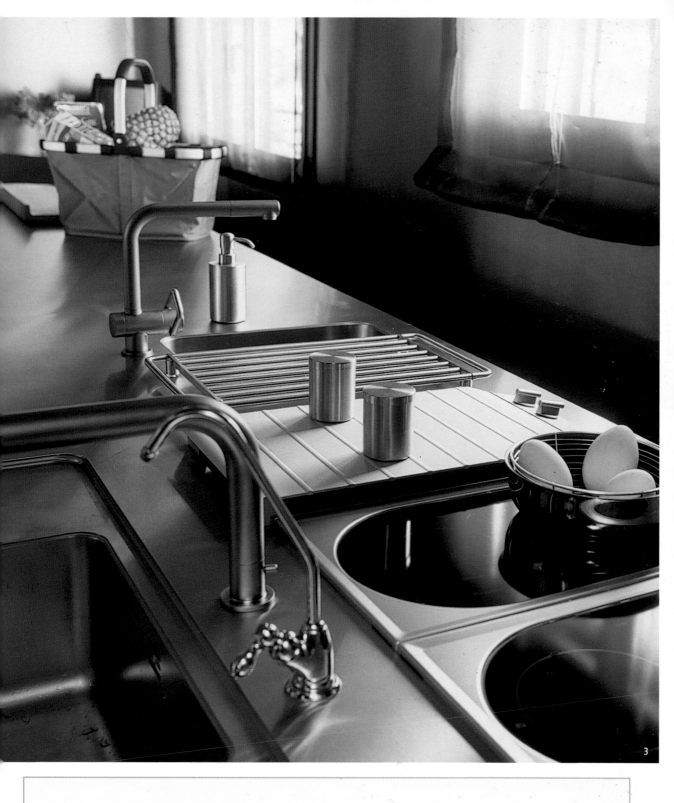

3

2, 3 Interior Design: Josep Font/Greek; Photographer: José Luis Hausmann

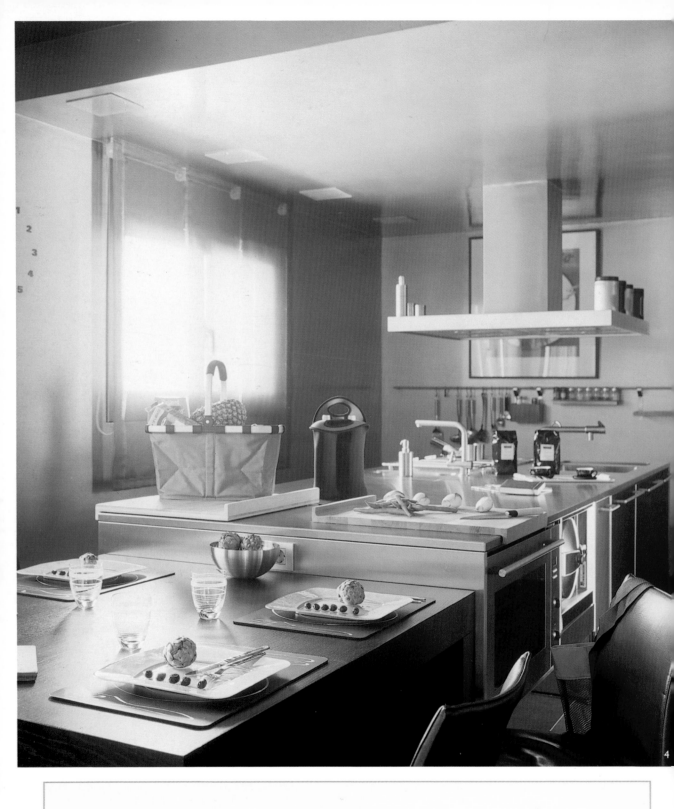

4, 5 Interior Design: Josep Font/Greek; Photographer: José Luis Hausmann

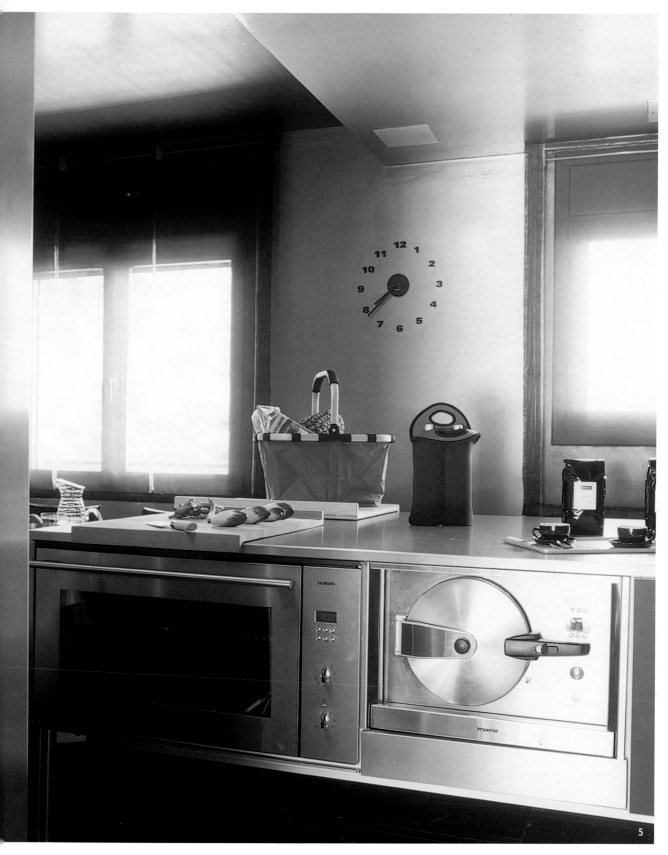

5

6 Interior Design: Josep Font/Greek; Photographer: José Luis Hausmann

1 Interior Design: L'Eix; Photographer: José Luis Hausmann

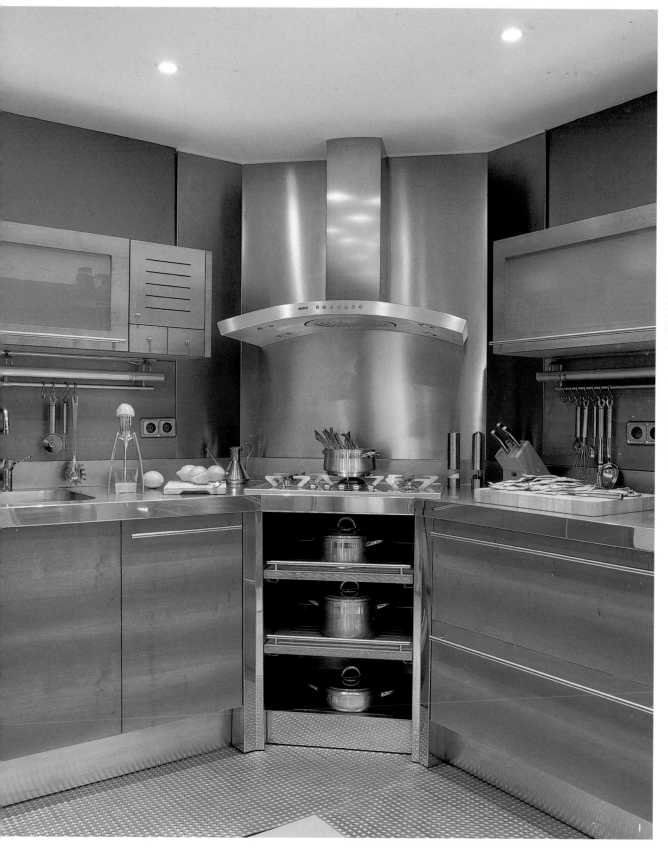

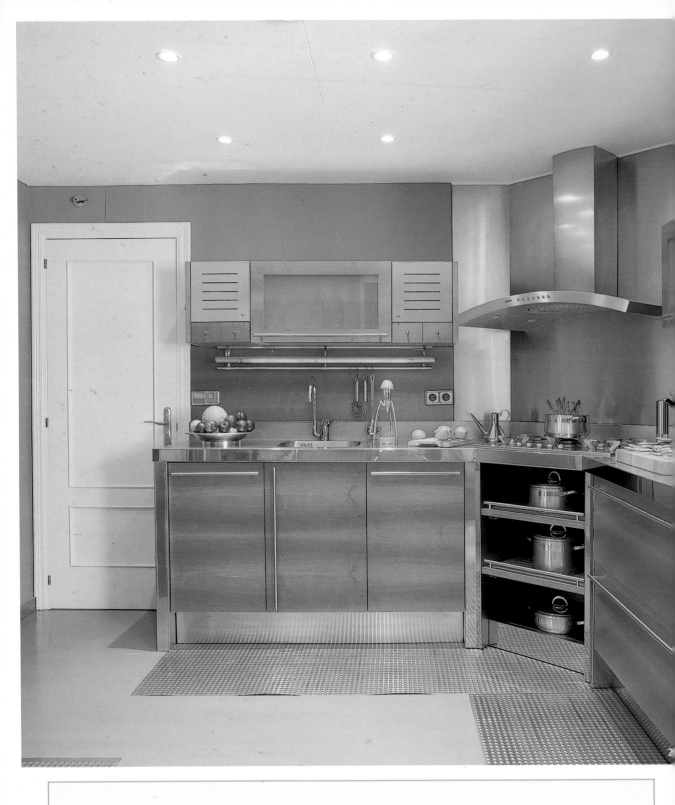

2, 3 Interior Design: L'Eix; Photographer: José Luis Hausmann

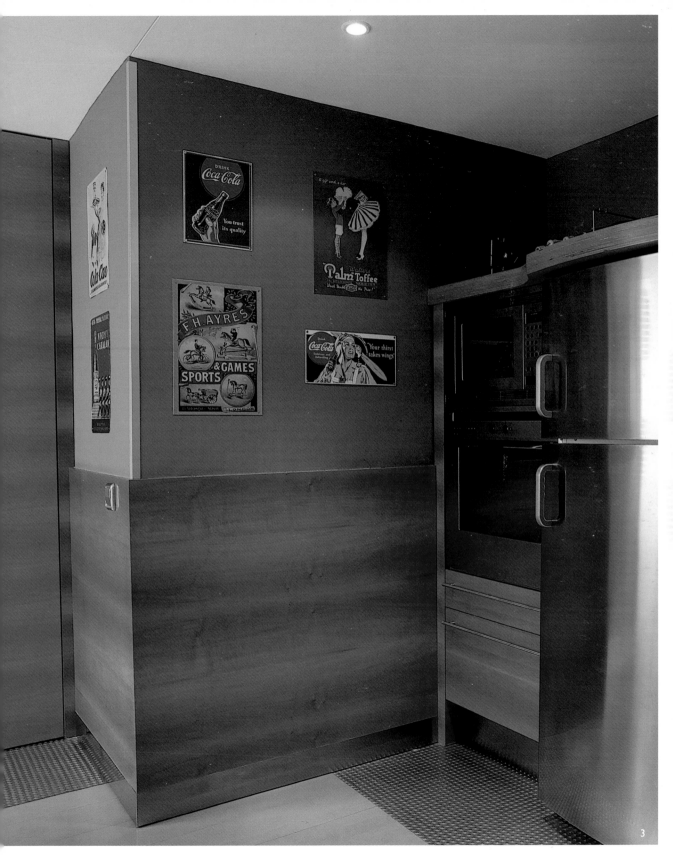

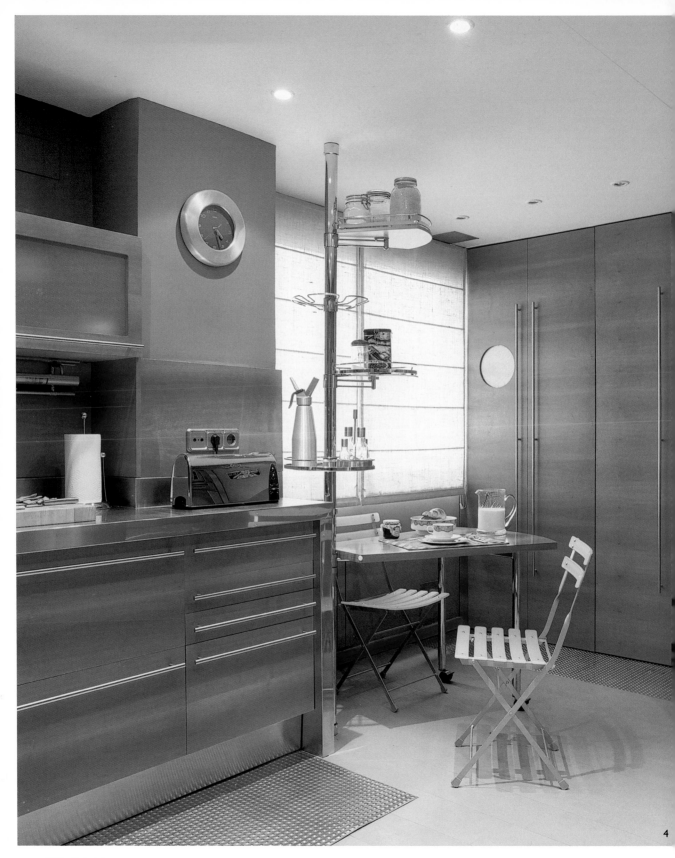

4

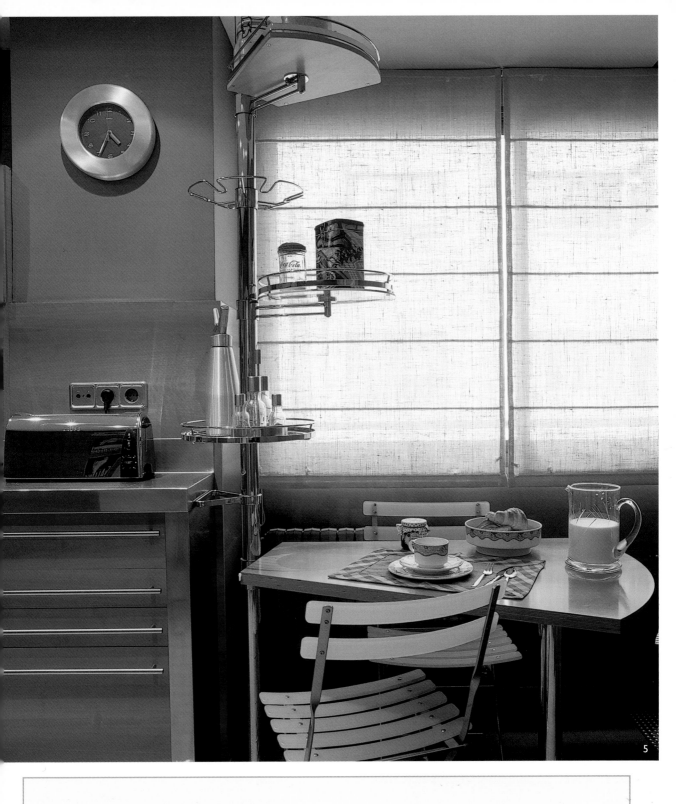

5

4, 5 Interior Design: L'Eix; Photographer: José Luis Hausmann

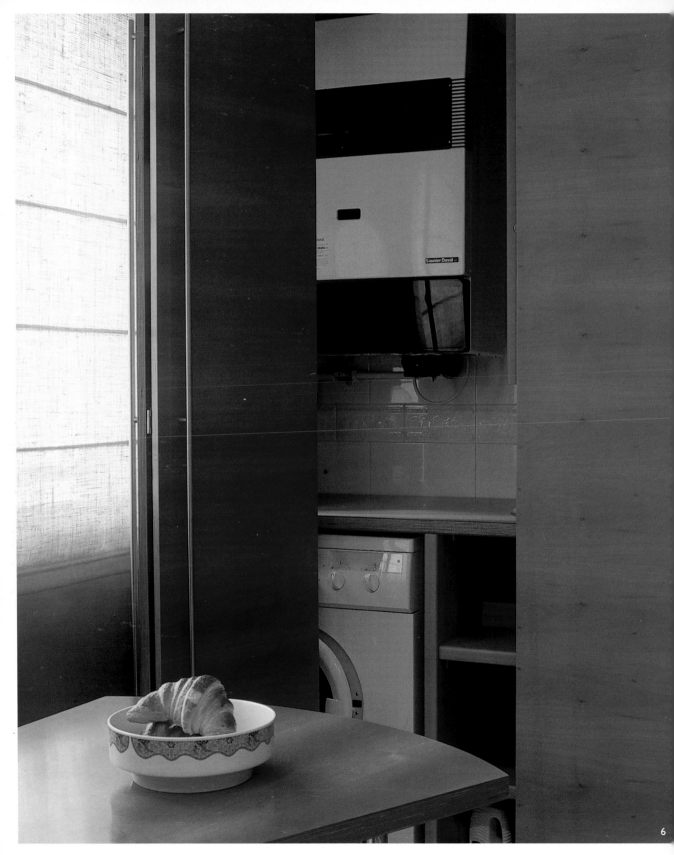

6

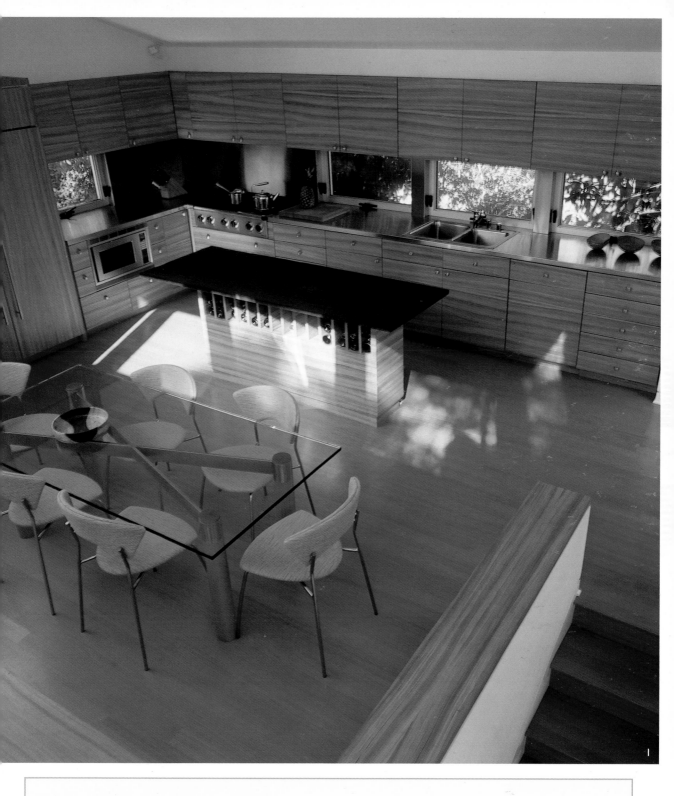

6 Interior Design: L'Eix; Photographer: José Luis Hausmann

1 Architects: Safdile/Rabines; Photographer: Undine Pröhl

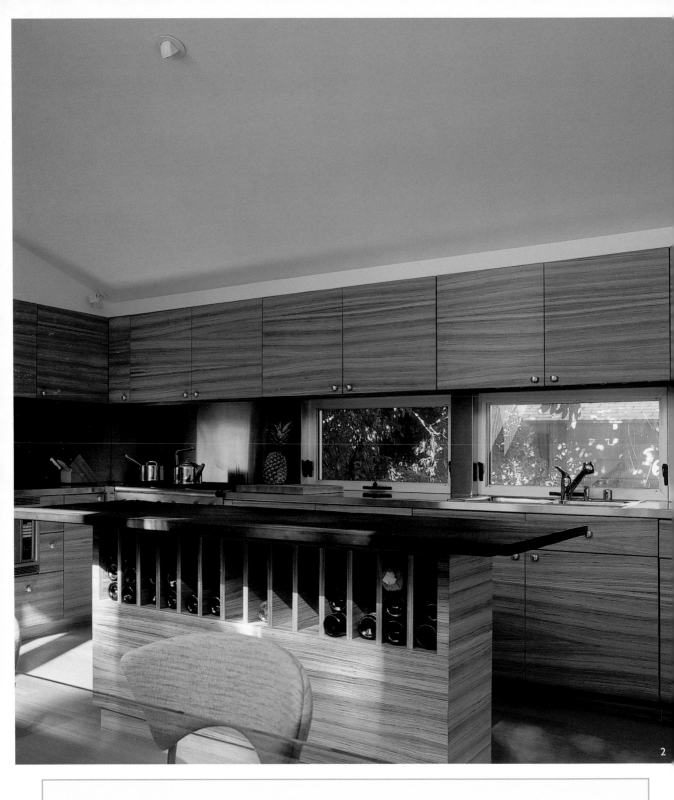

The design choice, in this case, was to line the kitchen walls with wood,
making the most of the space in order to devote it to storage.

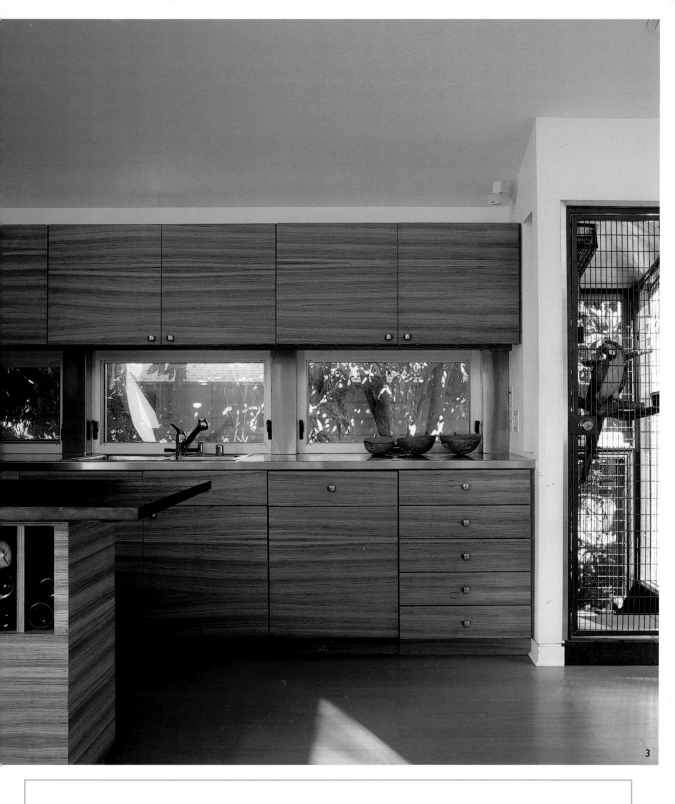

3

2, 3 Architects: Safdile/Rabines; Photographer: Undine Pröhl

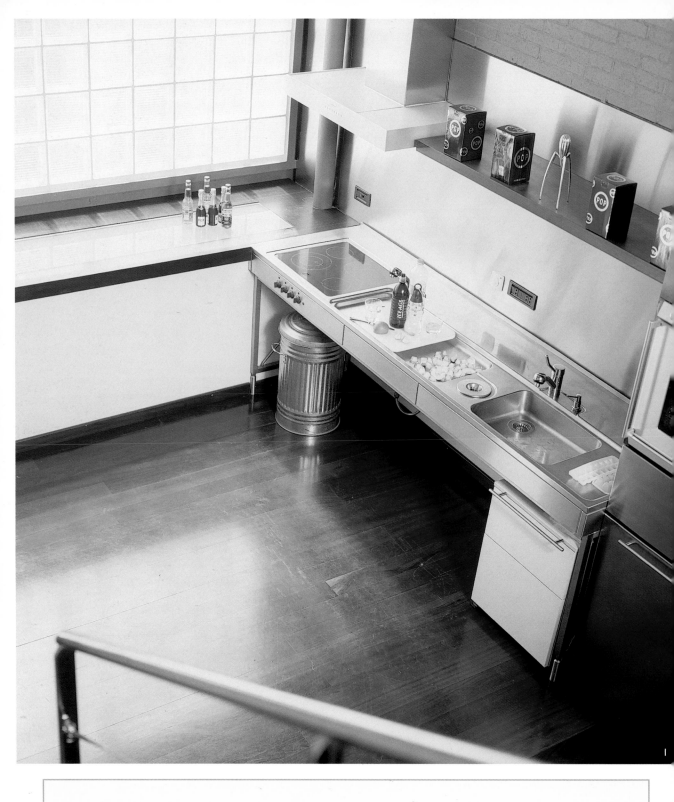

1, 2 Interior Design: Àlex Serra; Photographer: José Luis Hausmann

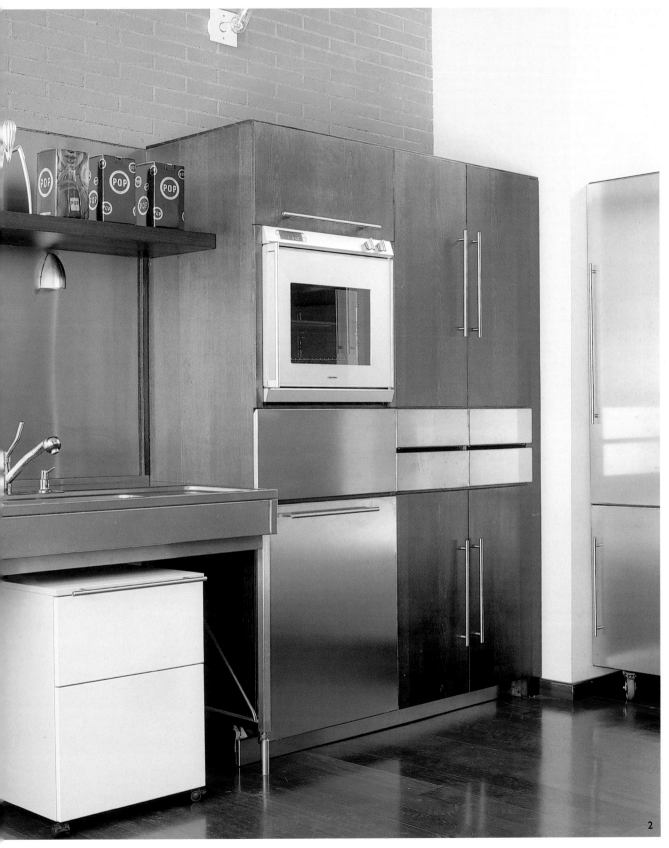

2

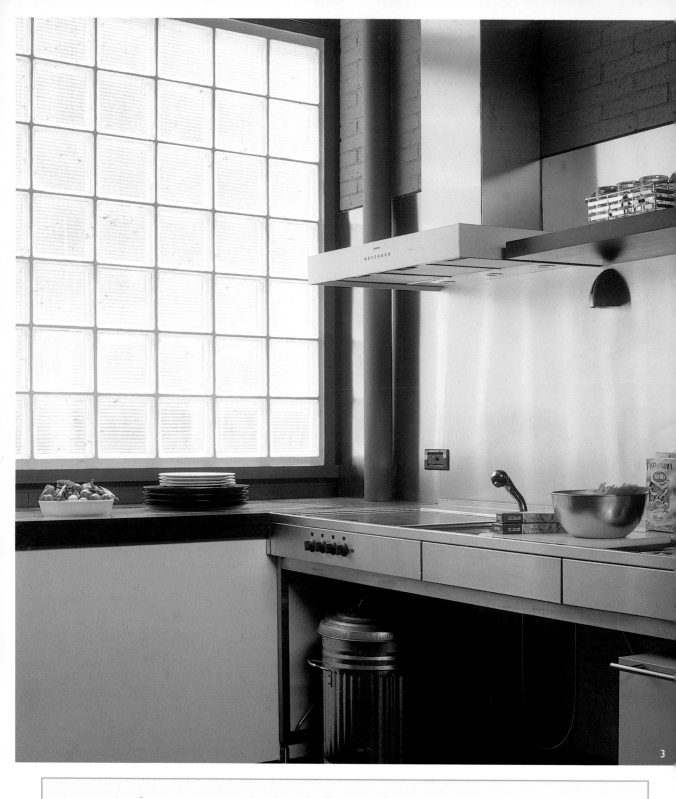

3

Metal gives many kitchens an industrial character, especially in loft-type homes.

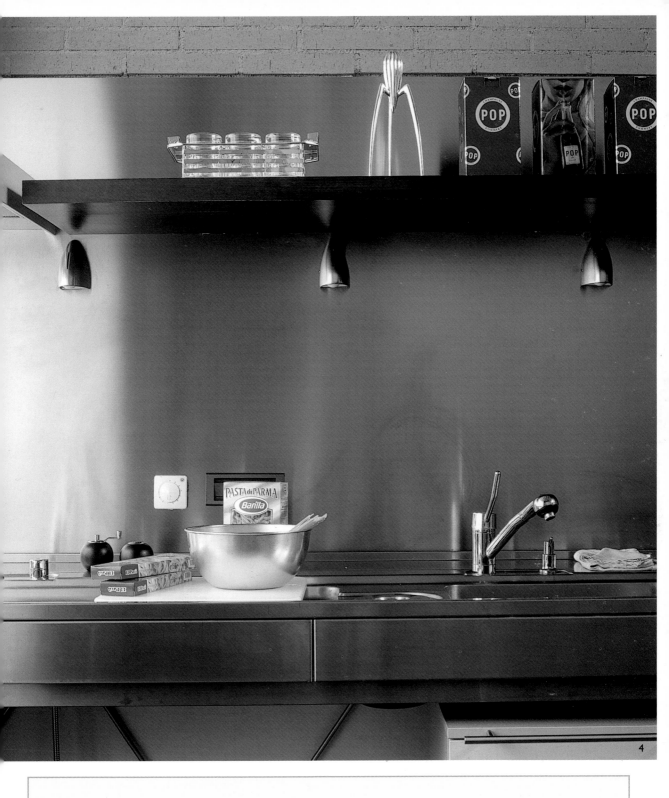

4

3, 4 Interior Design: Àlex Serra; Photographer: José Luis Hausmann

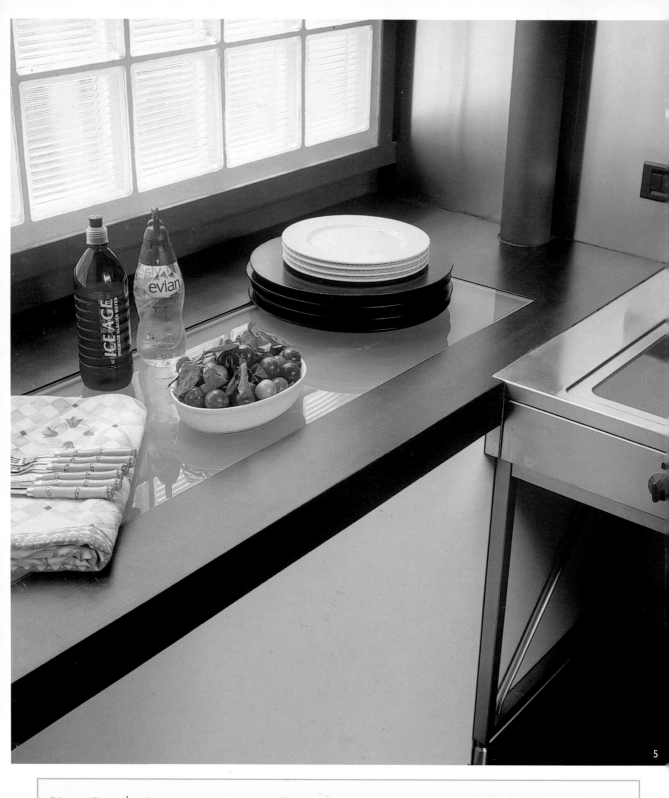

5 Interior Design: Àlex Serra; Photographer: José Luis Hausmann

1 Architect: Rick Joy; Photographer: Undine Pröhl

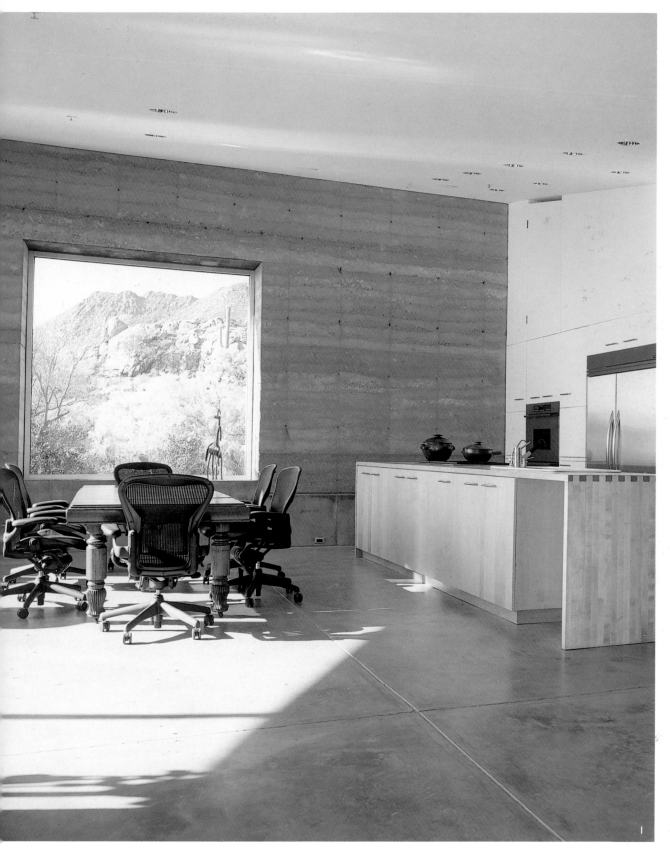

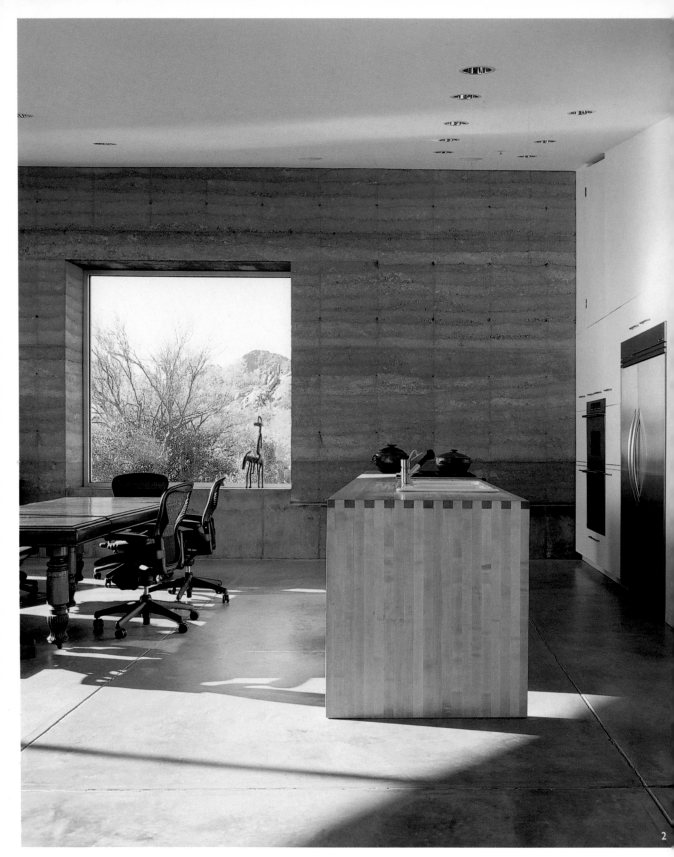

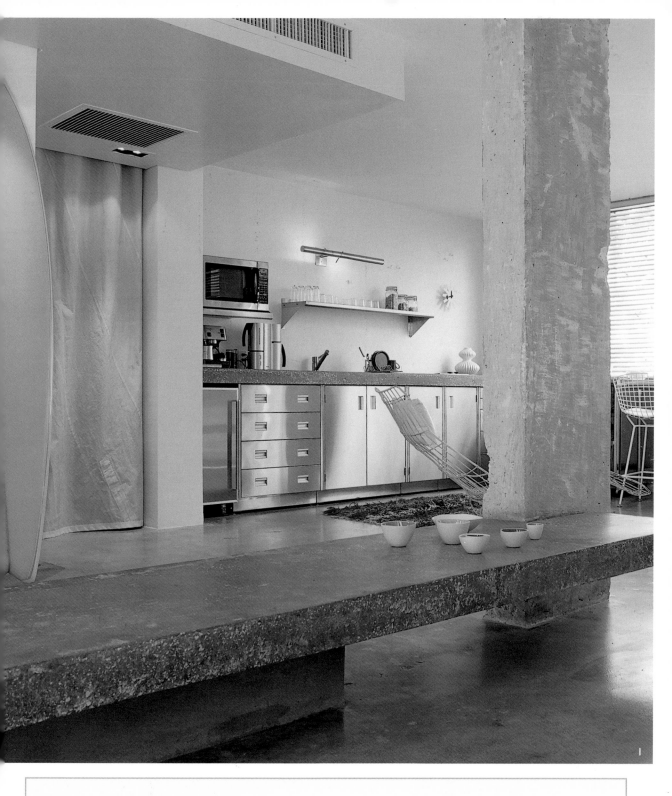

2 Architect: Rick Joy; Photographer: Undine Pröhl

1 Architect: Pablo Uribe; Photographer: Pep Escoda

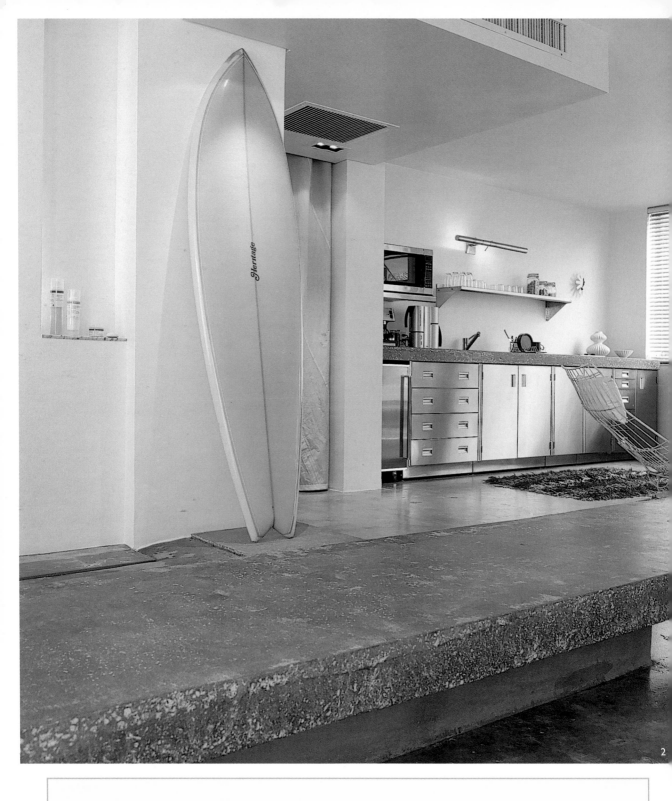

2, 3 Architect: Pablo Uribe; Photographer: Pep Escoda

The informal style of this loft is carried over into the kitchen area,
where the necessary elements were installed. The cabinets were reserved for the lower areas.

4, 5 Architect: Pablo Uribe; Photographer: Pep Escoda

5

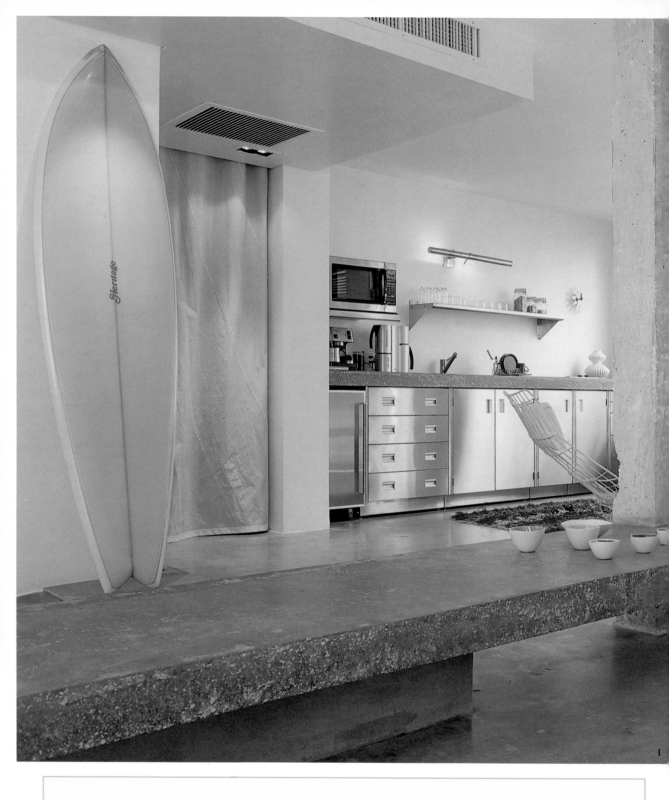

1, 2 Architects: Mackay-Lyons; Photographer: Undine Pröhl

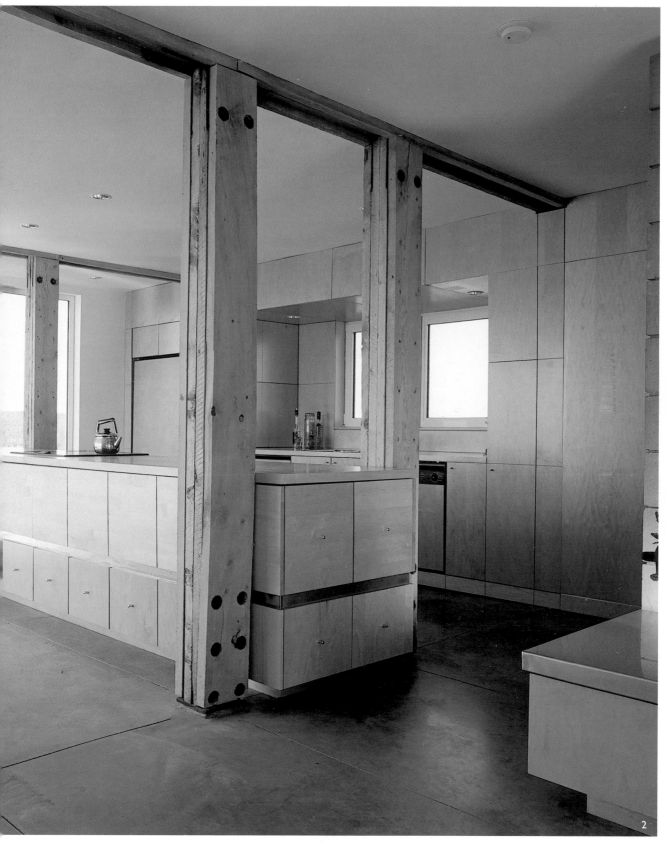

2

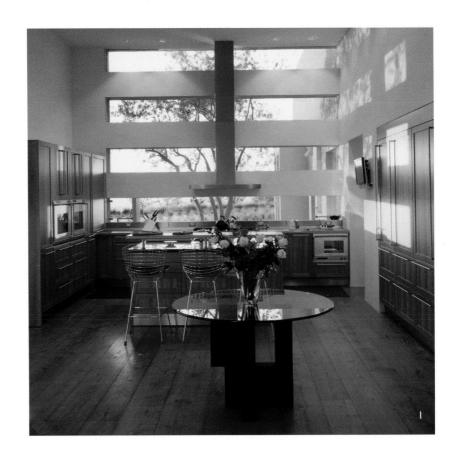

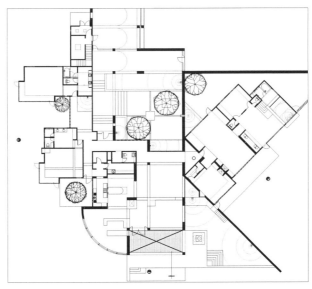

Ground floor plan

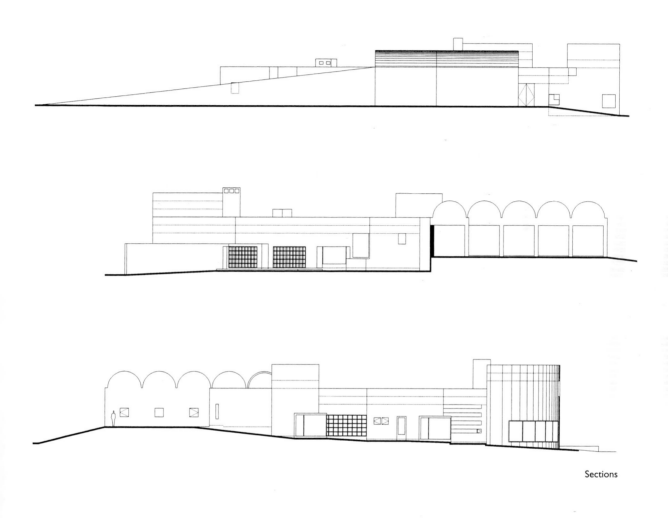

Sections

I Architects: Legorreta+Legorreta; Photographer: Lourdes Legorreta

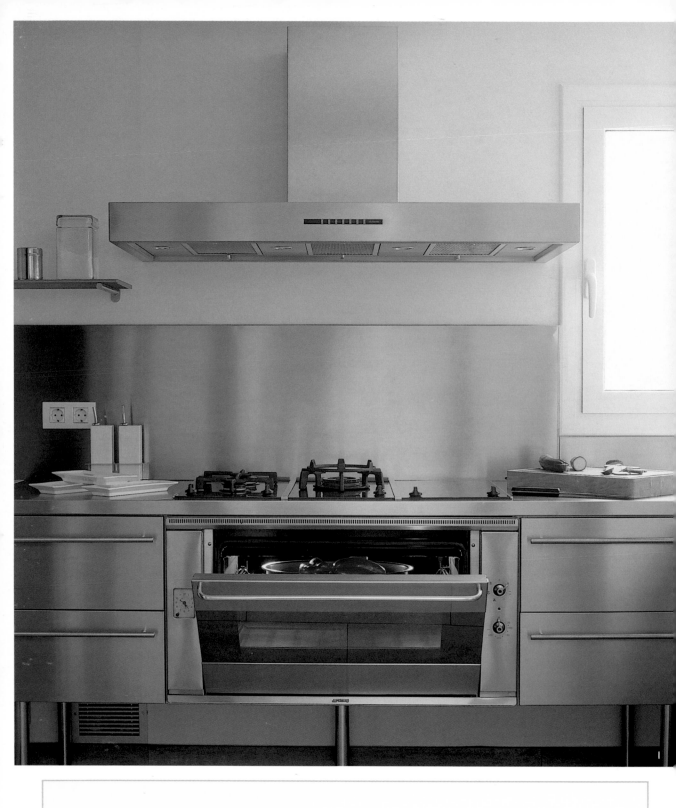

1, 2, 3 Interior Design: L'Eix; Photographer: José Luis Hausmann

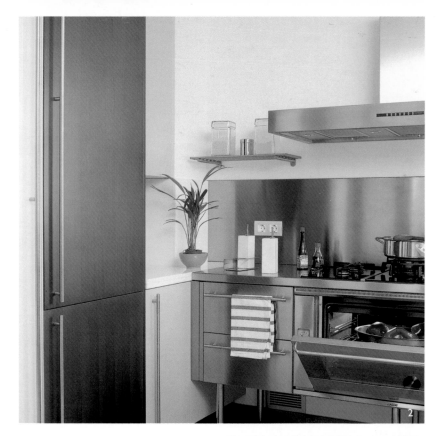

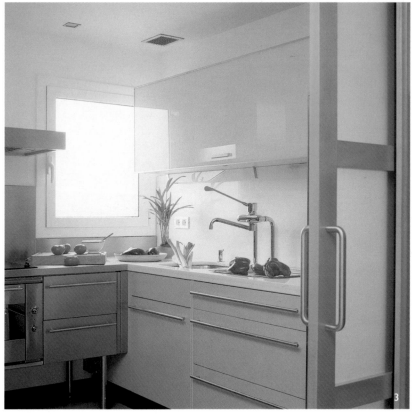

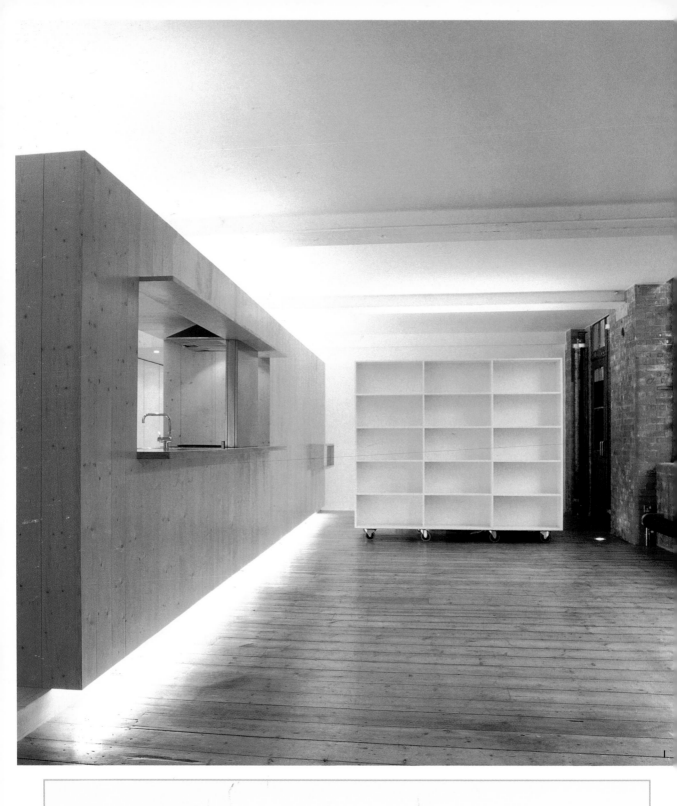

This kitchen was separated by covering the walls with wood, creating the illusion of an independent space.

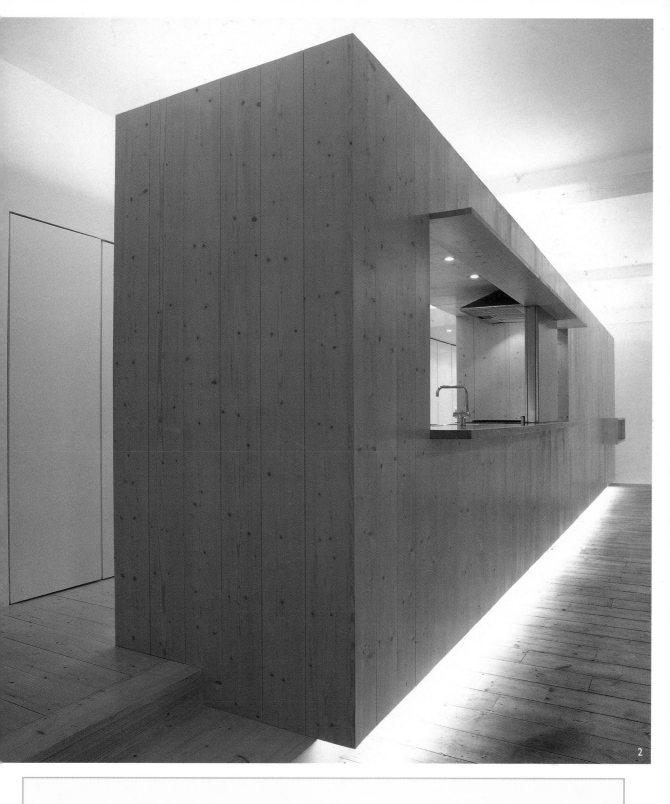

2

1, 2 Architects: Simon Conder Associates; Photographer: Peter Warren

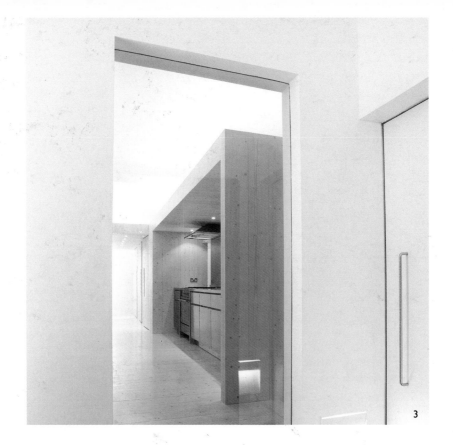

3

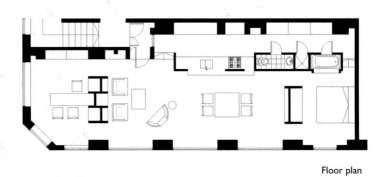

Floor plan

3, 4 Architects: Simon Conder Associates; Photographer: Peter Warren

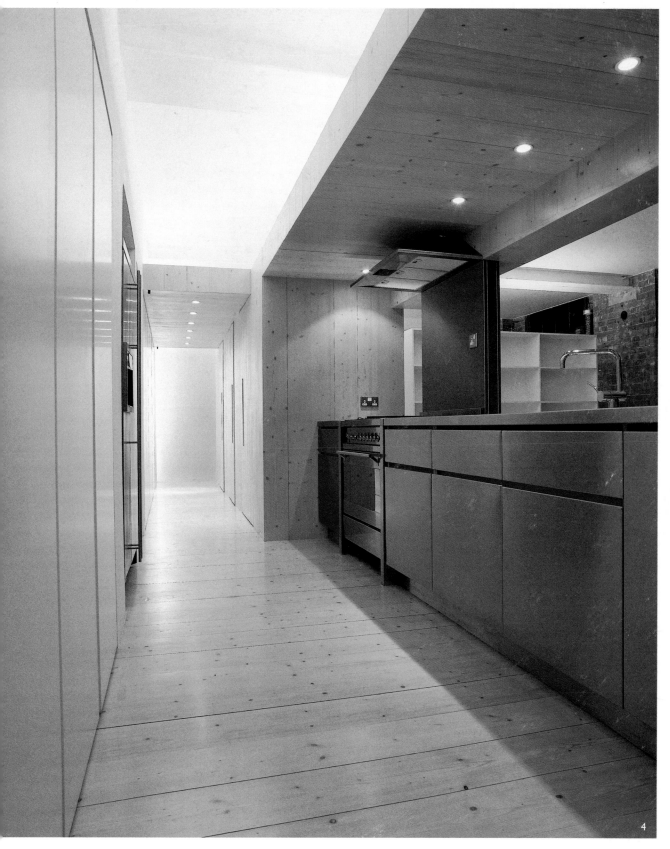

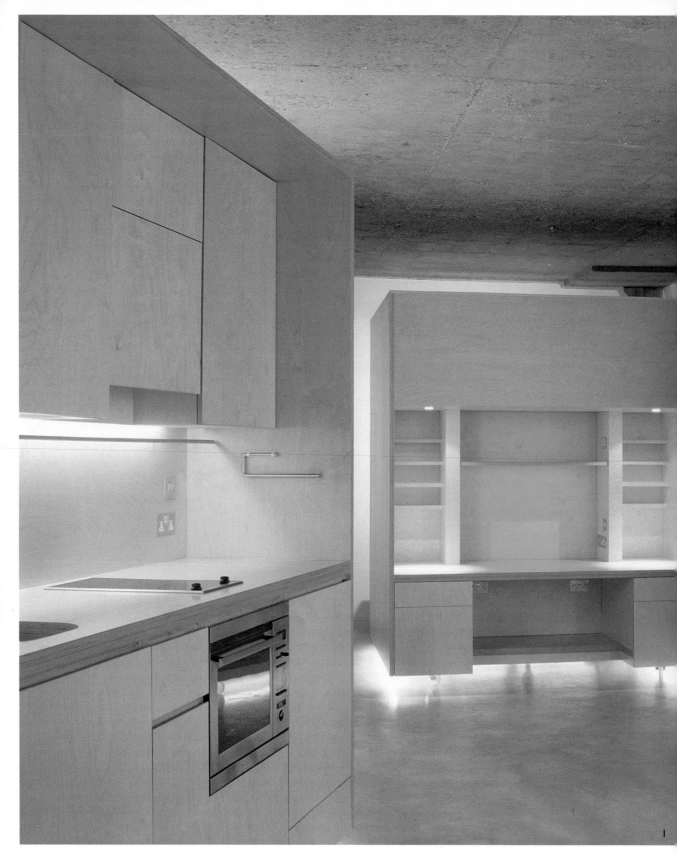

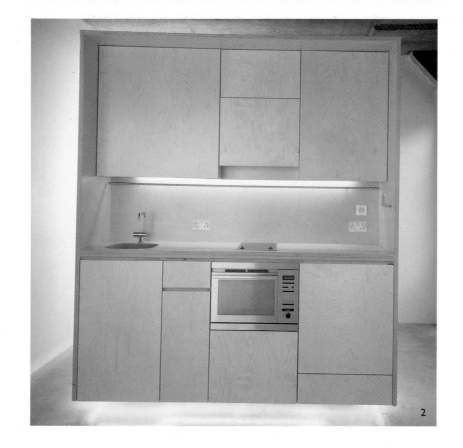

2

Floor plan

1, 2 Architects: Simon Conder Associates; Photographer: José Lasheras

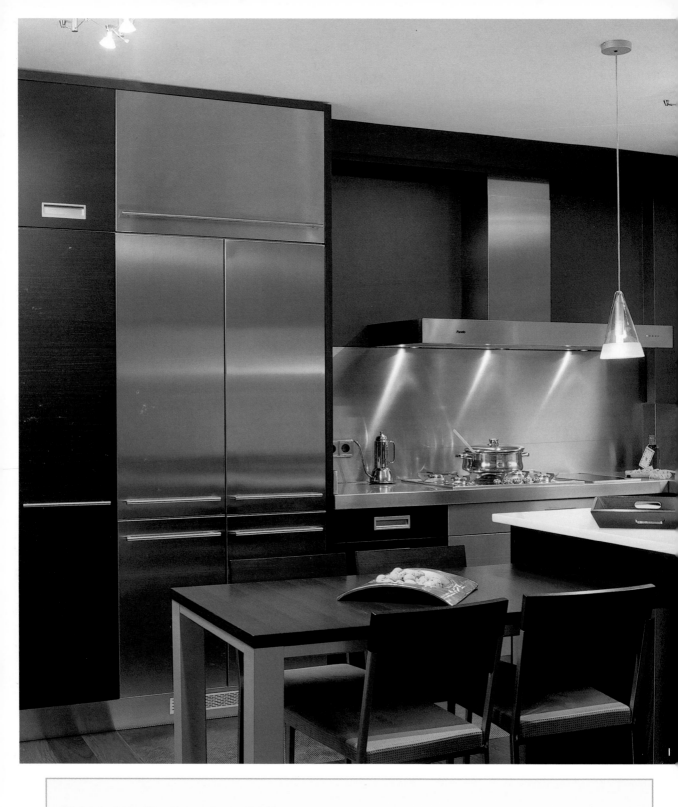

1, 2 Interior Design: L'Eix; Photographer: José Luis Hausmann

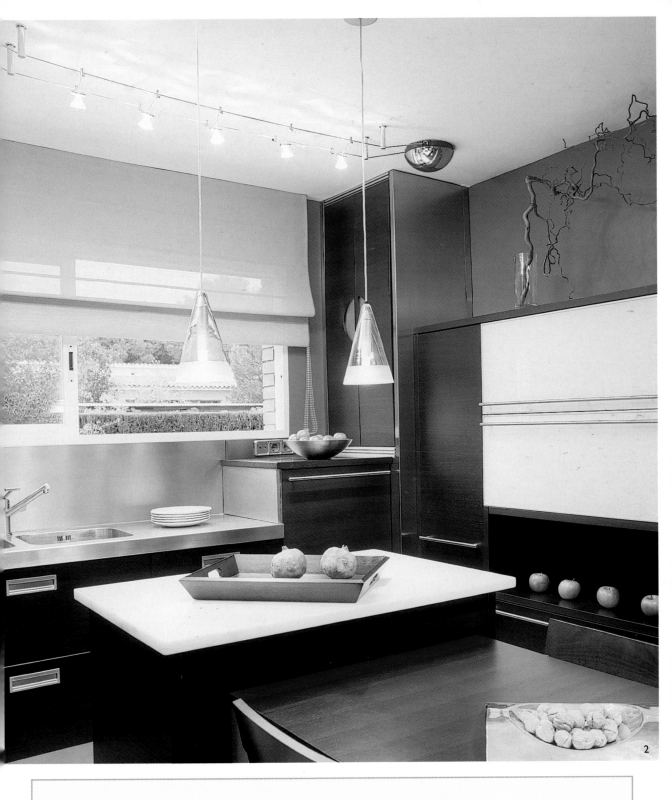

2

The combination of metal and dark wood balances the warmth and coldness of this kitchen setting.

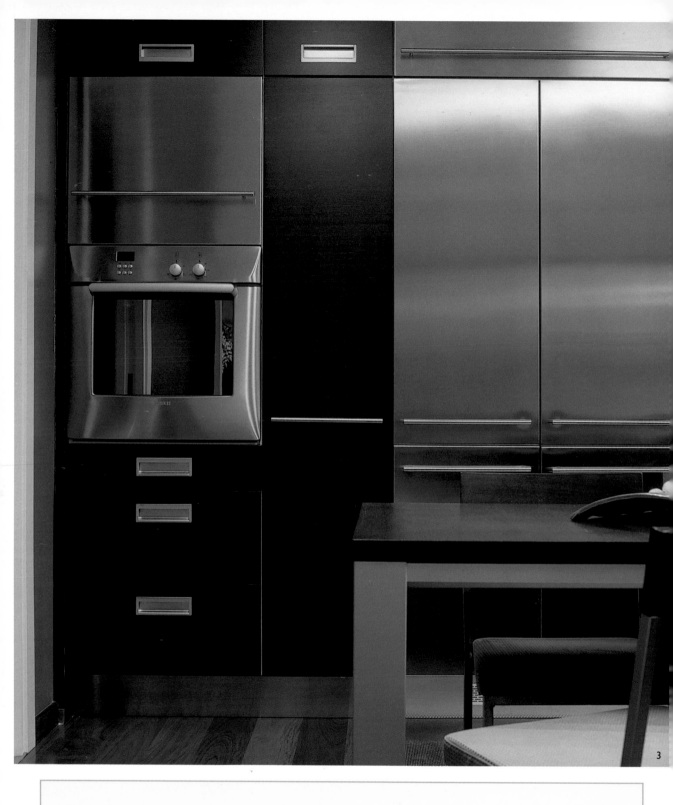

3

3, 4, 5 Interior Design: L'Eix; Photographer: José Luis Hausmann

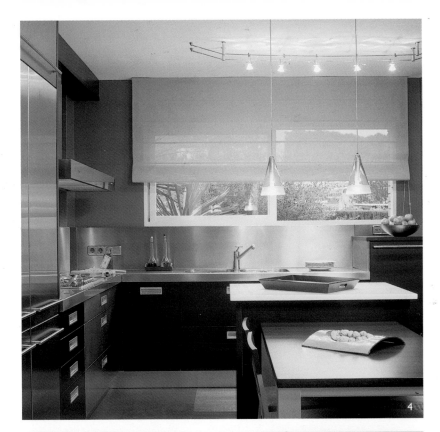

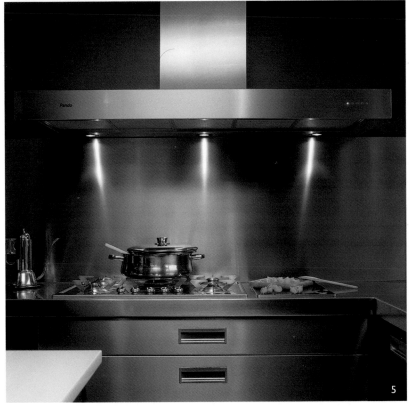

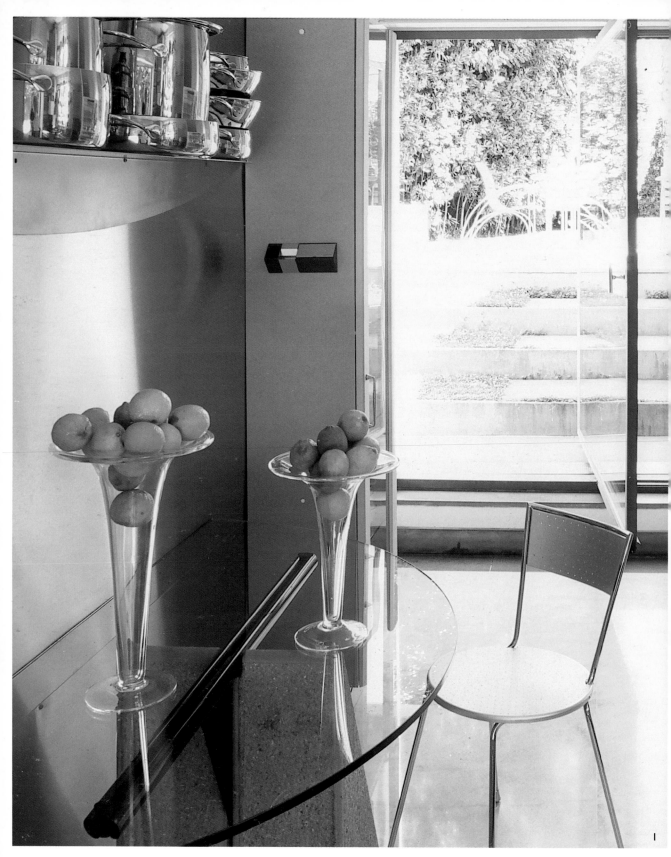

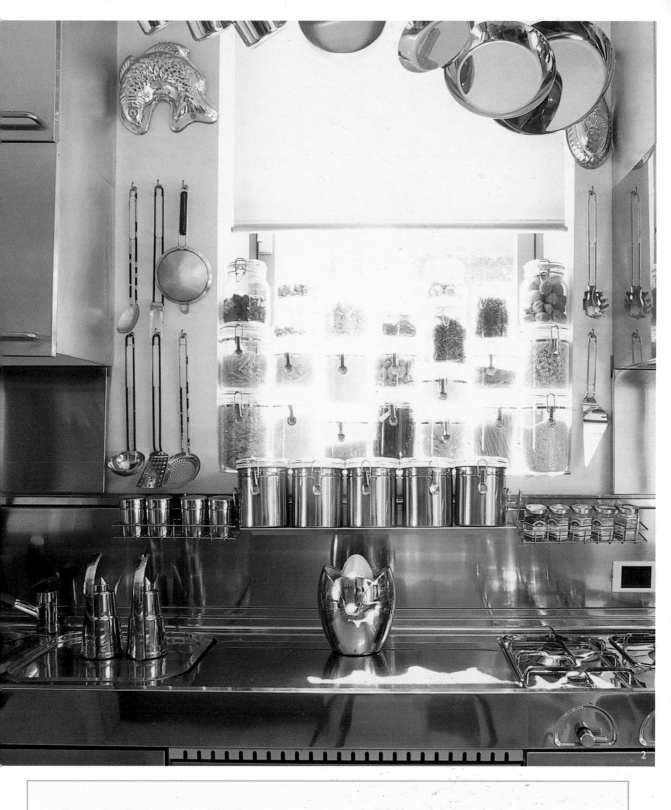

2

1, 2 Photographers: Guy Bouchet & Ana Cardinale

Ground floor plan

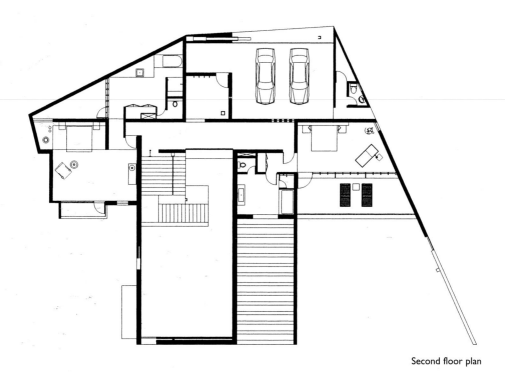

Second floor plan

I Architects: Legorreta+Legorreta; Photographer: Katsuhisa Kida

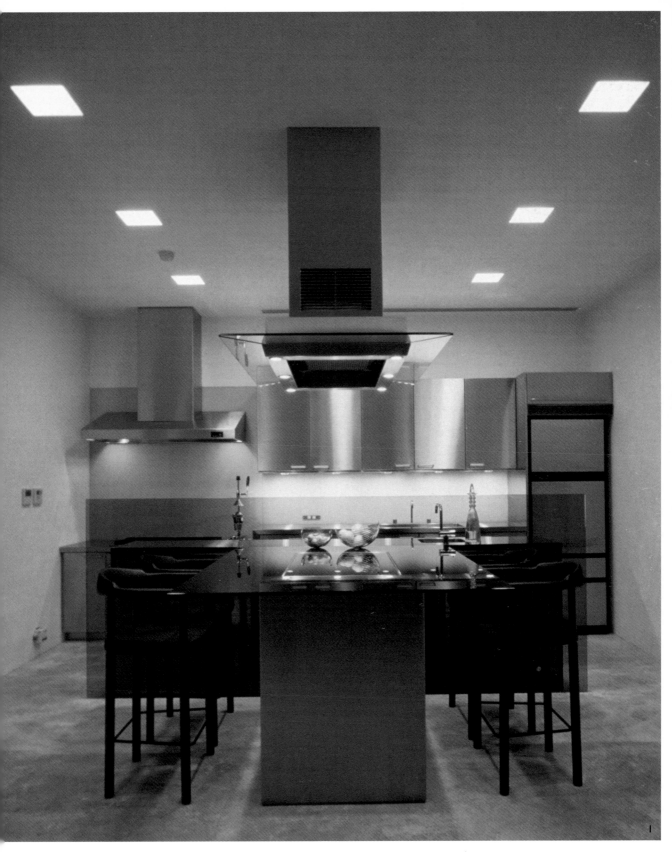

Designs for the Twenty-First Century

THE new designs that kitchen manufacturers have recently launched on the market demand the innovative use of color and different combinations of materials. The retro aesthetic continues to be incorporated into appliances, along with very cutting-edge, functional designs.

Manufacturers continue to investigate storage solutions that are simultaneously aesthetically pleasing, original, and in keeping with the residents' needs. To facilitate the integration of accessories into the kitchen, manufacturers are producing sufficiently versatile and even interchangeable pieces so that owners can select what they want without having to buy an entire suite of items. Modular kitchens accomodate this contemporary social need and thus have proven popular, since they allow for greater flexibility in their spatial arrangement.

Special attention is also devoted to the design of ovens and cooktops that facilitate work in the kitchen, saving the client time and effort, and to common kitchen components, such as dishes, bottles, and teapots, which are both decorative and functional.

Closets

Extractor Hoods

Ovens

Countertops

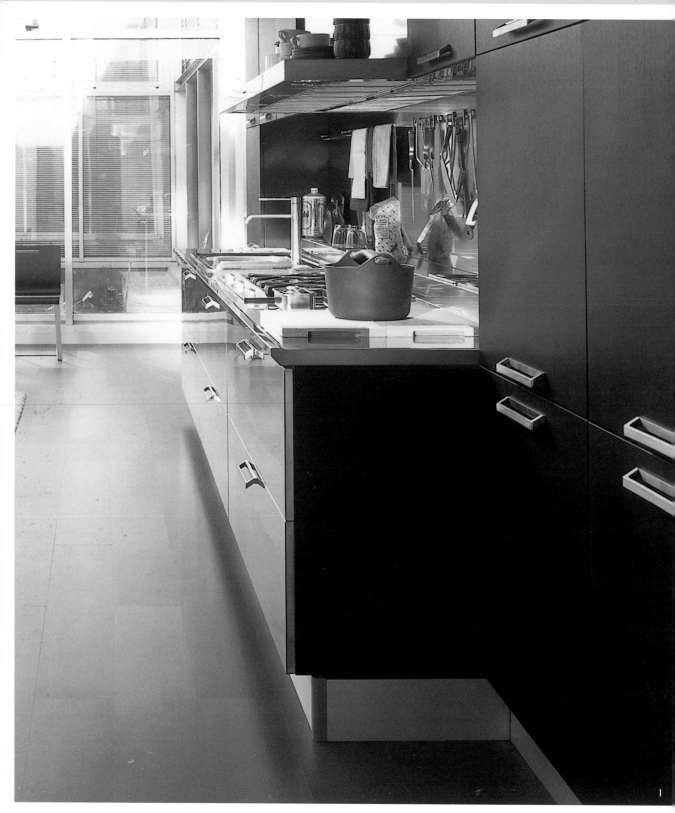

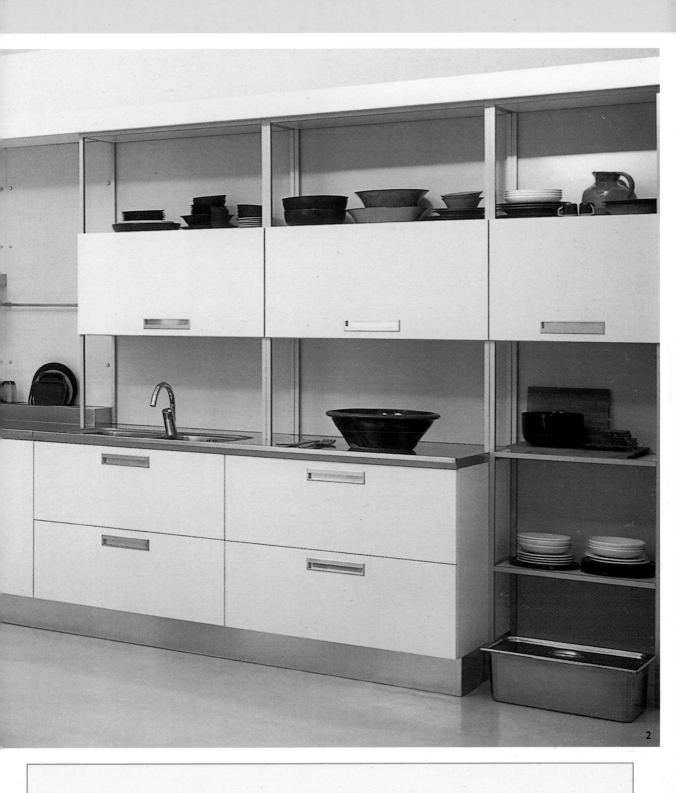

1, 2 Soya by Elam

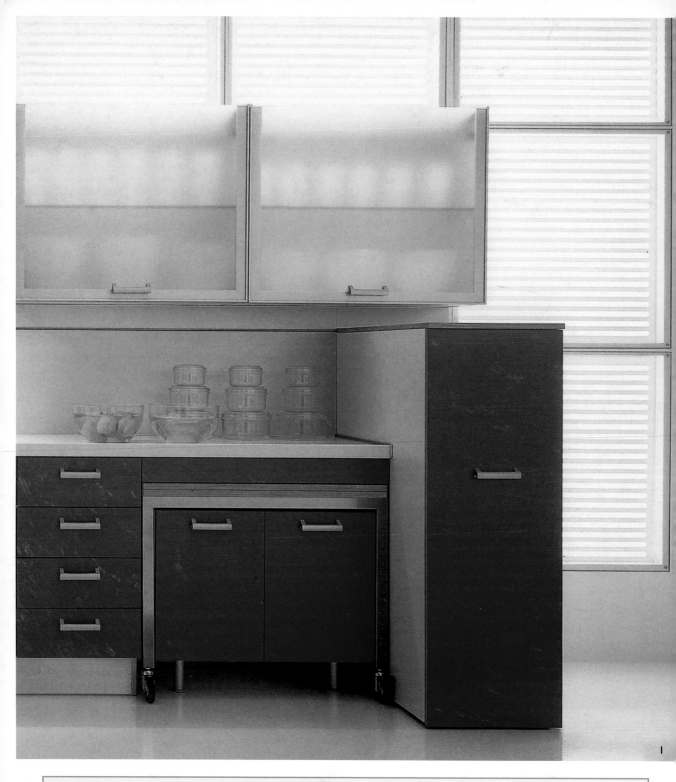

1

1 Basic System by Elmar Cucine; Designers: Adriani & Rossi Edizioni

2 Regula System by Binova; Designers: Paolo Nava & Fabio Casiraghi

3 Boffi

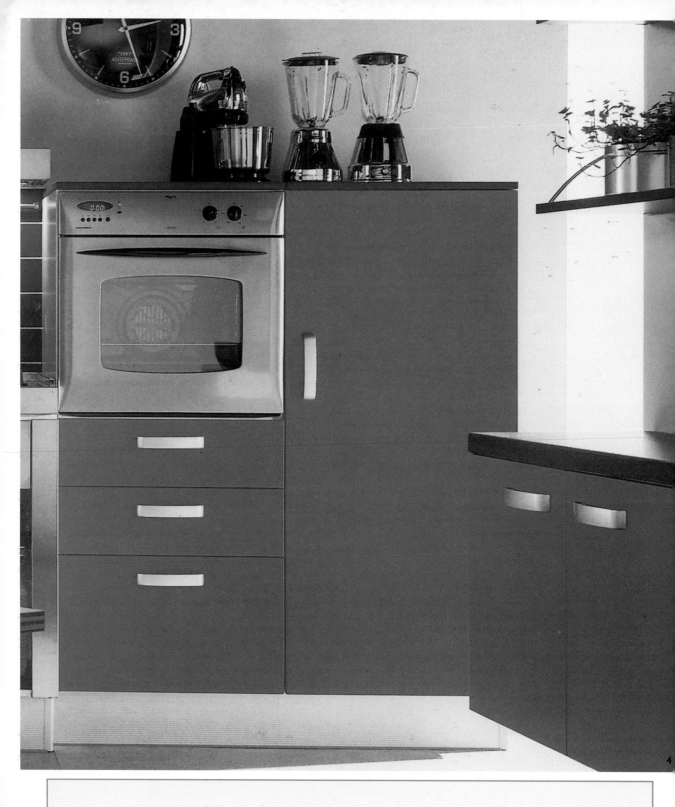

4

4 Class by Berloni Cucine

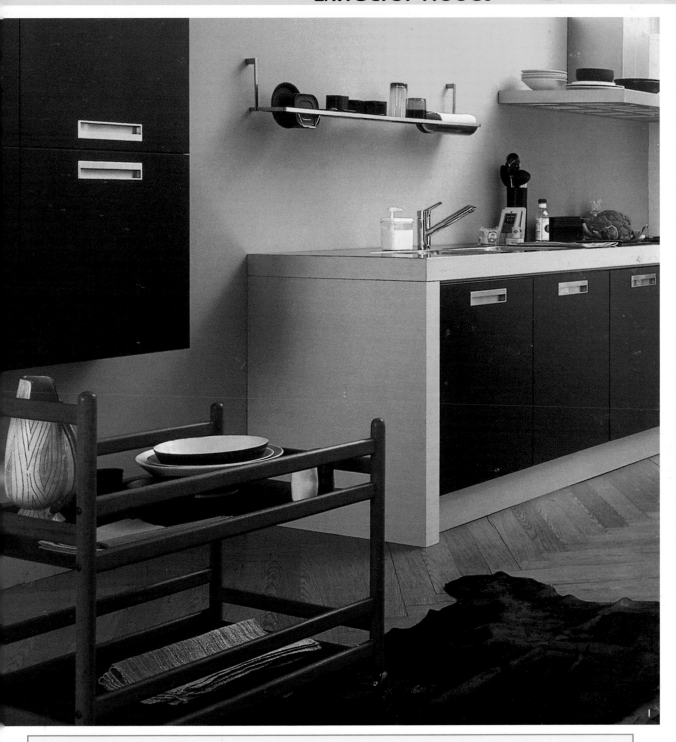

I Soya by Elam

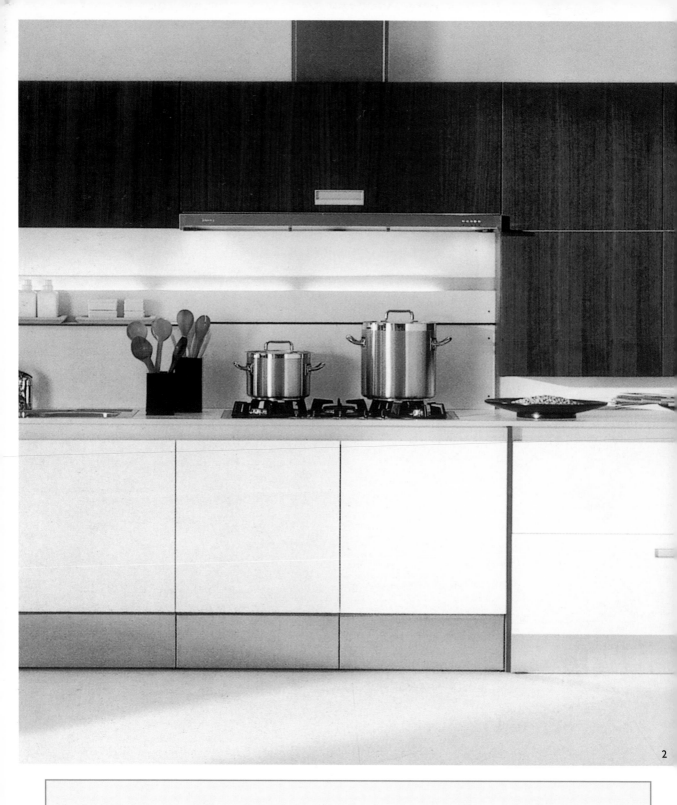

2

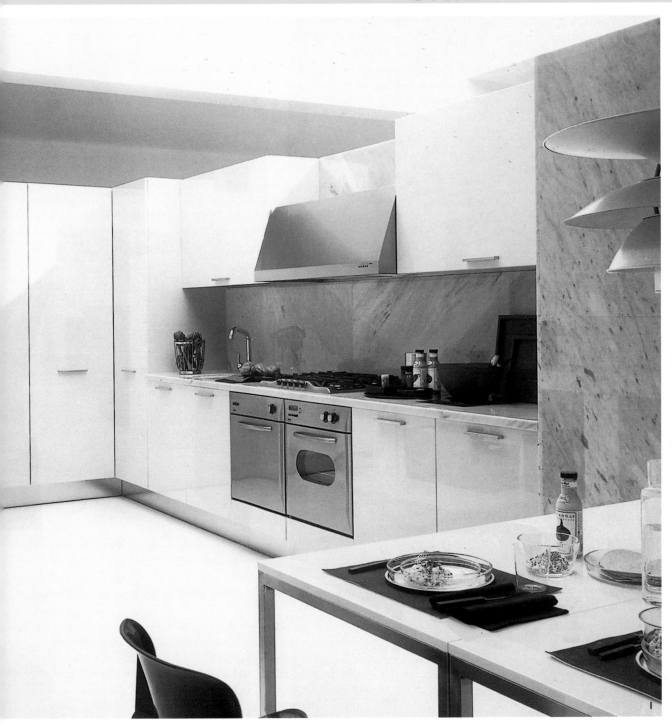

1 Soya by Elam

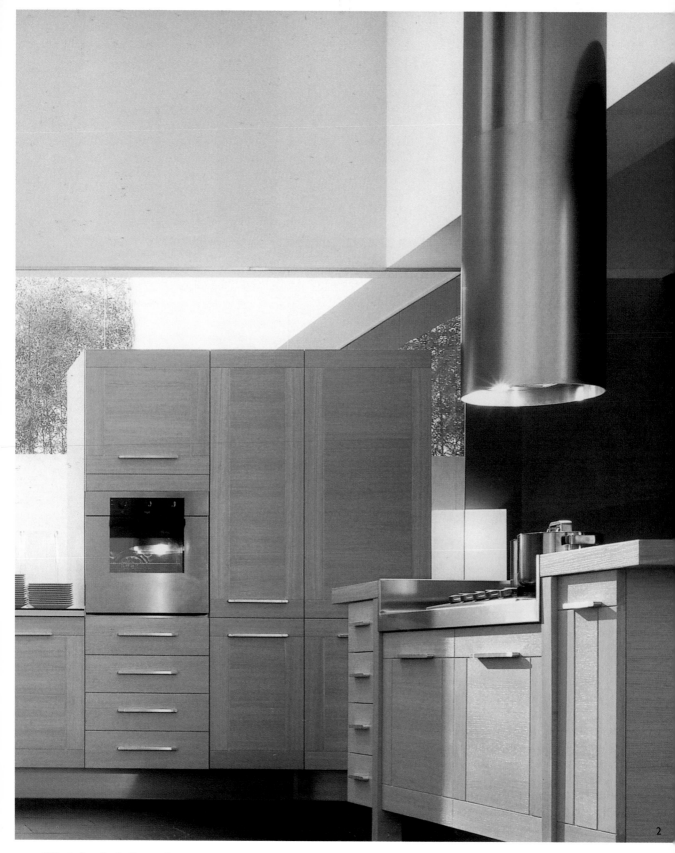

2

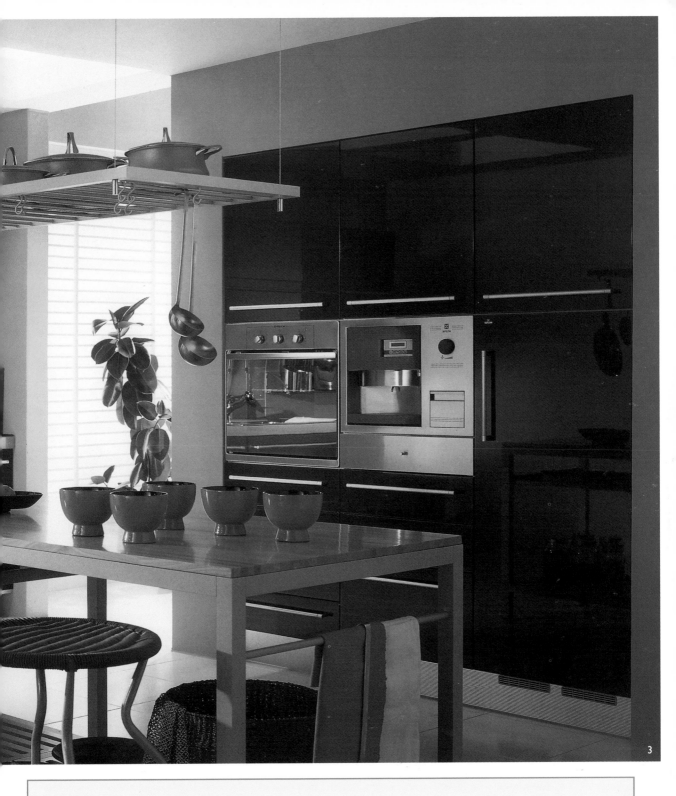

2 Kila by Elmar Cucine; Designer: G.V. Plazzogna

3 Cromatica by Berloni Cucine

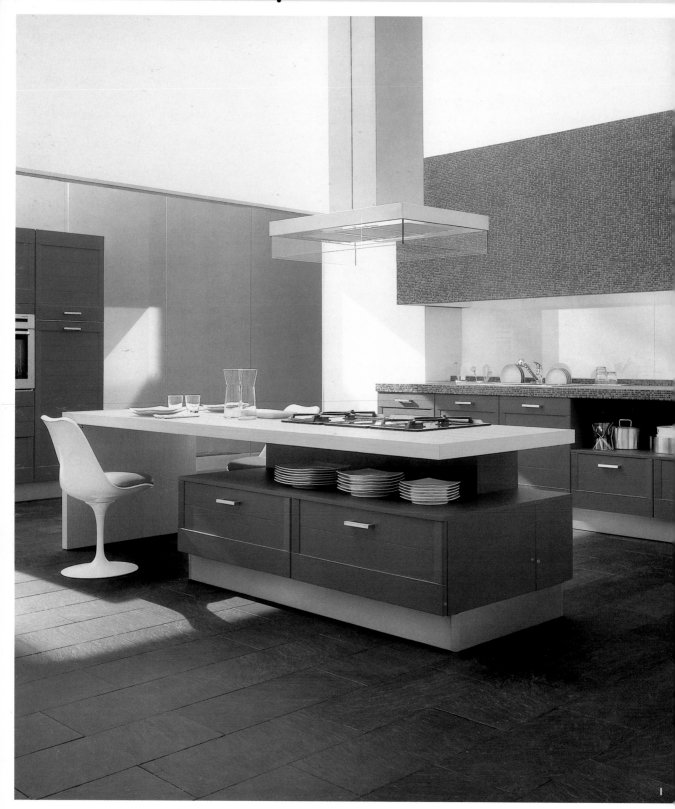

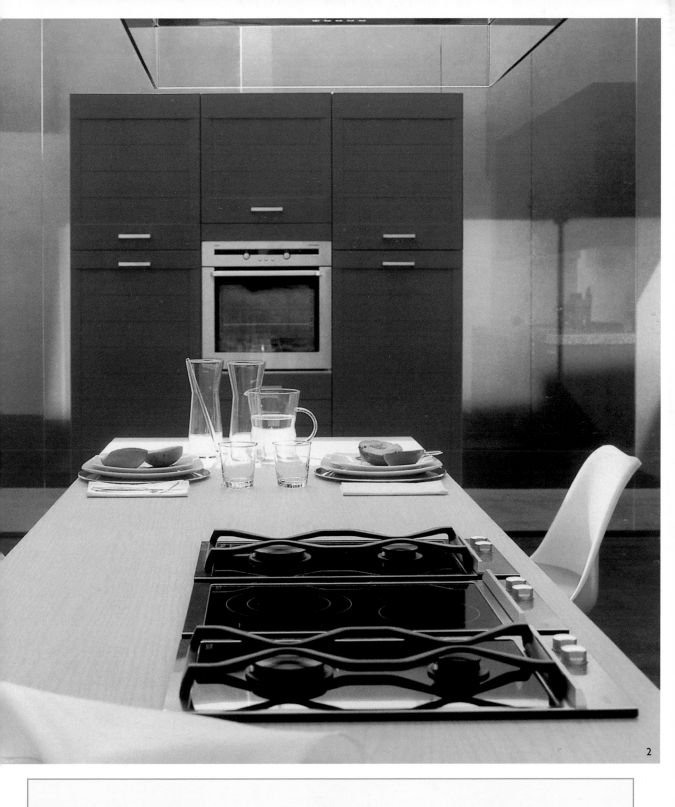

2

1, 2 Rgl by Elmar Cucine

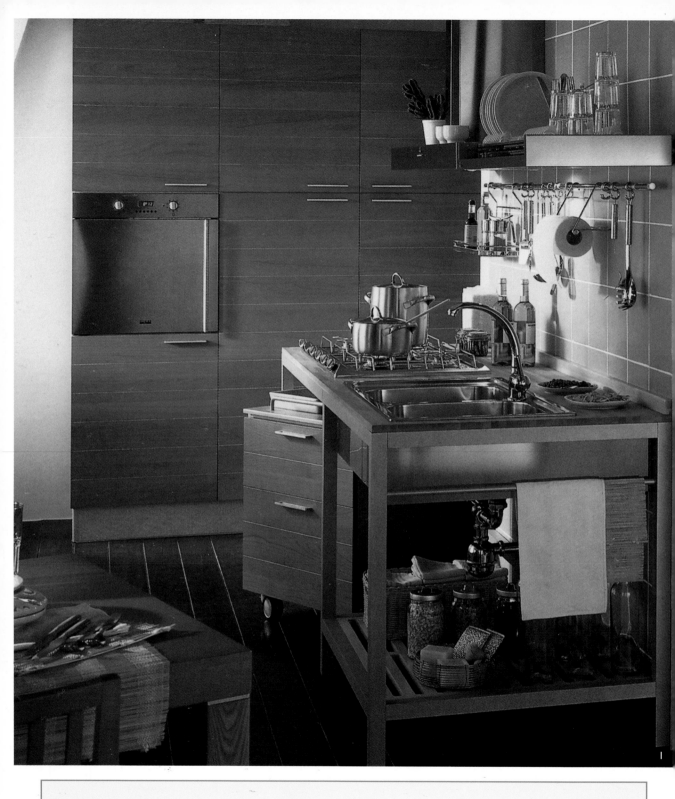

1 Ladoga by Berloni Cucine

2 Artica by Berloni Cucine

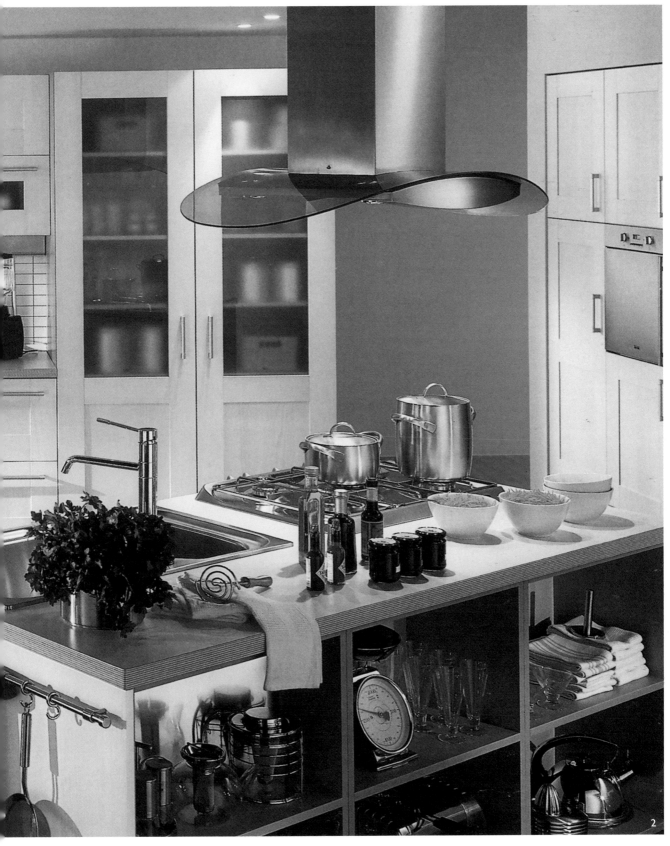

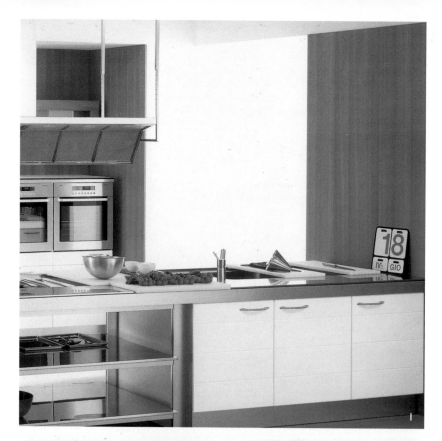

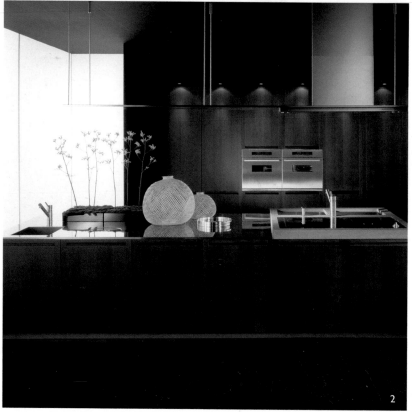

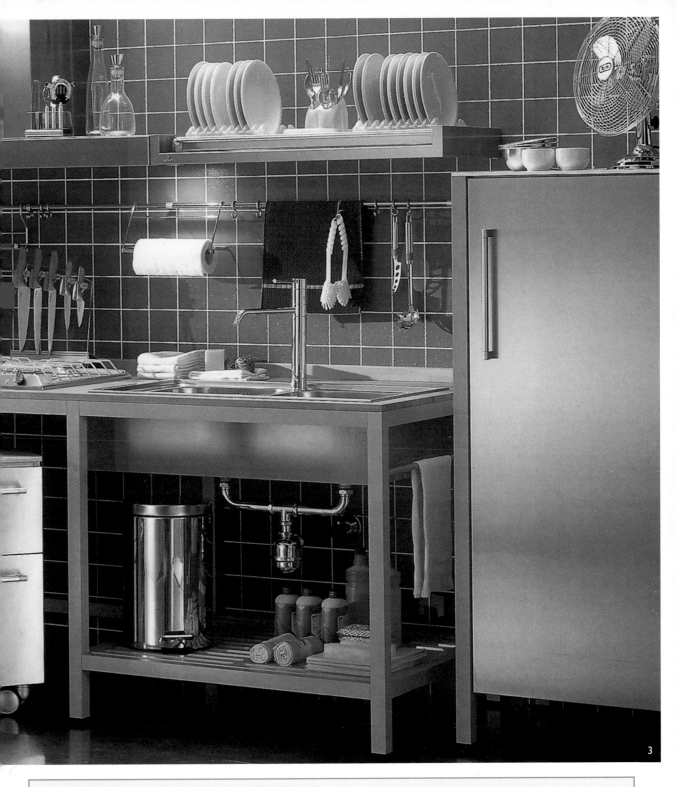

1 Sistema Prima by Binova; Designer: Paolo Nava & Fabio Casiraghi

2 Boffi

3 Cromatica by Berloni Cucine

Manufacturers Directory

www.binova.com

www.elmarcucine.com

www.elam.it

www.berloni.it

www.boffi.com

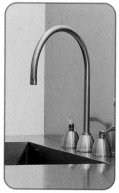